The Musée Picasso,
Paris

The Musée Picasso, Paris

II Drawings
Watercolours
Gouaches
Pastels

Catalogue Michèle Richet
Honorary Conservateur en chef

With 1840 illustrations, 41 in colour

Thames and Hudson
Editions de la Réunion des musées nationaux

Translated from the French
Musée Picasso: Catalogue sommaire des collections II
by Augusta Audubert

Photos (except where otherwise stated):
Réunion des musées nationaux, Paris

Printed and bound in Spain by La Polígrafa, S. A.
Parets del Vallès (Barcelona)
Dep. Leg.: B. 25.886 - 1988

Contents

Pablo Picasso
1881–1973

'My whole life has consisted simply of loving.
If there were no one left in the world,
Then I would love a plant, or a door-knob.
Life without love is inconceivable.'

Picasso, *Le Patriote*, 30 October 1961

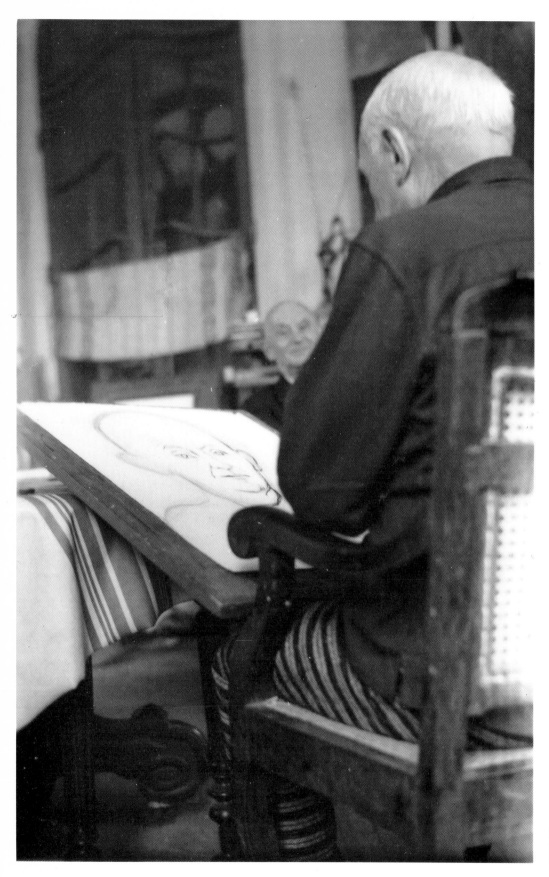

Picasso drawing Daniel-Henry
Kahnweiler's portrait, Cannes, 1957
(Photo Jacqueline Picasso)

The Collection of Drawings in the Musée Picasso

It is through his drawing that we can trace the essential image of Picasso.

CHRISTIAN ZERVOS[1]

If I had to make a choice from his entire output, I would unhesitatingly select his drawings.

HENRI MICHAUX[2]

A born 'master', to use the term of Daniel-Henry Kahnweiler,[3] Pablo Picasso could draw before he could talk. Several of his friends have quoted his comment on drawings done by twelve-year-old children: 'I never did any. At their age I could draw like Raphael.'

It would be inappropriate here to go into the history of Picasso's drawings. This has been discussed in a considerable number of publications, both books and prefaces to catalogues. Each text throws its own new light on the subject. Werner Spies has recently put together an outstanding selection of drawings and gouaches in Tübingen and Düsseldorf, heralding their appearance in an important introduction. Besides Jean Leymarie's *Picasso, dessins*, which is quoted here several times in the texts introducing each section, major studies by Maurice Jardot and Christian Zervos make essential reading if we are to understand the artist's work.

The purpose of this publication is to present the museum's collection as a whole and to explain how it was established. This is no 'fairy-tale museum' in which Picasso's major drawings have been brought together; it is essentially a collection of works selected from the artist's estate by way of a settlement. Dominique Bozo explains the motives governing that selection in the preface to the first volume: 'to keep the large compositions and not to break up sets, such as sketchbooks, subsidiary sheets, details, models and studies for the ballet. This was done deliberately and at the cost of abandoning some outstanding examples.'[4] This concise catalogue presents those choices, showing the soundness of judgment with which they were made. The museum's collection of Picasso's drawings is not confined to the 1,481 pieces of work done on loose sheets. There are in addition 33 notebooks full of sketches which will be examined in a subsequent volume, as well as drawings which were not done on paper and which have therefore been included in Volume I.[5] Likewise, it is impossible to convey a complete idea of Picasso's graphic art without including his *papiers collés*.[6]

Nearly all the drawings came directly from the artist's studio, and are therefore those which for one reason or another he had kept. Without further information or evidence we can only speculate for the moment on the reason why such important work was found to have been in Picasso's possession at his death. In both quality and quantity it was totally unlike what is usually to be found tucked away at the back of an artist's studio.

Taking into account both coincidence and a possible wish to set up his own personal museum, there is probably also a complex mixture of commercial, sentimental and aesthetic motives involved. At certain times in his life Picasso sold more work than at others, and he tended to sell his paintings rather than his drawings. However, the small number of drawings done in his later years which remained in his possession can probably be explained by the fact that such works were broken up for exhibitions at the Galerie Leiris.

Picasso obviously wanted to keep his own images of loved ones, or sketches which brought back precious memories. He also seemed anxious to keep those pieces he saw as 'landmarks'. According to the contractual letter sent by the artist to his dealer D.-H. Kahnweiler on 18 December 1912,[7] drawings 'which I deem necessary for my work' were to be exempt from exclusive rights of sale. Werner Spies writes: 'While we do not have concrete evidence

(1) C. Zervos, *Dessins de Pablo Picasso*, p. ix.
(2) Quoted from the Introduction, *90 dessins et œuvres en couleur*, Basle, 20 November 1971–15 January 1972.
(3) D.-H. Kahnweiler, Preface to the exhibition 'Picasso. Dessins 1903–1907', Paris, Galerie Berggruen, 1954.
(4) Cf. D. Bozo, cat. I, p. 13.
(5) Cf. cat I, nos 66, 68, 69, 70, 124, 124a, 141, 150.
(6) Cf. cat. I, pp. 115–127.
(7) Quoted by I. Monod-Fontaine in the catalogue for 'Donation Louise et Michel Leiris. Collection Kahnweiler-Leiris', Paris, Pompidou Centre, 22 November 1984–28 January 1985, p. 170.

regarding Picasso's personal opinion of the role drawing played in his work, a glance at those series of infinite variations he created gives us sufficient proof that he discovered his new forms through drawing.'[8] He was referring to *Trois femmes* (*Three Women*), but the application can be extended.

The collection brought together in the Musée Picasso is unique, and it is essential to an overall understanding of the artist's work. Henceforth it will be difficult to study, for example, *Les Demoiselles d'Avignon*, the major compositions of the following year, Cubism, Picasso's work for the theatre, Surrealism, his stay at Juan-les-Pins in the spring of 1936, *L'homme au mouton* (*Man with a Sheep*) or '*Les Femmes d'Alger' d'après Delacroix* ('*The Women of Algiers' after Delacroix*) without reference to the museum's holding.

The Cubist drawings put on show when the museum first opened and the Surrealist drawings subsequently exhibited in the summer of 1986 have demonstrated the value of presenting works in a coherent sequence, enabling useful comparisons to be made.

Despite the emphasis on sequence, however, it must not be forgotten that Picasso's drawings were very often done independently and planned as an end in themselves, just like the paintings. The catalogue, which contains photographs of several masterpieces,[9] illustrates this point splendidly. It is particularly rich in examples from the series of works created in the Boisgeloup period. This was one of the times when the artist's personal life, disguised, in the words of Maurice Jardot,[10] as 'mythological fiction', played an especially significant role. It was during this period that he confided to Tériade: 'The works I create are a way of keeping a diary.'[11] At the risk of oversimplifying, it could be said that until then Picasso had depicted what he saw, for example everything surrounding him in his youth, or ideas he conceived, such as the Cubist compositions. From the thirties onwards he portrayed what he felt. Describing the selection made by the artist for the exhibition at the Musée Réattu in Arles in 1957, Douglas Cooper writes of: 'thirty-eight superb drawings of major importance; singling them out from so many other splendid pieces in the same portfolios was a task requiring much thought.'[12] He thus confirmed both Picasso's personal interest in his drawings and his knowledge of his own collection.

Why, then, were so many drawings kept under wraps? We must take care not to leap to hasty conclusions. The vast majority have now in fact been published or exhibited. They have been acclaimed as some of the artist's most important works and are featured in several publications.

Each drawing is worthy of careful study.[13] In each case size is a distinguishing characteristic, as is their 'function'. They range from the rough sketch drawn quickly from life to painstakingly detailed compositions. The drawings are done on canvas, cardboard, wood and in the majority of cases on paper of various textures, on loose sheets or in notebooks. Picasso is well known for having drawn on every available surface. Although the museum does not possess examples of pieces of restaurant tablecloths, it does own some fine drawings done on the backs of and inside envelopes (for example, cat. 15, 1025, 1081). The artist did not limit his use of newspapers to the *papiers collés*: he sketched on pieces of newspaper (cat. 131, 132) and used photographs published in the daily papers as a basis for new compositions.

Picasso worked with a wide range of drawing materials, sometimes using one medium at a time, sometimes mixing them – pencil, black chalk, coloured crayons, charcoal, chalks, inks applied with a brush or pen, tinted wash, watercolour, gouache, pastels and red chalk. Various techniques were used with each medium. Thus by virtue of his own highly individual style of drawing Picasso created an enormous range of expression, in which the subtle play of light and shade has a very special significance.

It is equally important to note the great variety of subject matter. Certain themes stand out as being particularly dear to the artist: the woman gazing at herself in a mirror, the man watching over a sleeping woman (or vice versa) and the painter (or sculptor) and his model.

For all the wealth it contains, the collection is still incomplete, a fact which Dominique Bozo does not attempt to conceal.[14] It is most notably lacking in drawings done by the artist towards the end of his life.[15] However, the Musée Picasso's collection of graphic art seems destined to grow and reach completion. As it already stands, it is a truly remarkable treasure.

'If he felt like painting and was prevented from doing so he drew furiously, incessantly, with anything, on anything – on the back of theatre programmes, on the walls, on the ground, on sandy paths in parks, on marble-topped tables in cafés . . .'
Jaime Sabartés

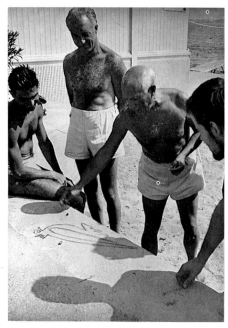

Picasso drawing on a wall at Golfe Juan, about 1950
(Photo Michel Mako, Nice)

(8) W. Spies, *Picasso: Pastels – Dessins – Aquarelles*, Paris, 1986, p. 24.
(9) A selection of these was presented on the publication of the catalogue.
(10) Maurice Jardot, *Pablo Picasso. Dessins*, Paris, 1959, p. x.
(11) Picasso to Tériade (quoted in *L'intransigeant*, 15 June 1932).
(12) 'Picasso. Dessins–Gouaches–Aquarelles. 1898–1957', Arles, Musée Réattu, 6 July–2 September 1957, Introduction by D. Cooper.
(13) According to Sabartés ('Documents iconographiques', no. 52), two of the figures in *Autoportraits et études* (*Self-portraits and Studies*, cat. 13) were drawn by Pallarés, and some sketches on the backs of pieces of paper, for example 920a, were not by Picasso.
(14) D. Bozo, op. cit., p. 14.
(15) In the interests of the national heritage, it should be noted that Picasso made a very generous donation to Arles in 1971.

Acknowledgments

I should like to express my particular gratitude to Pierre Georgel, Conservateur en chef of the Musée Picasso, who very kindly asked me to complete this work when it was interrupted by my departure from the museum. His encouragement made my task much easier.

I am grateful to Brigitte Leal, who is responsible for the collection of graphic art, and to Hélène Seckel, in charge of museum publications. Both have given me much advice and support.

I should also like to thank the following for their invaluable assistance: Brigitte Baer, Véronique Balu, Marie-Laure Bernadac, Laurence Berthon, Maria Bohusz, Bernadette Buiret, Marie-Hélène Breuil, Pierre Daix, Ludovic Ginguay de Beaugendre, Elzbieta Grabska-Wallis, Christopher Green, Monique Grémy, Catherine Hutin, Maurice Jardot, Gérald Lafond, Quentin Laurens. Edmée de Lillers, Isabelle Monod-Fontaine, Dianne O'Neal, Alexandra Parigoris, Claude Picasso, Christine Piot, Anne Roquebert, Maya Ruiz-Picasso, Yves Sangiovanni, Jonas Storsve, Dominique Taralon and Nicole Wild.

This catalogue was produced in collaboration with Jean-Pierre Chauvet, who identified the techniques, and Paule Mazouet, responsible for technical supervision and the cover photograph.

M.R.

Notes

This catalogue covers the drawings done on loose sheets. The sketchbooks will be featured in Volume III of the catalogue.

Each piece of work is numbered, the numbers being referred to in the text, as was the case in Volume I. This number is followed by an 'a' when another drawing has been done on the back of the same sheet.

The captions give the inventory number of each work, preceded by the initials M.P. (Musée Picasso). Numbers alone correspond to drawings acquired by the museum under the settlement in 1979. Numbers preceded by a date indicate works acquired since, both those which have been freely donated and those subject to certain conditions.

The background material used is mentioned only if it possesses special characteristics, and the technique used on the back of a sheet is only mentioned if it differs from that used on the front. The words 'study for' followed by a title in inverted commas indicate that the drawing relates to another work; it is not always possible to know which predates the other.

Dating

Many of the drawings, particularly those done after 1920, were dated by the artist. Where this is not the case, dates have been given using information from the catalogues quoted as references. Dates of unpublished drawings are suggested whenever relevant factors have made this possible. The works are presented in chronological order, with a few exceptions due to new information which has come to light in the course of preparing this volume. In such cases, where the year the drawings were done is known but not the exact month, the works are grouped together at the end of that particular year. Dates and places given in square brackets are hypothetical.

Abbreviations

M.P. refers to the museum's inventory numbering.
Dimensions are given in centimetres: height × width.
Only inscriptions in the artist's own hand are given. They are printed in italics in the catalogue.

S. signed
D. dated
a. above
b. below
l. left
r. right
c. centre
Inscr. inscribed

References to Other Publications

These are quoted in the catalogue captions in chronological order:

Baer	Brigitte Baer, *Picasso peintre-graveur* (sequel to catalogues by Bernhard Geiser), Vol. III, 1935–1943.
Cat. I	*Musée Picasso, Catalogue of the Collections*, Vol. I, London and Paris, 1985.
Cat. of the Settlement	*Picasso, œuvres reçues en paiement des droits de succession*, Paris, 1979.
Cooper	Douglas Cooper, *Picasso: Theatre*, London and New York, 1958.
Christophe Czwiklitzer	*Les affiches de Pablo Picasso*, Basle and Paris, 1970.
D.B.	Pierre Daix, Georges Boudaille, *Picasso 1900–1906, Catalogue raisonné de l'œuvre peint*, Neuchâtel, 1966.
D.R.	Pierre Daix, Joan Rosselet, *Picasso: The Cubist Years, 1907–1916*, London, 1979.
Duncan	David Douglas Duncan, *Picasso's Picassos*, London and New York, 1961.
G.	Bernhard Geiser, *Picasso peintre-graveur*, Vol. I, illustrated catalogue of the engravings and lithographs, 1899–1931, Berne, published by the author, 1933–1955; Vol. II, *Catalogue raisonné* of the engravings and monotypes, 1932–1934, Berne, 1968.
Guide	Hélène Seckel, *Musée Picasso, Guide*, Paris, 1985.
M.	Fernand Mourlot, *Picasso lithographe*, Paris, 1970.
P.i.F.	Josep Palau i Fabre, *Picasso, 1881–1907, Life and Work of the Early Years*, Oxford, 1981.
S.	Werner Spies, *Picasso, Das plastische Werk* (Sculpture catalogue in collaboration with Christine Piot), Stuttgart, 1983.
T.l.o.p.[1]	Alberto Moravia, Paolo Le Caldana, Pierre Daix, *Tout l'œuvre peint de Picasso, périodes bleue et rose*, Paris, 1980.
T.l.o.p.[2]	Françoise Cachin, Fiorella Minervino, *Tout l'œuvre peint de Picasso, 1907–1916*, Paris, 1977.
Z.	Christian Zervos, *Pablo Picasso*, Paris, Vol. I, 1932 to Vol. XXXIII, 1978.

'Birth of a Genius': 1893–1906

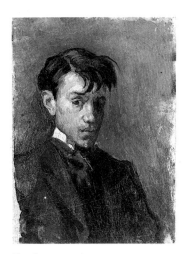

Fig. 1
Autoportrait (*Self-portrait*), 1896
Barcelona, Museo Picasso

(1) With a few rare exceptions, the drawings are undated. Places and dates have been given using information from the Zervos and Palau i Fabre catalogues for the early period, with advice from Maria Teresa Ocaña, and from the Daix Boudaille catalogue for the Blue and Rose Periods. When no information was available the Musée Picasso has suggested dates, using analogies or any supporting evidence available. For example *Etreinte* (*Embrace*, cat. 31), was drawn on the inside of an envelope posted in Barcelona on 9 March 1901 and addressed to Pablo in Madrid.

(2) Introduction to *Picasso. Œuvres reçues en paiement des droits de succession*, p. 15.

(3) See the catalogues for the Museo Picasso in Barcelona and the exhibition 'Der Junge Picasso' held at the Kunstmuseum, Berne, in 1984.

(4) W. Spies, *Picasso: Pastels – Dessins – Aquarelles*, p. 12.

(5) On the back of this drawing is an ink study with highlights in watercolour; the faces of the characters have been crossed out with purple ink. Jonas Storsve suggests that it could be a first rough sketch for *Science et charité* (*Science and Charity*, fig. 5).

The words of the title are those of Juan Eduardo Cirlot, while Alexandre Cirici Pellicer spoke of 'Picasso before Picasso'.

This preliminary chapter, featuring 122 drawings, covers the artist's early years: his childhood and adolescence, his first trips to Paris, his stays in Madrid, the Catalan period, his permanent move to France and his journeys to Holland and Gosol.[1] *Femme étendue* (*Nude Female Stretched Out*, cat. 122), given by Mr Guy Spitzer, and some portraits from the Apollinaire Collection (cat. 104–106, 108, 109) have been added. The Museo Picasso in Barcelona possesses a particularly fine collection of the artist's youthful works and, in the words of Dominique Bozo,[2] it seemed futile to 'enter into competition' with this when the settlement was being arranged. Our own holding is, however, of considerable interest, as was evident when certain drawings from the two museums were compared during the major exhibition organized by Jürgen Glaesemer at the Kunstmuseum in Berne in 1984.[3]

Independently of his sketchbooks, certain drawings done by the young Picasso reveal personal information which helps us to relate his life story. During his adolescence he sketched members of his family, his relatives in Barcelona and his poet friends in Paris, sometimes in caricature form. He noted a reference to a work by Alfred de Vigny along the margin of *Femme implorant le ciel* (*Woman Invoking the Heavens*, cat. 58), probably during a conversation with Max Jacob. His drawings also reveal his innermost thoughts: *La femme en prière au chevet d'un enfant* (*Woman Praying at a Child's Bedside*, cat. 17), which features sketches of his father on the back of the same sheet, would surely have brought back the memory of the death of his young sister Concepción three years earlier. Equally, we may wonder whether it is purely coincidental that Picasso should have drawn a crucified Christ on the back of *La mort du torero* (*Death of the Torero*, cat. 50), depicting a woman whose pitiful face is remarkably expressive.

We know that Picasso began drawing at a very early age. His father, José Ruiz Blasco, an art teacher, was on hand to give him the necessary technical advice, but he sent his son to the School of Fine Art in Corunna where he himself taught. From 1892 to 1894 Pablo studied decorative drawing and life-drawing and copied classical plaster casts. The study of Hercules (cat. 1) dates from this period; under his signature – then P. Ruiz – he added no. 11, his student number. Werner Spies writes: 'Picasso the artist clearly grew up as a child of the nineteenth-century academic tradition. It is equally clear that even before his contact with the avant-garde of his day he rebelled so strongly against that tradition that the rebellion itself reveals his true personality.'[4]

Picasso preferred drawing from life, and bullfights (see cat. 2, 3) were already firing his blood. With a keenness of observation and an energy of expression astonishing for a thirteen-year-old, he sketched characters and created his own illustrated periodicals: *La Coruña* (*Corunna*, cat. 4) and *Azul y Blanco* (*Blue and White*, cat. 5).

Some measure of psychological insight is already apparent in his early portraits – Lola going to school (cat. 6), for example, or his mother and sister embroidering (cat. 8)[5] – which are drawn with perfect accuracy and precision.

The portrait of Josefa Sabastia Membrado (cat. 14), done at Horta de Ebro where Picasso was convalescing at the house of his friend Pallarés in November 1898, displays the same technique. Here the use of black chalk creates simplicity and sharpness of line. The same medium is used for self-portraits (cat. 13, 13a), portraits of his father (cat. 17a), and a variety of studies drawn to different scales covering a sheet of paper (cat. 14a).

At the end of the nineteenth century Barcelona was an open-minded city rejoicing in a lively cultural life, where Modernist tendencies were influenced by the *Jugendstil*. Picasso soon joined the group of artists who frequented the famous Els Quatre Gats café, haunt of the avant-garde. Here he kept in touch with new ideas from abroad concerning the plastic arts, and discovered Forain, Gauguin, Munch, Steinlen and Lautrec, whose influence is evident in Pablo's entry for the Carnival Poster Competition of 1900 (cat. 18), announced in the review *Pel y Ploma*.[6] Their work was published in reviews such as *Arte Joven* (Madrid), to which Picasso contributed. It was at the Quatre Gats that he exhibited a set of portraits of his friends in February 1900. Among these were *L'homme barbu du profil* (*Bearded Man in Profile*, cat. 25) and *La lecture de la lettre* (*Reading the Letter*, cat. 26). The figures are very detailed and are drawn in a variety of media: black chalk, charcoal and oils; they are signed *P. Ruiz Picasso*.

Sabartés[7] contrasts the 'extremely limited' material means available to Picasso at that time with his 'highly developed' powers of analysis. It is not always easy to decide whether these early drawings were done in Barcelona, Madrid or Paris, as the subject matter is always similar: cafés, brothels and street scenes, which Picasso was able to depict with perfect accuracy thanks to his remarkable visual memory. Alongside these anecdotal pieces we already see evidence of a growing social and political awareness (cat. 42, 48) and scenes featuring lovers embracing. 'The sharpness of psychological and social observation gives way to human compassion, naturalist precision to poetic idealization. This signals the birth of the first independent and stylistically homogeneous phase, known as the Blue Period,' wrote Jean Leymarie.[8]

The Musée Picasso possesses the studies[9] for many of the major paintings now dispersed to museums and collections all over the world: *Evocation* or *Enterrement de Casagemas* (*Evocation* or *Burial of Casagemas*, fig. 6), following his friend's suicide; *L'entrevue, Les deux sœurs* or *Confidences* (*The Interview, The Two Sisters* or *Confidences*, fig. 8); *L'étreinte* (*The Embrace*, fig. 9); *La vie* (*Life*, fig. 10), showing Casagemas and his mistress Germaine; *La repasseuse* (*The Laundress*); and *Le couple* (*The Couple*). Some studies feature notations from which Picasso drew inspiration for paintings, such as *Le vieux juif* (*The Old Jew*, cat. 77). The collection also contains a number of drawings reflecting the emotion evidently felt by the artist when confronted with the misery of people he encountered, for example the mother embracing her child (cat. 57), the woman invoking the heavens (cat. 58, 59), the woman being strangled by a man (cat. 63) or crying out in her anguish, like the harrowing *Tête de femme* (*Head of a Woman*, cat. 65), drawn in brown and black ink. Having finally settled in Paris at the Bateau-Lavoir from April 1904, Picasso felt 'the need to refresh his eyes and senses with new visions, to depict characters not altogether free of tension, but in whom it was less apparent'.[10] The watercolour done in August 1904 (cat. 79) heralds the Rose Period.

His fascination with the figure of Harlequin, the nearby Medrano Circus and his meetings with the circus artistes outside performances inspired Picasso to make a particularly sensitive series of drawings, watercolours and gouaches, culminating in the major work on the theme of *Saltimbanques* (fig. 11), now in the National Gallery, Washington. Pepe Don José, the clown in the gouache *Bouffon et acrobates* (*Clown and Acrobats*, cat. 98), is the central figure. Christian Zervos[11] saw this work as Picasso's first major group composition,[12] the artist having previously 'limited himself to depicting single figures or couples'. The *Group of Saltimbanques* (cat. 99) might well have been an initial study for the painting.

One small sketch in the collection gives evidence of the trip to Holland Picasso made in August 1905, which helped to bring about his altered perception of art. The Musée National d'Art Moderne, however, holds the most important work of that period, the large gouache entitled *Les trois hollandaises* (*The Three Dutchwomen*, fig. 4).[13] These full-blooded women are totally removed from the emaciated figures of the Blue Period.

Sales of his work from the Rose Period enabled Picasso to spend the summer of 1906 in Gosol, in the Spanish Pyrenees, with his mistress Fernande Olivier (cat. 115). This stay marks another phase in his artistic development. *La femme à sa toilette* (*Woman at her Toilette*, cat. 116), a study for *Le harem* (*The Harem*, fig. 12), heralds the next period, while the portraits of Josep Fontdevila (cat. 118–120) pave the way for the self-portraits with their mask-like faces which Picasso was to produce that autumn.

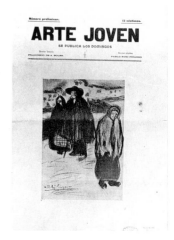

Fig. 2
Arte Joven, 10 March 1901

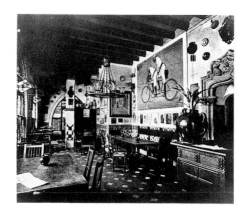

Fig. 3
The interior of Els Quatre Gats, Barcelona

(6) Issue no. 6, 23 December 1899.

(7) J. Sabartés, *Documents iconographiques*, p. 44.

(8) J. Leymarie, *Picasso, dessins*, p. 7.

(9) Not having the exact dates, it is impossible to state with certainty whether these drawings were done before, at the same time, or after the paintings.

(10) C. Zervos, *Dessins de Pablo Picasso*, p. xxxi, the chapter headed 'Maîtrise de l'émotion (période rose)'.

(11) Z. I, p. XXXVI.

(12) It has often been compared with Manet's *Le vieux musicien* (*The Old Musician*), exhibited at the Salon in the autumn of 1905.

(13) AM 2463 D, gift of Jeanne and André Lefèvre (fig. 4).

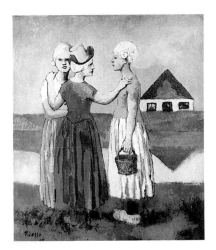

Fig. 4
Les trois hollandaises (*The Three Dutchwomen*), 1905
Paris, Musée National d'Art Moderne

Principal Related Works*

* Unless otherwise stated, all works illustrated are by Picasso.

Cat. 8a:
Science et charité (*Science and Charity*), 1897. Barcelona, Museo Picasso. Z. XXI, 56. (Fig. 5)

Cat. 22:
Pauvres génies (*The Poor Genii*), 1899. Barcelona, Museo Picasso. P.i.F., 353.

Cat. 35–36:
Evocation or *Enterrement de Casagemas* (*Evocation* or *Burial of Casagemas*), 1901. Paris, Musée d'Art Moderne de la Ville de Paris. Z. I, 55. (Fig. 6)

Cat. 43–45:
L'entrevue, Les deux sœurs or *Confidences* (*The Interview, The Two Sisters* or *Confidences*), 1902. Leningrad, The Hermitage Museum. Z. I, 163. (Fig. 8)

Cat. 40a:
La femme au bonnet (*Woman in a Bonnet*), 1901, Barcelona, Museo Picasso. Z. I, 101. (Fig. 7)

Fig. 5

Fig. 6

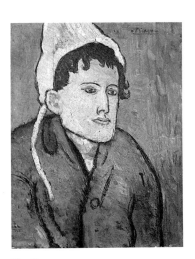

Fig. 7

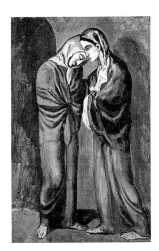

Fig. 8

Cat. 68:
L'étreinte (*The Embrace*), 1903. Paris, Musée de l'Orangerie. Z. I, 161. (Fig. 9)

Cat. 69:
La vie (*Life*), 1903. Cleveland, Museum of Art. Z. I, 179. (Fig. 10)

Cat. 77:
Le vieux juif (*The Old Jew*), 1903. Moscow, Pushkin Museum. Z. I, 175.

Cat. 78:
La repasseuse (*The Laundress*), 1904. New York, The Solomon R. Guggenheim Museum. Z. I, 247.

Cat. 81:
Le couple (*The Couple*), 1904. Ascona, private collection. Z. I, 224.

Cat. 89–99:
La famille de saltimbanques (*The Family of Saltimbanques*), 1905. Washington, D.C., The National Gallery of Art. Z. I, 285. (Fig. 11)

Cat. 113:
La mort d'Arlequin (*The Death of Harlequin*), 1906. Upperville, Virginia, Collection Mr and Mrs Paul Mellon. Z. I, 302.

Cat. 116:
Le harem (*The Harem*), early 1906. Cleveland, Museum of Art. Z. I, 321. (Fig. 12)

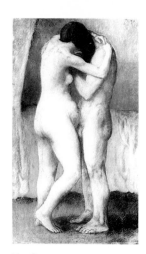

Fig. 9

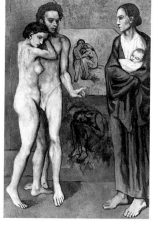

Fig. 10

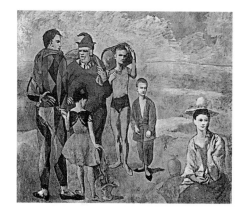

Fig. 11

Fig. 12

1 Academic Study of a Cast of a Classical Sculpture

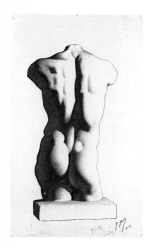

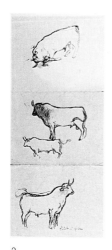

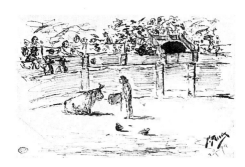

1
Etude académique d'un plâtre d'après l'antique
Academic Study of a Cast of a Classical Sculpture
[1893–1894]
Corunna
Charcoal and black chalk
49 × 31.5
S.b.r. in ink: *P. Ruiz*; D.b.r. in pencil:
93–94/Coruna
Inscr.b.l. in pencil: *un hercules de Fidias*,
and b.r. in ink: *nº 11*
Z. VI, 1; P.i.F., 19
M.P. 405

2
'Citado al quiebro'
'Goaded for the Swerve'
(a movement in bullfighting)
[1893–1895]
Corunna
Pen and brown ink
46.3 × 17
Inscr.b.r.: *Citado al quiebro*
Z. XXI, 17; P.i.F., 41
M.P. 404

3
Corrida
Bullfight
2 September 1894
Corunna
Pen and brown ink
12.7 × 19.2
S.b.r. in brown ink: *P. Ruiz*; D.b.r. in pencil:
2–9–94
Z. XXI, 19
M.P. 401 (r)

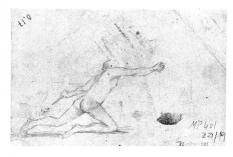

3a
Etude de personnage nu à genou tenant un couteau
Study of a Naked Figure on One Knee, Holding a Knife
[1894]
[Corruna]
Pencil
12.7 × 19.2
M.P. 401 (v)

4
'La Coruña'
'Corunna'
(double page of a newspaper manuscript)
16 September 1894
Corunna
Pen, brown ink and pencil
21 × 26
S.c. (r.h. page): *P. Ruiz*; D.a.l. (r.h. page):
Coruna 16 de Septembre 94
Z. XXI, 10; P.i.F., 31
M.P. 402 (r)

4a
'La Coruña'
'Corunna'
(double page of a newspaper manuscript)
16 September 1894
Corunna
Pen, brown ink and pencil
21 × 26
Z. XXI, 11
M.P. 402 (v)

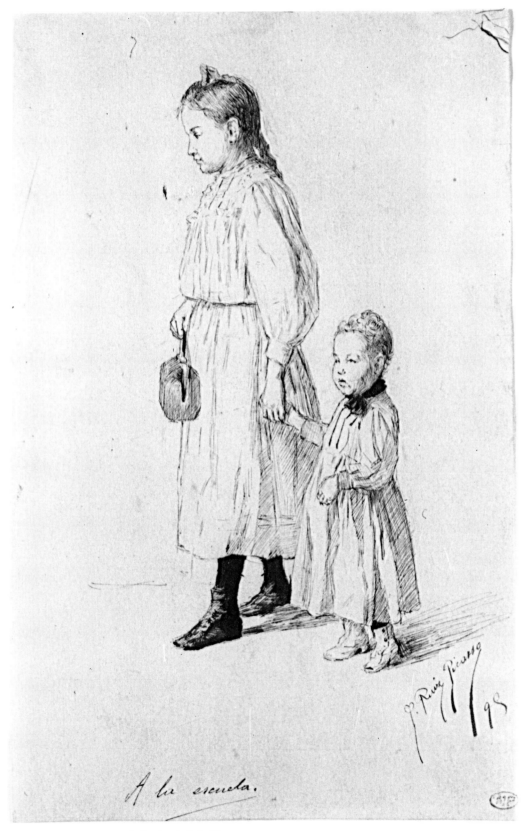

A la escuela.

6 On the Way to School: Lola, the Artist's Sister

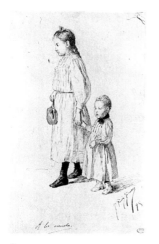

5
'Azul y Blanco'
'Blue and White'
(double page of a newspaper manuscript)
28 October 1894
Corunna
Pencil
20.5 × 26.5
Z. XXI, 13; P.i.F., 33
M.P. 403(r)

5a
'Azul y Blanco'
'Blue and White'
(double page of a newspaper manuscript)
28 October 1894
Corunna
Pencil
20.5 × 26.5
S. in several places and D.a.r.: *P. Ruiz;*
Domingo 28 de Octobre del 94–CORUNA
Z. XXI, 12; P.i.F., 34
M.P. 403(v)

6
A la escuela: Lola, sœur de l'artiste
On the Way to School: Lola, the Artist's Sister
1895
Corunna
Pen and black ink
22.9 × 15.1
S.D.b.r.: *P. Ruiz Picasso/95*
Inscr.b.l.: *A la escuela*
Z. XXI, 26; P.i.F., 80
M.P. 406

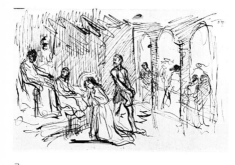

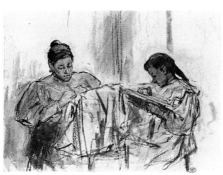

7
Le Christ devant Pilate?
Christ before Pontius Pilate?
1896
Barcelona
Pen and brown ink
13.8 × 21
Z. VI, 44
M.P. 407(r)

7a
Deux études de personnage assis
Two Studies of a Seated Figure
1896
Barcelona
Pen and brown ink
13.8 × 21
Z. VI, 35
M.P. 407(v)

8
La mère et la sœur de l'artiste brodant
The Artist's Mother and Sister Embroidering
1896
Barcelona
Brown ink wash and gouache
16.5 × 22.2
Z. XXI, 46; P.i.F., 155
M.P. 409(r)

8a
**Etude pour 'Science et charité'
(têtes biffées)**
*Study for 'Science and Charity'
(heads crossed out)*
1896
Brown ink, highlights in watercolour and
purple ink
16.5 × 22.2
M.P. 409(v)

9
Course de taureaux
Bull-racing
[1896–1899]
Indian ink
14.6 × 22.3
Z. VI, 43
M.P. 408

10
Scène de corrida
Bullfighting Scene
[1897–1898]
Pen, brown ink and coloured crayon
13.2 × 21
S.b.l.: *P. Ruiz Picasso*
Inscr.a.r.: *una Hora*
Z. VI, 179
M.P. 425

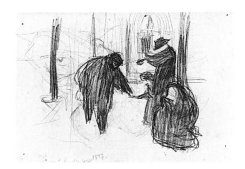

11
'Charité'
'Charity'
[1897–1899]
Black chalk
23.5 × 34
Z. VI, 283
M.P. 412(r)

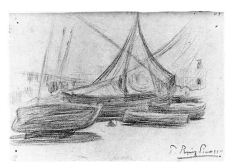

11a
Bateaux
Boats
1897
Black chalk
23.5 × 34
S.b.r.: *P. Ruiz Picasso*
Z. VI, 110
M.P. 412(v)

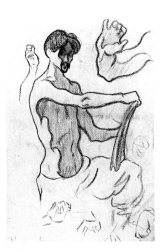

12
L'artiste dessinant et études de mains
The Artist Drawing and Studies of Hands
[1897–1899]
Charcoal
33.1 × 23.4
Z. VI, 63; P.i.F., 250
M.P. 410(r)

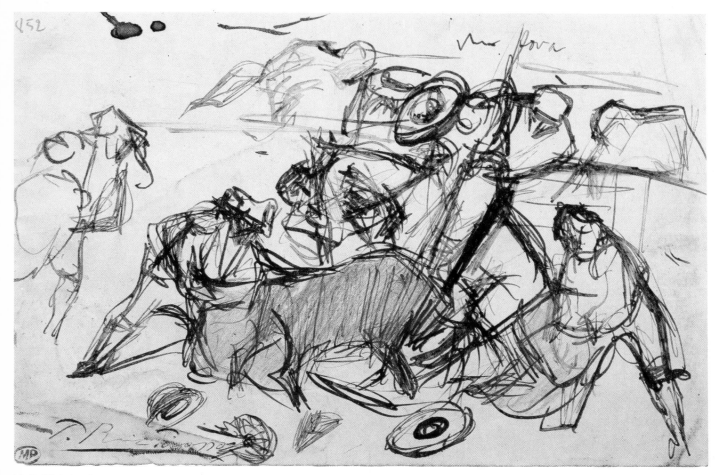

10 Bullfighting Scene

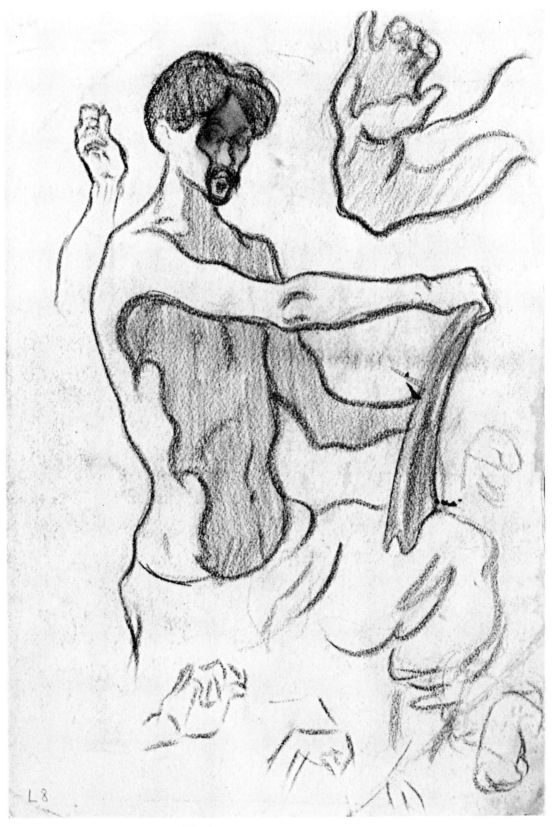

12 The Artist Drawing and Studies of Hands

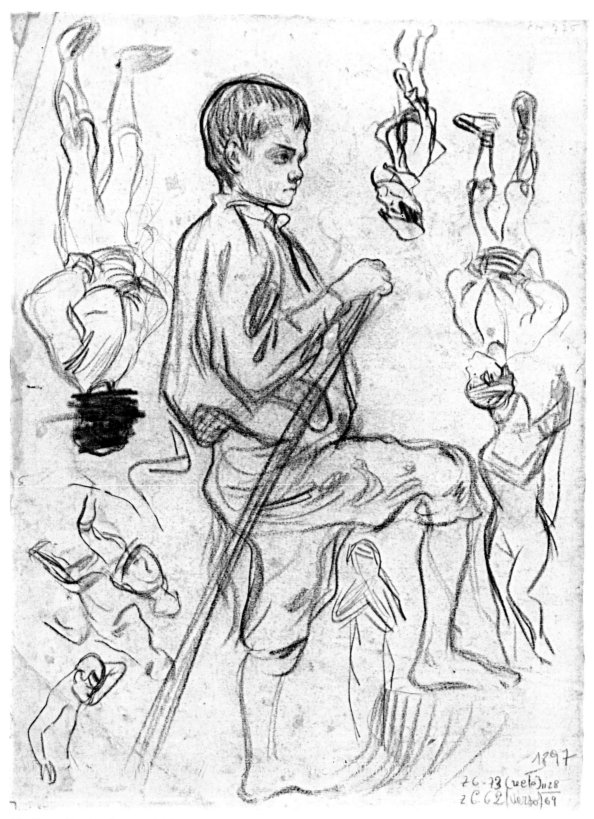

13a Young Boy Leaning on a Stick and Studies

12a
Deux autoportraits et silhouettes
Two Self-portraits and Outline Sketches
[1897–1899]
Charcoal
33.1 × 23.4
S.c.b.: *P.R.P.*
Z. VI, 61
M.P. 410(v)

13
Autoportraits et études
Self-portraits and Studies
[1897–1899]
Black chalk, pen and ink
32 × 24
Z. VI, 73
M.P. 411(r)

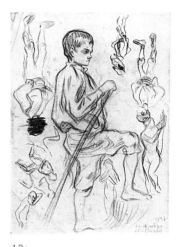

13a
Jeune garçon appuyé sur un bâton et études
Young Boy Leaning on a Stick and Studies
[1897–1899]
Black chalk
32 × 24
Z. VI, 62
M.P. 411(v)

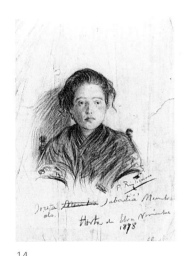

14
Portrait de Josefa Sabastia Membrado
Portrait of Josefa Sabastia Membrado
November 1898
Horta de Ebro
Black chalk
32 × 29.5
S.b.r. in Indian ink: *P. Ruiz Picasso*; D.b.r.:
Horta de Ebro
Noviembre/1898
Inscr.b.r.: *Josefa Sabastia Membra/do*
Z. VI, 136; P.i.F., 278
M.P. 415(r)

14a
Scènes de café et croquis divers
Café Scenes and Various Sketches
1898
Black chalk
29.5 × 32
Z. VI, 133; P.i.F., 281
M.P. 415(v)

15
Homme nu tendant un bras
Nude Man with Outstretched Arm
1898–1900
Pen and brown ink on the back of a blank
envelope
14 × 11.1
S.b. upside down: *P. Ruiz*; and verso:
P. Ruiz Picasso
Z. VI, 171
M.P. 421

16
Picador et taureau mort
Picador and Dead Bull
1899
Barcelona
Pen and black ink
20.5 × 13
S.a.: *Pablo Ruiz Picasso*
Z. VI, 205
M.P. 426(r)

16a
Croquis: tétes, . . . dont Père Romeu
*Sketches and Various Drawings of Heads,
Including Père Romeu*
[1899]
Barcelona
Pen and black ink
20.5 × 13
Z. VI, 211
M.P. 426(v)

17
Femme en prière au chevet d'un enfant
Woman Praying at a Child's Bedside
1899
Barcelona
Black chalk
22 × 32
Z. VI, 182; P.i.F., 341
M.P. 414(r)

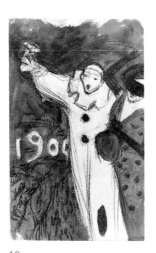

17a
**Silhouettes de José Ruiz (père de
l'artiste) en pardessus**
*Outline Sketches of José Ruiz (the Artist's
Father) in an Overcoat*
1899
Barcelona
Black chalk
32 × 22
Z. VI, 161; P.i.F., 306
M.P. 414(v)

18
Projet pour une affiche de Carnaval
Design for a Carnival Poster
Late 1899
Barcelona
Oil and black chalk
48.2 × 32
Z. XXI, 127; P.i.F., 371
M.P. 427(r)

18a
Projet pour une affiche de Carnaval
Design for a Carnival Poster
Late 1899
·Barcelona
Black chalk
48.2 × 32
Z. XXI, 128; P.i.F., 372
M.P. 427(v)

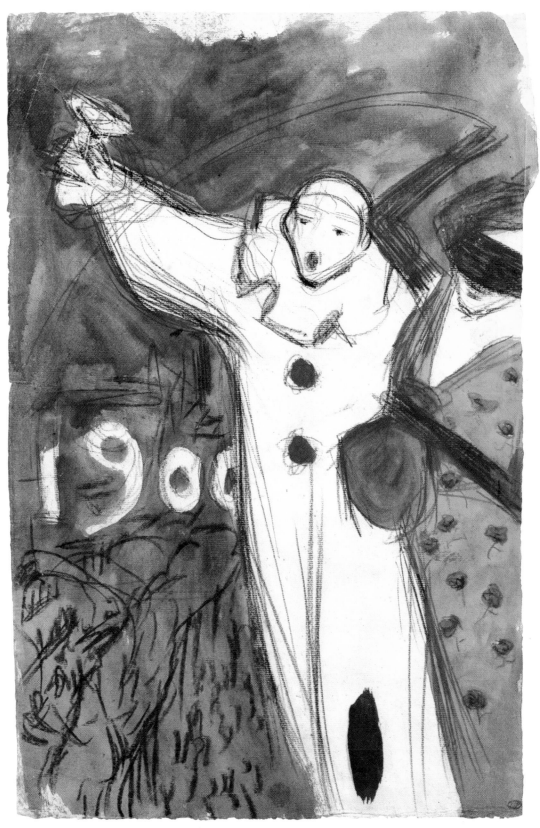

18 Design for a Carnival Poster

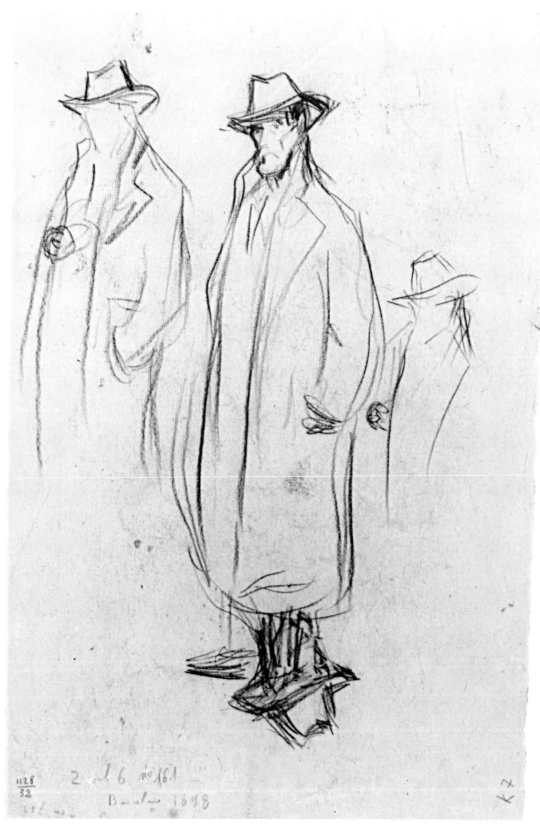

17a Outline Sketches of José Ruiz (the Artist's Father) in an Overcoat

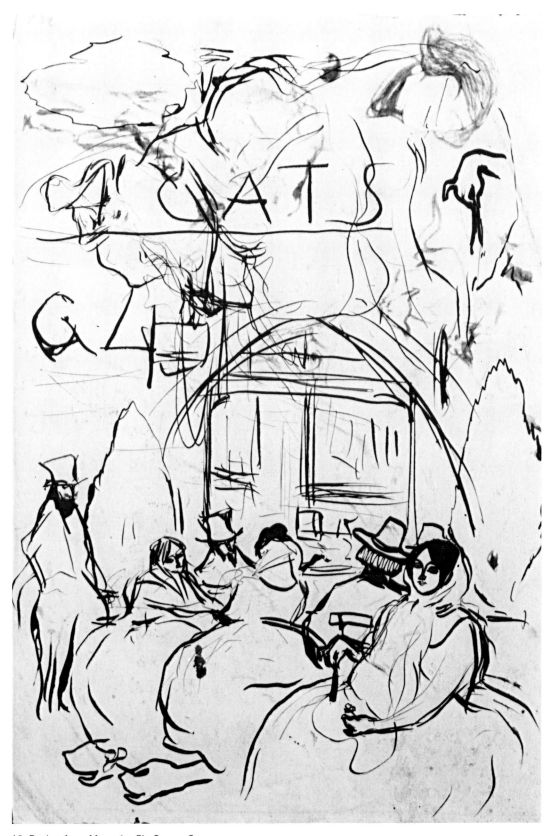

19 Design for a Menu for Els Quatre Gats

19
Projet de menu pour los 'Quatre Gats'
Design for a Menu for Els Quatre Gats
[1899–1900]
Barcelona
Pen and brown ink
32.2 × 22.7
Z. VI, 194
M.P. 416(r)

19a
Feuille d'études
Various Studies
[1899–1900]
Barcelona
Pen and brown ink
22.7 × 32.2
Z. VI, 224
M.P. 416(v)

20
Couple de buveurs
Couple Drinking
1899–1900
Barcelona
Black chalk
23.5 × 34
Z. VI, 225
M.P. 420(r)

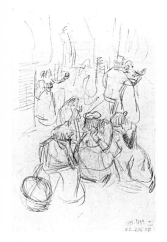

20a
Scène de rue
Street Scene
1899–1900
Barcelona
Pencil
34 × 23.5
Z. VI, 229
M.P. 420(v)

21
Figures en noir sur une place plantée d'arbres
Black Figures on a Square Planted with Trees
1899–1900
Barcelona
Black chalk
16.5 × 22
M.P. 422

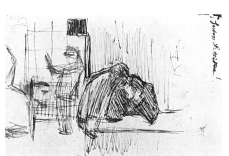

22
Etude pour 'Pauvres génies'
Study for 'Poor Genii'
[1899–1900]
Barcelona
Pen and brown ink
11.7 × 17.6
Inscr. sideways a.r.: *Sartrop Satristra!*
Z. VI, 87
M.P. 413(r)

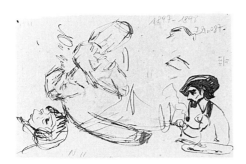

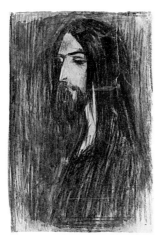

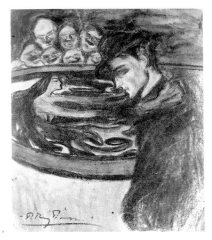

22a
Feuille d'études: 'Pauvres génies',
peintre à la palette et silhouette
Various Studies: 'Poor Genii', Painter with a
Palette and Outline Drawings
[1899–1900]
Barcelona
Pen and brown ink
11.7 × 17.6
Inscr. sideways a.l.: *Mi quer*
Z. VI, 84
M.P. 413(v)

23
Profil d'homme barbu
Bearded Man in Profile
1899–1900
Barcelona
Black chalk, watercolour, highlights in crayon
and varnish on lined paper
16 × 10.6
S.c.b.: *P.R. Picasso*
Z. XXI, 58
M.P. 418

24
Allégorie: jeune homme, femme et
grotesques
Allegory: Young Man, Woman and Grotesque
Characters
1899–1900
[Barcelona]
Charcoal and oil
34.1 × 31.2
S.b.l.: *P. Ruiz Picasso*
Z. XXI, 73
M.P. 419

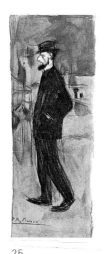

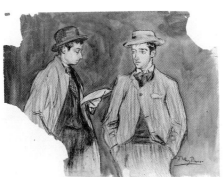

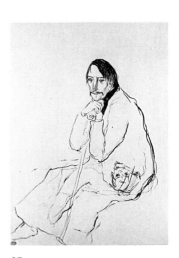

25
Homme barbu de profil
Bearded Man in Profile
1899–1900
Barcelona
Oil and black chalk
43.6 × 17
S.b.l.: *P. Ruiz Picasso*
Z. XXI, 99; P.i.F., 402
M.P. 423

26
La lecture de la lettre
Reading the Letter
1899–1900
Barcelona
Charcoal, black chalk and oil
48 × 63.7
S.b.r.: *P. Ruiz Picasso*
Z. VI, 300
M.P. 424

27
Homme assis à la canne et masque
Seated Man with a Cane and Mask
1900–1901
Indian ink
32.5 × 25
Z. XXI, 203
M.P. 440(r)

27a
Homme au couteau et masques
Man with a Knife and Masks
1900–1901
Black chalk
32.5 × 25
M.P. 440(v)

28
Feuille d'études: femme dans un intérieur, têtes de femme et couple enlacé
Various Studies: Woman in an Interior, Heads of a Woman and Couple Embracing
1900–1901
Paris
Pen, Indian ink and brown ink
15.4 × 23.5
M.P. 429

29
Danseuse de French-cancan
French Can-can Dancer
1900–1901
Paris
Pen and Indian ink
32.5 × 25
Z. XXI, 223; P.i.F., 652
M.P. 436(r)

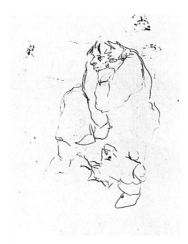

29a
Homme tenant un couteau
Man Holding a Knife
1900–1901
Paris
Pen and Indian ink
32.5 × 25
Z. XXI, 222
M.P. 436(v)

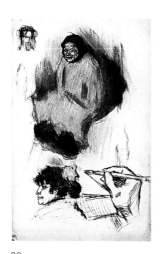

30
Fueille d'études: tête de Christ, vieille femme assise, profil de femme et main tenant un pinceau
Various Studies: Head of Christ, Old Woman Seated, Woman in Profile and Hand Holding a Paintbrush
Early 1901
Madrid
Indian ink and pastel
23.3 × 15.4
Z. XXI, 256; P.i.F., 550
M.P. 428

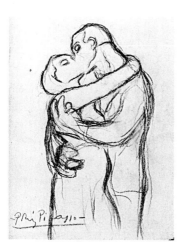

31
Etreinte
Embrace
Spring 1901
Madrid
Black chalk inside an envelope posted in Barcelona, 9 March 1901
14.1 × 11
S.b.l.: *P. Ruiz Picasso*
M.P. 433

32
Femme accoudée
Woman Leaning on her Elbow
Spring 1901
[Barcelona]
Brown ink
18 × 10.2
Z. XXI, 229
M.P. 439

33
Scène de rue
Street Scene
[Spring 1901]
[Barcelona]
Pen and brown ink
11.5 × 15.6
S.b.r.: *P. R. P.*
Z. XXI, 94
M.P. 417

34
Le coupeur de têtes
The Head-hunter
[Spring 1901]
[Barcelona]
Indian ink, tinted wash and gouache
50 × 32
Z. XXI, 202
M.P. 431(r)

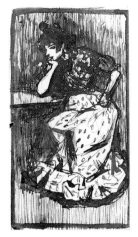

34a
**Feuille d'études: homme debout, femme
accroupie, danseuse devant un homme
et couple dans la rue**
*Various Studies: Standing Man, Crouching
Man, Woman Dancing in front of a Man
and Couple in the Street*
[Spring 1901]
[Barcelona]
Indian ink
50 × 32
Z. XXI, 200
M.P. 431(v)

35
Etude pour 'Evocation'
Study for 'Evocation'
Spring–summer 1901
Black chalk on the back of a reproduction of
*'Regreso de la fiesta di
Napoli . . . 1885'*
41.6 × 29
Z. VI, 356; P.i.F., 679
M.P. 442

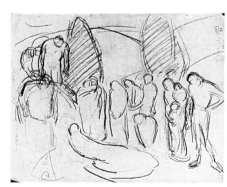

36
Etude pour 'Evocation'
Study for 'Evocation'
Spring–summer 1901
Paris
Black chalk
24 × 31
Z. VI, 328; P.i.F., 687
M.P. 454(r)

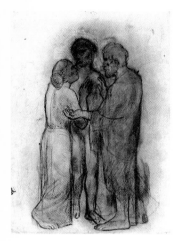

36a
Trois personnages
Three Figures
December 1902
Paris
Charcoal and pencil with scraping and
rubbing
31 × 24
Z. VI, 423
M.P. 454(v)

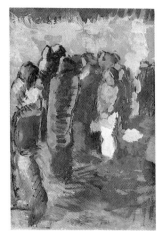

37
Groupe de femmes
Group of Women
[Summer] 1901
[Paris]
Oil
16 × 11.3
Z. XXI, 338; P.i.F., 691
M.P. 432

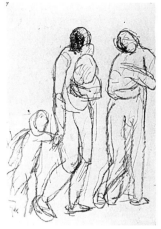

38
Deux femmes et enfants
Two Women with Children
[Summer] 1901
[Paris]
Pencil, touches of pen and black ink
16 × 11
Z. XXII, 55
M.P. 478(r)

38a
Enfant jouant aux quilles
Child Playing Skittles
1903–1904
[Paris]
Pencil
11 × 16
Z. XXII, 53
M.P. 478(v)

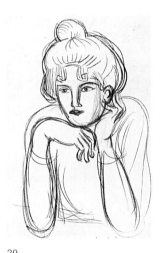

39
Femme au chignon
Woman with a Chignon
[Autumn 1901]
Paris
Black chalk
25.5 × 37.3
Z. XXI, 296
M.P. 438(r)

39a
**Femme prostrée au bord d'un lit et tête
de femme**
*Woman Huddled on the Edge of a Bed and
Head of a Woman*
[Autumn] 1901
Paris
Indian ink and tinted wash
25.5 × 37.3
M.P. 438(v)

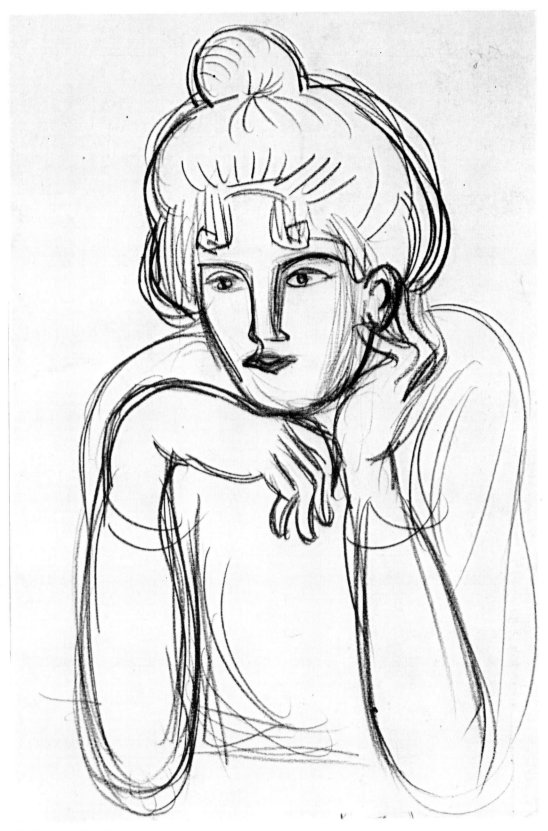

39 Woman with a Chignon

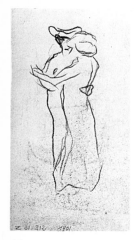

40
Danse
The Dance
[Autumn] 1901
Paris
Black chalk
16.6 × 9.7
Z. XXI, 311
M.P. 434(r)

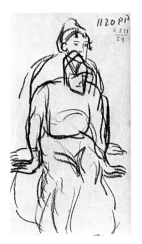

40a
Etude pour 'La femme au bonnet'
Study for 'Woman in a Bonnet'
[Autumn] 1901
Paris
Black chalk
16.6 × 9.7
Z. XXI, 312; P.i.F., 697
M.P. 434(v)

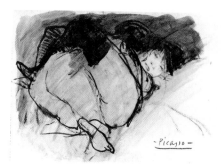

41
Couple enlacé
Couple Embracing
1901
Paris
Indian ink and tinted wash
25.5 × 36.4
S.b.r. in black chalk: *Picasso*
Z. XXI, 194; P.i.F., 663
M.P. 437

42
Le prisonnier
The Prisoner
1901
Paris
Indian ink
31.7 × 21.7
Z. VI, 312
M.P. 430(r)

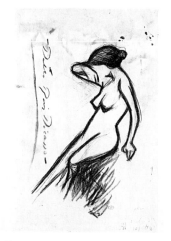

42a
Femme nue cachant son visage
Nude Woman Shielding her Face
1901
Paris
Black chalk
31.7 × 21.7
S.sideways l.: *Pablo Ruiz Picasso*
Z. VI, 124
M.P. 430(v)

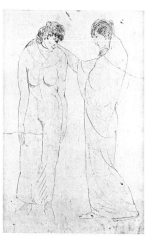

43
Etude pour 'L'entrevue'
Study for 'The Interview'
Winter 1901–1902
[Paris–Barcelona]
Pen and black ink on the back of a
reproduction of Michel-Lévy's
'Le Couvert' in *L'Art français*
34.6 × 27
Z. XXI, 368; P.i.F., 701
M.P. 448

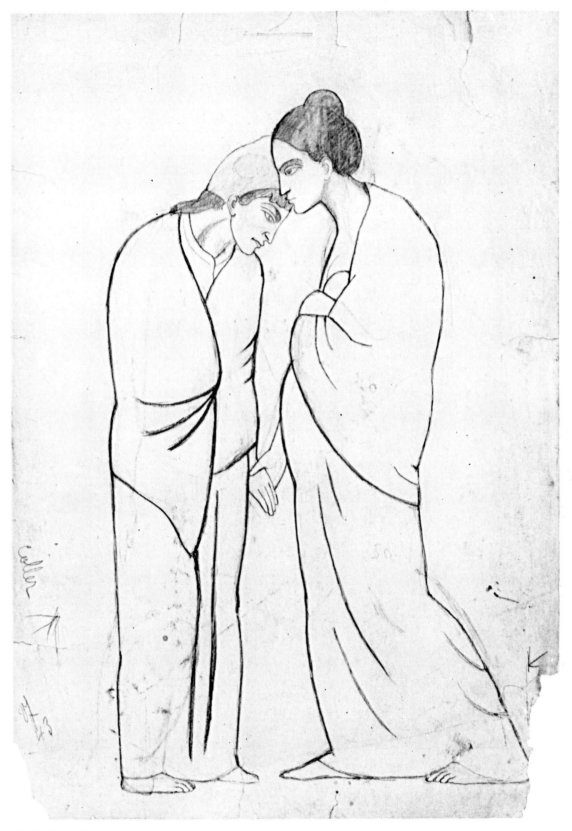

44 Study for 'The Interview'

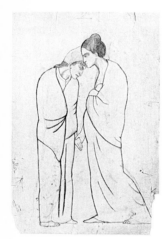

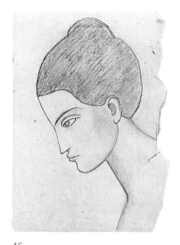

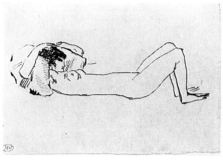

44
Etude pour 'L'entrevue'
Study for 'The Interview'
Winter 1901–1902
[Paris–Barcelona]
Pencil
45 × 32
Z. XXI, 369; P.i.F., 737
M.P. 447

45
Etude pour 'L'entrevue': profil de femme au chignon
Study for 'The Interview': Profile of a Woman with a Chignon
Winter 1901–1902
[Paris–Barcelona]
Pencil with rubbing
21.5 × 15.8
Z. XXII, 37; P.i.F., 740
M.P. 444

46
Femme nue étendue
Nude Woman Stretched Out
1901–1902
Pen and black ink
11 × 15.8
Z. VI, 324; repr. D.B. p. 180
M.P. 443

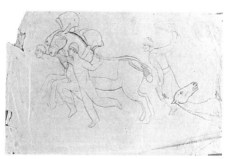

47
Femme accroupie
Crouching Woman
1901–1902
Pen and Indian ink
8.9 × 9
M.P. 441

48
Groupe d'hommes
A Group of Men
January 1902
[Paris–Barcelona]
Pen and brown ink over pencil lines
28 × 19.5
Z. XXI, 440; P.i.F., 860
M.P. 459

49
Course de taureaux: l'arrastre
The Bull-Race: Pulling
1902
Barcelona
Pencil
32.5 × 46.8
Z. XXI, 407
M.P. 445

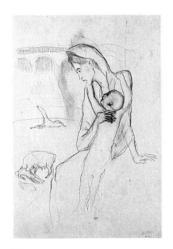

50
La mort du torero
Death of the Torero
1902
Barcelona
Black chalk
37.2 × 26.8
Z. VI, 611
M.P. 451(r)

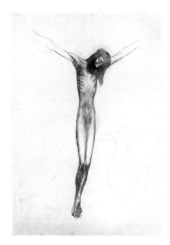

50a
Christ en croix
Crucified Christ
1902
Barcelona
Pencil
37.2 × 26.8
Z. VI, 390; P.i.F., 877
M.P. 451(v)

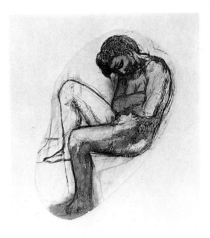

51
Nu assis aux bras croisés
Seated Nude with Arms Crossed
[1902]
[Barcelona]
Pen, brown ink, tinted wash with scraping on
oval paper cut-out
21.5 × 14
Z. XXI, 347
M.P. 460(r)

51a
Scène de cirque
Circus Scene
[1904–1905]
Pencil and red chalk on oval paper cut-out
14 × 21.5
M.P. 460(v)

52
**Homme, femme et enfant dans une
barque**
Man. Woman and Child on a Boat
1902
[Barcelona]
Pen, black ink and tinted wash
31.5 × 21.7
Z. XXI, 389
M.P. 475

53
Groupe de cinq personnages
Group of Five Figures
1902
[Barcelona]
Black chalk
14.1 × 22.5
Z. VI, 472
M.P. 463

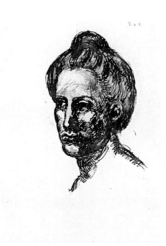

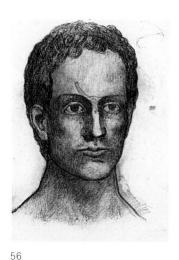

54
Singe à la pipe, personnage à la fleur et pyramides
Monkey Smoking a Pipe, Figure Holding a Flower and Pyramids
1902
Paris
Black and brown ink on a folded sheet from the French edition of the Flemish review *Onze Kunst*
22.8 × 41.7
Z. XXI, 413
M.P. 446

55
Tête de femme au chignon
Head of a Woman with a Chignon
December 1902
Paris
Pen and brown ink
23 × 18
Z. VI, 428
M.P. 469

56
Portrait d'homme
Portrait of a Man
December 1902
Paris
Charcoal
32 × 24.4
Z. XXI, 405
M.P. 465

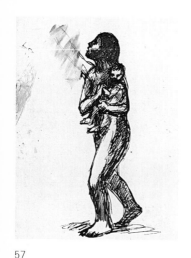

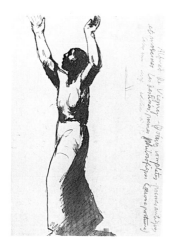

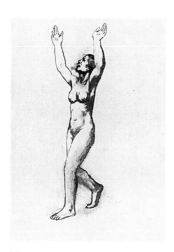

57
Mère et enfant
Mother and Child
December 1902
Paris
Pen and black ink
25.9 × 20.3
Z. VI, 561
M.P. 456

58
Femme implorant le ciel
Woman Invoking the Heavens
December 1902
Paris
Pen and black ink on beige paper
26.1 × 18.7
Inscr. sideways r.: *Alfred de Vigny – Poésies complètes – poèmes antiques/et modernes Les destinées, poèmes philosophiques (œuvre postume)* (sic)/Calman-Levy édition à l f.
Z. XXI, 360; P.i.F., 805
M.P. 458

59
Femme nue implorant le ciel
Nude Woman Invoking the Heavens
December 1902
Paris
Pen, brown ink and tinted wash with scraping
31 × 23.2
Z. VI, 412
M.P. 457

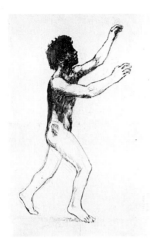

60
Homme nu les bras levés
Nude Man with Raised Arms
Winter 1902–1903
Paris–Barcelona
Pen and black ink on pencil outlines
55.8 × 38.9
Z. VI, 515
M.P. 464

61
Tête de femme
Head of a Woman
1902–1903
Paris–Barcelona
Pen and Indian ink on beige paper
23.8 × 16.3
Z. VI, 466
M.P. 466

62
Portrait d'homme barbu
Portrait of a Bearded Man
[1902–1903]
Paris–Barcelona
Pen and Indian ink
16.8 × 13.2
Z. VI, 464
M.P. 453

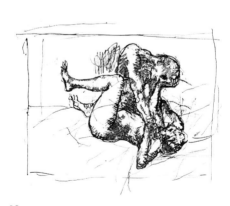

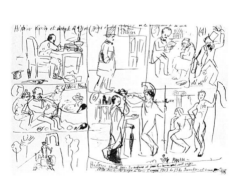

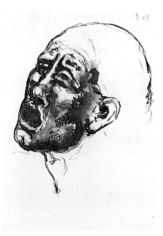

63
La femme étranglée
Woman Being Strangled
[1902–1904]
Pen and brown ink on squared paper
16 × 21
Z. XXII, 52
M.P. 462

64
Histoire claire et simple de Max Jacob
The Plain and Simple History of Max Jacob
13 January 1903
Paris
Pen and ink
19 × 28
Inscr.a.: *Histoire claire et simple de Max Jacob et sa gloire ou la récompense de la vertu* (sic) and b.r.: *Histoire écrite puer les enfants et pour les hommes s'ils sont sages/ éditée chez le café Mogin à Paris l'année 1903 le 13 Jiambier – et dessinée par Picasso* (sic)
Z. VI, 606; P.i.F., 837
M.P. 468

65
Tête de femme criant
Head of a Woman Crying Out
January 1903
Paris
Pen, brown and black ink
23 × 18.1
Z. VI, 539; P.i.F., 828
M.P. 470

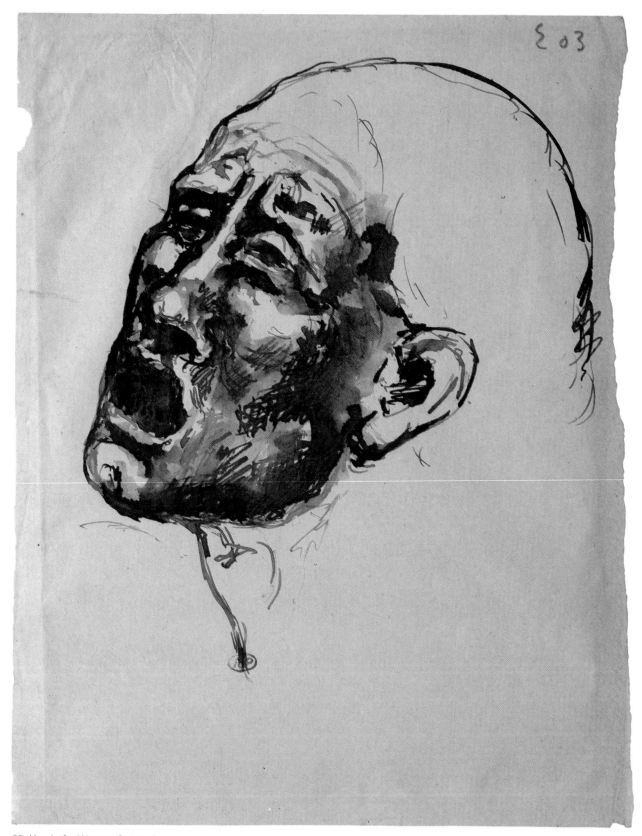

65 Head of a Woman Crying Out

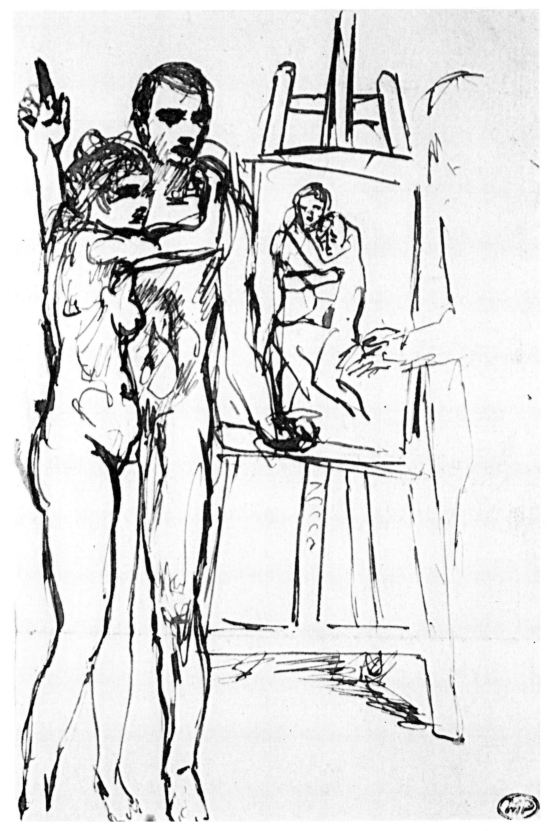

69 Study for 'Life'

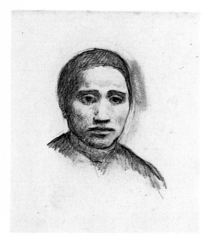

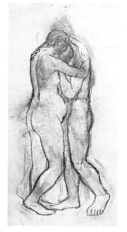

66
Tête de femme
Head of a Woman
January 1903
Barcelona
Black chalk
16.5 × 14.6
Z. VI, 599; P.i.F., 844
M.P. 467

67
Les adieux aux pêcheurs
Farewells to the Fishermen
January 1903
Barcelona
Pen and brown ink
23.5 × 31
Z. XXI, 354; P.i.F., 826
M.P. 449

68
Etude pour 'L'étreinte'
Study for 'The Embrace'
Early 1903
Barcelona
Pencil with scraping
34.2 × 17.3
Z. XXII, 8; P.i.F., 854
M.P. 474

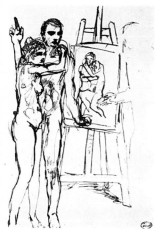

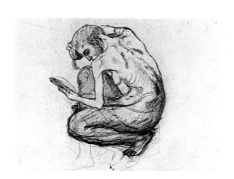

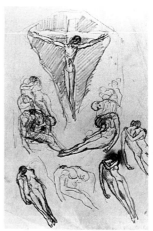

69
Etude pour 'La vie'
Study for 'Life'
Spring 1903
Barcelona
Pen and brown ink
15.9 × 11
Z. VI, 534; D.B. IX–D4; T.l.o.p.[1], 89A; P.i.F., 880
M.P. 473

70
Femme au miroir
Woman with a Mirror
1903
Barcelona
Pencil
21.8 × 23.1
Z. VI, 555
M.P. 476

71
Crucifixion et étreintes
Crucifixion and Embracing Couples
1903
Barcelona
Pencil with highlights in blue crayon
31.8 × 21.9
Z. XXII, 6; P.i.F., 873
M.P. 477

72
Femme nimbée de personnages
Woman Encircled with Figures
1903
Barcelona
Pen and brown ink
33.6 × 23.1
Z. XXII, 5; P.i.F., 875
M.P. 471

73
Homme barbu les bras croisés
Bearded Man with Arms Crossed
1903
Barcelona
Black ink on squared paper
27 × 29
Z. XXII, 9
M.P. 472

74
Femmes et enfant; visage
Women with a Child; a Face
1903
Barcelona
Pen, brown ink and pencil
23.2 × 16.5
Z. VI, 581
M.P. 455

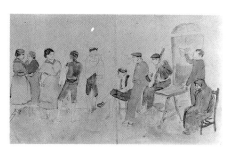

75
Deux femmes, l'une soutenant l'autre
Two Women, One Supporting the Other
[1903]
Barcelona
Pen and black ink on pencil outlines with
charcoal traces on paper glued to
the centre of a sheet
27.5 × 20.5
Z. VI, 565
M.P. 461

76
Répétition de jota
Practising the 'Jota' (a Spanish dance)
1903
Barcelona
Watercolour and gouache on the back of a
sheet headed Escuela
Superior/de/Artes i Industrias y Bellas Artes/
de/Barcelona
13 × 21
Z. VI, 348; P.i.F., 926
M.P. 435

77
**Feuille d'études: le vieux juif, pommeau
de canne et silhouette diverses . . .**
*Various Studies: the Old Jew, Knob of a Cane
and Various Outline Sketches . . .*
1903
Barcelona
Pen and brown ink
38 × 46
Z. XXI, 370; P.i.F., 934
M.P. 450

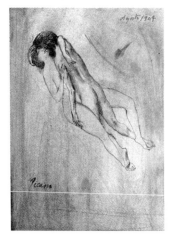

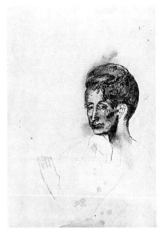

78
Etude pour 'La repasseuse'
Study for 'The Laundress'
Spring 1904
[Paris]
Pen and brown ink
37 × 26.9
Z. XXII, 48
M.P. 480

79
Les amants
The Lovers
August 1904
Paris
Ink, watercolour and charcoal
37.2 × 26.9
S.b.l.: *Picasso*; D.a.r.: *Agosto 1904*
Z. XXII, 104; Duncan, p. 204; D.B. D–XI, 13;
P.i.F., 986
M.P. 483

80
Tête de femme
Head of a Woman
1904
Paris
Pen, Indian ink and pencil
37.3 × 26.6
Z. VI, 540
M.P. 479

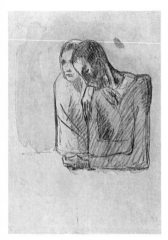

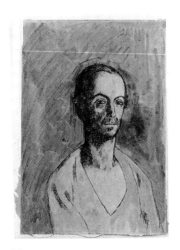

81
Etude pour 'Le couple'
Study for 'The Couple'
1904
Paris
Black chalk on wash tinted paper
37 × 27
Z. XXII, 54; P.i.F., 984
M.P. 481

82
Portrait de Manolo (Manuel Hugué)
Portrait of Manolo (Manuel Hugué)
1904
Paris
Pen, Indian ink and watercolour
37 × 26.5
Z. I, 211; Duncan, p. 204; D.B. D–XI, 10;
T.l.o.p.[1], 150; P.i.F., 995
M.P. 482

83
Caricature: maison close
Caricature: Brothel
1904
Paris
Black ink
29.5 × 41
Z. XXII, 76
M.P. 484

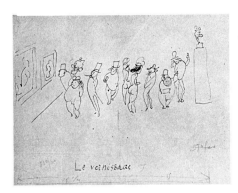

84
Caricature: le vernissage
Caricature: The Preview
1904
Paris
Black ink
29.3 × 41
Inscr.c.b.: *Le vernissage*
Z. XXII, 79
M.P. 485

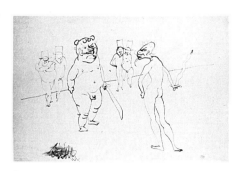

85
Caricature: le duel
Caricature: the Duel
1904
Paris
Black ink
30 × 41.5
Z. XXII, 83
M.P. 486

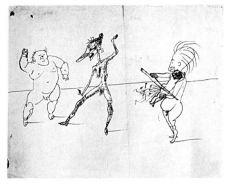

86
Caricature: danseurs et musicien
Caricature: Dancers and a Musician
[1904]
[Paris]
Pen and Indian ink
26 × 33.3
M.P. 491(r)

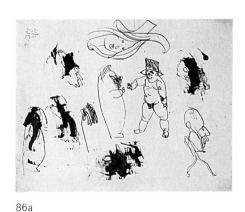

86a
Personnages
Figures
[1904]
[Paris]
Pen and Indian ink
26 × 33.3
M.P. 491(v)

87
Feuille d'études: formes géometriques et caricatures
Various Studies: Geometric Shapes and Caricatures
[1904]
[Paris]
Pen and black ink
18 × 11.5
M.P. 488

88
Loin du bal
Far from the Ball
[1904–1905]
[Paris]
Pen and brown ink
18 × 11.7
Inscr.c.l.: *Loin du bal*
Z. XXII, 86
M.P. 492

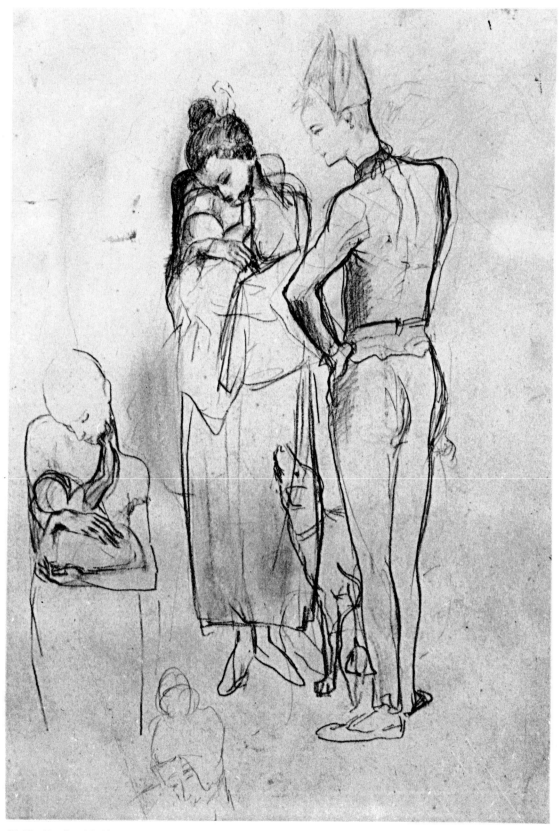

89 The Family of Saltimbanques

89
Famille de saltimbanques
The Family of Saltimbanques
1905
Paris
Pencil and black chalk with highlights in
brown crayon
37.2 × 26.7
Z. XXII, 154; P.i.F., 1023
M.P. 500

90
**Saltimbanques: conversation, toilette et
répétition du cheval**
*Saltimbanques: the Conversation, the Toilette
and Rehearsing with a Horse*
1905
Paris
Pen and black ink on pencil outlines
17.7 × 25.4
Inscr.a.l.: *J. Picasso* (after the drawing was
done)
Z. XXII, 212; P.i.F., 1099
M.P. 505

91
**Saltimbanques: la coiffure, la
conversation et le cavalier**
*Saltimbanques: Hairdressing, the
Conversation and the Rider*
1905
Paris
Pen and black ink
25 × 32.5
Z. VI, 693; P.i.F., 1098
M.P. 506

92
Saltimbanques au repos et cheval cabré
Saltimbanques Relaxing and Horse Rearing
1905
Paris
Pen and Indian ink
21 × 20
Z. VI, 707
M.P. 507

93
Saltimbanques: femmes se coiffant
Saltimbanques: Women Doing their Hair
1905
Paris
Pen and black ink
25.5 × 17.6
Z. XXII, 437; P.i.F., 1146
M.P. 512

94
Saltimbanque buvant à la cruche
Saltimbanque Drinking from a Jug
1905
Paris
Pen and black ink
18 × 11.5
Z. XXII, 208
M.P. 499

95
Saltimbanque au diadème assise le bras tendu
Seated Saltimbanque with Outstretched Arm, Wearing a Diadem
1905
Paris
Pen and brown ink on pinkish-beige paper
15.8 × 11.4
Z. XXII, 227
M.P. 502

96
Jeune femme saltimbanque agenouillée devant un saltimbanque à la couronne
Young Saltimbanque Woman Kneeling before a Saltimbanque Wearing a Crown
1905
Paris
Pen and ink on grey-blue paper
24 × 16
Z. XXII, 206
M.P. 501

97
Croquis: femme avec coiffure hollandaise, autres têtes; inscriptions
Various Sketches: Woman with a Dutch-style Coiffure, Other Heads; Inscriptions
Summer 1905
Pen and black ink on the front of a blank envelope
12 × 9.5
Z. VI, 721
M.P. 493(r)

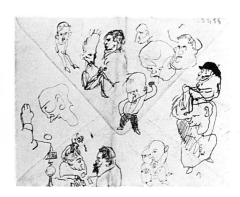

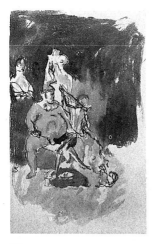

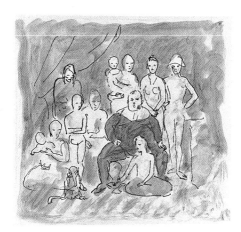

97a
Croquis: tireuse de carte, autoportrait . . .
Various Sketches: Fortune-teller, Self-portrait . . .
[Summer 1905]
Pen and black ink on the back of a blank envelope
95 × 12
Z. VI, 676
M.P. 493(v)

98
Bouffon et acrobates
Clown and Acrobats
1905
Paris
Gouache, Indian ink and tinted wash on bluish-grey paper
23.5 × 15.6
Z. XXII, 210; T.I.o.p.[1], 329; P.i.F., 1095
M.P. 504

99
Groupe de saltimbanques
Group of Saltimbanques
1905
Paris
Pen, Indian ink and watercolour on charcoal outline
20.2 × 31.2
Z. XXII, 221; T.I.o.p.[1], 330; P.i.F., 1094
M.P. 503

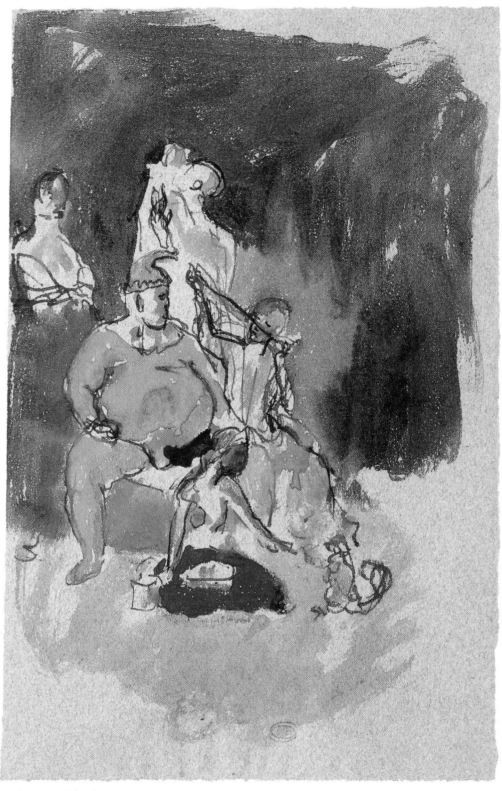

98 Clown and Acrobats

100
Feuille d'études: nus, tête de femme, main et bol avec cuiller
Various Studies: Nudes, Head of a Woman, Hand and Bowl with Spoon
1905
[Paris]
Pen and Indian ink
10.7 × 24
Z. XXII, 479
M.P. 498

101
Feuilles d'études: écuyères au travail
Various Studies: Circus Riders at Work
1905
Paris
Pen, black ink and red chalk
26.5 × 32.5
Z. XXII, 100
M.P. 508(r)

101a
Croquis: Ubu, Paco Durio, Renée Péron . . .
Various Sketches: Ubu, Paco Durio, Renée Péron . . .
1905
Paris
Pencil and coloured crayon
26.5 × 32.5
M.P. 508(v)

102
Caricatures et portraits: Apollinaire, Paul Fort, Jean Moréas, Fernande Olivier, André Salmon, Henri Delormel . . .
Caricatures and Portraits: Apollinaire, Paul Fort, Jean Moréas, Fernande Olivier, André Salmon, Henri Delormel . . .
1905
Paris
Pen, brown ink and pencil
25.5 × 32.7
Z. XXII, 200; P.i.F., 1016
M.P. 494

103
Trois croquis de Guillaume Apollinaire
Three Sketches of Guillaume Apollinaire
1905
Paris
Pen and Indian ink on bluish-grey paper
16.7 × 22
M.P. 496

104
Portrait-charge de Guillaume Apollinaire en académicien
Caricature of Guillaume Apollinaire as a Member of the Academy
[1905]
Paris
Pen, ink and tinted wash
22 × 12
Acquired in 1986, formerly part of the Apollinaire Collection
M.P. 1986–40(r)

104a
Feuille d'études: caricatures
Various Studies: Caricatures
1905
Paris
Pen and ink
22 × 12
S.b.l. in pencil: *Picasso*
Acquired in 1986, formerly part of the
Apollinaire Collection
M.P. 1986–40(v)

105
Portrait-charge de Paul Fort
Caricature of Paul Fort
[1905]
Paris
Ink wash
23.5 × 26
S.b.r. in pencil: *Picasso*
Inscr.a.r. in pencil: *PAUL FORT*
Acquired in 1986, formerly part of the
Apollinaire Collection
M.P. 1986–42

106
Portrait-charge de Jean Moréas
Caricature of Jean Moréas
[1905]
Paris
Ink wash
28 × 24
S.b.r.: *Picasso*
Acquired in 1986, formerly part of the
Apollinaire Collection
M.P. 1986–41

107
Jean Moréas fumant
Jean Moréas Smoking
[1905]
Paris
Pen and black ink
21.1 × 13.6
Z. XXI, 385
M.P. 495

108
Portrait-charge de Henri Delormel
Caricature of Henri Delormel
[1905]
Paris
Ink wash
29 × 22.8
S.b.l. in pencil: *Picasso*
Acquired in 1986, formerly part of the
Apollinaire Collection
M.P. 1986–43(r)

108a
Esquisse du portrait-charge de Henri Delormel
Sketch for the Caricature of Henri Delormel
[1905]
Paris
Ink wash
29 × 22.8
Acquired in 1986, formerly part of the
Apollinaire Collection
M.P. 1986–43(v)

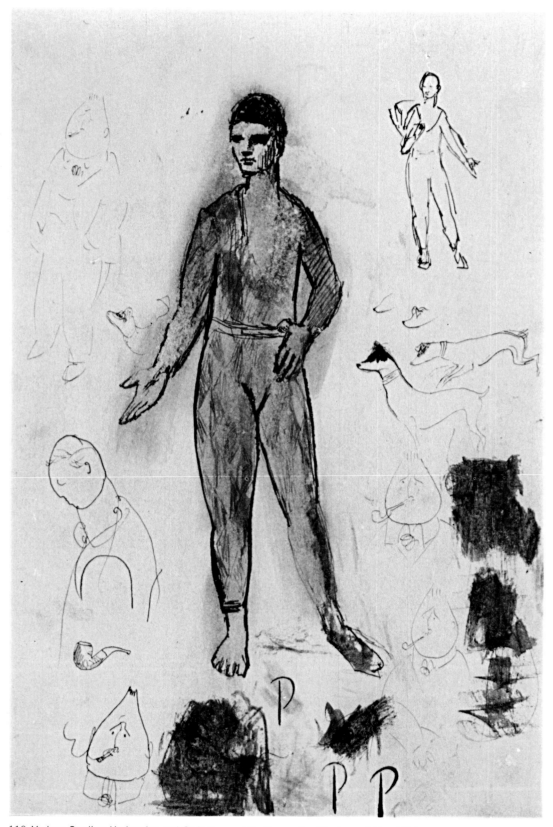

110 Various Studies: Harlequins and Caricatures of Guillaume Apollinaire and Henri Delormel

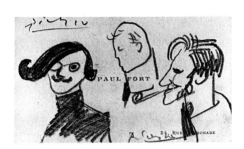

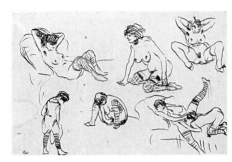

109
Portraits-charge de Paul Fort, Henri Delormel et André Salmon
Caricature of Paul Fort, Henri Delormel and André Salmon
[1905]
Paris
Pencil on a visiting card belonging to Paul Fort
5.6 × 8.8
S.a.l. and b.r.: *Picasso*
Acquired in 1986, formerly part of the Apollinaire Collection
M.P. 1986–44

110
Feuille d'études: arlequins et portraits-charge de Guillaume Apollinaire et d'Henri Delormel
Various Studies: Harlequins and Caricatures of Guillaume Apollinaire and Henri Delormel
24 December 1905
Paris
Indian ink
25.2 × 17.5
D.a.r.: *Paris 24 Diciem/bre 1905*
Inscr.a.r.: *media/noche/Paris/Paris*
Z. XXII, 235; D.B. D–XIII, 12; T.l.o.p.[1], 223; P.i.F., 1175; Cooper, 30
M.P. 509

111
Scènes érotiques
Erotic Scenes
[1905]
[Paris]
Pen and Indian ink
20 × 31
M.P. 452

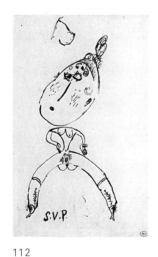

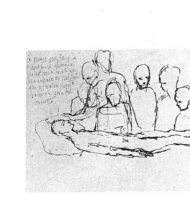

112
S.V.P.
S.V.P.
[Late 1905–1906]
Paris
Pen and brown ink
21.7 × 13.5
Inscr.c.b.: *S.V.P.*
Z. XXII, 296
M.P. 487(r)

112a
Tête
Head
[Late 1905–1906]
Paris
Pen and brown ink
21.7 × 13.5
M.P. 487(v)

113
Etude pour la 'La mort d'Arlequin'
Study for 'The Death of Harlequin'
1905–1906
Paris
Pen and black ink on bluish-grey paper
16.7 × 23.7
Inscr.a.l.: *la mujer que tiene la/mano en la almoada/no est aris mal que levantase un panuela/que estuviese puesto/sobre la cara del/muerto*
Z. XXII, 334; P.i.F., 1180
M.P. 511

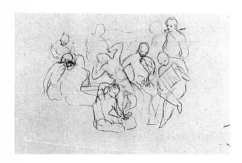

114

Saltimbanques au repos: musique et danse

Saltimbanques Resting: Music and Dance
[1905–1906]
Black chalk
30 × 41.5
Inscr.verso in ink: *P/06*
Z. VI, 709
M.P. 513

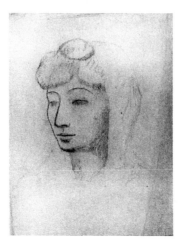

115

Fernande à la mantille blanche

Fernande in a White Mantilla
Spring–summer 1906
Gosol
Charcoal
63.1 × 47.4
Z. VI, 802; P.i.F., 1270
M.P. 510

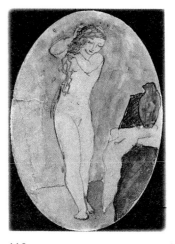

116

Etude pour 'Le harem': femme à sa toilette

Study for 'The Harem': Woman at her Toilette
Spring–summer 1906
Gosol
Pen, ink and watercolour on the back of an oval-shaped label advertising 'Crème Simon'
7 × 5
Z. XXII, 425; P.i.F. (repr. in col.), 1263
M.P. 514

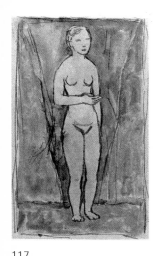

117

Femme nue devant une tenture

Nude Woman in Front of a Hanging
Spring–summer 1906
Gosol
Pencil and watercolour on lined paper
21 × 13
Z. VI, 887; T.l.o.p.[(1)], 292; P.i.F., 1282
M.P. 515

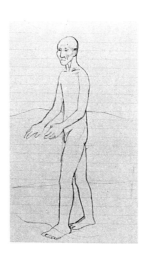

118

Josep Fontdevila nu marchant

Josep Fontdevila Nude, Walking
Spring–summer 1906
Gosol
Black chalk on lined paper
21 × 13
Z. XXII, 443; P.i.F., 1315
M.P. 516

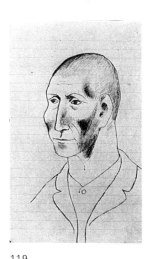

119

Portrait de Josep Fontdevila

Portrait of Josep Fontdevila
Spring–summer 1906
Gosol
Black chalk on lined paper
21 × 13
Z. XXII, 453; P.i.F., 1302
M.P. 518

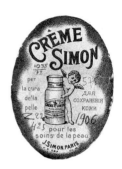

116 Study for 'The Harem':
Woman at her Toilette

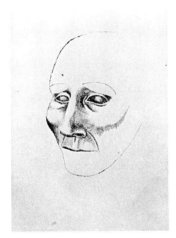

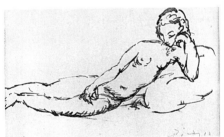

120
Visage-masque de Josep Fontdevila
Mask-like Face of Josep Fontdevila
Summer 1906
Gosol–Paris
Indian ink
31.5 × 24.3
Z. VI, 765; T.l.o.p.[(1)], 297B; P.i.F., 1340
M.P. 517

121
Paysage
Landscape
[1906]
[Gosol]
Gouache and black chalk
47.5 × 61.5
S. verso: *Picasso*
M.P. 489

122
Femme étendue
Woman Stretched Out
[1906]
Pen and Indian ink
10.7 × 17.3
S.b.r. in pencil: *Picasso*
Gift of Guy Spitzer, 1985
M.P. 1985–74

From *Les Demoiselles d'Avignon* to Cubism: 1906–1909[1]

The studies for self-portraits produced by Picasso in the autumn of 1906 on his return from Gosol (cat. 125, 126) develop the mask theme, and were probably influenced by Iberian art. The extraordinary depth of the brooding gaze creates a striking impression. The palette held by the artist has given rise to suggestions that they might have been preparatory studies for *Autoportrait à la palette* (*Self-portrait with a Palette*, fig. 3), now in the Philadelphia Museum of Art. The strong, broad shoulders supporting the cylindrical neck (see cat. 125, right-hand side) also herald the Musée Picasso's *Autoportrait* (*Self-portrait*, fig. 4),[2] probably painted at a slightly later date. The artist was so attached to the latter work that he uncharacteristically kept it on his wall, a detail recorded by André Malraux in his description of his visit to Notre-Dame-de-Vie.[3] Picasso saw himself as a draughtsman as well as a painter; on the right-hand side of *Etudes pour autoportraits* (*Studies for Self-portraits*, cat. 126) he holds a pencil to a sheet of paper. The collection also contains a self-portrait drawn at the end of the year in black chalk on newspaper (cat. 132),[4] together with the partially turned back of a man's head in the same medium on a piece of the same newspaper (cat. 131). There is a certain similarity between the face in the portrait, chiefly the eyes, and the faces of the women featured in the centre of *Les Demoiselles d'Avignon* (fig. 5). The preparatory sketches for this famous painting have long been left unexplored; several were in fact kept by Picasso. They are currently the object of intense interest both in the United States and in France. A tentative list of various pieces of research and opinions will appear in the catalogue for the exhibition based on *Les Demoiselles d'Avignon*.[5] This will contain not only drawn and painted studies but also the full set of sketchbooks, four of which are in the possession of the Musée Picasso and stand out as gems in the collection of Picasso's drawings from that period. The successive influences of Iberian and African art on the development of the work will also be analysed.

Before he engaged on research directly related to *Les Demoiselles d'Avignon* the artist had drawn portraits of women which could be seen as early precedents of the work but were primarily the direct source of another painting. The *Femme nue de profil* (*Nude Woman in Profile*, cat. 123) culminated in the *Deux femmes nues* (*The Two Nudes*, fig. 6), now in The Museum of Modern Art, New York. The seated and standing nude, a small picture within a picture among various studies (cat. 130), also bears a resemblance to *The Two Nudes* and introduces the curtain motif. The date set for work directly related to the composition is spring 1907.

The museum's collection is as rich in paintings[6] as in drawings done on loose sheets (cat. 135–148) or in sketchbooks. The five women in *Demoiselles* were prefigured by standing female nudes of a notably sculptural quality, such as the *Nu féminin debout* (*Standing Female Nude*, cat. 134) with her broad shoulders and well-developed breasts. She has a 'sister' currently held in the Fogg Art Museum, Cambridge, Mass.[7] The equivalent in sculpture is to be found in the *Figure* carved in oak with painted highlights (fig. 7).

The initial project for the painting included studies for certain characters such as the medical student (cat. 140, 141) and the sailor (cat. 145), as well as the five women appearing in the completed version. Besides the major individual studies done in pastel, watercolour or gouache, the museum possesses two small pen and ink sketches (cat. 143, 144) showing the artist's vision of the whole composition. It is not yet in its final state, however: the sailor is still there, the faces have not acquired their definitive features, and the bodies of the women on the right-hand side in particular have not been fully developed.

(1) Dates in this chapter have been established in accordance with the chronology suggested for the *Demoiselles d'Avignon* exhibition. We are grateful to Pierre Daix for his answers to questions on specific points in his texts.

(2) Cf. p. 18 in Hélène Seckel, *Musée Picasso. Guide* and pp. 10–11 in Marie-Laure Besnard Bernadac, *Le Musée Picasso*, fig. 2, 1985.

(3) Cf. A. Malraux, *La tête d'obsidienne*, Paris, 1974, p. 12.

(4) Laurence Berthon has succeeded in tracing the date of the newspaper.

(5) Musée Picasso, Paris, spring 1988.

(6) See cat. I, pp. 33–40.

(7) Z, VI, 877.

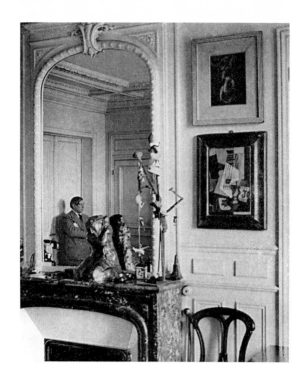

Fig. 1
The apartment in the rue La Boétie, 1932.
(Photo Brassaï © Gilberte Brassaï; Picasso Archives)

Picasso had been led to envisage the *Demoiselles* after studying *Les baigneuses* (*The Bathers*) by Cézanne and the *Bain Turc* (*Turkish Bath*) by Ingres. He was to follow the latter even more closely with his *Odalisque* (*Odalisk*, cat. 151), inspired by *La grande odalisque* (*The Great Odalisk*) in the Louvre (fig. 8); he kept a copy of this painting in his studio. The woman in Picasso's work emanates as much sensuality as the original whose languid pose she imitates, but the composition is generally cruder. This is partly due to the hatched lines and the contrasting orange and blue tones. It bears some resemblance to a study for *Nu à la draperie* (*Nude with Drapery*, cat. 152), where the use of pastel creates softer shades. Here the woman is reclining, whereas in the other sketches and in the painting (fig. 9) she is standing. She is similar to the woman depicted on the left-hand side of the *Demoiselles*. *Nu à la serviette* (*Nude with a Towel*) also features in the collection, with a gouache study of the head (cat. 154): the bridge of the nose, the large ear and the eyes are all significant.

L'amitié (*Friendship*, fig. 10) is commonly thought to have been painted during the winter of 1907–1908. The Musée Picasso holds two important studies for the work, one in Indian ink (cat. 155), the other in gouache (cat. 156). The two figures reappear in the spring of 1908 in the left-hand section of studies for *Baigneuses dans la forêt* (*Bathers in the Forest*, cat. 199–200), a work never carried out. A considerable amount of preparatory studies led to the large *Nue debout* (*Standing Nude*, cat. 157–168) in the Museum of Fine Arts, Boston (fig. 11). For these Picasso used a variety of mediums: pencil, ink and gouache. The series culminates in a drawing accompanied by handwritten notes showing the colours to be used. A detailed examination of the series would enable us to follow the entire development of the work, but each study is of interest in itself.

Trois femmes (*Three Women*, fig. 12) was also the subject of extensive studies. The magnificent series (cat. 169–193) includes drawings developing one of the characters; two fine gouache studies for the head (cat. 171) and the head and shoulders of the woman featured on the left (cat. 172) stand out as particularly admirable. The composition as a whole is developed through a variety of sketches in pencil, ink and gouache. The series is preceded by a study (cat. 153) which Pierre Daix sees as preparation for an initial version of the painting.

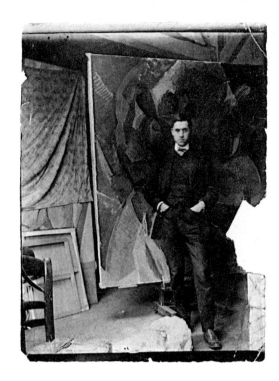

Fig. 2
André Salmon in front of *Trois femmes*
(*Three Women*) at the Bateau-Lavoir,
summer 1908
(Picasso Archives)

Links with Picasso's sculpture are evident in *Nu assis* (*Seated Nude*, cat. 205) and *Nu debout de profil* (*Standing Nude in Profile*, cat. 206); the two figures appear to have been carved. According to Pierre Daix,[8] *Nu aux bras levés* (*Nude with Raised Arms*, cat. 204) is a study for an oil painting on a wood panel from the Jacqueline Picasso Collection 'deriving from the work on the theme of *Nu couché avec personnages*' (*Reclining Nude with Figures*).[9] Picasso had such a fondness for *Nu aux bras levés* that he had it framed and hung it next to the mirror in the sitting-room of his home in the rue la Boétie, as recorded in Brassaï's photographs (fig. 1). The dramatic still-life drawings featuring a skull (cat. 208, 209) have been linked to the death of Wiegels, a German painter from the Bateau-Lavoir who committed suicide on 1 June 1908. They were therefore done before Picasso's departure for La Rue-des-Bois in August. Besides a study for *La fermière* (*The Farmer's Wife*, cat. 214), the sculptural *Nu debout* (*Standing Nude*, cat. 212) and *Une femme de dos les bras levés* (*Back of a Woman with Raised Arms*, cat. 213) probably date from this period. Next to the nude there is a drawing of a very large foot, while on the back of the sheet featuring the woman with raised arms is a charcoal outline of an enormous hand looking as if it has been carved out with a knife.

The drawings in the final series, *Carnival au bistrot* (*Carnival at the Bistro*), a theme from the *commedia del'arte* culminating in the great work *Pain et compotier aux fruits sur une table* (*Loaves and Fruit Bowl on a Table*, Kunstmuseum, Basle, fig. 14), have been classified thanks to the work of William Rubin.[10] A study, probably for *La dryade* (*The Wood Nymph*, fig. 13), which had been cut up, was reassembled by joining together the reverse sides of two sketches (cat. 221a and 217a). The final section of this chapter features isolated works difficult to place; it is to be hoped that further research will enable them to be classified.

(8) Cf. D.R., 165.

(9) Cat. I, 22.

(10) W. Rubin, 'From narrative to "Iconic" in Picasso: The Buried Allegory in Bread and Fruit Dish on a Table and the Role of Les Demoiselles d'Avignon', *Art Bulletin*, Vol. LXV, no. 4, December 1983.

Principal Related Works

Cat. 125:
Autoportrait à la palette (*Self-portrait with a Palette*), 1906. Philadelphia, The Philadelphia Museum of Art. Z. I, 375. (Fig. 3)
Autoportrait (*Self-portrait*), 1906. Paris, Musée Picasso, cat. I, 8; Z. II¹, 1. (Fig. 4)

Cat. 135–148:
Les Demoiselles d'Avignon, 1907. New York, The Museum of Modern Art. Z. II¹, 18. (Fig. 5)

Cat. 128:
Deux femmes nues (*The Two Nudes*), 1906. New York, The Musuem of Modern Art. Z. I, 366. (Fig. 6)

Cat. 134:
Figure (*Figure*), 1907. Paris, Musée Picasso, cat. I, 281; Z. II², 607. (Fig. 7)

Cat. 149, 150:
Les moissoneurs (*The Reapers*), 1907. New York, The Museum of Modern Art. Z. II¹, 2.

Cat. 151:
Ingres, *La grande odalisque* (*The Great Odalisk*). Paris, The Louvre. (Fig. 8)

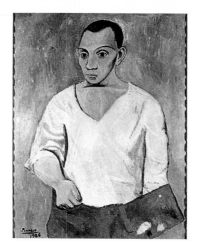

Fig. 3

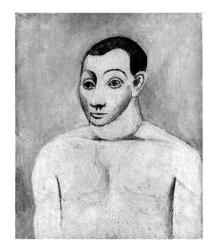

Fig. 4

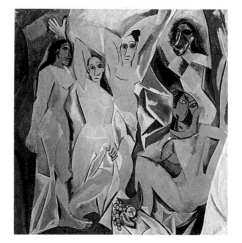

Fig. 5

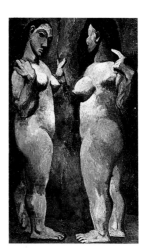

Fig. 6

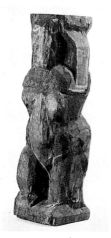

Fig. 7

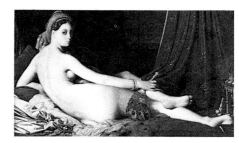

Fig. 8

Cat. 152:
Nu à la draperie (*Nude with Drapery*), 1907.
Leningrad, The Hermitage Museum. Z. II¹, 47.
(Fig. 9)

Cat. 154:
Nu à la serviette (*Nude with Towel*), 1907.
Private collection. Z. II¹, 48.

Cat. 155–156:
L'amitié (*Friendship*), 1907–1908. Leningrad,
The Hermitage Museum. Z. II¹, 60. (Fig. 10)

Cat. 157–168
Nu debout (*Standing Nude*), 1908. Boston,
The Museum of Fine Arts. Z. II¹, 103. (Fig. 11)

Cat. 153, 169–193
Trois femmes (*Three Women*), 1907.
Leningrad, The Hermitage Museum. Z. II¹,
108. (Fig. 12)

Cat. 215a, 221a, 217a:
La dryade (*The Wood Nymph*), 1908.
Leningrad, The Hermitage Museum. Z. II¹,
113. (Fig. 13)

Cat. 214:
La fermière (*The Farmer's Wife*), 1908.
Leningrad, The Hermitage Museum. Z. II¹, 91.

Cat. 215–217, 221, 222:
Pains et compotier aux fruits sur une table
(*Loaves and Fruit Bowl on a Table*), 1909.
Basle, Kunstmuseum. Z. II¹, 134. (Fig. 14)

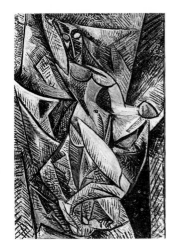

Fig. 9

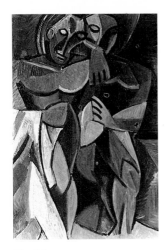

Fig. 10

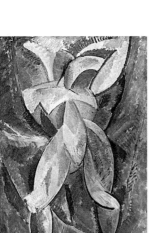

Fig. 11

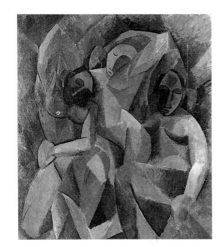

Fig. 12

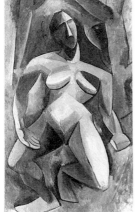

Fig. 13

Fig. 14

123
Femme nue de profil
Nude Woman in Profile
Summer–autumn 1906
Paris
Watercolour
21.2 × 13.5
Z. VI, 808; P.i.F., 1336
M.P. 520

124
La parisienne et figures exotiques
The Parisienne and Exotic Figures
Autumn 1906
Paris
Pen and black ink
30 × 42
Z. XXII, 177; P.i.F., 1451
M.P. 490

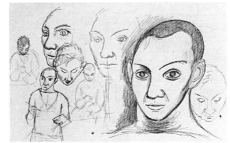

125
Etudes pour autoportraits
Studies for Self-portraits
Autumn 1906
Paris
Pencil
31.5 × 47.5
Z. XXVI, 5; P.í.F., 1377
M.P. 524(r)

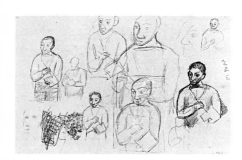

125a
Etudes pour autoportraits
Studies for Self-portraits
Autumn 1906
Paris
Pencil
31.5 × 47.5
Z. XXVI, 4; P.i.F., 1373
M.P. 524(v)

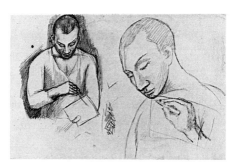

126
Etudes pour autoportraits
Studies for Self-portraits
Autumn 1906
Paris
Pencil
32.5 × 48
Z. XXVI, 3; P.i.F., 1379
M.P. 526(r)

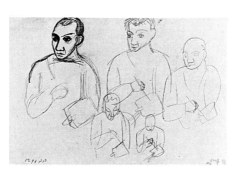

126a
Etudes pour autoportraits
Studies for Self-portraits
Autumn 1906
Paris
Pencil
32.5 × 48
Z. XXVI, 2; P.i.F., 1374
M.P. 526(v)

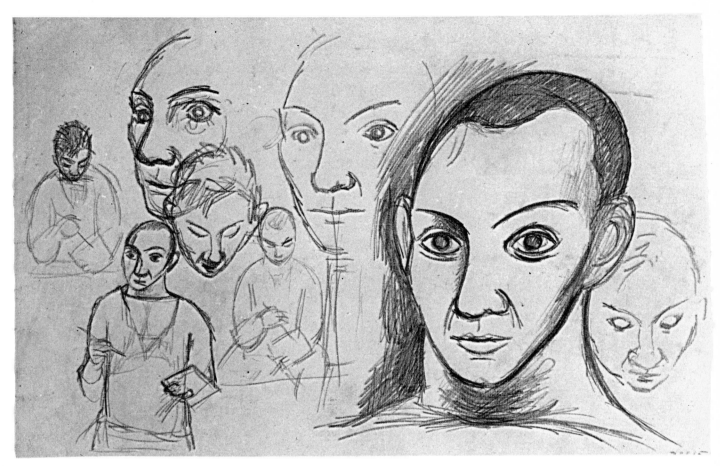

125 Studies for Self-portraits

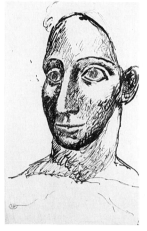

127
Femme assise de face
Front View of a Seated Woman
Autumn 1906
Paris
Pencil and black chalk
63 × 48
Z. VI, 898
M.P. 521

128
Etude pour 'Deux femmes nues'
Study for 'Two Nudes'
Autumn 1906
Paris
Black chalk
63 × 48
M.P. 522

129
Tête
Head
[Autumn] 1906
Paris
Indian ink
21 × 13.5
Z. XXII, 472
M.P. 519

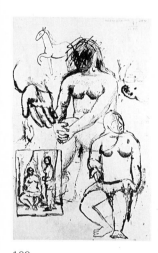

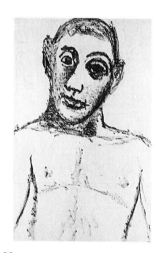

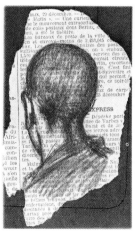

130
Feuille d'études' nus féminins assis, nu assis et nu debout, main, cheval et oreille
Various Studies: Seated Female Nudes, Seated and Standing Nude, Hand, Horse and Ear
Autumn 1906
Paris
Indian ink
48 × 31.9
P.i.F., 1408
M.P. 528(r)

130a
Torse d'homme nu
Torso of a Nude Man
Winter 1906–1907
Paris
Oil
48 × 31.9
P.i.F., 1432
M.P. 528(v)

131
Tête d'homme vu de 3/4 dos
Partially Turned Back of a Man's Head
Winter 1906–1907
Paris
Black chalk on an extract from *Le Matin*, 30 December 1906
12.5 × 7.7
M.P. 525

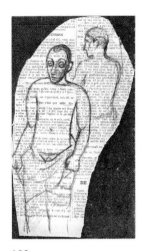

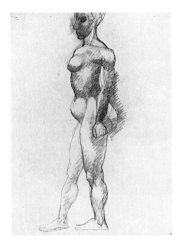

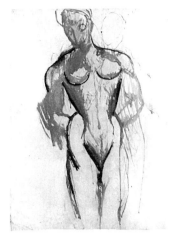

132
Autoportraits
Self-portraits
Winter 1906–1907
Paris
Black chalk on an extract from *Le Matin*, 30
December 1906
32.5 × 13.5
Z. VI, 926
M.P. 527

133
Nu de profil marchant
Walking Nude in Profile
Winter 1906–1907
Paris
Charcoal and black chalk
63 × 48
Z. XXII, 468; P.i.F., 1430
M.P. 523

134
Nu féminin debout
Standing Female Nude
Winter 1906–1907
Paris
Watercolour
63.5 × 48
Z. XXVI, 8; P.i.F., 1418
M.P. 529(r)

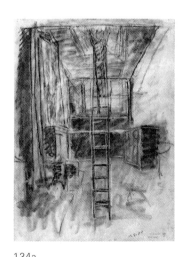

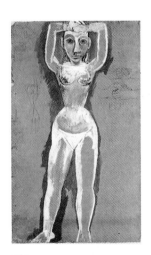

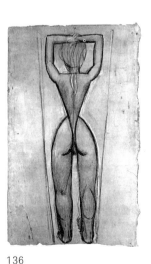

134a
**Personnage sur une échelle dans un
interieur (au Bateau–Lavoir?)**
*Figure on a Ladder in an Interior (at the
Bateau-Lavoir?)*
Winter 1906–1907
Paris
Pastel
63.5 × 48
Z. XXII, 457
M.P. 529(v)

135
**Etude pour 'Les demoiselles d'Avignon':
nu de face aux bras levés**
*Study for 'Les Demoiselles d'Avignon': Front
View of a Nude with Raised Arms*
Spring 1907
Paris
Gouache, charcoal and pencil on paper
backed with canvas
131 × 75.5
Z. XXVI, 190; D.R., 17
M.P. 13

136
**Etude pour 'Les demoiselles d'Avignon':
nu de dos aux bras levés**
*Study for 'Les Demoiselles d'Avignon': Back
View of a Nude with Raised Arms*
Spring 1907
Paris
Charcoal, gouache and white chalk on paper
backed with canvas
134 × 82.5
Z. XXVI, 189; D.R., 19
M.P. 12

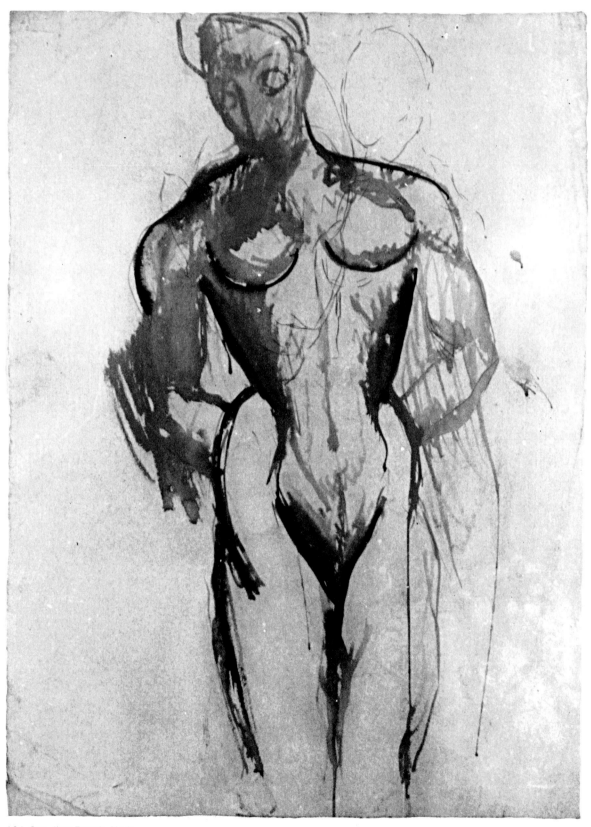

134 Standing Female Nude

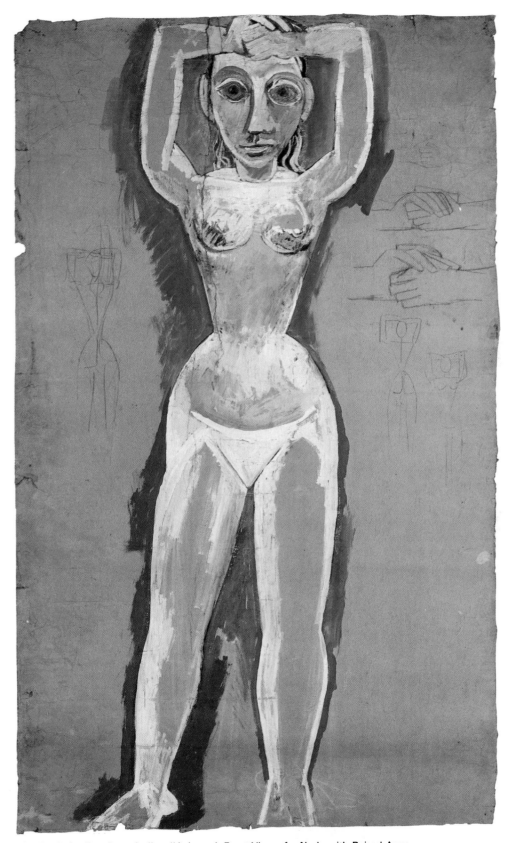

135 Study for 'Les Demoiselles d'Avignon': Front View of a Nude with Raised Arms

137
Etude pour 'Les demoiselles d'Avignon':
nu debout
Study for 'Les Demoiselles d'Avignon':
Standing Nude
Spring 1907
Paris
Pen and Indian ink on tracing paper
25.5 × 12
M.P. 536

138
Etude pour 'Les demoiselles d'Avignon':
nu debout
Study for 'Les Demoiselles d'Avignon':
Standing Nude
Spring 1907
Paris
Pen and Indian ink on tracing paper
22.7 × 12.2
M.P. 537

139
Etude pour 'Les demoiselles d'Avignon':
nu debout
Study for 'Les Demoiselles d'Avignon':
Standing Nude
(study for proportions)
Spring 1907
Paris
Pen and Indian ink on tracing paper
31 × 12.6
M.P. 535

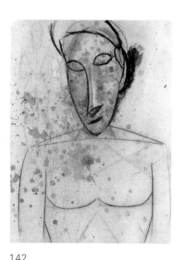

140
Etude pour 'Les demoiselles d'Avignon':
l'étudiant en médecine
Study for 'Les Demoiselles d'Avignon': the
Medical Student
Spring 1907
Paris
Pastel and charcoal
63.1 × 47.6
Z. XXVI, 16; D.R., 10; T.l.o.p.(2), 15 (repr. in
col. pl. IV); P.i.F., 1507
M.P. 530

141
Etude pour 'Les demoiselles d'Avignon':
l'étudiant en médecine
Study for 'Les Demoiselles d'Avignon': the
Medical Student
Spring 1907
Paris
Gouache
64 × 49
Z. VI, 904; D.R., 11; T.l.o.p.(2), 14; P.i.F.,
1467
M.P. 531

142
Buste de femme
Head and Shoulders of a Woman
Spring 1907
Paris
Indian ink, black chalk, highlights in chalk,
charcoal and dabs of oil-paint
63.5 × 48
Z. XXVI, 261
M.P. 542(r)

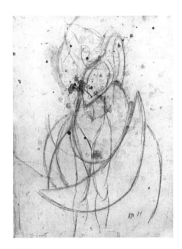

142a
Etude pour 'Les demoiselles d'Avignon':
nature morte et nu féminin
Study for 'Les Demoiselles d'Avignon': Still-
life and Female Nude
Spring 1907
Paris
Charcoal
63.5 × 48
M.P. 542(v)

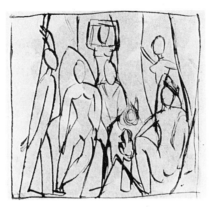

143
Etude pour 'Les demoiselles d'Avignon'
Study for 'Les Demoiselles d'Avignon'
May 1907
Pen and black ink
8.2 × 9
Z. VI, 981; P.i.F., 1542
M.P. 533

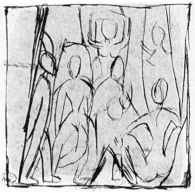

144
Etude pour 'Les demoiselles d'Avignon'
Study for 'Les Demoiselles d'Avignon'
May 1907
Paris
Pen and brown ink
8.7 × 9
Z. VI, 980; P.i.F., 1541
M.P. 534

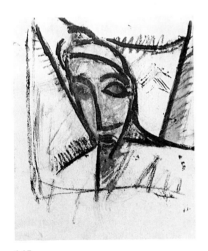

145
Etude pour 'Les demoiselles d'Avignon':
buste de marin
Study for 'Les Demoiselles d'Avignon': Head
and Shoulders of a Sailor
May–June 1907
Paris
Gouache
22.4 × 17.5
Z. VI, 978; D.R., 27; P.i.F., 1491
M.P. 538

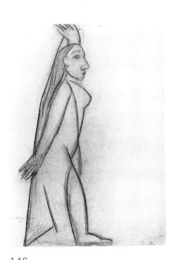

146
Etude pour 'Les demoiselles d'Avignon:
femme nue écartant un rideau
Study for 'Les Demoiselles d'Avignon': Nude
Woman Parting a Curtain
May–June 1907
Paris
Charcoal
63.4 × 48
Z. XXVI, 98; repr. D.R. p. 15; P.i.F., 1544
M.P. 541

147
Etude pour 'Les demoiselles d'Avignon':
nu de profil aux bras levés
Study for 'Les Demoiselles d'Avignon': Profile
of a Nude with Raised Arms
May–June 1907
Paris
Watercolour
22.3 × 17.5
Z. VI, 992; P.i.F., 1492
M.P. 540(r)

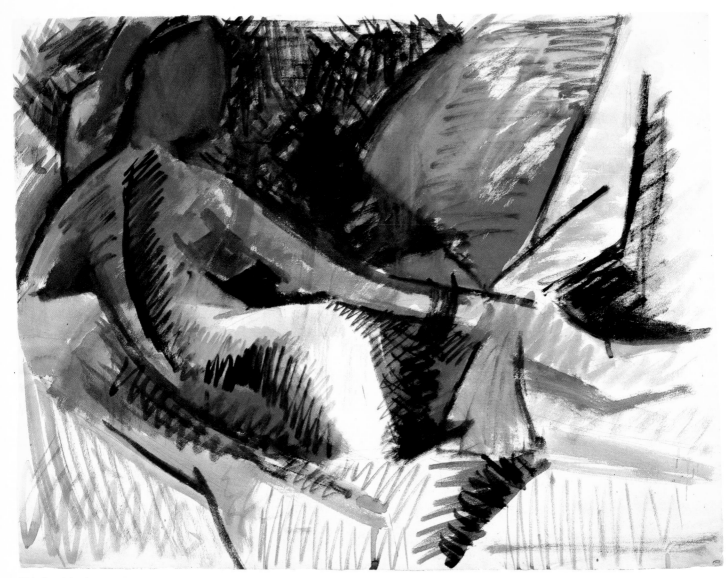

151 Odalisk after Ingres

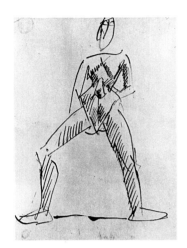

147a
Nu debout
Standing Nude
June–July 1907
Paris
Pen and Indian ink
27.3 × 17.5
M.P. 540(v)

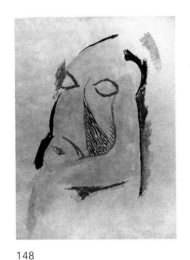

148
**Etude pour 'Les demoiselles d'Avignon':
tête de la demoiselle accroupie**
*Study for 'Les Demoiselles d'Avignon': Head
of the Crouching Woman*
June–July 1907
Paris
Gouache
63 × 48
Z. XXVI, 276; D.R., 45
M.P. 539

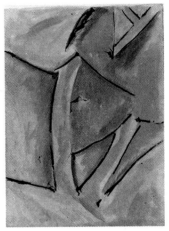

149
Paysage lié aux 'Moissonneurs': arbres
Landscape Related to 'The Reapers': Trees
June–July 1907
Paris
Gouache and pencil
63 × 48.4
Z. XXVI, 173; D.R., 57; P.i.F., 1465
M.P. 544

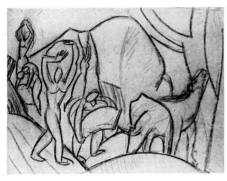

150
Etude pour 'Les moissonneurs'
Study for 'The Reapers'
June–July 1907
Paris
Charcoal
48.2 × 63
Z. XXVI, 169
M.P. 543

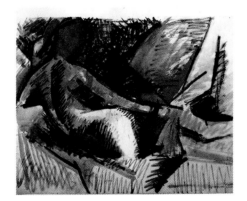

151
Odalisque d'après Ingres
Odalisk after Ingres
Summer 1907
Paris
Blue ink and gouache on pencil outlines
47.7 × 62.5
Z. XXVI, 194
M.P. 545

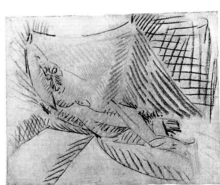

152
Etude pour 'Nu à la draperie': nu couché
*Study for 'Nude with Drapery': Reclining
Nude*
[Summer] 1907
Paris
Pastel
48 × 63.5
Z. XXVI, 264; D.R., 76
M.P. 547

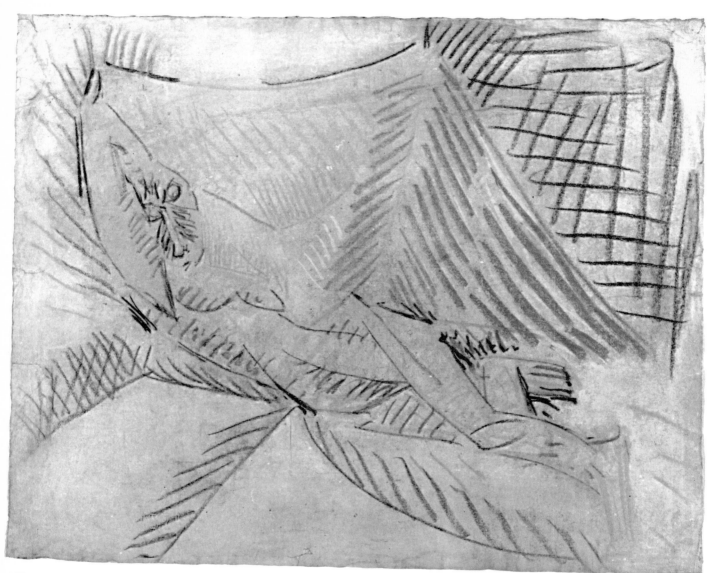

152 Study for 'Nude with Drapery': Reclining Nude

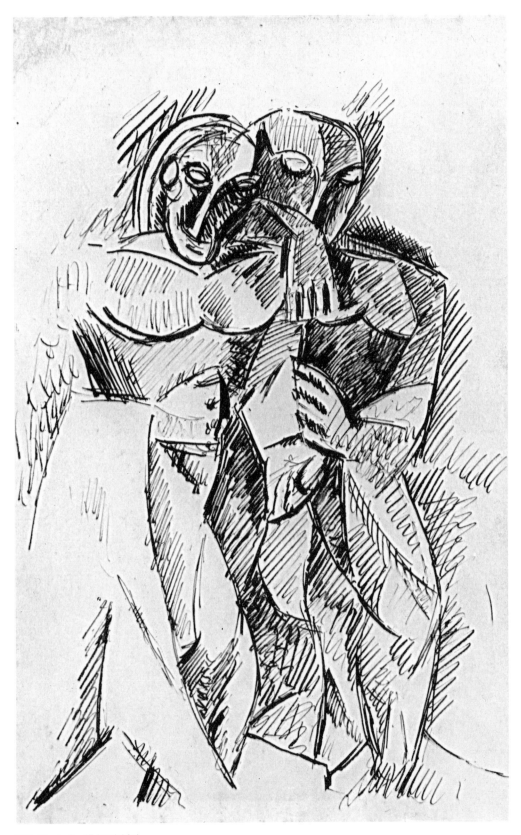

155 Study for 'Friendship'

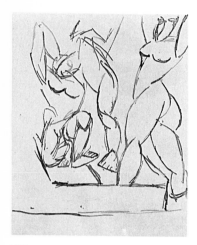

153
Etude pour la première version de 'Trois femmes': trois nus
Study for the First Version of 'Three Women': Three Nudes
Autumn 1907
Paris
Pen and brown ink
19.7 × 15.5
Z. XXVI, 294
M.P. 581

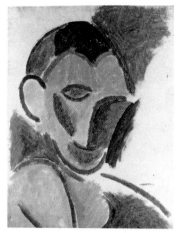

154
Etude de tête pour 'Nu à la serviette'
Study of Head for 'Nude with Towel'
Autumn 1907
Paris
Gouache
62.7 × 48
Z. XXVI, 273; D.R., 98; T.l.o.p.[2], 107
M.P. 550

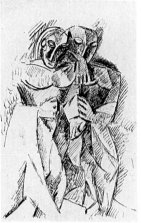

155
Etude pour 'L'amitié'
Study for 'Friendship'
Winter 1907–1908
Paris
Pen and Indian ink
48.4 × 31.6
Z. VI, 1011; T.l.o.p.[2], 116
M.P. 558

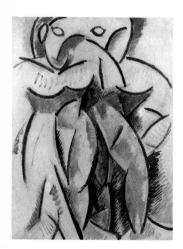

156
Etude pour 'L'amitié'
Study for 'Friendship'
Winter 1907–1908
Paris
Gouache on charcoal outlines
62.8 × 48
Z. XXVI, 280; D.R., 101
M.P. 559

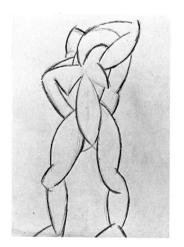

157
Etude pour 'Nu debout'
Study for 'Standing Nude'
Early 1908
Pencil
32.7 × 25
Z. XXVI, 305
M.P. 563

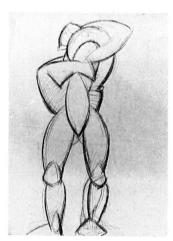

158
Etude pour 'Nu debout'
Study for 'Standing Nude'
Early 1908
Pencil
65.3 × 50
Z. XXVI, 307
M.P. 562

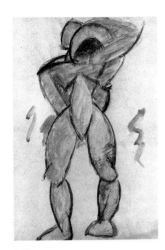

159
Etude pour 'Nu debout'
Study for 'Standing Nude'
Early 1908
Paris
Gouache
64.5 × 45
Z. VI, 1024; D.R., 110; T.l.o.p.(2), 185
M.P. 567

160
Etude pour 'Nu debout'
Study for 'Standing Nude'
Early 1908
Paris
Pencil, pen and purple ink
32.5 × 25
Z. XXVI, 306
M.P. 565

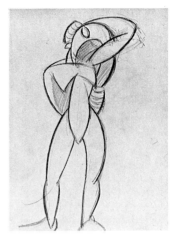

161
Etude pour 'Nu debout'
Study for 'Standing Nude'
Early 1908
Paris
Pencil
32.5 × 25
Z. XXVI, 304
M.P. 564

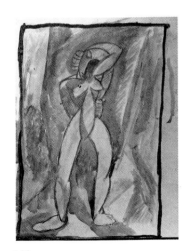

162
Etude pour 'Nu debout
Study for 'Standing Nude'
Early 1908
Paris
Gouache on pencil outlines
32.6 × 24.9
Z. XXVI, 329; D.R., 113
M.P. 569

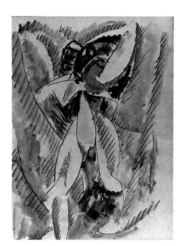

163
Etude pour 'Nu debout'
Study for 'Standing Nude'
Early 1908
Paris
Purple ink, purple ink wash and gouache
32.4 × 25
Z. XXVI, 326
M.P. 570

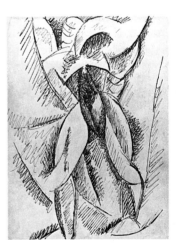

164
Etude pour 'Nu debout'
Study for 'Standing Nude'
Early 1908
Paris
Pen and black ink
32.6 × 25.1
Z. XXVI, 309
M.P. 571

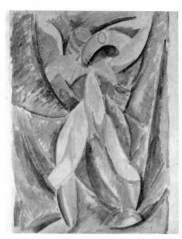

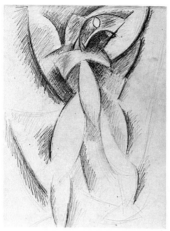

165
Etude pour 'Nu debout'
Study for 'Standing Nude'
Early 1908
Paris
Gouache and pencil
62.6 × 47.8
Z. XXVI, 325; D.R., 112
M.P. 568

166
Etude pour 'Nu debout'
Study for 'Standing Nude'
Early 1908
Paris
Pencil
33 × 25.1
Z. XXVI, 310
M.P. 561

167
Etude pour 'Nu debout'
Study for 'Standing Nude'
Early 1908
Paris
Pencil
32.7 × 25.1
Z. XXVI, 313
M.P. 566

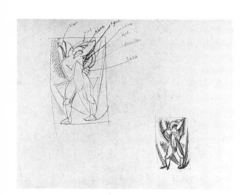

168
Deux études pour 'Nu debout', l'une avec des annotations manuscrites de couleurs
Two Studies for 'Standing Nude', one with handwritten notes showing colours to be used
[1908]
Pencil
25.3 × 32.5
Z. XXVI, 320
M.P. 560

169
Etude pour 'Trois femmes': buste de femme
Study for 'Three Women': Head and Shoulders of a Woman
Spring 1908
Paris
Gouache
31.5 × 24
Z. XXVI, 330
M.P. 573

170
Etude pour 'Trois femmes': nu debout de profil
Study for 'Three Women': Standing Nude in Profile
Spring 1908
Paris
Pencil
32.6 × 24.9
Z. XXVI, 312
M.P. 574

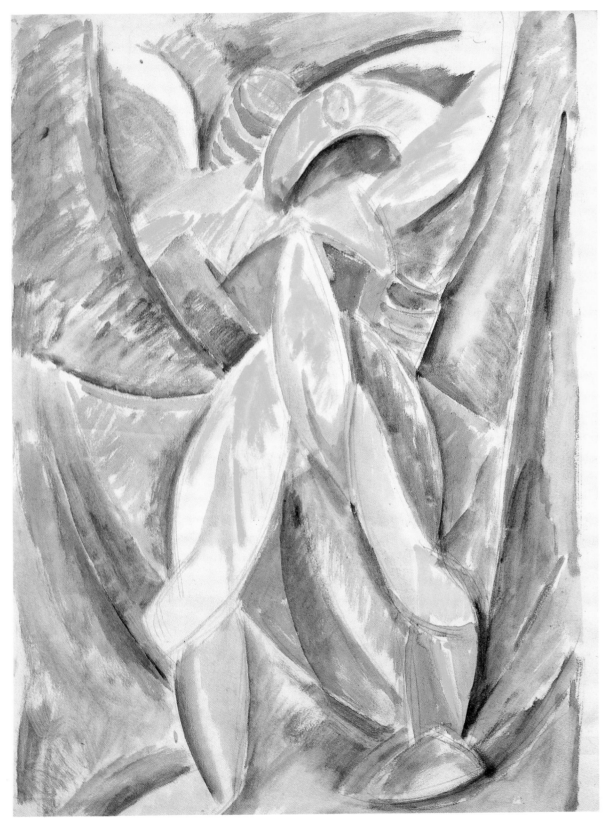

165 Study for 'Standing Nude'

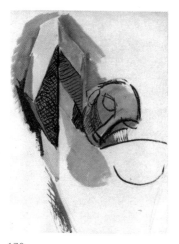

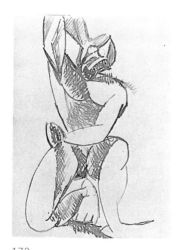

171
Etude pour 'Trois femmes': tête de la femme de gauche
Study for 'Three Women': Head of the Woman on the Left
Spring 1908
Paris
Gouache
62.7 × 48
Z. XXVI, 271; D.R., 130
M.P. 576

172
Etude pour 'Trois femmes': buste de la femme de gauche
Study for 'Three Women': Head and Shoulders of the Woman on the Left
Spring 1908
Paris
Pen and Indian ink on pencil outlines
62.5 × 48
Z. VI, 1014; D.R., 129
M.P. 577

173
Etude pour 'Trois femmes': la femme de gauche
Study for 'Three Women': the Woman on the Left
[Spring] 1908
Paris
Pen and brown ink
19.7 × 15.2
Z. XXVI, 296
M.P. 578

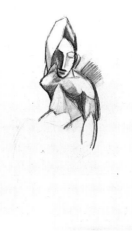

174
Etude pour 'Trois femmes': la femme de droite
Study for 'Three Women': the Woman on the Right
[Spring 1908]
Black chalk
63 × 48
Z. XXVI, 351
M.P. 555

175
Etude pour 'Trois femmes': les trois nus
Study for 'Three Women': the Three Nudes
Spring 1908
Paris
Brown ink
24.8 × 32.7
Z. XXVI, 314
M.P. 579

176
Etude pour 'Trois femmes': les trois nus
Study for 'Three Women': the Three Nudes
Spring 1908
Paris
Pen and brown ink
32.2 × 24.4
Z. XXVI, 315
M.P. 580

177
Etude pour 'Trois femmes': les trois nus
Study for 'Three Women': the Three Nudes
Spring 1908
Paris
Pencil
32.5 × 25.2
Z. XXVI, 318
M.P. 583

178
Etude pour 'Trois femmes': les trois nus
Study for 'Three Women': the Three Nudes
Spring 1908
Paris
Pen, Indian ink and pencil on tracing paper
31 × 21
Z. XXVI, 317
M.P. 582

179
Etude pour 'Trois femmes': les trois nus
Study for 'Three Women': the Three Nudes
Spring 1908
Paris
Pencil
32.5 × 24.7
Z. XXVI, 321
M.P. 588

180
Etude pour 'Trois femmes': les trois nus
Study for 'Three Women': the Three Nudes
Spring 1908
Paris
Purple ink and pencil on the back of a
reproduction of a painting by Othon Friez: *Le
port d'Anvers*, dated Anvers 06
18.6 × 14.3
Z. XXVI, 338
M.P. 596

181
Etude pour 'Trois femmes': les trois nus
Study for 'Three Women': the Three Nudes
Spring 1908
Paris
Indian ink and black chalk
32.6 × 25
Z. XXVI, 333
M.P. 597

182
Etude pour 'Trois femmes': les trois nus
Study for 'Three Women': the Three Nudes
Paris
Watercolour and pencil
32.5 × 25.2
Z. XXVI, 341
M.P. 598

183
Etude pour 'Trois femmes': les trois nus
Study for 'Three Women': the Three Nudes
Spring 1908
Paris
Gouache and pencil
33 × 24.7
Z. XXVI, 336
M.P. 589

184
Etude pour 'Trois femmes': les trois nus
Study for 'Three Women': the Three Nudes
Spring 1908
Gouache and pencil
32.5 × 24.7
Z. XXVI, 332
M.P. 590

185
Etude pour 'Trois femmes': les trois nus
Study for 'Three Women': the Three Nudes
Spring 1908
Paris
Gouache
25.4 × 32.8
Z. XXVI, 335; D.R., 121
M.P. 591

186
Etude pour 'Trois femmes': les trois nus
Study for 'Three Women': the Three Nudes
Spring 1908
Paris
Gouache, blue ink, brown ink and pencil
24.5 × 33
Z. XXVI, 328
M.P. 592

187
Etude pour 'Trois femmes': les trois nus
Study for 'Three Women': the Three Nudes
Spring 1908
Paris
Watercolour on pencil outlines
32.5 × 25
Z. XXVI, 340
M.P. 593

188
Etude pour 'Trois femmes': les trois nus
Study for 'Three Women': the Three Nudes
Spring 1908
Paris
Watercolour, pencil and charcoal
33 × 25
Z. XXVI, 337
M.P. 594

189
Etude pour 'Trois femmes': les trois nus
Study for 'Three Women': the Three Nudes
Spring 1908
Paris
Watercolour and pencil
33 × 25.2
Z. XXVI, 339
M.P. 595

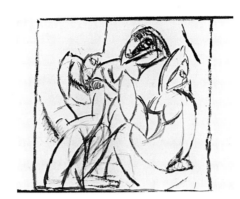

190
Etude pour 'Trois femmes': les trois nus
Study for 'Three Women': the Three Nudes
Spring 1908
Paris
Blue ink
24 × 32.2
Z. XXVI, 324
M.P. 584

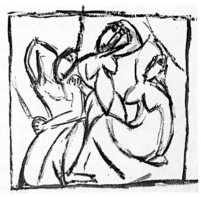

191
Etude pour 'Trois femmes': les trois nus
Study for 'Three Women': the Three Nudes
Spring 1908
Paris
Blue ink and gouache
30.9 × 23.6
Z. XXVI, 323
M.P. 585

192
Etude pour 'Trois femmes': les trois nus
Study for 'Three Women': the Three Nudes
Spring 1908
Paris
Purple ink, charcoal and gouache
31 × 24.5
Z. XXVI, 322
M.P. 586

193
Etude pour 'Trois femmes': les trois nus
Study for 'Three Women': the Three Nudes
Spring 1908
Paris
Indian ink wash and gouache
32.9 × 25
Z. XXVI, 334
M.P. 587

194
Nu debout au bras levé
Standing Nude with Raised Arm
[Spring] 1908
Paris
Indian ink and pencil
62.6 × 48.3
Z. XXVI, 279
M.P. 557

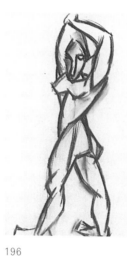

195
Nu debout au bras levé
Standing Nude with Raised Arm
[Spring] 1908
Paris
Charcoal
62.7 × 48.1
M.P. 554

196
Etude pour 'Baigneuses dans la forêt': la femme de droite
Study for 'Bathers in the Forest': the Woman on the Right
Spring 1908
Paris
Charcoal
62.7 × 48
Z. XXVI, 278
M.P. 556

197
Etude pour 'Baigneuses dans la forêt'
Study for 'Bathers in the Forest'
Spring 1908
Paris
Gouache on pencil outlines
48.4 × 62.7
Z. XXVI, 331; D.R., 125
M.P. 605

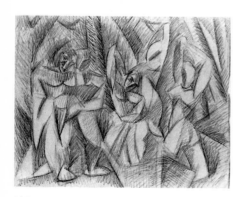

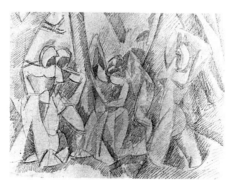

198
Etude pour 'Baigneuses dans la forêt'
Study for 'Bathers in the Forest'
Spring 1908
Paris
Charcoal
47.7 × 60.2
M.P. 604

199
Etude pour 'Baigneuses dans la forêt'
Study for 'Bathers in the Forest'
Spring 1908
Paris
Pencil
32 × 43.5
Z. XXVI, 292
M.P. 603

200
Etude pour 'Baigneuses dans la forêt'
Study for 'Bathers in the Forest'
Spring 1908
Paris
Indian ink and charcoal
37 × 48.2
Z. XXVI, 295
M.P. 602

201
Etude pour 'Baigneuses dans la forêt'
Study for 'Bathers in the Forest'
Spring 1908
Paris
Indian ink on pencil outlines
23.7 × 30.7
Z. XXVI, 298
M.P. 601

202
Etude pour 'Baigneuses dans la forêt'
Study for 'Bathers in the Forest'
Spring 1908
Paris
Pen and Indian ink
11 × 13.4
Z. XXVI, 289
M.P. 600

203
Etude pour 'Baigneuses dans la forêt'
Study for 'Bathers in the Forest'
Spring 1908
Paris
Pen and brown ink
19.7 × 15.3
Z. XXVI, 290
M.P. 599

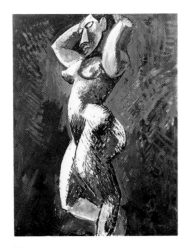

204
Nu au bras levés
Nude with Raised Arms
Spring 1908
Paris
Gouache
32 × 25
Z. II¹, 39; D.R., 165; T.l.o.p.[2], 45
M.P. 575(r)

204a
Tête
Head
Spring 1908
Paris
Charcoal
25 × 32
M.P. 575(v)

205
Nu assis
Seated Nude
Spring 1908
Indian ink and gouache on charcoal outlines
62.8 × 48
Z. XXVI, 308; D.R., 145; T.l.o.p.[2], 139
M.P. 572

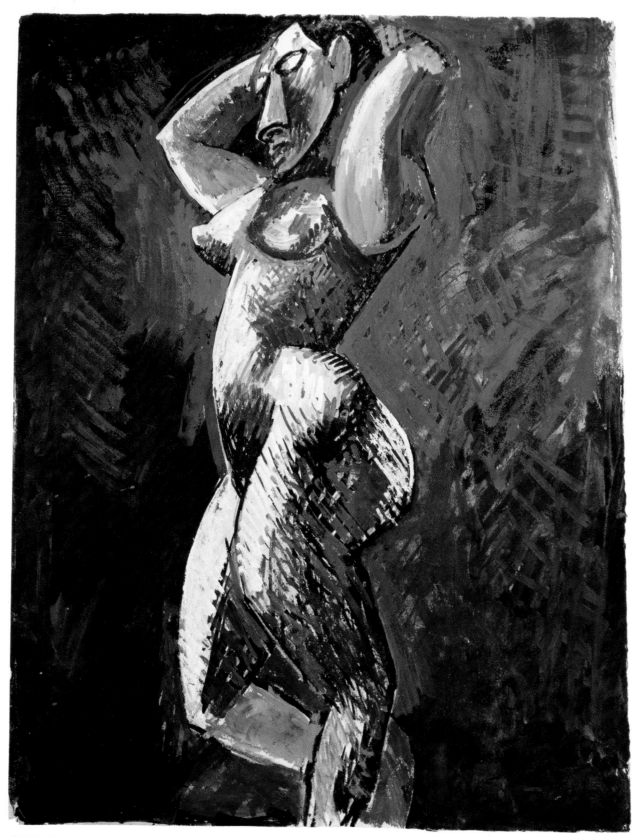

204 **Nude with Raised Arms**

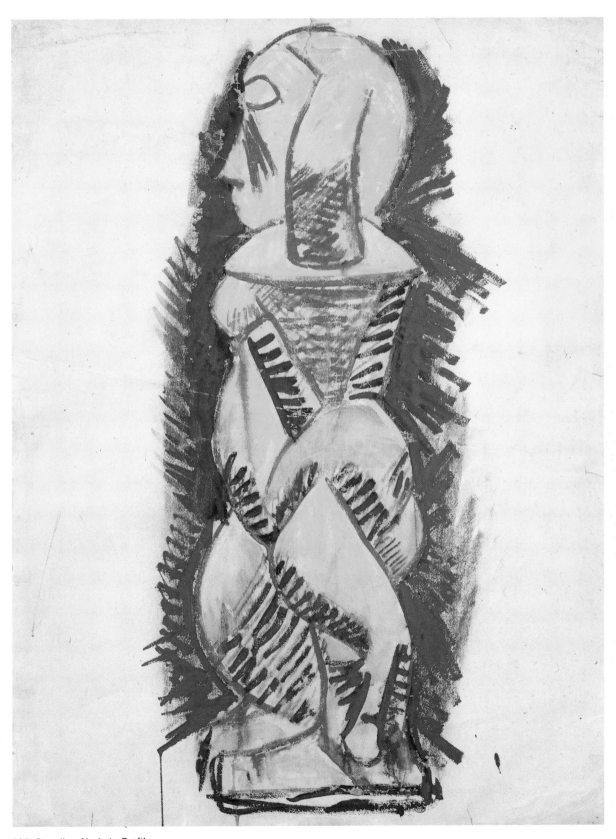

206 Standing Nude in Profile

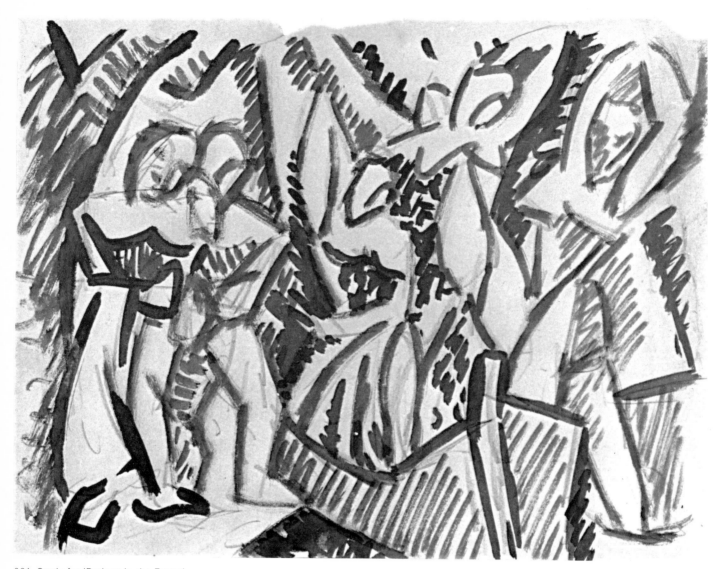

201 Study for 'Bathers in the Forest'

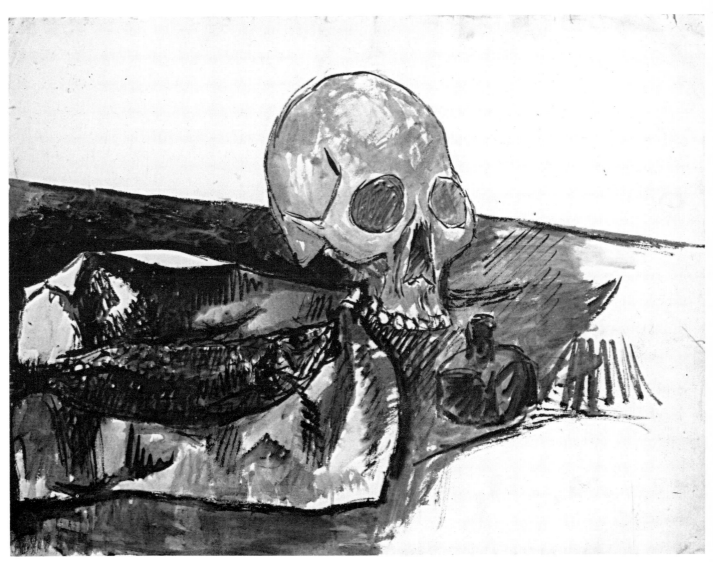

208 Still-life: Fish, Skull and Inkwell

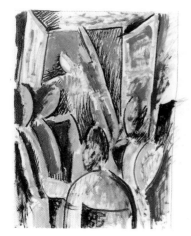

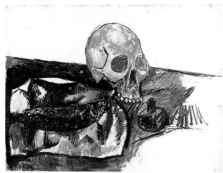

206
Nu debout de profil
Standing Nude in Profile
Spring 1908
Paris
Gouache and pastel
62.5 × 48
Z. XXVI, 275; D.R., 72; T.l.o.p.(2), 74
M.P. 546

207
Marins en bordée
Sailors on a Spree
Spring–summer 1908
Paris
Oil, Indian ink, charcoal and pencil
64.2 × 49
Z. XXVI, 188; D.R., 1; P.i.F., 1514
M.P.532

208
Nature morte: poisson, crâne et encrier
Still-life: Fish, Skull and Inkwell
Spring–summer 1908
Paris
Indian ink and tinted wash
47.7 × 63
Z. XXVI, 193
M.P. 548

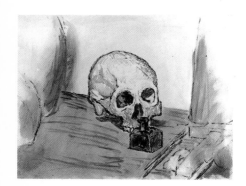

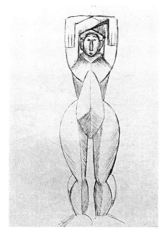

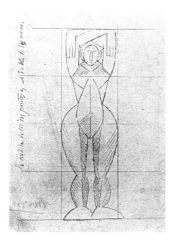

209
Nature morte: crâne, encrier et marteau
Still-life: Skull, Inkwell and Hammer
Spring–summer 1908
Paris
Indian ink and tinted wash
48.2 × 63.5
Z. XXVI, 192
M.P. 549

210
Etude de nu au visage hiératique, les bras croisés au-dessus de la tête
Study of a Nude with Hieratic Face, Arms Crossed above the Head
[Summer] 1908
[Paris, Rue-des-Bois]
Pen and brown ink
26.7 × 19.6
S. verso in pencil: *Picasso*
Inscr. verso in pencil: *9*
Z. VI, 917
M.P. 551

211
Etude de nu au visage hiératique, les bras croisés au-dessus de la tête
Study of a Nude with Hieratic Face, Arms Crossed above the Head
(with handwritten notes showing the proportions)
[Summer] 1908
[Paris, Rue-des-Bois]
Pencil on tracing paper divided into squares
31 × 21
S. verso: *Picasso*
Inscr. sideways l.: *la medita de los dos pantos es el doble de las ancas*
M.P. 552

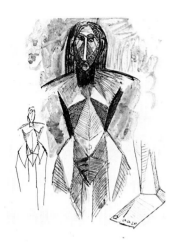

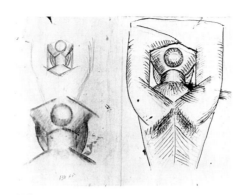

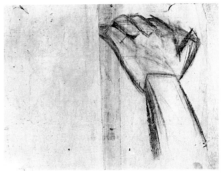

212
Nus debout et étude de pied
Standing Nudes and Study of a Foot
Summer 1908
[Rue-des-Bois]
Pen, Indian ink and watercolour on the back
of an article entitled 'La Torre del lavoro di
Rodin'
30 × 22.6
Z. XXVI, 354
M.P. 608

213
**Trois études: femme de dos au chignon,
les bras levés**
*Three Studies: Back of a Woman with a
Chignon, Arms Raised*
Summer 1908
[Rue-des-Bois]
Pencil (woman above left); pencil and
charcoal (woman below left); Indian ink on
pencil outlines (woman on the right), on a
folded double sheet
48.2 × 62.7
Z. XXVI, 344 (right-hand side)
M.P. 553(r)

213a
Main
Hand
[Summer 1908]
[Rue-des-Bois]
Charcoal
48.2 × 62.7
M.P. 553(v̇)

214
Etudes pour 'La fermière'
Studies for 'The Farmer's Wife'
Summer 1908
Rue-des-Bois
Black chalk
48.2 × 62.8
Z. VI, 1006
M.P. 606(r)

214a
Etude pour 'La fermière'
Study for 'The Farmer's Wife'
Summer 1908
Rue-des-Bois
Black chalk
48.2 × 62.8
Z. VI, 1002; T.l.o.p.(2), 172
M.P. 606(v)

215
Etude pour 'Carnaval au bistrot'
Study for 'Carnival at the Bistro'
(drawn on a study of space, June–July 1907)
Late 1908
Paris
Pencil
17.5 × 22.3
Z. VI, 1065
M.P. 619(r)

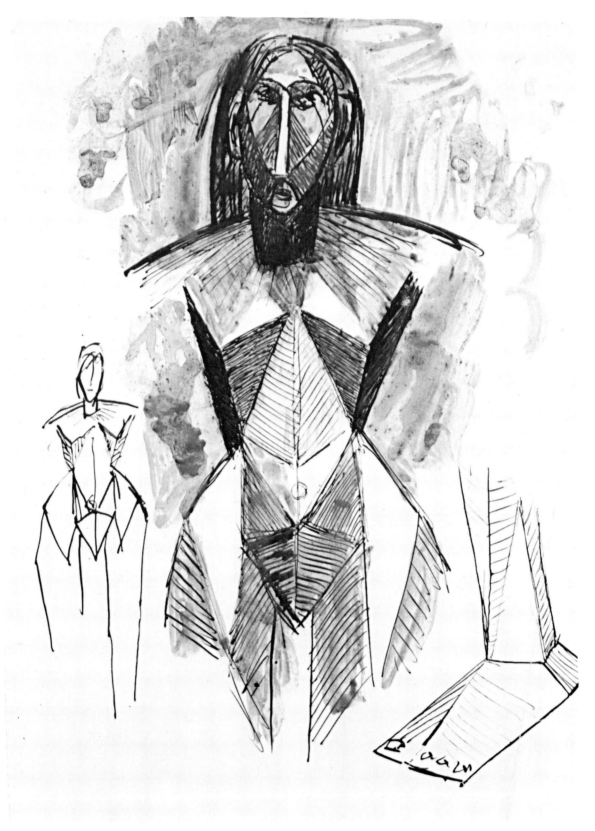

212 Standing Nudes and Study of a Foot

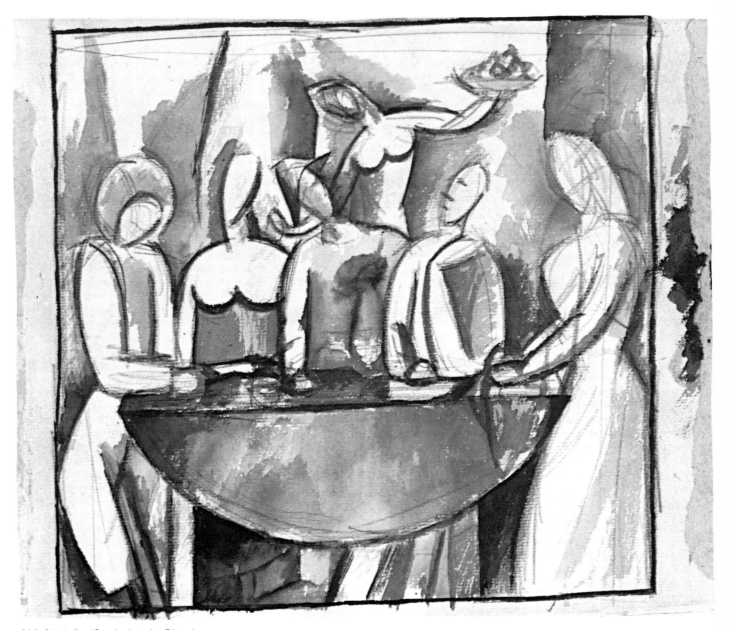

216 Study for 'Carnival at the Bistro'

215a
Etude pour 'La dryade'?
Study for 'The Wood Nymph'?
June–July 1907
[Paris]
Pencil
22.3 × 17.5
Z. VI, 912
M.P. 619(v)

216
Etude pour 'Carnaval au bistrot'
Study for 'Carnival at the Bistro'
Late 1908
Paris
Blue ink and pencil
24.1 × 27.4
S. verso: *Picasso*
Z. VI, 1066; D.R., 217; T.l.o.p.[2], 132
M.P. 623

217
Etudes pour 'Carnaval au bistrot'
Studies for 'Carnival at the Bistro'
Late 1908
Paris
Indian ink and gouache highlights on black
chalk outlines
32 × 49.4
Z. VI, 1073
M.P. 621(r)

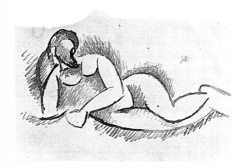

218
Femme nue allongée
Nude Woman Stretched Out
1908
[Paris]
Pen and brown ink
11.7 × 15.2
Z. XXVI, 316
M.P. 625

219
Personnages
Figures
[1908]
Paris
Pen and Indian ink on pencil outlines
14.5 × 5.7
Z. VI, 1010
M.P. 615(r)

219a
Femme les bras levés?
Woman with Raised Arms?
[1907]
[Paris]
Pen and Indian ink
5.7 × 14.5
M.P. 615(v)

220
Personnages
Figures
[1908–1909]
Paris
Pencil
32.2 × 28.1
M.P. 616

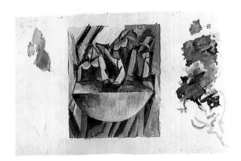

221
Etude pour 'Carnaval au bistrot'
Study for 'Carnival at the Bistro'
Winter 1908–1909
Paris
Gouache and Indian ink on black chalk
outlines
32 × 49.5
Z. VI, 1074; D.R., 219; T.l.o.p.[2], 133
M.P. 620(r)

221a and 217a
Etude pour 'La dryade'
Study for 'The Wood Nymph'
Spring–summer 1908
Paris
Pen and Indian ink
64.4 × 49.5
S.a.r. and c. in pencil: *Picasso*
Z. VI, 970
M.P. 620/621(v)

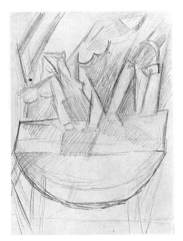

222
Etude pour 'Carnaval au bistrot'
Study for 'Carnival at the Bistro'
Winter 1908–1909
Paris
Pencil
31.3 × 23.8
S. verso: *Picasso*
Z. VI, 1067
M.P. 622

223
Arlequin et sa compagne sur un banc
Harlequin and his Mistress on a Bench
Winter 1908–1909
Paris
Shaded black chalk
22.3 × 27.9
Z. XXVI, 375
M.P. 617

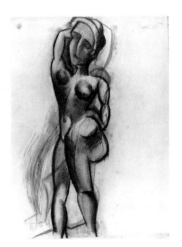

224
Femme nue debout
Standing Nude Woman
Winter 1908–1909
Paris
Charcoal with black chalk highlights
62.5 × 48.2
S. verso: *Picasso*
Z. VI, 1072; T.l.o.p.[2], 197
M.P. 631

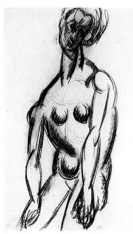

225
Nu assis
Seated Nude
Winter 1908–1909
Paris
Black chalk
32.6 × 21.4
M.P. 630

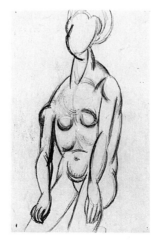

226
Nu assis
Seated Nude
Early 1909
Paris
Black chalk
32.3 × 21.3
M.P. 628

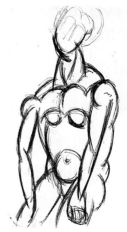

227
Nu assis
Seated Nude
Early 1909
Paris
Black chalk
32.3 × 21.6
Z. VI, 1021
M.P. 629

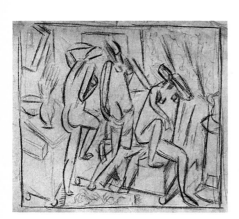

228
Trois nus dans un intérieur
Three Nudes in an Interior
[Early 1909]
Paris
Black chalk
31 × 35.5
M.P. 618(r)

228a
Maison
House
[Early 1909]
Paris
Black chalk
35.5 × 31
M.P. 618(v)

229
Personnages en barque dans un paysage
Figures in a Boat in a Landscape
Early 1909
Paris
Pencil
31 × 48
Z. XXVI, 374
M.P. 614

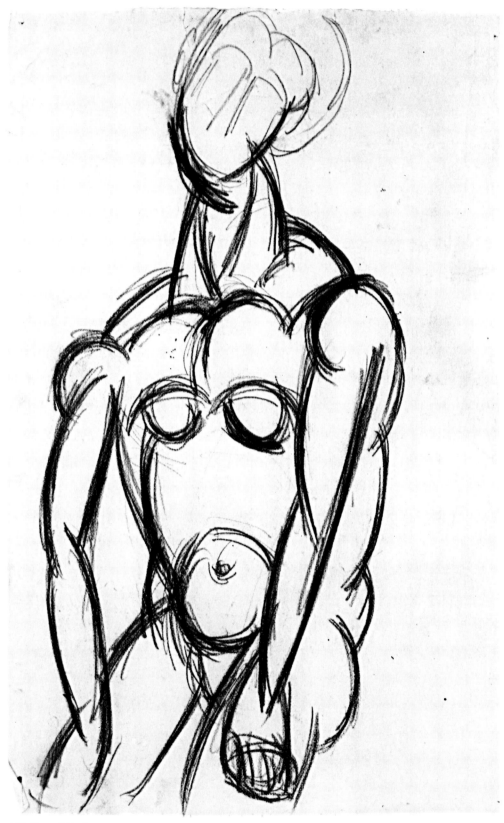

227 Seated Nude

230
Nus dans un paysage
Nudes in a Landscape
Early 1909
Paris
Pen and Indian ink on the back of a bill from
Felix Potin, 28/10/1908
21.1 × 27.4
Z. XXVI, 380
M.P. 612

231
Nus dans un paysage
Nudes in a Landscape
[Early 1909]
[Paris]
Pen and brown ink, coloured crayon and
gouache highlights
13.2 × 17.4
M.P. 607

232
Nus dans un paysage
Nudes in a Landscape
Early 1909
Paris
Gouache, pen and Indian ink
32.3 × 49.5
Z. XXVI, 381; D.R., 232b
M.P. 613

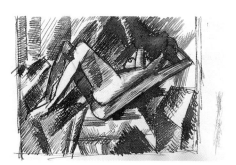

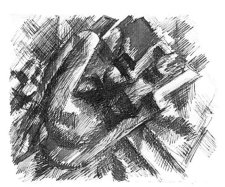

233
Baigneuse
Bather
Early 1909
Paris
Gouache on newspaper
30 × 18.2
Z. VI, 986; D.R., 231
M.P. 611

234
Femme nue allongee
Nude Woman Stretched Out
Early 1909
Paris
Pen and brown ink on pencil outlines on a
folded double sheet
11.5 × 17.7
Inscr. sideways in pencil, crossed out: *Horte*
[?] *190* [?]
Z. VI, 1090
M.P. 609

235
Femme nue allongée
Nude Woman Stretched Out
Early 1909
Paris
Pen and black ink
13.2 × 17
Z. VI, 1089
M.P. 610

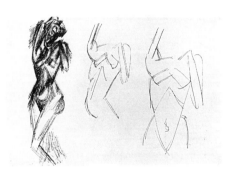
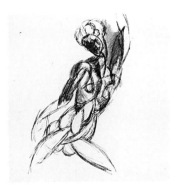

236
Trois études de nu féminin
Three Studies of a Female Nude
Early 1909
Paris
Pen and Indian ink
31.5 × 48.5
Z. XXVI, 384
M.P. 627

237
Femme nue au bras levé
Nude Woman with Raised Arm
Early 1909
Paris
Pen, Indian ink and tinted wash
31.7 × 23.6
S. verso in pencil: *Picasso*
Z. VI, 1015
M.P. 626

The Golden Age of Cubism 1909–1917[1]

When we created Cubism, we had no intention of creating Cubism, but of expressing what lay within ourselves. Nobody drew up a plan of action for us and although our poet friends followed our efforts with interest they never dictated to us.

PICASSO TO CHRISTIAN ZERVOS[2]

It is generally agreed that Picasso first created works described as 'Cubist' at Horta; at that time they were basically characterized as being broken up into facets. Eight years passed from the drawings done at Horta in the summer of 1909 to the final sketches of 1916–1917. In the course of those years Picasso, closely tied to Braque until the war broke out, single-mindedly pursued his own aim, defined by Douglas Cooper as 'essential Cubism'. The 155 drawings held in the Musée Picasso offer evidence of this; the collection is unrivalled anywhere in the world and will certainly throw new light on Picasso's work once it has been fully understood.

In 1981 John Golding, one of Cubism's most eminent experts, and Roland Penrose, a friend and frequent guest of Picasso, went to study a selection of works from the Musée Picasso which had been set aside in the Palais de Tokyo in Paris. They were to choose pieces for an exhibition of part of the settlement planned to take place in London – no easy task in view of the treasures they discovered in the collection dating from this period.

Roland Penrose[3] suggests that although Picasso was obliged to sell his paintings he would have wished to keep some as illustrations of his new artistic vision. It is incidentally worth noting that the majority of drawings from this series have been published in the supplementary volumes of the Zervos Catalogue (XXVIII and XXIX). Did the artist one day decide to open his portfolios and show work he had hitherto not revealed?

A study of the drawings, even including those in the sketchbooks, would not, however, give us a sufficiently comprehensive view of Cubism. Of all the periods in Picasso's life this shows the most marked interconnection of techniques: painting, sculpture – including some superb miniature constructions – picture-reliefs, a category defined by Hélène Seckel as being 'situated mid-way between plane and volume',[4] and engravings. Likewise, it would be impossible to gain a complete understanding of the problems posed by Picasso's Cubist drawings without including his *papiers collés*. These other works, excluding the engravings, are listed in Volume I of the catalogue.

Describing the concept of Cubism, Zervos writes:[5] 'at its most successful it is not superior to the traditional concept, but entirely different. It marks the beginning of a relentless conflict between the notion of art based on the principle of reproducing the surface planes of an object to correspond to its outward appearance and the notion based on introducing the principle of structure.' The collection begins with *Maisons* (*Houses*, cat. 238–240). Zervos thought that the houses were in Horta, but Pierre Daix[6] places the views as those seen from the bedroom window of the hotel in Barcelona where Picasso stayed with Fernande Olivier on the way to Horta in the spring of 1909. According to Gertrude Stein,[7] Cubism is a Spanish phenomenon inherent in the architecture of that country. In her book on Picasso she describes the landscapes which were the fruits of the artist's stay – some of which she herself acquired – emphasizing how realistic they are when compared to photographs taken by him.[8] She adds: 'These three landscapes express exactly what I wish to make clear, that is to say the opposition between nature and man in Spain. The round is opposed to the cube, a small number of houses gives the impression of a great quantity of houses in order to dominate the landscape . . .'

(1) We are very grateful to Elzbieta Grabska, Christopher Green and Alexandra Parigoris for their advice on the dating of some of these drawings.

(2) 'Conversation avec Picasso', quoted by Christian Zervos in *Picasso 1930–1935*, *Cahiers d'Art*, Vol. X, nos 7–10, 1935, published 1936.

(3) Roland Penrose, 'The Drawings of Picasso', *Picasso's Picassos*, London, 1981, pp. 90–100.

(4) See cat. I, p. 129.

(5) C. Zervos, *Dessins de Pablo Picasso*, op. cit., p. xxiv.

(6) D.R., p. 241.

(7) G. Stein, *Picasso*, p. 24 (reprinted 1984).

(8) Cf. fig. 1.

Cézanne's influence is so obvious that the Cubism of this period is often qualified as 'Cézannian'. These were to be the last landscapes, the Cubist repertoire being limited to figures and still-life compositions, as people and objects lent themselves more easily to the process of breaking down and re-composing. The collection does contain, however, a study for *The Pont-Neuf* (cat. 257)[9] done in the spring of 1911 and a *Paysage de Céret* (*Céret Landscape*, cat. 261). At Horta during the same period Picasso applied his new technique – the breaking up of planes – to his mistress's face (cat. 244). In this the expression is preserved, paving the way for the sculpture he made on their return to Paris in the autumn.

Analytical Cubism grew to its full development at Cadaqués during the summer of 1910. At that time Picasso was preparing some etchings to illustrate *Saint Matorel*, a work by Max Jacob. *Maisons et palmier* (*Houses and a Palm Tree*, cat. 249) is not unlike *Couvent de Saint Matorel* (*The Convent of Saint Matorel*), and *Figure assise* (*Seated Figure*, cat. 253) is similar to *Mlle Léonie*.[10] Could the calculations and writing on the proof-copy date from the day Picasso wrote to Kahnweiler deploring the size of its margins and lettering?[11] The *Nu debout* (*Standing Nude*, cat. 251), which reveals a subtle analysis of form, is smaller in size but certainly equal in quality to the famous nude in the Steiglitz Collection (fig. 6). It could have been among the 83 Picasso drawings in the exhibition organized in March 1911 at the '291' Gallery in New York.

Two important studies featuring heads, one of a man, the other of a woman (cat. 255 and 256 respectively), stand out somewhat from the rest of the artist's work, carrying no indications which would enable us to give them an exact date. They were drawn using charcoal and crayon in a series of planes superimposed with light and shaded areas. In spite of their similarity they may not be exactly contemporaneous. If we compare the *Tête de femme* (*Head of a Woman*, cat. 244) done at Horta to the previously mentioned *Tête d'espagnole* (*Head of a Spanish Woman*, cat. 256), long referred to as *L'algérienne* (*The Algerian Woman*), we can discern the move from a sculptural to a pictorial phase emphasized by Gary Tinterow.[12] Although these portraits bear resemblances to certain people, the exact identity of the models remains a mystery. According to Edward Fry the man could be Apollinaire.

Between 1910 and 1912 a series of more or less 'hermetic' still-life compositions was produced. Numerals first appear in *Nature morte au trousseau de clés* (*Still-life with a Bunch of Keys*, cat. 272), a drawing for a dry-point etching (fig. 7). It is oval in shape, as is the famous *Nature morte à la chaise canée* (*Still-life with Chair-caning*, cat. I, 35), dating from the same period, and the *Nature morte à la pendule* (*Still-life with a Clock*, cat. 289). The small *Nature morte à la guitare* (*Still-life with a Guitar*, cat. 293) bears the inscription *A JOLIE* (*Ma Jolie*), the only evidence of Picasso's love for his mistress Eva Gouel. On another drawing the letters *JOUR* indicate a newspaper (cat. 294). *Porte-buvard* (*Blotting-paper Holder*, cat. 270), drawn in fine, hatched lines, appears alone. It is the sole object featured apart from musical instruments, familiar Cubist motifs which the artists hung on their studio walls. Unlike Braque, Picasso did not play any instruments, but they held an aesthetic or sentimental importance for him. Werner Spies[13] quite justifiably speaks of 'anthropomorphous' guitars. With a few rare exceptions, such as *Le peintre* (*The Painter*, cat. 301), all the figures are musicians, usually guitarists. The styles of these drawings reveal the specific feature distinguishing each phase of Cubism.

A series of small sketches (cat. 335–348) shed light on *Guitare et bouteille de Bass* (*Guitar and Bottle of Bass*, figs 8, 9), allowing us to follow the stages of its development. They provide us with a perfect example of drawing and sculpture overlapping. Other sketches, however, such as *Guitaristes* (*Guitar Players*, cat. 307 and following), are probably related to ideas for paintings which never materialized.

Picasso's return to Concrete Art in 1913 was marked by the famous and extraordinary work, *Femme en chemise dans un fauteuil* (*Woman in a Chemise Sitting in an Armchair*, fig. 10). 'The enormous sculptural mass representing this woman in her armchair, her head as big as a Sphinx's, her breasts nailed to her chest – all these elements contrast marvellously . . .' writes Paul Eluard.[14] Picasso produced several drawings based on this painting, two of which are held in the museum. One is done in crayon, the other in gouache (cat. 321, 322); both are full of poetic inspiration. He was to use the same theme once more in Avignon the following summer,

Fig. 1
Landscape of Horta photographed by Picasso, 1907
(Picasso Archives)

(9) Z. VI, no. 453, private collection, Switzerland.

(10) Cf. G. 26 and G. 25.

(11) Letter published by Isabelle Monod Fontaine, in *Donation Louise et Michel Leiris. Collection Kahnweiler-Leiris*, Paris, Pompidou Centre, 1984, p. 165.

(12) G. Tinterow, *Master Drawings by Picasso*, Cambridge, Mass., 1981, no. 36.

(13) W. Spies, 'La guitare anthropomorphe', *Revue de l'Art*, no. 12, 1971, pp. 89–92.

(14) P. Eluard, 'Je parle de ce qui est bien', *Picasso, 1930–1935, Cahiers d'Art*, Vol. X, nos 7–10, 1935, published 1936.

integrating it into a fantasy composition (cat. 355) forming part of a notably Surrealistic series (cat. 354–356).

The representation of a piece of wallpaper on a drawing (cat. 318) shows the links with *papiers collés* which Picasso produced in large quantities during his stay in Céret in 1913. *Bouteille de vin et verre* (*Bottle of Wine and a Glass*, cat. 353), seen on the wall in a photograph of the studio in the rue Schoelcher (fig. 3), must have been drawn at roughly the same time as the *papier collé* showing the same bottle (held by the museum, cat. I, 216), that is in the spring of 1914, before Picasso's departure for Avignon. *Verre, pipe, journal et carte à jouer* (*Glass, Pipe, Newspaper and Playing Card*, cat. 352), is not related to any other work, but its motifs are taken from everyday life, as is the case with the tondo of the same period;[15] it is a Cubist composition similar to the *papiers collés* of 1914.

That year Picasso indicated the locality of his still-life drawings; he wrote *FETE DE AVIGNON* in capital letters on *Verres et bouteille* (*Glasses and a Bottle*, cat. 350) and *AVIGNON* on a study of glasses (cat. 351). During the summer of 1914, living near Braque and Derain until they were mobilized, Picasso reverted to a naturalistic style. Besides the study of glasses an example of this occurs with the *Nature morte aux biscuits* (*Still-life with Wafers*, cat. 349); the distinctive SULTANE wafer-biscuits are drawn with extraordinary precision. The appearance of pears and grapes confirms that the still-life compositions (cat. 365) were drawn in the autumn. Colour was virtually absent throughout the whole of the Cubist period

(15) Cat. I, 248; Z. II², 830.

Fig. 2
Daniel-Henry Kahnweiler in the studio on the boulevard de Clichy, 1910 (Picasso Archives)

Fig. 3
The studio in the rue Schoelcher, 1914 (Picasso Archives)

and just glimpsed in 1913 with *Homme au chapeau* (*Man with a Hat*, cat. 317). It made a fresh appearance with the works featuring men reading newspapers (cat. 357, 358) and remained in evidence in 1915 and 1916 (cat. 382, 383, 388, 392).

Home attablé (*Man Seated at Table*, cat. 359), must have been drawn, together with its very realistic counterpart (cat. 360), when the artist was painting *Le peintre et son modèle* (*The Painter and his Model*, fig. 11). Part of this work, which is painted on canvas, is in fact drawn. The man is dressed in identical clothes, strikes the same pose, has the same large hands and the same moustache. If, as is commonly agreed, it dates from the Avignon period, what drawings would Kahnweiler have seen in the spring of 1914? 'Picasso showed me two drawings, Classical rather than Cubist, two drawings of a seated man.'[16]

This character was to be developed. He became the man with a pipe seated at a table who appeared in a different guise in a sketchbook from Barcelona as late as 1917. The museum holds several variations (cat. 361–363, 370–377, 379).[17]

The collection is completed with two emotive and beautiful decorated letters, sent by Picasso to his friends Guillaume Apollinaire and André Salmon during the war (cat. 366, 378). They are the gifts of Mr William MacCarthy Cooper and M. and Mme Alain Mazo respectively.

(16) D.-H. Kahnweiler, *Mes galeries et mes peintres*, pp. 73–74.

(17) Dating these is no easy task; several suggestions have been given. After having studied all the parameters and having sought the advice of Christopher Green we grouped the majority of drawings together in the period [1914–1915]. Only drawings of which we were certain are given an exact date.

Principal Related Works

Cat. 243:
Le réservoir de Horta (*The Reservoir at Horta*), 1909. New York, The Museum of Modern Art. Z. I, 177. (Fig. 4)

Cat. 244–245:
Tête de femme (*Fernande*) (*Head of a Woman* [*Fernande*]), 1909. Paris, Musée Picasso, cat. I, 286; S. 24. (Fig. 5)

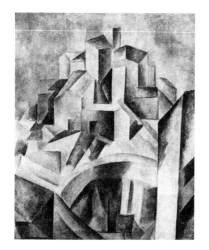

Fig. 4 Fig. 5

Cat 251:
Femme nue (*Female Nude*), 1910. New York, The Metropolitan Museum of Art. Z. II¹, 208. (Fig. 6)

Cat 272:
Nature morte, trousseau de clés (*Still-life with a Bunch of Keys*), 1912, rough draft. Paris, Musée Picasso, M.P. 1925. G. 30. (Fig. 7)

Cat. 335–348:
Guitare et bouteille de Bass (*Guitar and Bottle of Bass*), 1913. Paris, Musée Picasso, cat. I, 241. Z. II², 575, original state (fig. 8); S. 33b, present state (fig. 9).

Cat. 321–322:
Femme en chemise dans un fauteuil (*Woman in a Chemise Sitting in an Armchair*), 1913. New York, V. Ganz Collection. Z. II², 522. (Fig. 10)

Cat. 359–360:
Le peintre et son modèle (*The Painter and his Model*), 1914. Paris, Musée Picasso, cat. I, 48. (Fig. 11)

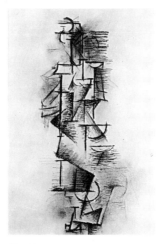

Fig. 6

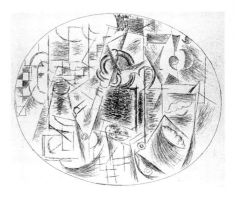

Fig. 7

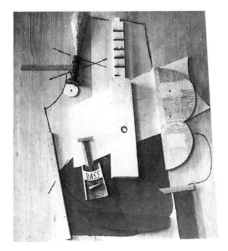

Fig. 8

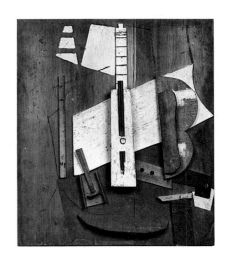

Fig. 9

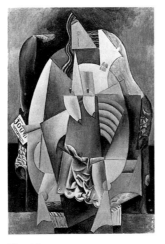

Fig. 10

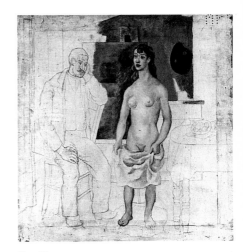

Fig. 11

238 **Houses**

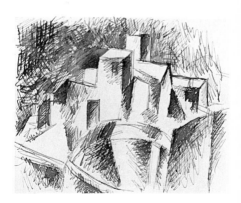

238
Maisons
Houses
April–May 1909
Barcelona
Pen and black ink
17 × 13
Z. VI, 1085; T.l.o.p.$^{(2)}$, 270
M.P. 632

239
Maisons et palmiers
Houses and Palm Trees
April–May 1909
Barcelona
Pen and black ink
17.3 × 13.5
Z. VI, 1093; T.l.o.p.$^{(2)}$, 274
M.P. 636

240
Maisons et palmiers
Houses and Palm Trees
April–May 1909
Barcelona
Pen and black ink
17 × 11
Z. VI, 1092; T.l.o.p.$^{(2)}$, 273
M.P. 637

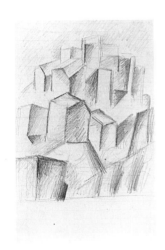

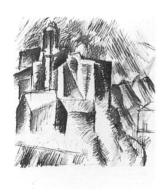

241
Maisons sur la colline
Houses on the Hill
Spring–summer 1909
Horta de Ebro
Pencil on lined paper
20.3 × 13.3
Z. VI, 1078; T.l.o.p.$^{(2)}$, 262
M.P. 633

242
Maisons
Houses
Spring–summer 1909
Horta de Ebro
Pen and brown ink on lined paper
20.2 × 13.2
Z. VI, 1088
M.P. 634

243
Le réservoir de Horta
The Reservoir at Horta
Spring–summer 1909
Horta de Ebro
Pen and ink on a blank envelope
11.2 × 14.4
Z. VI, 1081; T.l.o.p.$^{(2)}$, 265
M.P. 635

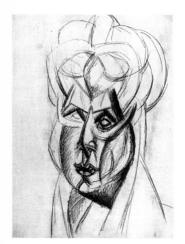

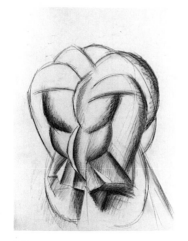

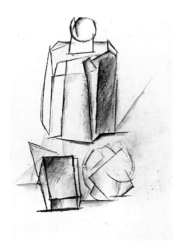

244
Etude pour 'Tête de femme' (Fernande)
Study for 'Head of a Woman' (Fernande)
Summer 1909
Horta de Ebro
Black chalk
62.8 × 48
Z. XXVI, 414
M.P. 642

245
Etude pour 'Tête de femme' (Fernande)
Study for 'Head of a Woman' (Fernande)
Summer 1909
Horta de Ebro
Charcoal with black chalk highlights
63.2 × 48
Z. XXVI, 417
M.P. 641

246
Feuille d'études: flacon, boîte et pomme
Various Studies: Flask, Bottle and Apple
Autumn 1909
Paris
Black chalk and Indian ink wash
31.5 × 23.7
S. verso in pencil: *Picasso*
Z. VI, 1104
M.P. 640

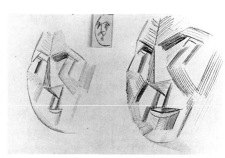

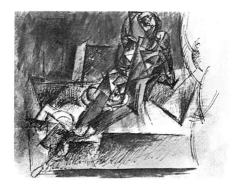

247
Etudes de visage
Studies of a Face
[Autumn 1909]
[Paris]
Pen and Indian ink on pencil outlines drawn
on paper and on the back of a photograph
pinned to it
32 × 48.8
Z. VI, 1117
M.P. 624

248
Femme assise sur un lit
Woman Seated on a Bed
Spring 1910
Paris
Pen and ink wash
11.6 × 15.5
Z. XXVIII, 5; D.R., 354
M.P. 648

249
Maisons et palmier
Houses and a Palm Tree
[Summer 1910]
[Cadaqués]
Pen and brown ink
22.7 × 17.4
M.P. 639

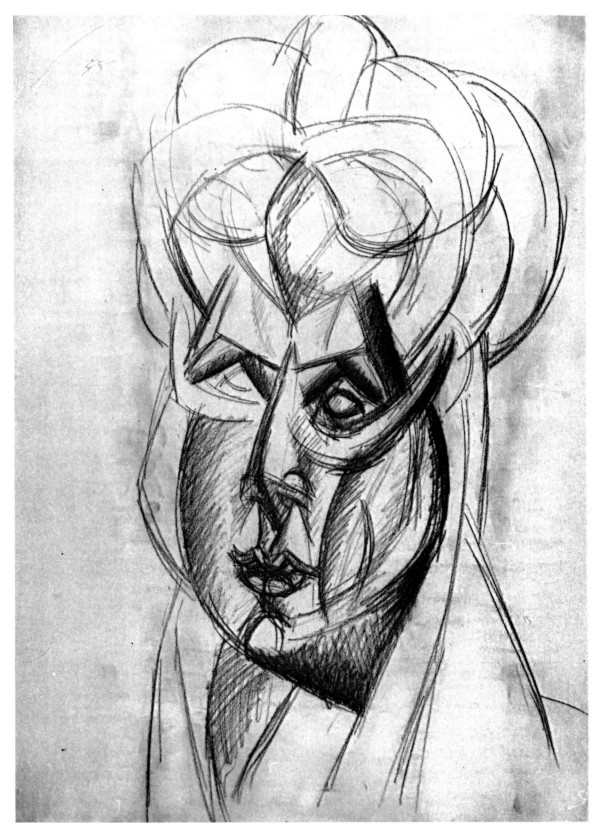

244 **Study for 'Head of a Woman'** (Fernande)

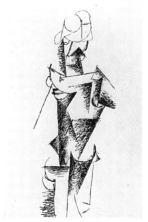

250
Etudes de barque
Studies of a Boat
[Summer 1910]
[Cadaqués]
Pen and brown ink
22.6 × 17.4
M.P. 644

251
Nu debout
Standing Nude
[Summer 1910]
[Cadaqués]
Pen and black ink
31.5 × 21.5
M.P. 645

252
Femme au chapeau
Woman with a Hat
[1910]
Pen and black ink
31.8 × 21.7
M.P. 646

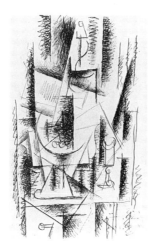

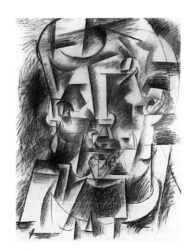

253
Figure assise
Seated Figure
1910–1911
Pen and brown ink on pencil outlines with scraping on the back of the folded page of a proof-copy of Max Jacob's *Saint Matorel*, figures in ink and letters in pencil
31.2 × 22
M.P. 647

254
Nature morte
Still-life
1910–1911
Pen and brown ink on pencil outlines
30.7 × 19.5
Z. XXVIII, 13
M.P. 649

255
Tête d'homme
Head of a Man
1910–1911
Charcoal and black chalk
64.2 × 48.6
M.P. 643

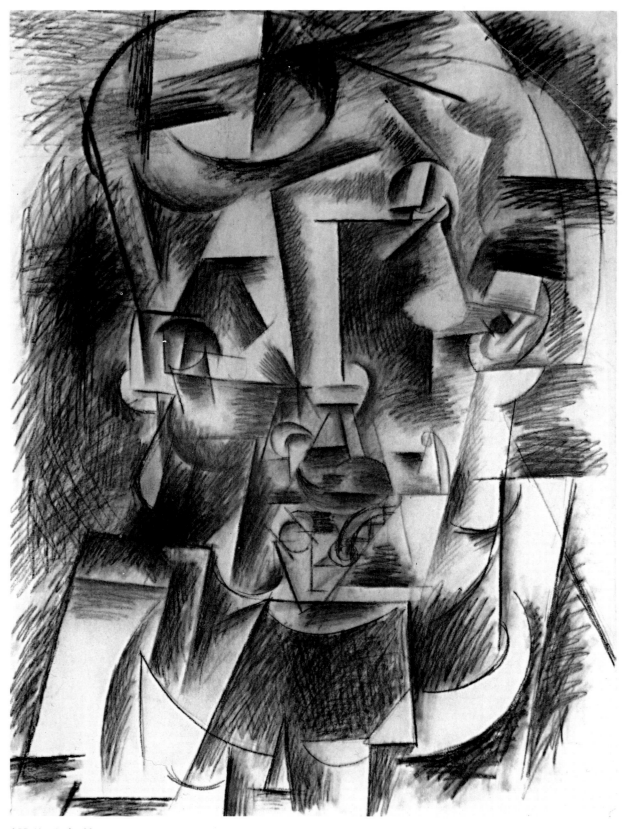

255 Head of a Man

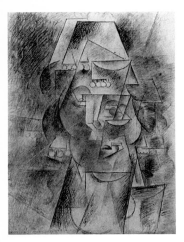

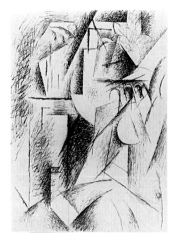

256
Tête d'espagnole
Head of a Spanish Woman
[1910–1911]
Charcoal with black chalk highlights
64 × 49
Z. VI, 1126
M.P. 657

257
Etude pour 'Le Pont Neuf'
Study for 'The Pont Neuf'
Spring 1911
Paris
Pen and brown ink on squared paper
27.2 × 20.7
Z. XXVI, 423
M.P. 638

258
Nature morte: bouteille et verre
Still-life: Bottle and Glass
Spring 1911
Paris
Indian ink wash
44.5 × 48.7
Z. XXVIII, 11; D.R., 403
M.P. 652

259
Bateaux?
Boats?
[Spring–summer] 1911
[Catalonia]
Indian ink wash
24.2 × 31.7
Z. VI, 1143
M.P. 651

260
Accordéoniste
Accordion Player
Summer 1911
Céret
Pen and ink
28.9 × 22.6
Z. XXVIII, 40
M.P. 658

261
Paysage de Céret
Céret Landscape
Summer 1911
Céret
Pen and brown ink
19.4 × 30.7
Inscr.a.r. in pencil: *Céret*
Z. XXVIII, 26
M.P. 660

The Grand Café in Céret, a postcard sent by Picasso on
22 August 1911 (Kahnweiler-Leiris Archives)

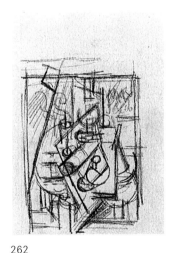

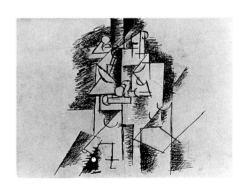

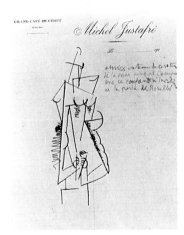

262
Nature morte et compotier sur une table
Still-life and Fruit Bowl on a Table
[Spring–summer] 1911
[Paris]
Black chalk on thick orange paper on the
inside of the cover of a catalogue for a Van
Dongen exhibition at Bernheim
Jeune, 6–24 June 1911
16.1 × 12.6
M.P. 650

263
Les boxeurs
The Boxers
[Summer] 1911
[Céret]
Pen and black ink on black chalk outlines
16.9 × 24.3
Z. XXVIII, 18
M.P. 661

264
Buste de Céretane
Head and Shoulders of a Woman from Céret
Summer 1911
Céret
Pen and brown ink on lined paper headed
'Grand Café de Céret/Michel Justafré'
26.8 × 21.4
Inscr.a.r. in pencil: *amics cantenu la ceratana/
De la mar fines al Canigu/ans se coufant à la
catalana/es la perla del Rosельó*
Z. XXVIII, 33
M.P. 653

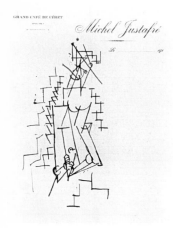

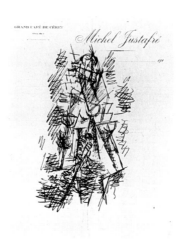

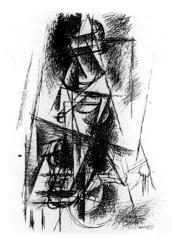

265
Buste de Céretane
Head and Shoulders of a Woman from Céret
Summer 1911
Céret
Pen and brown ink on lined paper headed
'Grand Café de Céret/
Michel Justafré'
26.8 × 21.4
Z. XXVIII, 34
M.P. 654

266
Buste de Céretane
Head and Shoulders of a Woman from Céret
Summer 1911
Céret
Pen and brown ink on lined paper headed
'Grand Café de Céret/Michel Justafré'
26.8 × 21.4
Z. XXVIII, 36
M.P. 655

267
Femme dans un fauteuil
Woman in an Armchair
[Summer] 1911
[Céret]
Pen and brown ink on squared paper
27.3 × 20.8
Z. XXVIII, 46
M.P. 663

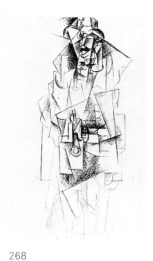

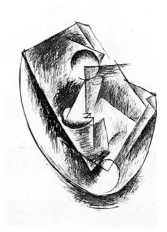

268
Homme moustachu à la clarinette
Man with a Moustache and a Clarinet
[Summer–autumn] 1911
[Céret–Paris]
Pen, Indian ink and black chalk
30.8 × 19.5
Z. XXVIII, 48
M.P. 659

269
Guitariste
Guitar Player
[Summer–autumn] 1911
[Céret–Paris]
Pen and brown ink
38.8 × 11.5
Z. XXVIII, 29
M.P. 662

270
Porte-buvard
Blotting-paper Holder
Autumn 1911
Paris
Pen and black ink
24.1 × 16.7
Z. XXVIII, 54
M.P. 664

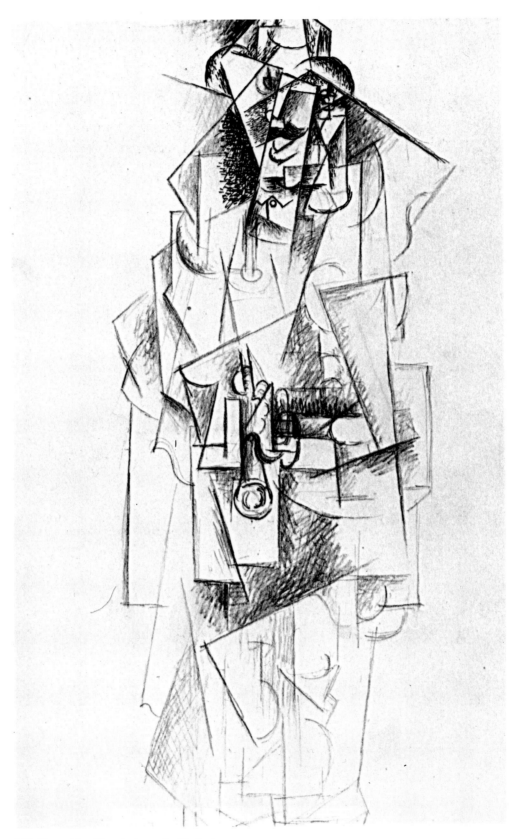

268 Man with a Moustache and a Clarinet

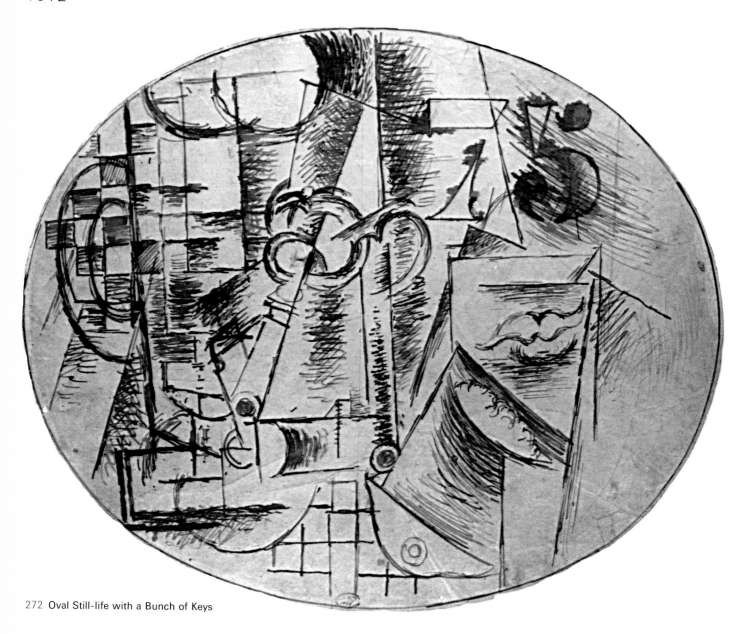

272 Oval Still-life with a Bunch of Keys

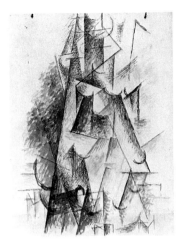

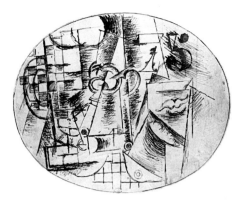

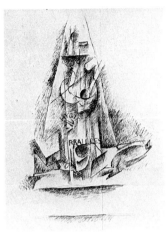

271
Homme assis
Seated Man
[1911–1912]
Ink wash on pencil outlines
28.8 × 22.6
Z. XXVIII, 101
M.P. 697

272
Nature morte ovale au trousseau de clés
Oval Still-life with a Bunch of Keys
Spring 1912
[Paris]
Pen and brown ink on transparent paper
19.2 × 24.3
Z. II², 737
M.P. 665

273
Nature morte
Still-life
[Spring] 1912
Pen and brown ink on pencil outlines
27 × 21
M.P. 677

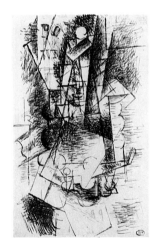

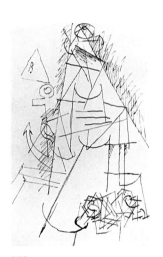

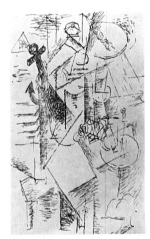

274
Guitariste
Guitar Player
Spring 1912
Pen and brown ink
21.2 × 13.4
Z. XXVIII, 65
M.P. 685

275
Marin jouant de l'accordéon
Sailor Playing the Accordion
Spring 1912
Pen and brown ink
21.2 × 13.1
Z. XXVIII, 207
M.P. 675

276
Composition 'Souvenir du Havre'
Composition 'Souvenir of Le Havre'
Spring 1912
Pen and brown ink
21.2 × 13.2
Z. XXVIII, 205
M.P. 676

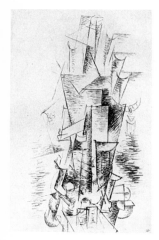

277
Musicien assis
Seated Musician
Spring 1912
Charcoal
48.5 × 31.5
Z. XXVIII, 109
M.P. 691

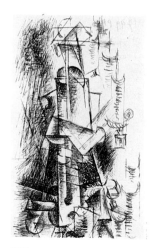

278
Musicien assis
Seated Musician
Spring 1912
Pen and brown ink
21.3 × 13.4
Z. XXVIII, 115
M.P. 686

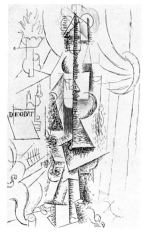

279
Déodat de Séverac au piano
Déodat de Séverac Playing the Piano
Spring 1912
Céret
Pen, Indian ink and pencil
34.2 × 22.2
Z. XXVIII, 152
M.P. 674

280
Musicienne assise tenant une partition
Seated Female Musician Holding a Score
Spring 1912
Pen, Indian ink and pencil
34.2 × 22
Z. XXVIII, 226
M.P. 684

281
Musicienne assise tenant une partition
Seated Female Musician Holding a Score
Spring 1912
Pen, Indian ink and pencil
34.2 × 22.2
Z. XXVIII, 237
M.P. 728

282
Guitariste au chapeau
Guitar Player with a Hat
Spring 1912
Céret
Pen and Indian ink
30.8 × 19.5
Inscr. verso in pencil: *Céret*
Z. XXVIII, 76
M.P. 833

283
Danseurs à la Fête Nationale
Dancers on the National Holiday
July 1912
Sorgues
Pen and Indian ink on pencil outlines
34.2 × 21.7
Z. XXVIII, 112
M.P. 671

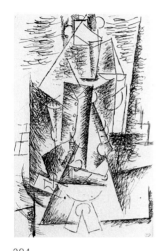

284
Homme à la mandoline
Man with a Mandolin
Summer 1912
Sorgues
Pen and Indian ink on pencil outlines
30.8 × 19.5
Z. XXVIII, 111
M.P. 672

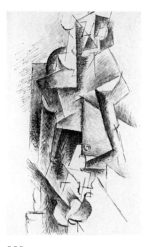

285
Violoniste
Violin Player
Summer 1912
Sorgues
Pen, brown ink, Indian ink and oil
30.7 × 19.5
Z. XXVIII, 102
M.P. 673

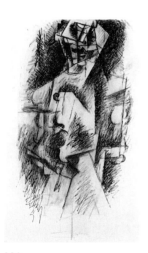

286
Violoniste moustachu
Violin Player with a Moustache
Summer 1912
[Céret–Sorgues]
30.8 × 18.8
Inscr. verso in pencil: *Céret*
Z. XXVIII, 78
M.P. 666

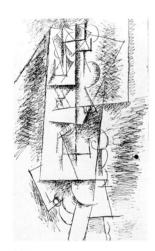

287
Femme nue debout
Standing Female Nude
[Summer] 1912
Pen and Indian ink on pencil outlines
34.3 × 22
Z. XXVIII, 114
M.P. 687

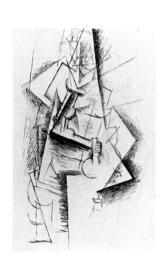

288
Moissonneur
Reaper
Summer 1912
Sorgues
Pen and brown ink on pencil outlines
30.7 × 19.6
Z. XXVIII, 100
M.P. 670

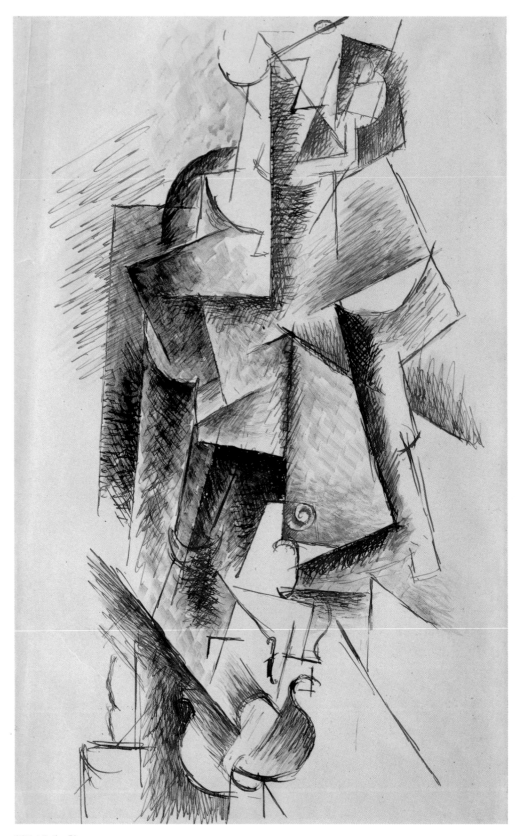

285 **Violin Player**

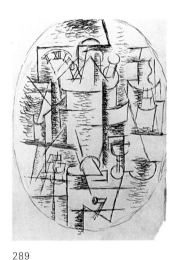

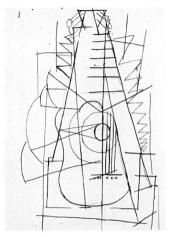

289
Nature morte ovale à la pendule
Oval Still-life with a Clock
Summer 1912
[Sorgues]
Pen and Indian ink on black chalk outlines on the back of a competition slip in the supplement to the *Petit Journal Illustré*, 28 July 1912
32.6 × 24.9
Z. XXVIII, 14
M.P. 656

290
Guitare
Guitar
Summer 1912
Sorgues
Pen and Indian ink on pencil outlines
34.3 × 22.2
Z. XXVIII, 196
M.P. 667

291
Guitare
Guitar
Summer 1912
Sorgues
Pen and Indian ink on pencil outlines
34 × 22
Z. XXVIII, 201
M.P. 668

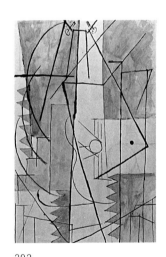

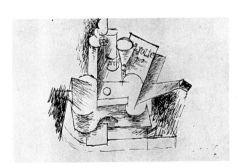

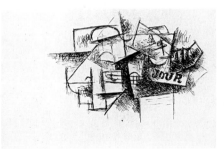

292
Guitare
Guitar
[Summer 1912]
Sorgues
Oil, Indian ink and pencil
34.3 × 22.1
Z. XXVIII, 195

293
Nature morte à la guitare
Still-life with a Guitar
Summer–autumn 1912
Pen and brown ink on a sheet of paper folded in half
13.3 × 21.2
Z. XXVIII, 64
M.P. 679

294
Nature morte au journal et à la guitare
Still-life with Newspaper and Guitar
Summer–autumn 1912
Pen and Indian ink on black chalk outlines
19.6 × 31
Inscr. verso in pencil: *Céret*
Z. XXVIII, 73
M.P. 678

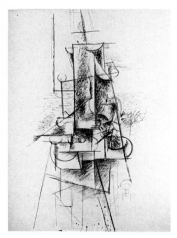

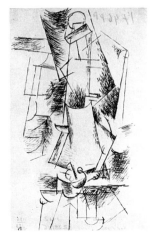

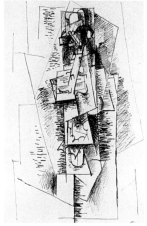

295
Guitariste
Guitar Player
Summer–autumn 1912
Ink and black chalk
64 × 49
Z. XXVIII, 67
M.P. 680

296
Figure assise à la mandoline
Seated Figure with a Mandolin
Summer–autumn 1912
Pen and black ink
21.2 × 13.3
Z. XXVIII, 116
M.P. 689

297
Violoniste
Violin Player
Summer–autumn 1912
Pen and brown ink
34.2 × 22.4
Z. XXVIII, 113
M.P. 690

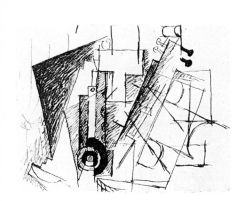

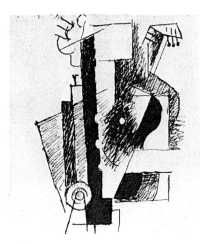

298
Violon et clarinette
Violin and Clarinet
Summer–autumn 1912
Pen and black ink on cardboard
11.7 × 12.5
Z. XXVIII, 210
M.P. 682(r)

298a
Empreintes de motifs de broderie
Designs for Embroidery Motifs
[1912]
Black ink on cardboard
12.5 × 11.7
M.P. 682(v)

299
Guitare et clarinette
Guitar and Clarinet
Summer–autumn 1912
Pen and black ink on cardboard
12.5 × 11.6
Z. XXVIII, 211
M.P. 681(r)

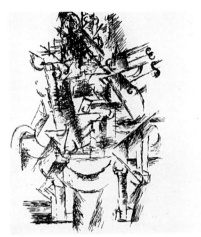

**299a
Empreintes de motifs de broderie**
Designs for Embroidery Motifs
[1912]
Black ink on cardboard
11.6 × 12.5
M.P. 681(v)

**300
Nature morte sur un guéridon**
Still-life on a Pedestal Table
1912
Pen and black ink
27.1 × 21.3
Z. XXVIII, 107
M.P. 696

**301
Le peintre**
The Painter
1912–1913
Pen, brown ink and black chalk on double
sheet (piece inserted in the upper section)
38 × 20.2
Z. XXVIII, 75
M.P. 688

**302
Guitariste au gibus**
Guitar Player with an Opera Hat
1912–1913
Pen, Indian ink, pencil and brown ink
27.5 × 21.5
Z. XXVIII, 179
M.P. 694

**303
Guitariste**
Guitar Player
1912–1913
Pencil
27.6 × 21.5
Z. XXVIII, 234
M.P. 729

**304
Feuille d'études: guitares**
Various Studies: Guitars
1912–1913
Pen, Indian ink and pencil on the back of an
administrative document with inscriptions in
brown ink
35.7 × 22.6
Z. XXVIII, 282
M.P. 683

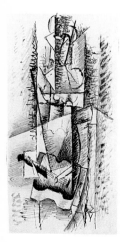

305
Femme jouant de la guitare
Woman Playing the Guitar
[1912–1913]
Pen, Indian ink and pencil
21.2 × 13.2
Z. XXVIII, 175
M.P. 695

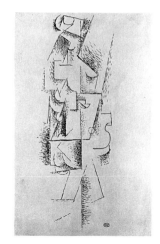

306
Femme à la guitare
Woman with a Guitar
[1912–1913]
Pen and Indian ink
30.7 × 19.6
Z. XXVIII, 166
M.P. 692

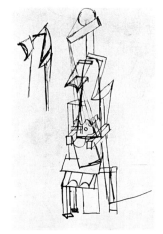

307
Guitariste (idée pour une construction?)
Guitar Player (idea for a construction?)
1912–1913
Pen and black ink
16.8 × 12
Z. XXVIII, 127
M.P. 698

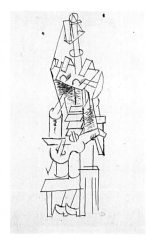

308
Guitariste (idée pour une construction?)
Guitar Player (idea for a construction?)
1912–1913
Pen and brown ink on pencil outlines
31 × 29
Z. XXVIII, 131
M.P. 699

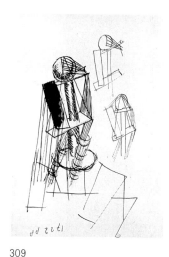

309
Trois études de tête (idée pour une construction?)
Three Studies of a Head (idea for a construction?)
1912–1913
Pen and ink on black chalk outlines
31.2 × 20
Z. XXVIII, 136
M.P. 705(r)

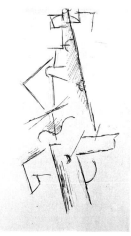

309a
Personnage
Figure
1912–1913
Pen and black ink on black chalk outlines
31.2 × 20
Z. XXVIII, 167
M.P. 705(v)

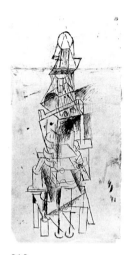

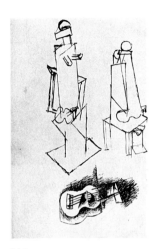

310
Guitariste (idée pour une construction?)
Guitar Player (idea for a construction?)
1912–1913
Pen and brown ink on charcoal outlines
(piece inserted in the upper section)
40.5 × 19.5
Z. XXVIII, 146
M.P. 700

311
**Feuille d'études: guitariste et guitare
(idée pour une construction?)**
*Various Studies: Guitar Player and Guitar
(idea for a construction?)*
1912–1913
Pen and brown ink
21.2 × 13.2
Z. XXVIII, 129
M.P. 702

312
**Feuille d'études: guitariste (idée pour
une construction?)**
*Various Studies: Guitar Player (idea for a
construction?)*
1912–1913
Pen and brown ink
21.2 × 13.2
Z. XXVIII, 130
M.P. 703

313
Guitariste (idée pour une construction?)
Guitar Player (idea for a construction?)
1912–1913
Céret
Black chalk
30.7 × 19.4
Inscr. verso in pencil: *Céret*
Z. XXVIII, 132
M.P. 701

314
Violon
Violin
1912–1913
Pencil
27.5 × 21.5
Z. XXVIII, 313
M.P. 737

315
Orchestre
Orchestra
[1912–1914]
Pen and brown ink
10.5 × 13.5
M.P. 704

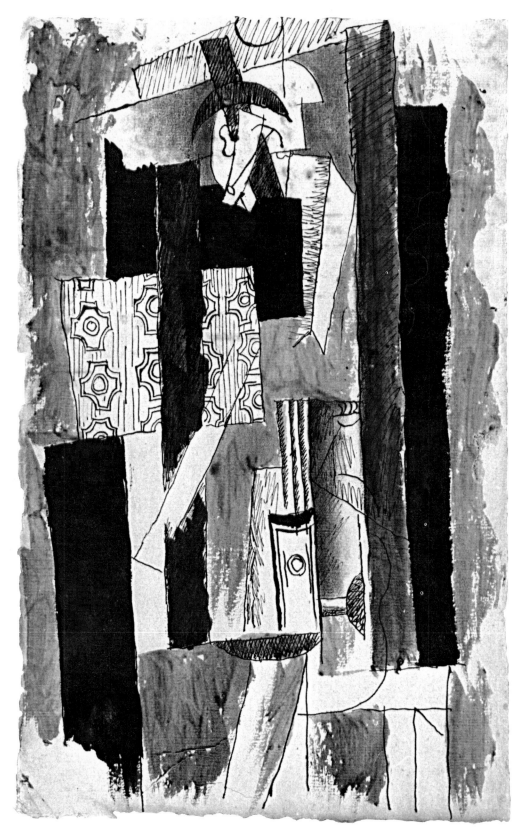

318 **Guitar Player with a Hat**

316
Guitariste
Guitar Player
[Early 1913]
Céret
Pen and Indian ink
30.8 × 19.6
Inscr. verso in pencil: *Céret*
Z. XXVII, 165
M.P. 693

317
Homme au chapeau
Man with a Hat
Spring 1913
Oil and pencil
31.5 × 24
Z. XXVIII, 239; D.R., 558
M.P. 727

318
Guitariste au chapeau
Guitar Player with a Hat
[Spring–summer] 1913
Céret
Indian ink and tinted wash on a sheet from a
tax register dating from the Revolution, with
inscriptions in brown ink
35.7 × 23.1
Z. XXVIII, 278
M.P. 734

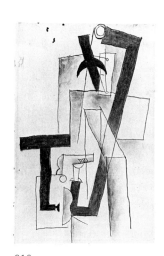

319
Guitariste au chapeau
Guitar Player with a Hat
[Spring–summer] 1913
Céret
Charcoal, pen and Indian ink on pencil
outlines
42.8 × 28.4
S. verso in pencil: *Picasso*
M.P. 735

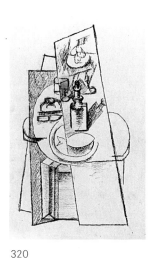

320
Nature morte à la table servie
Still-life on a Set Table
Spring–summer 1913
Céret
Black chalk
30.6 × 19.4
Inscr. verso in pencil: *Céret*
Z. XXVIII, 155
M.P. 669

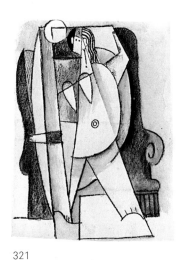

321
**Etude pour 'Femme en chemise dans un
fauteuil'**
*Study for 'Woman in a Chemise Sitting in an
Armchair'*
Autumn 1913
Paris
Tinted wash, black chalk with brown crayon
highlights
18.5 × 14.6
Z. VI, 1266; T.l.o.p.[(2)], 630
M.P. 766

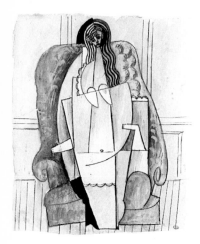

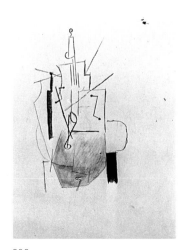

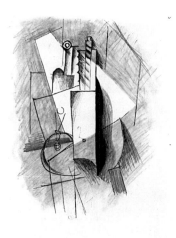

322
Etude pour 'Femme en chemise dans un fauteuil'
Study for 'Woman in a Chemise Sitting in an Armchair'
Autumn 1913
Paris
Gouache and black chalk
32.7 × 27
Z. VI, 1267; D.R., 637; T.I.o.p.[(2)], 627
M.P. 767

323
Violon. bouteille et verre sur une table ronde
Violin, Bottle and Glass on a Round Table
1913
Pencil, Indian ink and shaded brown crayon
27.7 × 21.5
Z. XXVIII, 332
M.P. 708

324
Guitare, bouteille et verre sur une table ronde (projet pour une construction)
Guitar, Bottle and Glass on a Round Table (design for a construction)
1913
Shaded brown crayon, pencil and Indian ink
27.5 × 21.5
Z. XXVIII, 346
M.P. 725

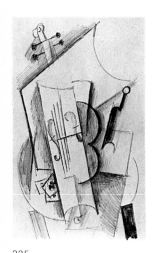

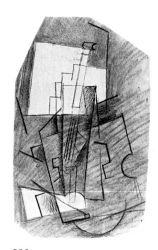

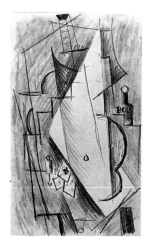

325
Violon, bouteille et cartes à jouer sur une table ronde
Violin, Bottle and Playing Cards on a Round Table
1913
Pencil
17.5 × 10.9
Z. XXVIII, 338
M.P. 722

326
Violon
Violin
1913
Pencil and brown crayon on grained paper cut in an octagonal shape
25.5 × 16.8
Z. XXVIII, 305
M.P. 736

327
Guitare, bouteille de Bols et cartes à jouer (projet pour une construction)
Guitar, Bottle of Bols and Playing Cards (design for a construction)
1913
Pencil and brown crayon
17.5 × 11
Z. XXVIII, 347
M.P. 726

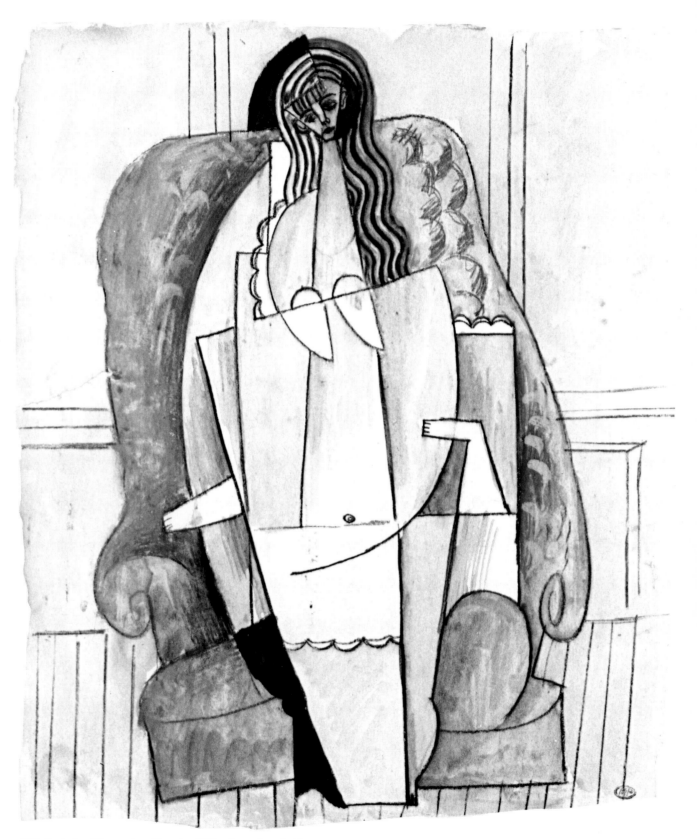

322 Study for 'Woman in a Chemise Sitting in an Armchair'

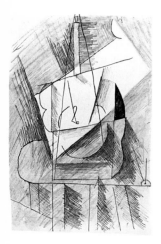

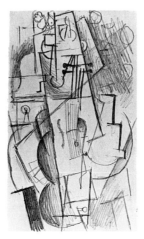

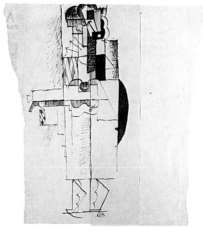

328
Guitare sur une table ovale (projet pour une construction)
Guitar on an Oval Table (design for a construction)
1913
Brown crayon, pencil and Indian ink
27 × 17.9
Z. XXVIII, 345
M.P. 724

329
Guitare et compotier sur un guéridon
Guitar and Fruit Bowl on a Pedestal Table
1913
Pencil
17.3 × 10.8
Z. XXVIII, 337
M.P. 721

330
Guitariste
Guitar Player
1913
Pen, Indian ink and pencil
26.1 × 13.2
M.P. 731

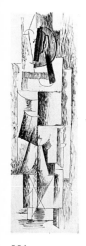

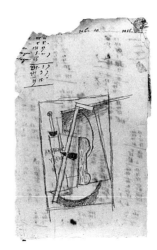

331
Homme au chapeau
Man with a Hat
[1913]
Pen and Indian ink on two sheets glued together
33.5 × 11.1
Z. XXVIII, 272
M.P. 732

332
Trois études pour une guitare et une bouteille sur une table (idée pour une construction?)
Three Studies for a Guitar and Bottle on a Table (idea for a construction?)
1913
Pencil on cardboard
31.8 × 6.7
M.P. 707

333
Guitare et bouteille d'Armagnac (idée pour une construction?)
Guitar and Bottle of Armagnac (idea for a construction?)
1913
Pencil on pieces of an administrative document with inscriptions handwritten in brown ink
25.1 × 15.6
Z. XXIX, 56
M.P. 706

334
Feuille d'études: quatre têtes (projet pour une sculpture?)
Various Studies: Four Heads (design for a sculpture?)
1913
Pen, Indian ink and tinted wash on a sheet from a tax register dating from the Revolution, with inscriptions in brown ink
35.6 × 27.7
Z. XXVIII, 279
M.P. 730

335
Etude pour 'Guitare et bouteille de Bass'
Study for 'Guitar and Bottle of Bass'
1913
[Céret]
Pencil
11 × 17.5
Z. XXVIII, 189
M.P. 710

336
Etude pour 'Guitare et bouteille de Bass'
Study for 'Guitar and Bottle of Bass'
1913
[Céret]
Pencil
11 × 17.5
Z. XXVIII, 182
M.P. 712

337
Etude pour 'Guitare et bouteille de Bass'
Study for 'Guitar and Bottle of Bass'
1913
[Céret]
Pencil
11 × 17.5
Z. XXVIII, 181
M.P. 711(r)

337a
Etude de tête
Study of a Head
1913
[Céret]
Indian ink with handwritten notes on colours to be used
17.5 × 11
M.P. 711(v)

338
Etude pour 'Guitare et bouteille de Bass'
Study for 'Guitar and Bottle of Bass'
1913
[Céret]
Pencil
11 × 17.5
Z. XXVIII, 186
M.P. 713(r)

338a
Etude de tête
Study of a Head
1913
[Céret]
Indian ink
17.5 × 11
Z. XXVIII, 140
M.P. 713(v)

339
Etude pour 'Guitare et bouteille de Bass'
Study for 'Guitar and Bottle of Bass'
1913
[Céret]
Pencil
11 × 17.5
Z. XXVIII, 183
M.P. 1087

340
Etude pour 'Guitare et bouteille de Bass'
Study for 'Guitar and Bottle of Bass'
1913
[Céret]
Pencil
11 × 17.5
Z. XXVIII, 184
M.P. 714

341
Etude pour 'Guitare et bouteille de Bass'
Study for 'Guitar and Bottle of Bass'
1913
Pencil
11 × 17.5
Z. XXVIII, 185
M.P. 715

342
Etudes pour 'Guitare et bouteille de Bass'
Studies for 'Guitar and Bottle of Bass'
1913
Pencil
11 × 17.5
Z. XXVIII, 187
M.P. 716(r)

342a
Etude de tête
Study of a Head
1913
Indian ink
17.5 × 11
Z. XXVIII, 139
M.P. 716(v)

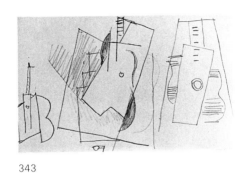

343
Etudes pour 'Guitare et bouteille de Bass'
Studies for 'Guitar and Bottle of Bass'
1913
Pencil
11 × 17.5
Z. XXVIII, 188
M.P. 718(r)

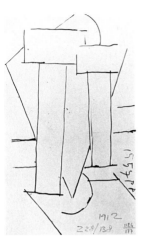

343a
Etude de tête
Study of a Head
1913
Indian ink
17.5 × 11
Z. XXVIII, 138
M.P. 718(v)

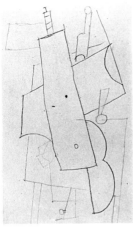

344
Etude pour 'Guitare et bouteille de Bass'
Study for 'Guitar and Bottle of Bass'
1913
Pencil
17.3 × 11.1
Z. XXVIII, 335
M.P. 717

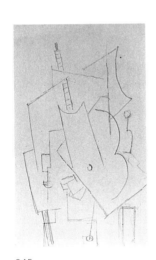

345
Etude pour 'Guitare et bouteille de Bass'
Study for 'Guitar and Bottle of Bass'
1913
Pencil
17.3 × 11.1
Z. XXVIII, 333
M.P. 720

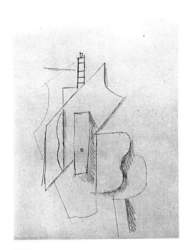

346
Etude pour 'Guitare et bouteille de Bass'
Study for 'Guitar and Bottle of Bass'
1913
Pencil
27.5 × 21.5
Z. XXVIII, 328
M.P. 719

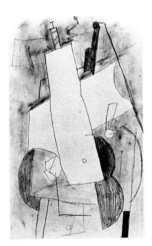

347
Etude pour 'Guitare et bouteille de Bass'
Study for 'Guitar and Bottle of Bass'
1913
Pencil with shading
17.3 × 10.7
Z. XXVIII, 339
M.P. 723

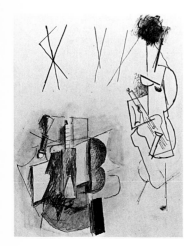

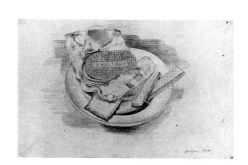

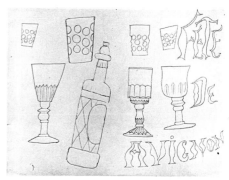

348
Etudes pour 'Guitare et bouteille de Bass'
Studies for 'Guitar and Bottle of Bass'
1913
Indian ink on pencil outlines (study on the right); pencil, brown crayon and Indian ink (study on the left)
27.5 × 21.5
Z. XXVIII, 173
M.P. 709

349
Nature morte aux biscuits
Still-life with Wafers
Summer 1914
Avignon
Pencil
30.8 × 48.2
D.b.r.: *Avignon 1914*
Z. VI, 1238; T.l.o.p.[2], 708
M.P. 742

350
Verres et bouteille
Glasses and a Bottle
Summer 1914
Avignon
Pencil
37.8 × 49.6
D. verso: *Avignon 1914*
M.P. 741

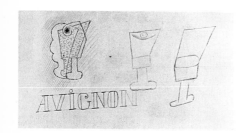

351
Trois verres à pied
Three Stemmed Glasses
Summer 1914
Avignon
Pencil
12.9 × 24.1
Z. VI, 1255
M.P. 740

352
Verre, pipe, journal et carte à jouer
Glass, Pipe, Newspaper and Playing Card
[Spring] 1914
[Paris]
Pencil
32.2 × 23.5
Z. XXIX, 32
M.P. 765

353
Bouteille de vin et verre
Bottle of Wine and a Glass
[Spring] 1914
Paris
Charcoal
47.5 × 63.5
Z. XXIX, 21
M.P. 763(r)

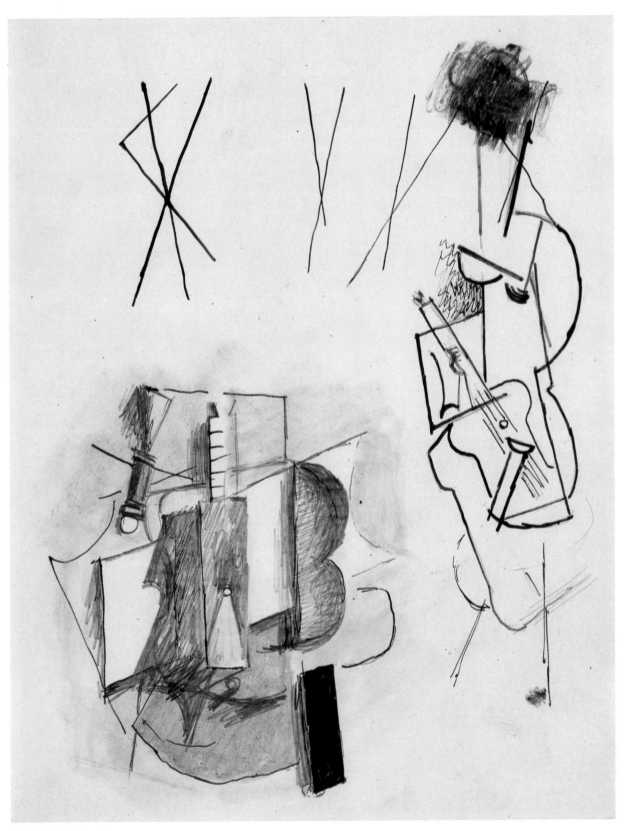

348 Studies for 'Guitar and Bottle of Bass'

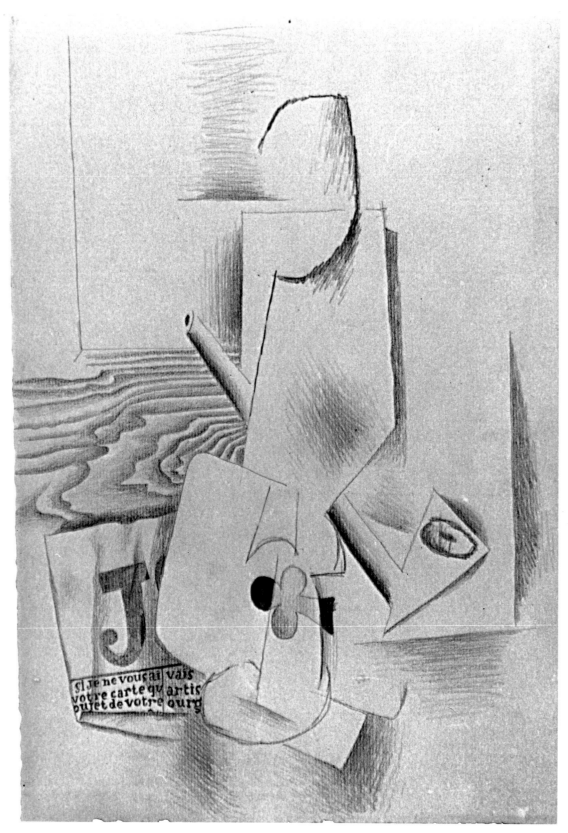

352 Glass, Pipe, Newspaper and Playing Card

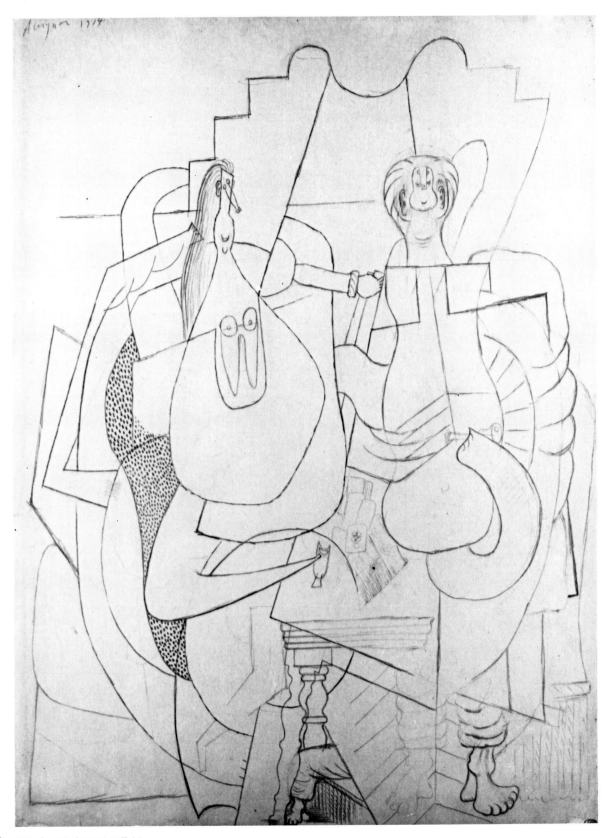

356 Couple Seated at Table

353a
Deux études de guitariste
Two Studies of a Guitar Player
Summer 1914
Avignon
Charcoal
47.5 × 63.5
Z. XXIX, 92
M.P. 763(v)

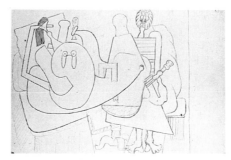

354
Femme allongée et guitariste
Woman Stretched Out and a Guitar Player
Summer 1914
Avignon
Pencil
20 × 29.8
Z. VI, 1151
M.P. 760

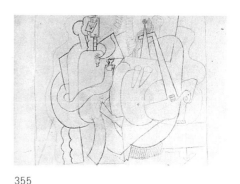

355
Homme tenant un verre et femme assise dans un fauteuil
Man Holding a Glass and Woman Seated in an Armchair
Summer 1914
Avignon
Pencil
19.8 × 29.8
M.P. 761

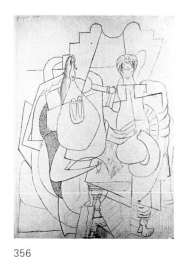

356
Couple attablé
Couple Seated at Table
Summer 1914
Avignon
Pencil
49.5 × 38
D.a.l.: *Avignon 1914*
Z. II(2), 841
M.P. 762

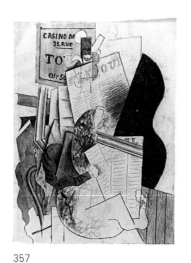

357
Homme lisant un journal
Man Reading a Newspaper
Summer 1914
Avignon
Watercolour and pencil
32.1 × 23.9
Z. XXIX, 66
M.P. 759

358
Homme lisant un journal
Man Reading a Newspaper
1914
Gouache and pencil on the back of an invitation card for the Alfred Flechtheim Gallery in Düsseldorf, December 1913
16 × 12.7
Z. XXIX, 65
M.P. 758(r)

357 **Man Reading a Newspaper**

361 Bearded Man with a Pipe, Seated at Table

358a
Homme lisant un journal
Man Reading a Newspaper
[Summer] 1914
[Avignon]
Pencil on the front of an invitation card for
the Alfred Flechtheim Gallery in Düsseldorf,
December 1913
16 × 12.7
Z. XXIX, 64
M.P. 758(v)

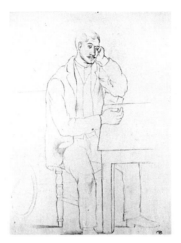

359
Homme attablé
Man Seated at Table
Summer 1914
Pencil
31 × 24
Z. VI, 1198
M.P. 746

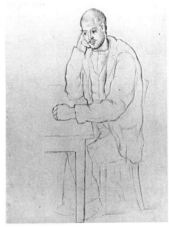

360
Homme attablé
Man Seated at Table
Summer 1914
Avignon
Pencil
31 × 23.7
D.a.l.: *Avignon 1914*
Z. VI, 1199; T.l.o.p.[2], 709
M.P. 745

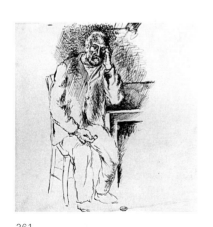

361
Homme barbu à la pipe, attablé
Bearded Man with a Pipe, Seated at Table
Summer 1914
Avignon
Pen and brown ink
20.9 × 21.8
Z. XXIX, 77
M.P. 744

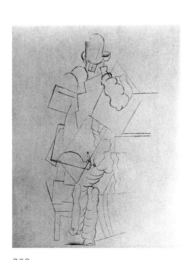

362
Homme à la pipe attablé
Man with a Pipe Seated at Table
1914
Avignon
Pencil
32.2 × 24.6
D. verso: *Avignon/1914*
Z. VI, 1194
M.P. 747

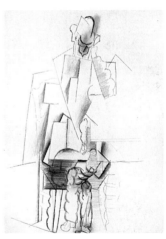

363
Homme à la pipe attablé
Man with a Pipe Seated at Table
1914
[Avignon]
Pencil with shaded brown crayon highlights
32.4 × 24.6
D. verso: *1914*
Z. VI, 1195
M.P. 750

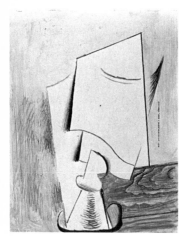

364
Verre
Glass
Summer 1914
Avignon
Pencil and gouache on the back of a page
from a book
15.8 × 12.7
Z. XXIX, 28
M.P. 739

365
Trois nature mortes
Three Still-life Drawings
Autumn 1914
Avignon
Pen and brown ink
38 × 49.5
D. verso in pencil: *1914*
Z. XXIX, 78
M.P. 743

366
Lettre à Guillaume Apollinaire
Letter to Guillaume Apollinaire
31 December 1914
Paris
Pen, ink and coloured crayons
26.7 × 21.3
On the back is a letter of 1 January 1915 from
Serge Ferat
Gift of William MacCarthy Cooper, 1985
M.P. 1985-72

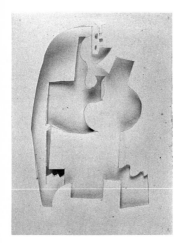

367
Homme attablé
Man Seated at Table
[1914]
Two sheets cut to follow the outlines of a
pencil drawing, one inserted into the other
27 × 21
M.P. 399

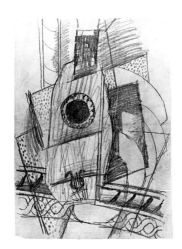

368
Guitare
Guitar
1914–1915
Pencil and gouache
63 × 47.7
Z. XXIX, 114
M.P. 738

369
Feuille d'études: guitare et table
Various Studies: Guitar and Table
1914–1915
Pencil and Indian ink wash
22 × 17.2
S.c.: *Picasso*
Inscr.c.a. in ink: *Guillaume Kostrovoiszoy
Witzky/38ème artillerie/70ème batterie/
canonnier conducteur/Nîmes*
M.P. 764(r)

369a
Verre, journal et poire
Glass, Newspaper and Pear
[1914–1915]
Pencil on a sheet from an account book
22 × 17.2
M.P. 764(v)

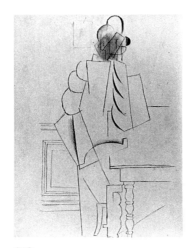

370
Homme attablé
Man Seated at Table
[1914–1915]
Pencil
32 × 24.5
Z. VI, 1216
M.P. 748

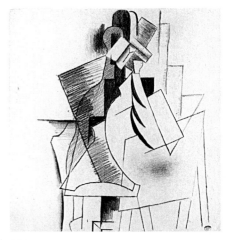

371
Homme attablé
Man Seated at Table
[1914–1915]
Pencil
24.5 × 25
Z. VI, 1233
M.P. 757

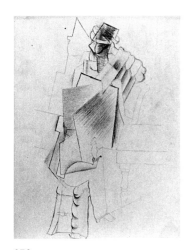

372
Homme à la pipe attablé
Man with a Pipe Seated at Table
[1914–1915]
Pencil with shading
32.2 × 24.8
Z. VI, 1228
M.P. 749

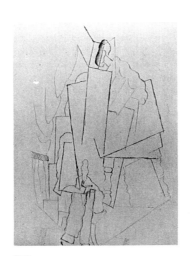

373
Homme à la pipe attablé
Man with a Pipe Seated at Table
[1914–1915]
Pencil
32.2 × 24.8
Z. VI, 1196
M.P. 756

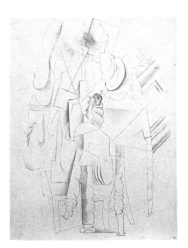

374
Homme à la pipe attablé
Man with a Pipe Seated at Table
[1914–1915]
Pencil
32.1 × 24.8
Z. XXIX, 60
M.P. 755

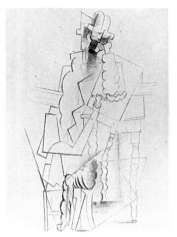

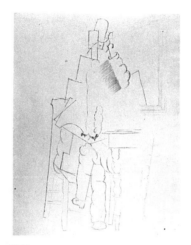

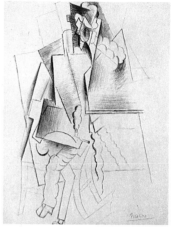

375
Homme à la pipe attablé
Man with a Pipe Seated at Table
[1914–1915]
Pencil with black chalk highlights
32.2 × 24.4
Z. VI, 1215
M.P. 752

376
Homme à la pipe attablé
Man with a Pipe Seated at Table
[1914–1915]
Pencil
31.2 × 24
Z. XXIX, 54
M.P. 753

377
Homme à la pipe attablé
Man with a Pipe Seated at Table
[1914–1915]
Pencil
32.3 × 24.5
S.b.r.: *Picasso*
Z. XXIX, 61
M.P. 754

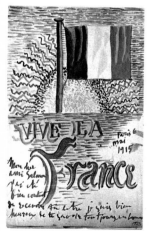

378
'VIVE LA FRANCE'
'LONG LIVE FRANCE'
(letter to André Salmon)
6 May 1915
Paris
Gouache, watercolour and Indian ink
17.5 × 11.1
S.b.r. (3rd page): *Picasso*
Gift of M. and Mme Alain Mazo, 1980
M.P. 1980–108

379
Homme à la pipe attablé
Man with a Pipe Seated at Table
1915
Paris
Ink wash
31.5 × 24
Z. XXIX, 85
M.P. 751

380
Femme à la guitare
Woman with a Guitar
1915
Pencil
29.8 × 20
Z. XXIX, 129
M.P. 768

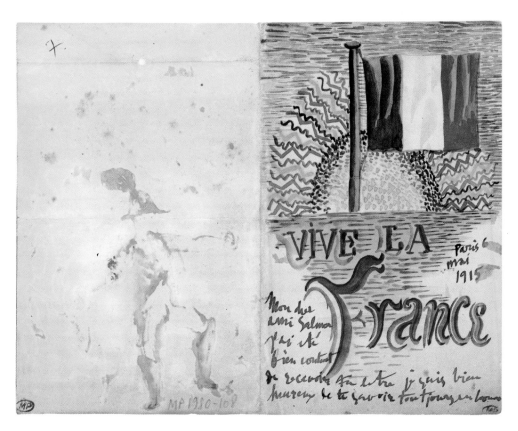

378 'LONG LIVE FRANCE'

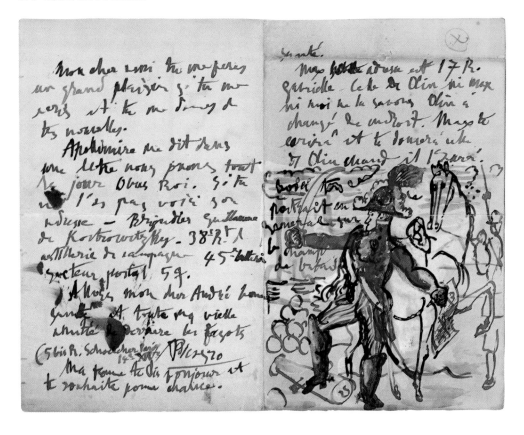

381
Portrait de Jacques Doucet
Portrait of Jacques Doucet
[1915]
Black chalk
31.3 × 24.3
Inscr. a.l. in ballpoint pen: *Portrait de Jacques Doucet*
Z. XXIX, 162
M.P. 771(r)

381a
Esquisse d'un portrait (de Jacques Doucet?)
Sketch of a Portrait (of Jacques Doucet?)
[1915]
Black chalk
31.3 × 24.3
M.P. 771(v)

382
Femme nue assise dans un fauteuil
Nude Woman Seated in an Armchair
Late 1915–early 1916
Paris
Watercolour and pencil
22.3 × 19.9
Z. VI, 1302; D.R., 882
M.P. 773

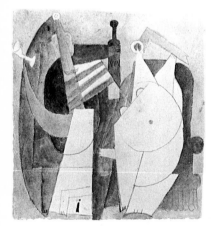

383
Femme nue dans un fauteuil et homme à la moustache tenant une bouteille de vin
Nude Woman in an Armchair and Man with a Moustache Holding a Bottle of Wine
Late 1915–early 1916
Paris
Watercolur and pencil
16.2 × 14.9
Z. VI, 1321; D.R., 883
M.P. 774

384
Personnage assis
Seated Figure
Late 1915–early 1916
Pencil
64.5 × 49.5
Z. VI, 1306
M.P. 780

385
Quatre études de l'atelier de l'artiste
Four Studies of the Artist's Studio
[1914–1917]
Pencil
7.2 × 24.7
M.P. 769

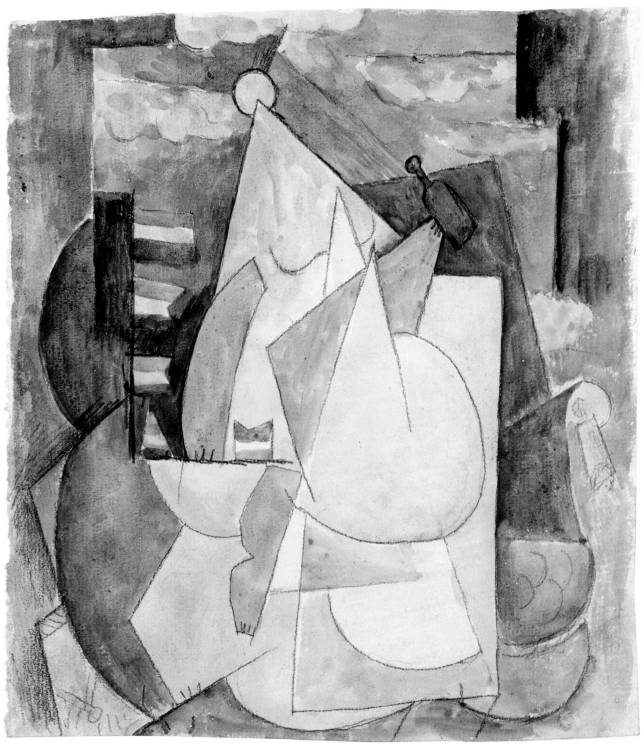

382 Nude Woman Seated in an Armchair

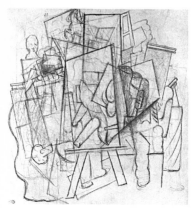

386
L'atelier de l'artiste
The Artist's Studio
[1914–1917]
Pencil
25.2 × 24.7
M.P. 770(r)

386a
Femme dans un intérieur
Woman in an Interior
[1914–1917]
Pencil
25.2 × 24.7
M.P. 770(v)

387
Crucifixion
Crucifixion
[1915–1918]
Pencil
36 × 26.6
Z. VI, 1331
M.P. 772

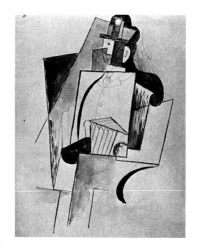

388
Accordéoniste
Accordion Player
Early 1916
Paris
Watercolour and pencil
27.5 × 22.6
Z. XXIX, 187; D.R., 877
M.P. 775

389
La glace au-dessus de la cheminée
The Mirror above the Fireplace
1916
Montrouge
Pen and Indian ink
24.3 × 16
Z. XXIX, 211
M.P. 777

390
Le réveil sur la cheminée
The Alarm Clock on the Mantelpiece
1916
[Montrouge]
Pencil
14.3 × 11.8
M.P. 778

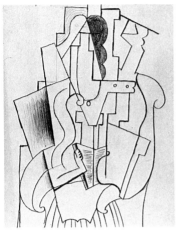

391
Femme dans un fauteuil
Woman in an Armchair
[1916–1917]
Pencil on charcoal outlines
34.5 × 32.6
Z. XXIX, 455
M.P. 835

392
La glace au-dessus de la cheminée?
The Mirror above the Fireplace?
[1916–1917]
[Montrouge]
Gouache
61.5 × 49
Z. III, 99
M.P. 779

393
Femme dans un fauteuil lisant
Woman in an Armchair Reading
1916–1917
Pencil
22.3 × 17.5
Z. VI, 1339
M.P. 776

The Post-War Period and the Theatre: 1917–1924

(1) This is well illustrated by the painting *Etudes* (*Studies*, cat. I, 60).

(2) J. Cocteau, *Journals*, Paris, 1923, p. 100.

(3) D. Milhau, *Picasso et le théâtre*, Toulouse, Musée des Augustins, 1965, p. 21, catalogue of the first exhibition on this theme. Picasso had generously allowed the author access to his portfolios, and several of the drawings which featured in the exhibition went to the Musée Picasso under the settlement.

(4) As the principle of this catalogue is to proceed in chronological order, the drawings have been grouped together, ballet by ballet, in the year they were executed. We are grateful to Nicole Wild, Conservateur of the Bibliothèque de l'Opéra, for her advice. In the *Guide du Musée*, room 6a, Hélène Seckel has brought out the essential points of the ballets and given a synopsis of the plots.

Picasso's return to more naturalistic representation, first evident in 1914, reached full fruition immediately after the war and during the period which followed. It is generally defined as the 'recall to order', the 'classical' or 'Ingres' phase. Initially there was an overlapping[1] of the Naturalist and Cubist styles, culminating in such seemingly diverse masterpieces as the *Trois musiciens* (*Three Musicians*, fig. 1) and the *Trois femmes à la fontaine* (*Three Women at the Fountain*, fig. 2): both were painted during the summer of 1921.

In Picasso's work for the theatre we see a fusion of the two styles. Jean Cocteau relates: 'I shall never forget the Rome studio. A small crate held the model for *Parade*, its houses, trees and its booth. On a table, opposite the Villa Medici, Picasso painted the Chinaman, the managers, the American woman and the horse.'[2] We know that in 1916 Cocteau, who wrote the libretto for *Parade*, asked Picasso to design the drop-curtain, the sets and costumes. Erik Satie composed the music. 'Stealing furtively into the world of the theatre at the invitation of his accomplice Cocteau, [Picasso] strolls through it with the nonchalant ease of someone who has spent his life doing nothing else,' wrote Denis Milhau.[3] Diaghilev was excited by the painter's first collaboration with the Russian ballet company he directed, and later sought his assistance in productions of *The Three-cornered Hat*, 1919, *Pulcinella*, 1920, and *Cuadro Flamenco*, 1921.

From Rome, Picasso went on to Naples and Pompei. Inspired by what he saw there, he embarked upon his classical period. In Italy the artist gained access to Russian ballet circles and fell in love with one of the dancers, Olga Kokhlova. She was to become the first Madame Picasso in 1918 and in 1921 bore him a son, Paulo.

These were the influential factors on the artist's work during this period, much of which consists of studies for the theatre.[4] When selecting works from the settlement Dominique Bozo's aim was to keep the collection of studies as complete as possible, so that they might serve as a starting point for museum research and exhibitions.

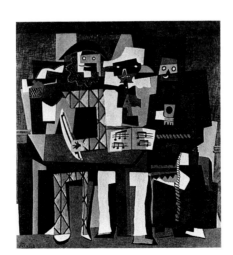

Fig. 1
Trois musiciens (*Three Musicians*), 1921
Philadelphia, The Philadelphia
Museum of Art

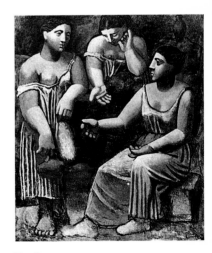

Fig. 2
Trois femmes à la fontaine (*Three Women at the Fountain*), 1921
New York, The Museum of Modern Art

For *Parade*, which was set in a circus, Picasso designed a drop-curtain (fig. 3) featuring a combination of academic and popular elements; some figures seem to have stepped out of the Rose Period. Jean Cassou had this curtain put in the Musée National d'Art Moderne. The Musée Picasso holds four studies for the curtain, as well as ten for the set and forty-nine for the costumes, including that of the little American girl (cat. 464, 465). This was never made, since we know from photographs that she finally appeared in a sailor-suit (fig. 3).[5] The greatest number of sketches feature the managers, who were not part of the original plan: 'When Picasso showed us his sketches we saw the advantage of contrasting three real people with non-human figures apparently made from colour-prints stuck on to the canvas; they looked super-human, more solemnly transposed,' wrote Cocteau.[6] Some of the drawings for these managers are clearly similar to the 1913 constructions; in fact it was through their costumes that the public came face to face with Cubism. These elements were reflected in the set, which created the impression of constructions put in motion; they are also inherent in the very concept of the ballet.

The plot of *The Three-cornered Hat* transported Picasso back to his native Spain and inspired him to design a bullfight scene for the drop-curtain in 1919 (cat. 544). The set was the subject of much research, as confirmed by the museum's holding (cat. 544–574). Different techniques were used for the miller's house in the foreground, the arch of the bridge and the village in the background, seen under a starlit sky. Although the costumes perhaps lack the panache of those worn in *Parade* they are nonetheless bright, colourful and remarkably well finished, down to the last detail.[7] The general style seems more classical after what Denis Milhau[8] describes as the 'Cubism on stage' seen in *Parade*.

When visiting Rome in 1917 Picasso formed a friendship with Stravinsky, and by late 1919 he had prepared a design for the cover of the score of *Ragtime* (cat. 656–662). A few months later he was delighted to assist in the production of a new ballet, *Pulcinella*. Its setting – the world of the *commedia dell'arte* – was especially dear to his heart, possibly all the more so since his trip to Naples.[9] He found the hero of *Pulcinella* particularly intriguing, and there are several sketches drawn in brisk lines depicting him on stage, some even indicating gestures he might make (cat. 730–734). He wears a loose, white garment and a pointed hat; his most distinctive feature is an extraordinary nose created from a mask made of wood, paper and painted cloth (fig. 10), seen in a drawing of the artist's studio in the rue La Boétie (cat. 791). It reappears in several compositions, either with musical instruments (cat. 761, 782), or as part of a harlequin's attire (cat. 769a). Picasso's contribution to *Pulcinella* culminates in studies for the set, or, to be more precise, for two versions of the set: the original idea, a theatre within a theatre, complete with boxes and a ceiling, was rejected by Diaghilev. It was replaced by a simpler, less baroque décor, which could be described as more Cubist in design (cat. 717–723). Picasso took up his initial project again in 1921 for *Cuadro flamenco* (cat. 834–838). The spectators in the boxes were based directly on those in Renoir's *La Loge* (*The Box*).

Some months earlier, at about the time of Renoir's death, Picasso had drawn a portrait of the painter from a photograph (cat. 666). A reproduction of *Fiancés* (*The Engaged Couple*) in the Cologne Museum inspired him to do a series of drawings featuring Sisley and his wife (cat. 665).

A highly stylized drawing in Indian ink (cat. 873) shows a design for a curtain intended for a Mardi-Gras ball given by Comte Etienne de Beaumont (fig. 14). Under the count's patronage Leonid Massine produced the ballet *Mercure* in 1924, with music by Erik Satie, for which Picasso painted the drop-curtain, henceforth on show at the Musée National d'Art Moderne (fig. 17). The Musée Picasso holds the design (cat. 890), depicting Harlequin playing the guitar while Pierrot plays the violin, together with one other study. Both are illustrations of what Alfred Barr terms curvilinear Cubism.[10]

Picasso intended to put a still-life with a musical instrument at the foot of the drop-curtain for *The Three-cornered Hat* (cat. 538). After the first performance in London he went to Saint-Raphaël, where he took up the theme once more. He placed the instrument in front of an open window, thus suggesting a drop-curtain opening on to a stage-set. The exhibition held at the Galerie Paul Rosenberg in October 1919 featured the drawings and gouaches on the same theme; in the words of John Richardson,[11] Naturalist and Cubist elements were 'deliberately

Fig. 3
Parade, the little American girl
(Picasso Archives)

(5) Douglas Cooper even specifies where it was made: at Williams, the Parisian theatrical outfitters (Cooper, p. 24).

(6) *Nord-Sud*, nos 4–5, July 1917.

(7) In 1920 Paul Rosenberg published a portfolio of the stencil-plates, *Le Tricorne/Ballet d'après les dessins en couleurs de Picasso*. A new edition, entitled *Designs for the Three-Cornered Hat* (*Le Tricorne*)/*Pablo Picasso*, with an introduction by Parmenia Migel, was published in New York in 1978.

(8) D. Milhau, op. cit., p. 26.

(9) He brought back some postcards on this theme, which inspired him for Pimpinella's costume (cat. 747, 750).

(10) A. Barr, *Picasso: Fifty Years of his Art*, New York, 1946, p. 132.

(11) J. Richardson, *Pablo Picasso. Aquarelles et gouaches*, no. 17.

Fig. 4
Leonid Massine as the miller in *The Three-cornered Hat*
(Photo by Cecil Beaton, Bibliothèque de l'Opéra, Kochno Bequest)

(12) Op. cit., p. 64.

(13) Similar harlequins illustrate Jean Cocteau's work, *Le coq et l'Arlequin*, Paris, 1918.

(14) The work featured as cat. 529 was drawn from a photograph which also served as the cover illustration of a publicity folder for the ballets.

(15) A. Vallentin, *Picasso*, p. 137.

(16) Study for *La liseuse* (*Woman Reading*), cf. fig. 11.

combined'. Picasso developed the idea in Paris. He kept the still-life and the wrought-iron balcony; only the empty sky lay beyond the windows (cat. 640, 647). He created a *papier collé* on the same theme (cat. I, 218), as well as a small construction entitled *Table et guitare devant une fenêtre* (*Table and Guitar in front of a Window*, fig. 8); a study in pencil and gouache is directly related to this (cat. 642). The window was to disappear, but the still-life with a musical instrument remained one of the artist's favourite motifs. A series of small gouaches executed in February and March 1920 provide fine variations based on one theme: a mandolin lying alternately on a dresser or a pedestal table. In these the severely angulated appearance of the piece of furniture contrasts with the curves of the fruit bowl and the musical instrument. Picasso took care to indicate not simply the day they were produced, but also to place them in chronological order.

Picasso is known to have identified with the character of Harlequin, who features prominently in his drawings for the ballet. Gertrude Stein[12] refers to the 'Rose Period' of the artist's mature years, the expression being particularly apt when applied to the small, elegant circus scenes drawn in December 1922 (cat. 865–871). One series depicts little characters from that world dancing while holding a harlequin's bat (cat. 498–513).[13] They are drawn with one brisk line, as are the trainers and their horses (cat. 822–829).

When visiting Rome in 1917, the artist had drawn caricatures of his friends Cocteau, Bakst, Diaghilev and Massine (cat. 476–481) in which their personalities are humorously conveyed. This series culminates in a caricature assumed to be of Stravinsky, drawn during the period when Picasso was working on designs for the cover of the *Ragtime* score (cat. 655). The same touch of lively satire can be found in the portrait of the dancer *Léonide Massine et sa partenaire* (*Leonid Massine and his Partner*, cat. 635).

Picasso's association with Russian ballet circles had led him to observe the dancers in motion. Watercolour lent itself particularly well to the rapid depiction of movements (cat. 517–524). These hieroglyphs are drawn with great gusto and reflect a universal theme dating back to the first cave-paintings. Pencil, however, was better suited to more detailed studies (cat. 633, 634, 667).

Photographs also served as a basis for the portrayal of groups of dancers, drawn in pencil and charcoal (cat. 529, 531).[14] These two large works differ in their composition: the first displays a concentrated arrangement of figures, the latter is a conventional composition grouped symmetrically around a central axis. Picasso also used a photograph for a double portrait, drawn with purity of line, featuring Sergei Diaghilev and probably Alfred Seligsberg (cat. 530). The latter was the representative of Otto Kahn, the great patron of ballet.

Picasso's return to realistic portraiture dates from 1915. He worked 'with the painstaking virtuosity of a Holbein' writes Antonina Vallentin,[15] describing the portrait of Ambroise Vollard (Zervos II², 922) held in The Metropolitan Museum, New York. Included in this series are the *Self-portrait* (cat. 489), together with portraits of Max Jacob (cat. 483), André Derain (cat. 632), Leon Bakst (cat. 863), and three others featuring the musicians Erik Satie (cat. 785), Igor Stravinsky (cat. 786) and Manuel de Falla (cat. 788). The simplicity of the technique used for the as yet undated self-portrait does not detract from the striking impression created by the piercing gaze. Within the space of a few days the artist depicted the three musicians in the same position, sitting in the same chair, using the same technique, in portraits of a similar size. We can glimpse their personalities even in the drawing of their hands.

Olga was the artist's favourite model. She appears in the foreground of drawings featuring groups of dancers, as well as in several quite conventional portraits he drew of her, emphasizing her fine, regular features and depicting with meticulous accuracy every detail of her elegant costumes such as the hat with a feather (cat. 830) or the fur-trimmed jacket (cat. 664). He illustrates her activities as a young woman of the *bourgeoisie*; we see her sewing or embroidering (cat. 779, 798, 807), playing the piano (cat. 846), reading (cat. 802)[16] or feeding Paulo after the birth of their son (cat. 849). A large pastel drawing, *Olga pensive* (*Olga in Pensive Mood*, cat. 885), completes the series of portraits of her; inner grace emanates from the elegant, clean-featured figure. Picasso produced two contrasting drawings in the same summer of 1918 in Biarritz, during that complex period when the twin currents of Realism and

post-Cubism ran side by side. One is *Portrait d'Olga sur un sofa* (*Portrait of Olga on a Sofa*, cat. 493), a fine, precisely drawn study of the casually reclining model. The other is *Femme dans un fauteuil* (*Woman in an Armchair*, cat. 492), which has its roots in Synthetic Cubism. His two women with feathered hats, drawn in the same winter of 1920, also display contrasting styles (cat. 776, 830).

When characters are grouped together in a setting, the likenesses tend to be equally realistic and accurate. In *Salon de l'artist rue La Boétie* (*The Artist's Sitting-room in the Rue La Boétie*, cat. 649), where spatial composition operates on many different levels, Picasso created individual portraits of Olga's guests Clive Bell, Erik Satie and Jean Cocteau. The furniture and decoration of the sitting-room are also reproduced with the greatest accuracy, as if on an inventory. During this period, the artist depicted all his settings for everyday life in similar fashion – the dining-room at Montrouge (cat. 484) showing a Grebo mask, the dining-room in the rue La Boétie (cat. 527, 528) and the house rented in Fontainebleau in 1921 with its bourgeois, Louis-Philippe style furnishings. The order apparent in the reception rooms of the Paris apartments is in contrast to the 'disorder' which reigned in the studios (cat. 775, 777, 791). These are drawn with the same minute attention to detail, down to the little harlequin decorating a chair. Books, palettes and portfolio lie as if abandoned on the floor.

During the summer of 1920 Picasso observed the anatomy and movements of the human body on Mediterranean beaches. In his drawings of dancers only the hands were out of proportion, but the water nymphs of Juan-les-Pins with their inordinately long bodies show deliberate distortion. They play or relax on the beach while heads or bodies, out of scale with the rest of the picture, emerge from the water (cat. 804, 816). This use of disproportion reaches its peak with the large pastel *Deux baigneuses* (*Two Bathers*, cat. 820), done on Picasso's return to Paris. Here the breasts are out of place, and the size of the heads is summarily reduced in relation to the bodies and limbs. In the words of Antonina Vallentin, 'Their firm flesh seems to imprison them.'[17]

In 1920 Picasso turned to mythological themes with an ink drawing of *Nessus et Déjanire* (*Nessus and Deianira*, cat. 812), an illustration of the violence of passion. The supreme example of a classical work, however – due to its subject-matter as much as to its style and points of reference – is the *Trois femmes à la fontaine* (*Three Women at the Fountain*, fig. 2). Picasso painted this at Fontainebleau in the full flush of happiness after the birth of his first child. Several studies and much reflection on the balance of the composition preceded the painting. The large work in red chalk (cat. I, 69), which the artist kept, was another version. Besides the study in crayon and body on a wood panel (cat. I, 68), the collection contains studies of faces imbued with classical Greek purity (cat. 851, 852) and of hands grasping the jug, markedly sculptural in quality (cat. 848–850). They are included in various series of studies of hands, one of Picasso's favourite motifs.

Les trois nus (*Three Nudes*, cat. 876, 877, 881) take up the same theme of the Three Graces in the Mediterranean atmosphere of Antibes in 1923; the drawings are very linear in style. That same summer Picasso painted *La flûte de Pan* (*The Pipes of Pan*, fig. 15). A study of a man playing the pipes of Pan (cat. 883a) is the only work related to the painting in the museum's collection.

(17) A. Vallentin, op. cit., p. 152.

Principal Related Works

Cat. 407–410:
Le rideau de scène de Parade (*The drop-curtain for Parade*), 1917. Paris, Musée National d'Art Moderne. Z. II², 851. (Fig. 5)

Cat. 470:
La sieste (*The Siesta*), 1919. Winterthur, Kunstmuseum. Z. III, 370. (Fig. 6)

Cat. 485:
Noël, la neige (*Christmas Snow*), 1917. Z. III, 98.

Cat. 518a:
L'Italienne (*The Italian Woman*), 1917. Zurich, Fondation Bührle. Z. III, 18. (Fig. 7)

Cat. 642:
Table et guitare devant une fenêtre (*Table and Guitar in front of a Window*), 1919. Paris, Musée Picasso, cat. I, 298; Z. III, 415. (Fig. 8)

Cat. 665:
Renoir, *Les fiancés* (*The Engaged Couple*). Cologne, Wallraf-Richartz Museum. (Fig. 9)

Cat. 724–735:
Masque de Pulcinella (*Pulcinella Mask*), 1920. Paris, Musée Picasso, cat. I, 299; S. 61E. (Fig. 10)

Fig. 5

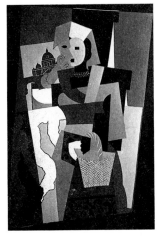

Fig. 7

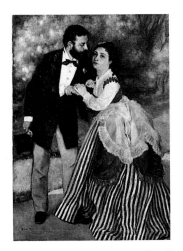

Fig. 6

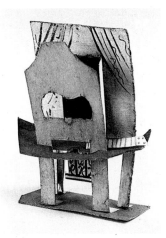

Fig. 8

Fig. 10

Fig. 9

Cat. 802:
La liseuse (*Woman Reading*), 1920. Paris,
Musée National d'Art Moderne. Z. IV, 180.
(Fig. 11)

Cat. 836–838:
Renoir, *La loge* (*The Box*). London, Courtauld
Institute Galleries. (Fig. 12)

Cat. 848–852:
Trois femmes à la fontaine (*Three Women at
the Fountain*), 1921. New York, The Museum
of Modern Art. Z. VI, 322. (Fig. 2)

Cat. 864:
Famille au bord de la mer (*Family on the Sea-
shore*), 1922. Paris, Musée Picasso, cat. I, 75.
(Fig. 13)

Cat. 873:
*Composition pour un rideau pour un bal de
Mardi-Gras* (*Composition for a Curtain for a
Mardi-Gras Ball*), 1923. Provincetown, The
Chrysler Art Museum. (Fig. 14)

Cat. 883a:
La flûte de Pan (*The Pipes of Pan*), 1923.
Paris, Musée Picasso, cat. I, 76; Z. V, 141.
(Fig. 15)

Cat. 887:
Corrida (*Bullfight*) [1922]. Paris, Musée
Picasso, cat. I, 73. (Fig. 16)

Cat. 889–890:
Le rideau de scène de Mercure (*The Drop-
curtain for Mercure*), 1924. Paris, Musée
National d'Art Moderne. Z. V, 192. (Fig. 17)

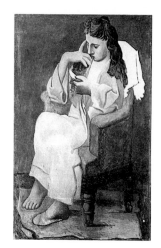
Fig. 11

Fig. 12

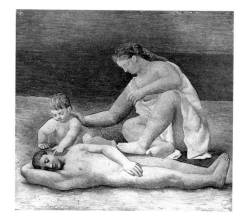
Fig. 13

Fig. 14

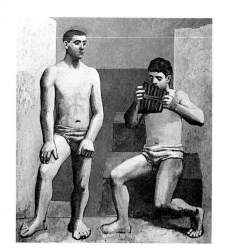
Fig. 15

Fig. 16

Fig. 17

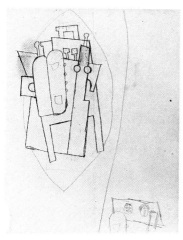

394
Ballet et spectateurs
Ballet and Spectators
Early 1916
Paris
Gouache and pencil
29 × 22.5
Z. XXIX, 207
M.P. 1546

395
Acteurs et deux croquis de tête
Actors and Two Sketches of a Head
[1916]
Pencil
23 × 18
Z. XXIX, 204
M.P. 1548

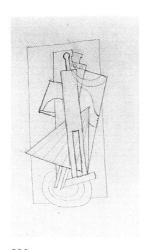

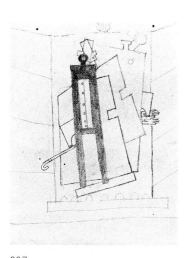

396
Couple dansant
Couple Dancing
[1916]
Pencil on a lined sheet
27.3 × 21
Z. VI, 1328
M.P. 1552

397
Acteurs avec canne et gants
Actors with a Cane and Gloves
[1916]
Pencil
29 × 22.5
Z. XXIX, 206
M.P. 1550

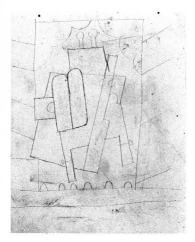

398
Acteurs sur une scène de théâtre
Actors on a Theatre Stage
[1916]
Pencil
29 × 22.5
M.P. 1547

399
Etude de personnages avec une ombrelle et une canne devant un rideau
Study of Figures with a Parasol and a Cane in front of a Curtain
[1916]
Pencil
23 × 29
Z. VI, 1305
M.P. 1549

400
Composition à l'Arlequin et au Pierrot
Composition with Harlequin and Pierrot
[1916]
Pencil
31.5 × 24
M.P. 1551

401
Arlequin à la batte et au loup
Harlequin with a Bat and Mask
1916
Paris
Pencil and black chalk
49 × 31
M.P. 781

402
Tête d'Arlequin
Head of Harlequin
1916
Pencil
22.5 × 15
M.P. 782

403
Arlequin
Harlequin
[1916–1917]
Pen and Indian ink
16.4 × 12.6
M.P. 806

404
Arlequin à l'épée
Harlequin with a Sword
[1917]
Pen and Indian ink
11.1 × 8.3
M.P. 807

405
Acrobats et arlequins
Acrobats and Harlequins
[1917]
Pen and Indian ink
15.7 × 24.2
M.P. 805

406
Programme des ballets russes
Programme of the Ballets Russes
1917
Montrouge
Gouache and pencil
20 × 27
M.P. 1554

407–469
Designs for the Curtain, Sets and Costumes for

Parade
Paris–Rome 1916–1917

Ballet by Jean Cocteau
Music by Erik Satie
Choreography by Leonid Massine
1st performance: Théâtre du Châtelet, Paris, 18 May 1917

407
Projet pour le rideau de scène
Design for the Drop-curtain
Pencil
20 × 27
Z. XXIX, 249; Cooper, 117
M.P. 1555

408
Projet pour le rideau de scène
Design for the Drop-curtain
Pencil
24.7 × 30
Z. II², 949 T.l.o.p.[2], 880; Cooper, 114
M.P. 1556

409
Projet pour le rideau de scène
Design for the Drop-curtain
Watercolour and pencil
27.3 × 39.5
Z. II², 950; T.l.o.p.[2], 881; Cooper, 116
M.P. 1557

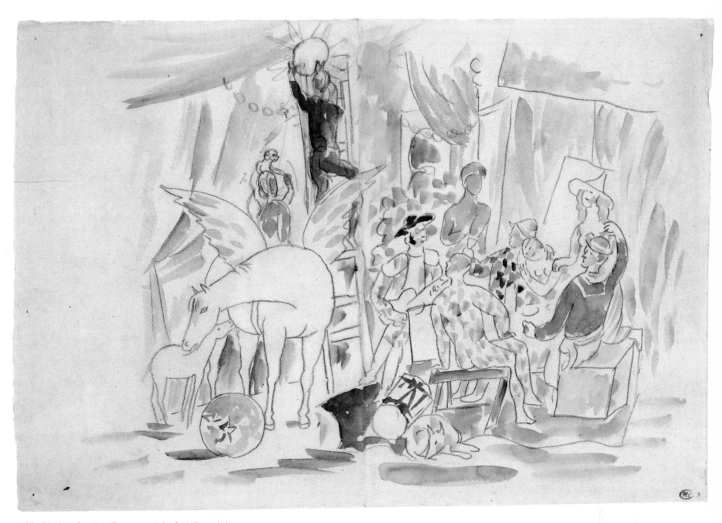

409 Design for the Drop-curtain for 'Parade'

410
Etudes pour le rideau de scène: personnage féminin de droite, chapeau et bras du marin
Studies for the Drop-curtain: Female Figure on the Right, Hat and Sailor's Arm
Watercolour and pencil
27.5 × 20.4
Z. XXIX, 294
M.P. 1558

411
Esquisses pour un décor et pour le rideau de scène
Studies for a Set and the Drop-curtain
Pencil
28 × 22.5
Z. XXIX, 247
M.P. 1568

412
Etude pour le décor
Studies for the Set
Pencil
28 × 22.5
Z. XXIX, 244
M.P. 1569

413
Etude pour le décor
Studies for the Set
Pencil
21 × 28
Z. XXIX, 241
M.P. 1567

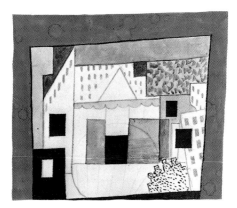

414
Etude pour le décor
Study for the Set
Gouache and pencil
12.2 × 14
Z. XXIX, 258
M.P. 1561

415
Etude pour le décor
Study for the Set
Pencil
22.5 × 28
Z. XXIX, 256
M.P. 1560

416
Etude pour le décor
Study for the Set
Pencil
27.7 × 22.5
Z. XXIX, 255
M.P. 1562

417
Etudes pour le décor
Studies for the Set
Pencil
25.5 × 14
Z. XXIX, 254
M.P. 1563

418
Etude pour le décor
Study for the Set
Pencil
17 × 18.5
Z. XXIX, 257; Cooper, 99
M.P. 1564(r)

418a
Fragment
Fragment
Pencil
17 × 18.5
M.P. 1564(v)

419
Etude pour le décor
Study for the Set
Pencil
27.5 × 22.5
Z. XXIX, 259
M.P. 1566

420
Etude pour le décor
Study for the Set
Pencil
27.7 × 22.5
Z. II², 946; T.l.o.p.⁽²⁾, 878; Cooper, 100
M.P. 1565

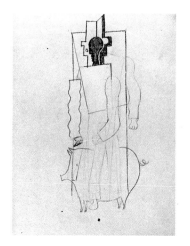

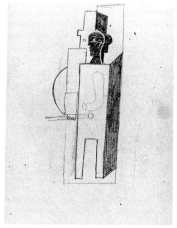

421
Etudes pour le décor et des costumes de manager
Studies for the Set and the Manager's Costumes
Pencil
27.7 × 22.5
Z. XXIX, 245; Cooper, 105
M.P. 1602

422
Etude pour un manager et un cochon
Study for a Manager and a Pig
Pencil
27.7 × 22.5
Z. II[2], 957; T.l.o.p.[(2)], 887; Cooper, 113
M.P. 1613

423
Etude pour un manager
Study for a Manager
Pencil
27.6 × 22.5
Z. II[2], 958; T.l.o.p.[(2)], 888; Cooper, 104
M.P. 1611

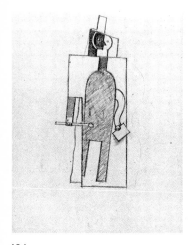

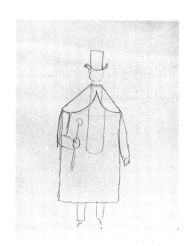

424
Etude pour un manager
Study for a Manager
Pencil
27.7 × 22.5
M.P. 1607

425
Etude pour un manager
Study for a Manager
Pencil
28 × 22.5
Z. XXIX, 271
M.P. 1603

426
Etude pour un manager
Study for a Manager
Pencil
28 × 22.5
Z. XXIX, 268
M.P. 1604

427
Etude pour un manager
Study for a Manager
Pencil
28.1 × 22.5
Z. XXIX, 270; Cooper, 110
M.P. 1601

428
Etude pour un manager
Study for a Manager
Pencil
27.5 × 22.5
Z. XXIX, 289; Cooper, 111
M.P. 1606(r)

428a
Projet pour un costume de danseuse
Design for a Dancer's Costume
Pencil
27.5 × 22.5
M.P. 1606(v)

429
Etude pour un manager
Study for a Manager
Pencil
28 × 22.5
Z. XXIX, 288; Cooper, 112
M.P. 1609

430
Etude pour un manager
Study for a Manager
Pencil
27.6 × 22.5
Z. II², 961; T.l.o.p.(2), 881; Cooper, 107
M.P. 1614

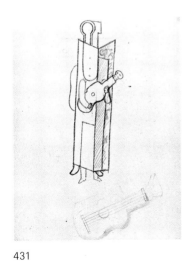

431
Etudes pour un manager musicien et son instrument de musique
Studies for a Manager Musician and his Musical Instrument
Pencil
27.7 × 22.5
Z. II², 960; T.l.o.p.(2), 890; Cooper, 103
M.P. 1610

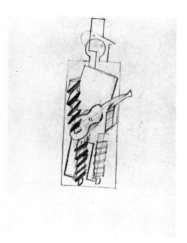

432
Etude pour un manager musicien
Study for a Manager Musician
Pencil
28 × 22.5
Z. II², 954; T.l.o.p.(2), 884; Cooper, 108
M.P. 1612

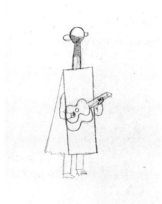

433
Etude pour un manager musicien
Study for a Manager Musician
Pencil
27.7 × 22.5
Z. II², 953; T.l.o.p.(2), 883; Cooper, 109
M.P. 1608

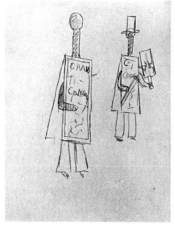

434
Etude pour des managers
Study for Managers
Pencil
28 × 22.5
Z. XXIX, 290; Cooper, 98
M.P. 1605

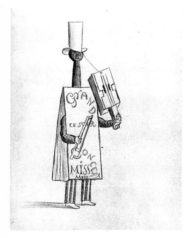

435
Etude pour un manager
Study for a Manager
Pencil
27.8 × 22.6
Z. II², 955; T.l.o.p.(2), 885; Cooper, 106
M.P. 1615

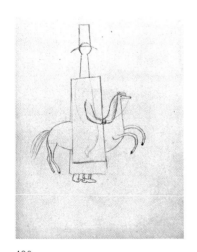

436
Etude pour 'les managers à cheval'
Study for 'the Managers on Horseback'
Pencil
28 × 22.5
Z. II², 952; T.l.o.p.(2), 882; Cooper, 90
M.P. 1581

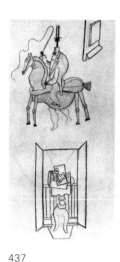

437
Etude pour 'les managers à cheval';
nature morte sur un guéridon
devant une fenêtre ouverte
*Study for 'the Managers on Horse-back'; Still-
life on a Pedestal Table in front of an Open
Window*
Pencil on a sheet from a sketchbook
31 × 15.5
Z. III, 110; Cooper, 96
M.P. 1583

438
Etude pour 'les managers à cheval'
Study for 'the Managers on Horse-back'
Pencil
27 × 21.2
Z. XXIX, 291
M.P. 1582

439
Etudes pour 'les managers à cheval'
Studies for 'the Managers on Horse-back'
Pencil
20.4 × 28
M.P. 1585

440
Etudes pour 'les managers à cheval';
instrument de musique
Studies for 'the Managers on Horse-back';
Musical Instrument
Pencil
20.5 × 28
M.P. 1584

441
Etudes pour 'les managers à cheval'
Studies for 'the Managers on Horse-back'
Pencil
20.5 × 28
Z. XXIX, 278
M.P. 1586

442
Etudes pour 'les managers à cheval'
Studies for 'the Managers on Horse-back'
Pencil
20.5 × 28
M.P. 1618

443
Etudes pour 'les managers à cheval'
Studies for 'the Managers on Horse-back'
Pencil
20.5 × 28
Z. XXIX, 281
M.P. 1588

444
Etudes pour 'les managers à cheval'
Studies for 'the Managers on Horse-back'
Pencil
28 × 22.5
Z. XXIX, 276
M.P. 1580

445
Etudes pour 'les managers à cheval'
Studies for 'the Managers on Horse-back'
Watercolour and pencil
28 × 20.4
Z. XXIX, 279; Cooper, 91
M.P. 1590

446
Etudes pour 'les managers à cheval'
Studies for 'the Managers on Horse-back'
Pencil and watercolour
28.5 × 20.7
M.P. 1593

447
Etude pour 'les managers à cheval'
Study for 'the Managers on Horse-back'
Brown ink, blue ink and pencil
20.7 × 28
M.P. 1587

448
Etudes pour 'les managers à cheval'
Studies for 'the Managers on Horse-back'
Brown and blue ink on pencil outlines
20.5 × 28.2
Z. II[2], 959; T.l.o.p.[(2)], 889; Cooper, 92
M.P. 1589

449
Etudes pour le manager américain et la tête du cheval
Studies for the American Manager and the Horse's Head
Gouache and pencil
20.5 × 28
Z. II[2], 956; T.l.o.p.[(2)], 886; Cooper, 94
M.P. 1598

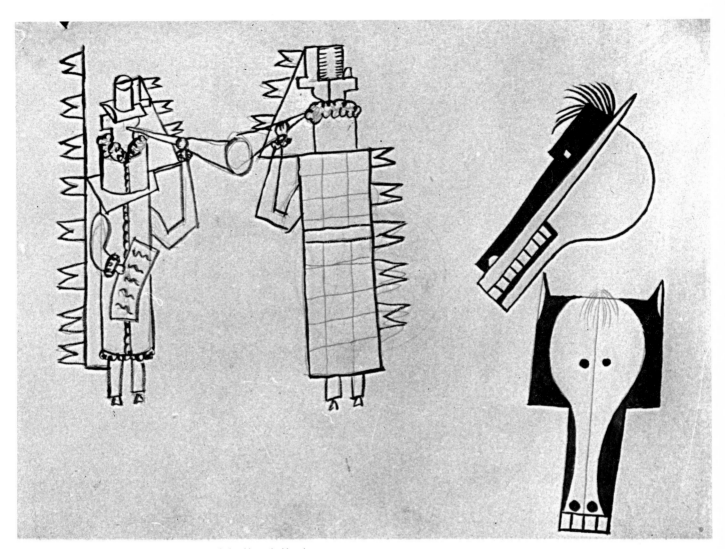

449 Studies for the American Manager and the Horse's Head

450
Etude pour le manager américain
Study for the American Manager
Watercolour and pencil
28 × 20.5
Z. XXIX, 264
M.P. 1596

451
Etude pour le manager français
Study for the French Manager
Pencil
27.5 × 21
M.P. 1594

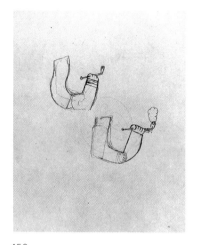

452
Etudes de bras et mains tenant une pipe pour le manager français
Studies for the French Manager: Arms and Hands Holding a Pipe
Pencil
27.5 × 21
Z. XXIX, 265
M.P. 1616

453
Etudes de détails pour le manager français
Studies of Details for the French Manager
Pencil and brown ink on a folded double¨ sheet
27.5 × 21
Z. XXIX, 267 (right-hand side)
M.P. 1617

454
Etudes d'éléments de costume du manager français
Studies of Details of the French Manager's Costume
Pencil
27.5 × 21
Z. XXIX, 266
M.P. 1619

455
Etude pour le manager français
Study for the French Manager
Pencil
28 × 20.5
Z. XXIX, 274
M.P. 1591

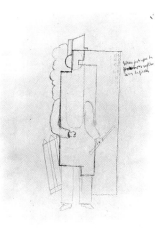

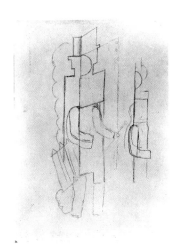

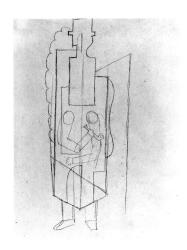

456
Etude pour le manager français et un rideau de fond
Study for the French Manager and a Backdrop
(with handwritten notes)
Pencil
28 × 20.8
Z. XXIX, 269
M.P. 1597

457
Etudes pour le manager français
Studies for the French Manager
Pencil
28.2 × 21
Z. XXIX, 272
M.P. 1592

458
Etude pour le manager français
Study for the French Manager
Pencil
28 × 20.7
Z. XXIX, 273
M.P. 1599

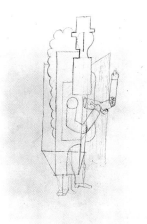

459
Etude pour le manager français
Study for the French Manager
Pencil
28.1 × 20.5
Z. XXIX, 275
M.P. 1600

460
Etude pour le costume de prestidigitateur chinois
Design for the Chinese Conjuror's Costume
Pencil
28 × 20.5
Z. XXIX, 251
M.P. 1579

461
Projet pour le costume du prestidigitateur chinois
Design for the Chinese Conjuror's Costume
Pencil
27.6 × 20.6
Z. XXIX, 250
M.P. 1578

462
**Etude de maquillage pour le
prestidigitateur chinois**
Study for the Chinese Conjuror's Make-up
Pencil and ink wash
28 × 20.7
Z. XXIX, 262
M.P. 1576

463
**Etude de maquillage pour le
prestidigitateur chinois**
Study for the Chinese Conjuror's Make-up
Pencil and watercolour
28.1 × 20.5
Z. XXIX, 261
M.P. 1577

464
**Etude pour le costume de la petite fille
américaine**
Study for the Little American Girl's Costume
Pencil
28 × 22.5
Z. XXIX, 246
M.P. 1574

465
**Etude pour le costume de la petite fille
américaine**
Study for the Little American Girl's Costume
Pencil
27.7 × 22.5
Z. XXIX, 243
M.P. 1575

466
**Etude pour le costume de l'acrobate
féminin**
Study for the Female Acrobat's Costume
Pencil
28 × 22.5
Z. XXIX, 248
M.P. 1570

467
**Projet pour le costume de l'acrobate
féminin**
Design for the Female Acrobat's Costume
Watercolour and pencil
27.5 × 20.7
M.P. 1571

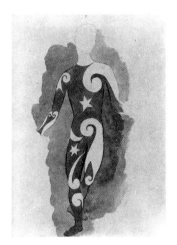

468
**Etude pour un costume d'acrobate et
étude de nu**
*Study for an Acrobat's Costume and Study of
a Nude*
Pencil on a sheet folded in two
27.5 × 20.5
Z. XXIX, 263
M.P. 1572

469
Projet pour un costume d'acrobate
Design for an Acrobat's Costume
Watercolour and pencil
28 × 20.5
Z. XXIX, 260
M.P. 1573

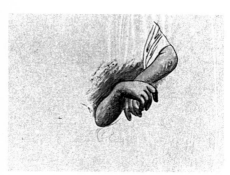

470
Etude de mains croisées
Study of Crossed Hands
[1919]
Watercolour and pencil on tracing paper
15.5 × 24.5
Z. XXIX, 292
M.P. 1559

471
Etude pour un personnage
Study for a Figure
[1917]
Pencil
28 × 20.7
Z. XXIX, 285
M.P. 1595

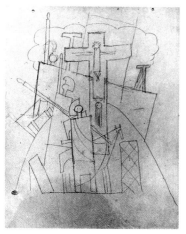

472
Crucifixion
Crucifixion
[1917]
Pencil
29 × 22.6
Z. XXIX, 277
M.P. 790

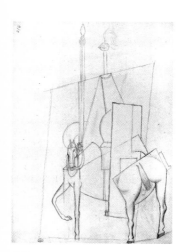

473
Etude pour une crucifixion: cavalier à la lance
Study for a Crucifixion: Horseman with a Spear
[1917]
Pencil
31.6 × 24.2
Z. XXIX, 282
M.P. 792

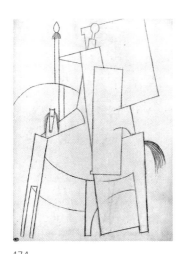

474
Etude pour une crucifixion: cavalier à la lance
Study for a Crucifixion: Horseman with a Spear
[1917]
Pencil
31.5 × 24.5
Z. XXIX, 283
M.P. 791

475
La Villa Medicis à Rome
The Villa Medici, Rome
1917
Rome
Pencil
20.9 × 28.1
D.a.r.: *Rome 1917*
Z. III, 9
M.P. 783(r)

475a
Tête
Head
1917
Rome
Pencil
28.1 × 20.9
M.P. 783(v)

476
Portrait-charge de Jean Cocteau
Caricature of Jean Cocteau
1917
Rome
Gouache
19.5 × 6.8
Z. XXIX, 217
M.P. 784

477
Portrait-charge de Léon Bakst
Caricature of Leon Bakst
1917
Rome
Gouache
12.7 × 7
M.P. 785

478
Portrait-charge de Léon Bakst
Caricature of Leon Bakst
1917
Rome
Gouache
13.7 × 5.8
M.P. 786

479
Portrait-charge de Serge de Diaghilev
Caricature of Sergei Diaghilev
1917
Rome
Gouache
8.4 × 6.6
Z. VI, 1347; Cooper (repr.in col.), 67
M.P. 787

480
**Portraits-charge de Michael Semenoff,
Léon Bakst et Serge de Diaghilev**
*Caricatures of Michael Semenoff, Leon Bakst
and Sergei Diaghilev*
1917
Rome
Gouache
19.2 × 27.6
Z. II², 947; Cooper, 69
M.P. 788

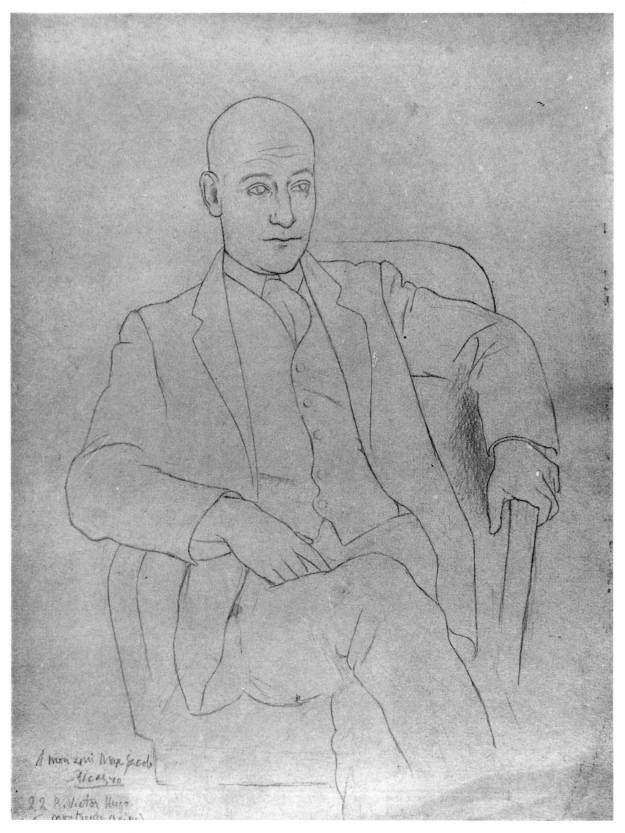

483 **Portrait of Max Jacob**

481
**Portraits-charge de Léonide Massine,
Léon Bakst et Serge de Diaghilev**
*Caricatures of Leonid Massine, Leon Bakst
and Sergei Diaghilev*
1917
Rome
Gouache
19.7 × 27.3
Z. II², 948
M.P. 789

482
Femme lisant
Woman Reading
1917
Montrouge
Black chalk
27 × 20
Z. III, 7
M.P. 800

483
Portrait de Max Jacob
Portrait of Max Jacob
1917
Montrouge
Pencil
32.6 × 25.3
S. and inscr.b.l.: *A mon ami Max Jacob/
Picasso/22 R. Victor
Hugo/Montrouge (Seine)*
Z. III, 73
M.P. 793

484
**La salle à manger de l'artiste à
Montrouge**
The Artist's Dining-room, Montrouge
9 December 1917
Montrouge
Pencil
27.7 × 22.6
D.b.r.: *Montrouge 9 Décembre 1917*
Z. III, 106
M.P. 795

485
Etude pour 'Noël, la neige'
Study for 'Christmas Snow'
[December] 1917
Montrouge
Pencil
16.7 × 18.8
Z. III, 100
M.P. 799

486
Pierrot Violoniste
Pierrot Playing the Violin
[1917]
[Montrouge]
Pencil
23 × 15.4
Z. III, 4; Cooper, 101
M.P. 1732

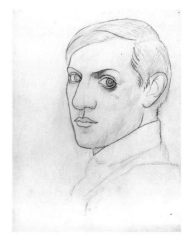

487
Arlequin
Harlequin
[1917–1918]
Pen and Indian ink
31.2 × 24.1
M.P. 809

488
Caricature (autoportrait?)
Caricature (Self-portrait?)
[1917–1918]
[Rome–Paris]
Pen and ink
17.1 × 8.5
M.P. 855

489
Autoportrait
Self-portrait
[1917–1919]
Pencil and charcoal
64 × 49.5
Z. XXIX, 309
M.P. 794

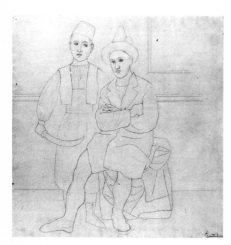

490
Deux jeunes saltimbanques ou danseurs
Two Young Saltimbanques or Dancers
1917–1919
Pencil
49 × 49.5
S.b.r.: *Picasso*
Z. XXIX, 313
M.P. 831

491
Femme étendue tricotant
Woman Stretched Out, Knitting
Late spring 1918
Pencil on writing-paper headed with the
address of the rest-home at 7, rue de la
Chaise, Paris 7, dated 1918
27.8 × 21.5
Z. III, 153
M.P. 802

492
Femme dans un fauteuil
Woman in an Armchair
Summer 1918
Biarritz
Gouache on cardboard
15 × 12
S.b.r.: *Picasso*
Z. III, 203
M.P. 801

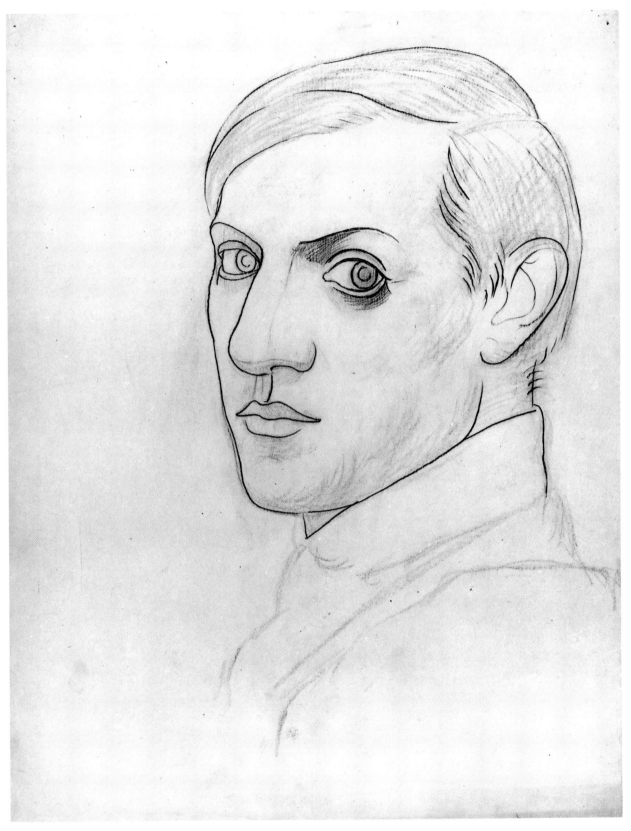

489 Self-portrait

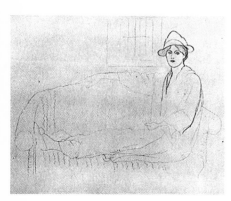

493
Portrait d'Olga sur un sofa
Portrait of Olga on a Sofa
Summer 1918
Biarritz
Pencil
26.7 × 36.8
Z. III, 198
M.P. 832

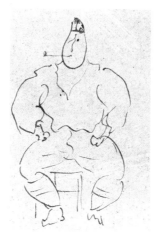

494
Portrait de Guillaume Apollinaire
Portrait of Guillaume Apollinaire
Summer 1918
Biarritz
Pen and purple ink
13.5 × 8.7
M.P. 497

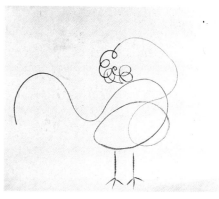

495
Coq
Cockerel
1918
Watercolour
22.6 × 27.8
Z. III, 90
M.P. 797

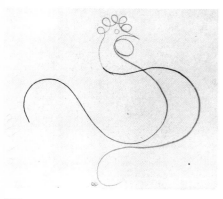

496
Coq
Cockerel
1918
Watercolour
22.6 × 27.8
Z. III, 91
M.P. 796

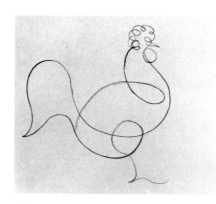

497
Coq
Cockerel
1918
Watercolour
22.6 × 27.8
Z. III, 94
M.P. 798

498
Arlequin à la batte
Harlequin with a Bat
1918
Pencil
11.1 × 10.4
M.P. 810(r)

498a
Arlequin à la batte
Harlequin with a Bat
1918
Pencil
11.1 × 10.4
M.P. 810(v)

499
Arlequin à la batte dansant
Harlequin Dancing, Bat in Hand
1918
Pencil
10.3 × 8.4
M.P. 815

500
Arlequin à la batte dansant
Harlequin Dancing, Bat in Hand
1918
Pencil
11 × 11
M.P. 816

501
Arlequin à la batte dansant
Harlequin Dancing, Bat in Hand
1918
Pencil
10.8 × 9.1
M.P. 817

502
Arlequin à la batte dansant
Harlequin Dancing, Bat in Hand
1918
Pencil
10.8 × 8.6
M.P. 818

503
Arlequin à la batte dansant
Harlequin Dancing, Bat in Hand
1918
Pencil
10.8 × 10.8
M.P. 819

504
Arlequin à la batte dansant
Harlequin Dancing, Bat in Hand
1918
Pencil
10.9 × 8.6
M.P. 820

505
Arlequin à la batte dansant
Harlequin Dancing, Bat in Hand
1918
Pencil
10.9 × 10.5
M.P. 821

506
Arlequin à la batte
Harlequin with a Bat
1918
Pencil
13.2 × 10.5
M.P. 822

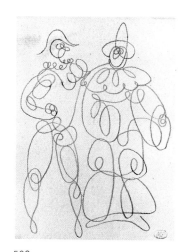

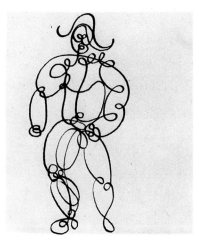

507
Arlequin
Harlequin
1918
Pencil
13.3 × 10.5
M.P. 824

508
Arlequin et Pierrot
Harlequin and Pierrot
1918
Pencil
13.4 × 10.3
M.P. 823

509
Arlequin
Harlequin
1918
Pen and Indian ink
11 × 9.6
M.P. 826(r)

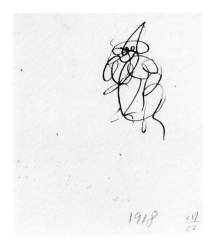

509a
Croquis d'un pierrot
Sketch of a Pierrot
1918
Pen and Indian ink
11 × 9.6
M.P. 826(v)

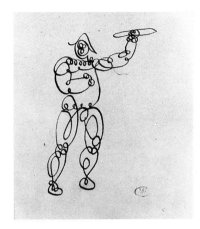

510
Arlequin à la batte
Harlequin with a Bat
1918
Pen and Indian ink
10.7 × 9.8
M.P. 827

511
Arlequin
Harlequin
1918
Pen and Indian ink
11.1 × 11
M.P. 828

512
Arlequin
Harlequin
1918
Pen and Indian ink
10.8 × 9.7
M.P. 829

513
Arlequin
Harlequin
1918
Pen and Indian ink
10.5 × 9.7
M.P. 830

514
Chien
Dog
1918
Pencil
12.8 × 11.1
M.P. 825

515
Arlequin à la guitare
Harlequin with a Guitar
[1918]
Pen and Indian ink
10.7 × 6.5
M.P. 811

516
Arlequin sur une chaise
Harlequin on a Chair
[1918]
Pen and Indian ink
24.5 × 19.5
M.P. 808

517
Groupe de danseurs
Group of Dancers
[1917]
Watercolour
20.2 × 27.5
M.P. 844

518
Danseurs
Dancers
[1917]
Watercolour
26.5 × 19.7
M.P. 845(r)

518a
Deux études de vanneries
Two Studies of Basketweave
[1917]
Pencil
26.5 × 19.7
M.P. 845(v)

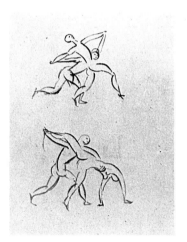

519
Danseurs
Dancers
[1917]
Watercolour
27 × 19.9
M.P. 846

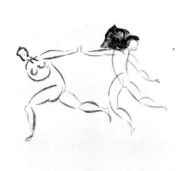

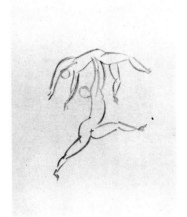

520
Couple de danseurs
Two Dancers
[1917]
Watercolour
19.7 × 27.3
M.P. 847

521
Couple de danseurs
Two Dancers
[1917]
Watercolour
19.8 × 27.4
M.P. 848

522
Couple de danseurs
Two Dancers
[1917]
Watercolour
26.5 × 19.5
M.P. 849

523
Danseur
Dancer
[1917]
Watercolour
19.7 × 26.9
M.P. 850

524
Couple de danseurs
Two Dancers
[1917]
Watercolour
19.8 × 26.9
M.P. 851

525
**Arlequin et Pierrot observant par la
fenêtre une femme nue**
*Harlequin and Pierrot Watching a Nude
Woman through a Window*
[1918]
Pencil (on the back: print of a guitar on a
table)
31 × 23.1
Z. III, 201
M.P. 1737

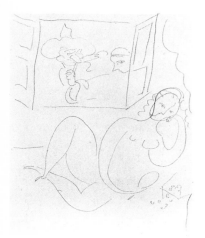

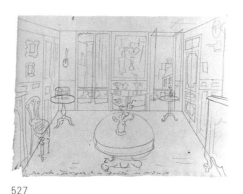

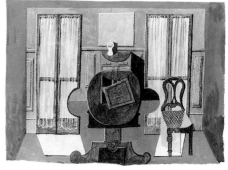

526
Arlequin et Pierrot observant par la fenêtre une femme nue
Harlequin and Pierrot Watching a Nude Woman through a Window
[1918]
Pencil
31 × 23.2
Z. VI, 1350
M.P. 1736

527
La salle à manger de l'artiste, rue La Boëtie
The Artist's Dining-room in the Rue La Boëtie
1918–1919
Paris
Pencil
20 × 27
Inscr. b. in ink: *Ma sale* (sic) *à manger R. La Boëtie en 1918 ou 19*
Z. III, 380
M.P. 836

528
La salle à manger de l'artiste, rue La Boëtie
The Artist's Dining-room in the Rue La Boëtie
1918–1919
Paris
Gouache and Indian ink
22.1 × 31.6
M.P. 837

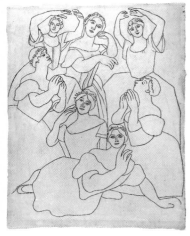

529
Sept danseurs dont Olga Kokhlova au premier plan
Seven Dancers, with Olga Kokhlova in the Foreground
(after a photograph by White)
Early 1919
Paris
Pencil with traces of charcoal
62.6 × 50
Z. III, 353
M.P. 841

530
Portrait de Serge de Diaghilev et d'Alfred Seligsberg?
Portrait of Sergei Diaghilev and Alfred Seligsberg?
(from a photograph)
Early 1919
Charcoal and black chalk
65 × 50
Z. III, 301; Cooper, 160
M.P. 839

531
Trois danseurs: Olga Kokhlova, Lydia Lopoukova et Loubov Chernicheva
Three Dancers: Olga Kokhlova, Lydia Lopukova and Lubov Chernicheva
(from a photograph)
Early 1919
Pencil and charcoal
62.7 × 47
Z. III, 352; Cooper, 138
M.P. 834

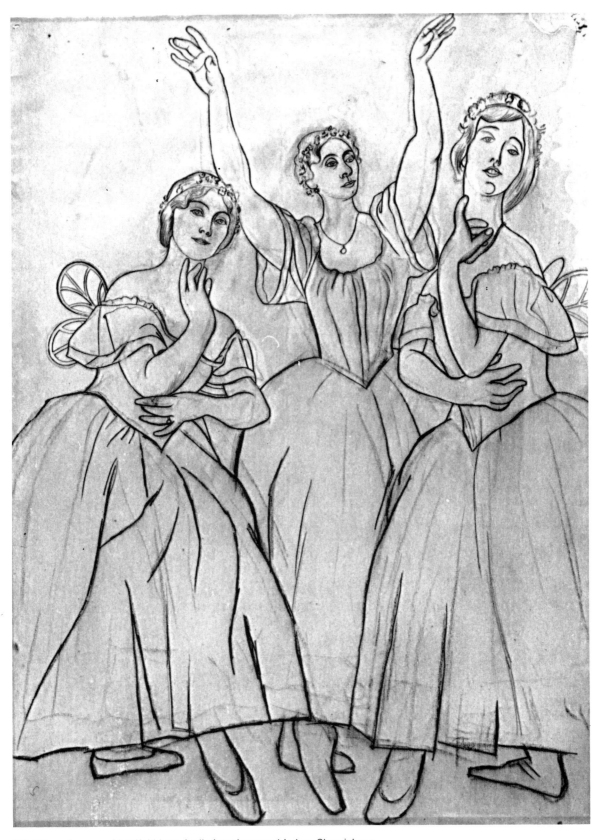

531 Three Dancers: Olga Kokhlova, Lydia Lopukova and Lubov Chernicheva

1919

532–631
Designs for the Curtain, Sets and Costumes for
The Three-cornered Hat
London 1919

Ballet by Martinez Sierra, after Alarcon
Music by Manuel de Falla
Choreography by Leonid Massine
1st performance: The Alhambra Theatre, London, 22 July 1919

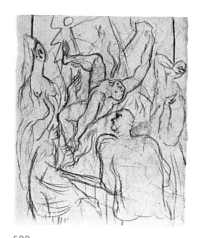

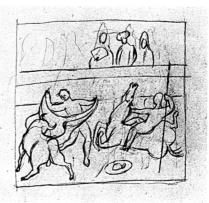

532
Etude pour le rideau de scène: l'arène
Study for the Drop-curtain: the Bull-ring
Gouache and Indian ink on pencil outlines
20.7 × 27.4
Z. XXIX, 352; Cooper (repr. in col.), 188
M.P. 1653

533
Etude pour le rideau de scène?
Study for the Drop-curtain?
Pencil
12 × 10
M.P. 1663

534
Etude pour le rideau de scène: corrida
Study for the Drop-curtain: Bullfight
Pencil
20 × 27
Z. XXIX, 347; Cooper, 187
M.P. 1658

535
Etude pour le rideau de scène: le picador
Study for the Drop-curtain: the Picador
Pencil
31.5 × 24
M.P. 1630

536
Etude pour le rideau de scène: le picador
Study for the Drop-curtain: the Picador
Pencil
20.6 × 26.5
Z. XXIX, 348; Cooper, 186
M.P. 1662(r)

536a
Scène biffée
Scene Crossed Out
Pencil
20.6 × 26.5
M.P. 1662(v)

537
Etudes pour le rideau de scène
Studies for the Drop-curtain
Pencil on a sheet folded in two
20.7 × 27.8
Z. XXIX, 366, 368; Cooper, 231, 232
M.P. 1656

538
Etude pour le rideau de scène: nature morte à l'instrument de musique sur une table
Study for the Drop-curtain: Still-life with a Musical Instrument on a Table
Pencil
20.5 × 27
Z. XXIX, 367
M.P. 1655

539
Etude pour le rideau de scène: nature morte à l'instrument de musique sur une table
Study for the Drop-curtain: Still-life with a Musical Instrument on a Table
Pencil
21 × 28
M.P. 1657

540
Etude pour le rideau de scène
Study for the Drop-curtain
Pencil
21 × 27.5
Z. XXIX, 351; Cooper, 189
M.P. 1659

541
Etude pour le rideau de scène
Study for the Drop-curtain
Gouache and pencil
20 × 26.5
M.P. 1631

542
Etude pour le rideau de scène
Study for the Drop-curtain
Pencil
31 × 24
Z. III, 304; Cooper, 185
M.P. 1660

543
Etude pour le rideau de scène
Study for the Drop-curtain
Pencil
31.5 × 24.2
Z. III, 305
M.P. 1661

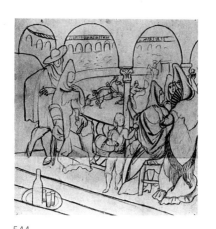

544
Projet pour le rideau de scène
Design for the Drop-curtain
Pencil
28 × 26.5
Z. III, 306; T.l.o.p.[2], 929; Cooper, 190
M.P. 1628

545
Etude pour le rideau de scène: la femme de droite
Study for the Drop-curtain: the Woman of the Right
Pencil
41.4 × 27.5
Z. XXIX, 369
M.P. 1629

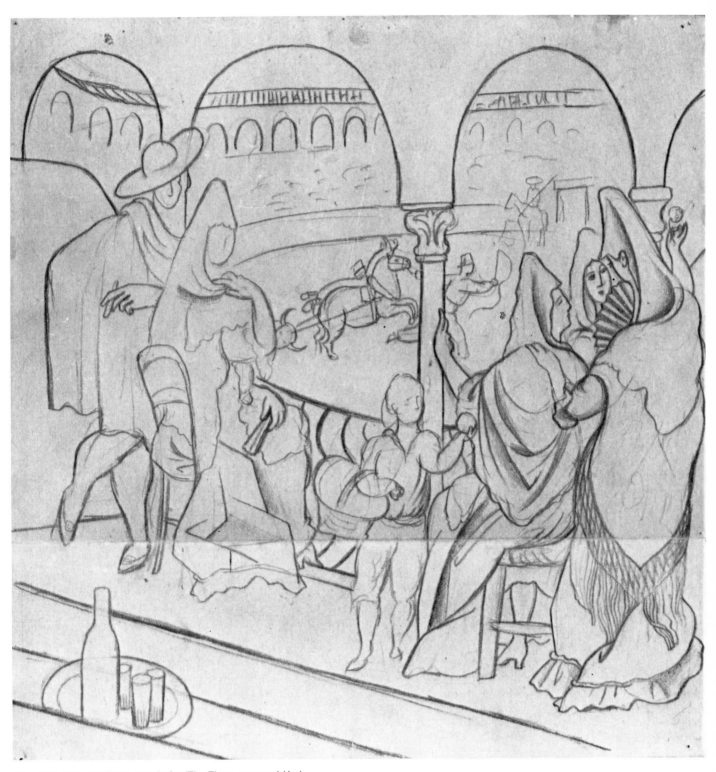

544 Design for the Drop-curtain for 'The Three-cornered Hat'

546
Etude pour un décor?
Study for a Set?
Pencil
31 × 24
Z. III, 349
M.P. 1652(r)

546a
Etude pour un décor?
Study for a Set?
Pencil
31 × 24
Z. III, 348
M.P. 1652(v)

547
Projet de décor
Design for a Set
Pencil
17.4 × 22.5
Z. XXIX, 360; Cooper, 176
M.P. 1645

548
Projet de décor
Design for a Set
Pencil
19.7 × 26.5
Z. XXIX, 356; Cooper, 173
M.P. 1646(r)

548a
Etude pour le décor
Study for the Set
Pencil
19.7 × 26.5
Z. XXIX, 359; Cooper, 171
M.P. 1646(v)

549
Projet de décor
Design for a Set
Pencil
19.5 × 26
Z. XXIX, 355; Cooper, 174
M.P. 1649

550
Maquette pour le décor
Model for the Set
Gouache and Indian ink
20 × 26.5
M.P. 1638

551
Etude pour le décor: le pont
Study for the Set: the Bridge
Gouache and Indian ink on pencil outlines
10.5 × 15
Z. XXIX, 385; Cooper (repr. in col.), 228
M.P. 1668

552
Etudes pour le décor
Studies for the Set
Watercolour
6.5 × 16
Z. XXIX, 392; Cooper (repr. in col.), 183
M.P. 1651

553
Etudes pour le décor
Studies for the Set
Gouache, Indian ink and pencil
8.9 × 20.5
Z. XXIX, 404; Cooper (repr. in col.), 184
M.P. 1666

554
Maquette pour le décor
Model for the Set
Gouache, Indian ink and pencil on paper cut-out
22 × 24
Z. XXIX, 354; Cooper, 172
M.P. 1639

555
Projet de décor
Design for a Set
Pencil
17.3 × 22.3
Z. XXIX, 361; Cooper, 168
M.P. 1647

556
Projet de décor
Design for a Set
Watercolour and pencil
17.4 × 22.3
M.P. 1636

557
Projet de décor
Design for a Set
Watercolour and pencil
17.3 × 22.3
Z. XXIX, 381; Cooper (repr. in col.), 169
M.P. 1637

558
Projet de décor
Design for a Set
Gouache, Indian ink and pencil
20 × 27
M.P. 1664

559
Projet de décor
Design for a Set
Pencil
19.5 × 26
Z. XXIX, 357; Cooper, 182
M.P. 1643(r)

559a
Projet de décor
Design for a Set
Pencil
19.5 × 26
Z. XXIX, 358; Cooper, 170
M.P. 1643(v)

560
Projet de décor
Design for a Set
Pencil
20.5 × 28
Z. XXIX, 365; Cooper, 177
M.P. 1644(r)

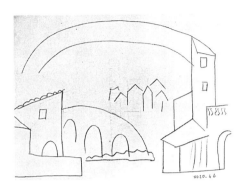

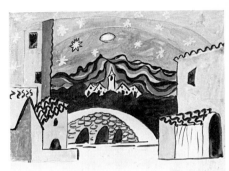

560a
Projet de décor
Design for a Set
Pencil
20.5 × 28
Z. XXIX, 364
M.P. 1644(v)

561
Etudes pour le décor
Studies for the Set
Gouache and Indian ink
20 × 26.5
Cooper (repr. in col.), 180
M.P. 1665

562
Projet de décor
Design for a Set
Watercolour and Indian ink on pencil outlines
27 × 27.3
M.P. 1632

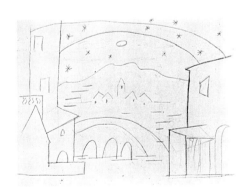

563
Projet de décor
Design for a Set
Pencil
20 × 26.5
Z. XXIX, 363; Cooper, 178
M.P. 1642

564
Projet de décor
Design for a Set
Watercolour on pencil outlines
19.5 × 26
Z. XXIX, 405; Cooper (repr. in col.), 179
M.P. 1635

565
Projet de décor
Design for a Set
Pencil
20 × 26
Z. XXIX, 350; Cooper, 164
M.P. 1641

566
Projet de décor
Design for a Set
Pencil
20 × 27
Z. XXIX, 362; Cooper, 165
M.P. 1648(r)

566a
Etudes
Studies
Pencil
27 × 20
M.P. 1648(v)

567
Projet de décor
Design for a Set
Watercolour
10.5 × 12.3
Z. XXIX, 407; Cooper (repr. in col.), 166
M.P. 1640

568
Projet de décor
Design for a Set
Gouache and black chalk
20.4 × 26.6
Z. III, 307; T.l.o.p.(2), 930
M.P. 1633

569
Maquette pour un décor
Model of a Set
Gouache and pencil on paper cut-out
20.5 × 27
M.P. 1634

570
Etude pour le décor: le puits
Study for the Set: the Well
Pencil
20 × 16
Z. XXIX, 382; Cooper, 194
M.P. 1669

571
Etudes pour le décor: maison, porte et fenêtre
Studies for the Set: House, Door and Window
Gouache and pencil
15.5 × 7.5
Z. XXIX, 389; Cooper (repr. in col.), 227
M.P. 1667

572
Etude pour le décor: fenêtres et corniche
Study for the Set: Windows and Cornice
Pencil
17.5 × 7
M.P. 1650(r)

572a
Etude pour le décor: fenêtres et corniche
Study for the Set: Windows and Cornice
Pencil
17.5 × 7
Z. XXIX, 390; Cooper, 226
M.P. 1650(v)

573
Etude pour le décor: l'échelle devant la fenêtre
Study for the Set: the Ladder in front of the Window
Gouache and pencil
20 × 5
M.P. 1670

574
Etude pour le décor: la carriole au pied de l'échelle
Study for the Set: the Cart at the Foot of the Ladder
Pencil
20 × 5.2
Z. XXIX, 391: Cooper, 229
M.P. 1671

575
Etude pour la chaise à porteur
Study for the Sedan-chair
Pencil
27.5 × 20.5
Z. XXIX, 383: Cooper, 196
M.P. 1673

576
Etude pour la chaise à porteur
Study for the Sedan-chair
Watercolour on pencil outlines
27.6 × 21
Z. VI, 1379
M.P. 1672

577
Projets de costume
Designs for a Costume
Pencil
11.5 × 26.5
Inscr.: *Archipenko/Hotel medical/R. du F. St Jacques*
Z. XXIX, 371
M.P. 1675(r)

577a
Projets de costume
Designs for a Costume
Pencil
11.5 × 26.5
M.P. 1675(v)

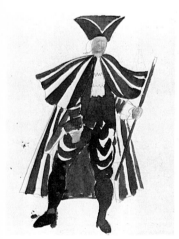

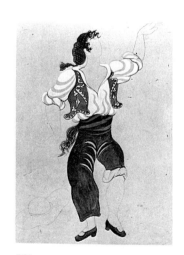

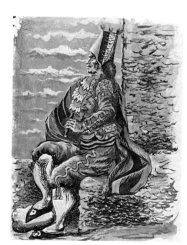

578
Projet de costume: l'alcade
Design for a Costume: the Mayor
Indian ink, gouache and pencil
22.2 × 17.3
Z. XXIX, 380; Cooper (repr. in col.), 221
M.P. 1679

579
Projet de costume: le meunier
Design for a Costume: the Miller
Gouache and pencil
26 × 19.5
Z. III, 320; Cooper (repr. in col.), 218
M.P. 1687

580
Projet de costume: le torero
Design for a Costume: the Torero
Gouache
26 × 20
Z. XXIX, 406; Cooper (repr. in col.), 233
M.P. 1676

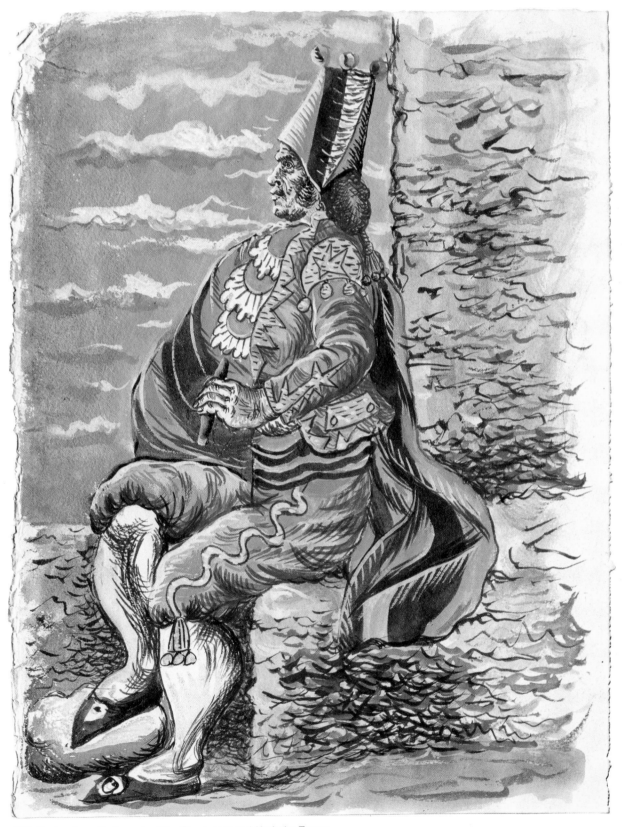

580 Design for a Costume for 'The Three-cornered Hat': the Torero

581
Projet de costume: le corregidor
Design for a Costume: the Chief Magistrate
Pencil
22.2 × 17.5
Z. XXIX, 370
M.P. 1678

582
Projet de costume: le corregidor
Design for a Costume: the Chief Magistrate
Gouache and pencil
23.1 × 17.5
Z. XXIX, 379; Cooper (repr. in col.), 225
M.P. 1677

583
Projet de costume: le corregidor?
Design for a Costume: the Chief Magistrate?
Gouache and pencil
26.5 × 19.5
Inscr. verso: *15/Waycikowsky- (Tarantelle)*
Z. III, 314
M.P. 1680

584
Projet de costume: le corregidor dans le manteau du meunier
Design for a Costume: the Chief Magistrate in the Miller's Coat
Gouache and pencil
26.5 × 19.7
Z. III, 327
M.P. 1692

585
Projet de costume pour un alguazil
Design for a Bailiff's Costume
Gouache, Indian ink and pencil
27 × 19.7
Inscr. verso: *n°9/Kovalsky/Pavlow/Stakeviz/Jasvinsky*
Z. III, 329; Cooper (repr. in col.), 215
M.P. 1682

586
Projet de costume pour un alguazil
Design for a Bailiff's Costume
Gouache, Indian ink and pencil
26.5 × 19.5
Inscr. verso: *n°10/Novac/Zverew*
Z. III, 337
M.P. 1681

587
Projet de costume: le dandy
Design for a Costume: the Dandy
Gouache and pencil
20.3 × 19.8
Inscr. verso: *17/Jozkotsky*
Z. III, 322
M.P. 1683

588
Projet de costume masculin et détail
Design for a Man's Costume, with Detail
Gouache and pencil
26 × 19.7
Inscr. verso: *23*
Z. III, 323
M.P. 1684

589
Projet de costume: aragonais
Design for a Costume: Man from Aragon
Gouache and pencil
27 × 19.8
Inscr. verso: *n°6/Kostrovskoy/Kremnew*
Z. III, 331; Cooper (repr. in col.), 214
M.P. 1685

590
Projet de costume masculin
Design for a Man's Costume
Gouache, Indian ink and pencil
27.3 × 19.7
Z. III, 325
M.P. 1686(r)

590a
**Croquis de jupe et indications
manuscrites**
Sketches of a Skirt, with Handwritten Notes
Pencil
27.3 × 19.7
Inscr.: *n°7/Kegler/Ochiminsky*
M.P. 1686(v)

591
**Projet de costume: un muletier portant
un sac de farine**
*Design for a Costume: a Muleteer Carrying a
Sack of Flour*
Gouache and pencil
26 × 19.7
Z. XXIX, 402; Cooper (repr. in col.), 206
M.P. 1688

592
Projet de costume: paysan
Design for a Costume: a Peasant
Gouache and pencil
12.5 × 11.3
Z. XXIX, 376; Cooper, 230
M.P. 1689

593
Projet de costume d'un 'voisin' avec indications manuscrits de couleurs
Design for a Neighbour's Costume, with handwritten notes showing colours to be used
Gouache and pencil
26.5 × 20
Inscr. verso: *18/Burman/Kostezky*
Z. III, 334
M.P. 1690

594
Projet de costume: un picador et esquisse du dos du costume
Design for a Costume: a Picador, with a Sketch of the Costume Seen from the Back
Gouache and pencil
26.5 × 19.7
Inscr. verso: *nº12/Mascagni*
Z. III, 311; Cooper (repr. in col.), 213
M.P. 1691

595
Projet de costume: vieil homme avec des béquilles
Design for a Costume: Old Man with Crutches
Gouache and pencil
26.5 × 19.7
Inscr. verso: *Alexandroff/nº21*
Z III, 317; Cooper (repr. in col.), 217
M.P. 1693

596
Projet de costume: la cape du 'bequillard'
Design for a Costume: Cloak for the Man on Crutches
Gouache, Indian ink and pencil
26.2 × 19.6
Z. VI, 1377
M.P. 1726

597
Projet de costume: un nègre avec indications manuscrites
Design for a Costume: a Black Man, with handwritten notes
Gouache and pencil
27 × 20
Inscr. verso: *14/un negre figurant*
Z. III, 319
M.P. 1694

598
Projet de costume masculin
Design for a Man's Costume
Gouache and pencil
22.5 × 17.5
Z. XXIX, 377; Cooper (repr. in col.), 207
M.P. 1695

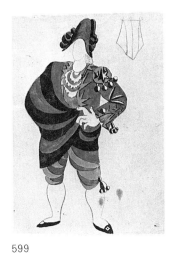

599
Projet de costume: le partenaire de la sevillana
Design for a Costume: the Partner of the Woman from Seville
Gouache and pencil
27 × 20
Inscr. verso: *n°11/Ribas*
Z. III, 313; Cooper (repr. in col.), 219
M.P. 1696

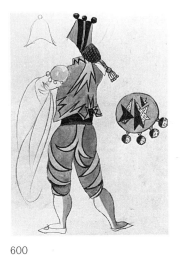

600
Projet de costume: le partenaire de la sevillana
Design for a Costume: the Partner of the Woman from Seville
Gouache and pencil
26.2 × 19.7
Inscr. verso: *n°11*
Z. III, 316
M.P. 1697

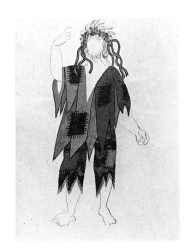

601
Projet de costume masculin: un fou
Design for a Man's Costume: a Lunatic
Gouache and pencil
26 × 19.8
Inscr. verso: *22*
Z. III, 335; Cooper (repr. in col.), 220
M.P. 1698

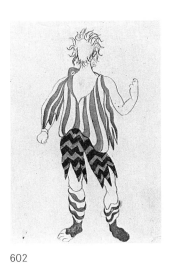

602
Projet de costume: le paysan à la barbe bleue
Design for a Costume: the Blue-Bearded Peasant
Gouache and pencil
27 × 19.5
Inscr. verso: *n°8/Lukine*
Z. III, 332; Cooper (repr. in col.), 216
M.P. 1699

603
Projet de costume féminin
Design for a Woman's Costume
Pencil
25 × 16
Z. XXIX, 393; Cooper (repr. in col.), 205
M.P. 1700

604
Projet de costume féminin
Design for a Woman's Costume
Pencil
13.5 × 10.5
Z. XXIX, 395; Cooper, 200
M.P. 1701

605
Projet de costume féminin
Design for a Woman's Costume
Pencil on the back of an invitation card for
the Galerie Branger, 24 February–16 May
1919
13.3 × 10.5
Z. XXIX, 400; Cooper, 201
M.P. 1702

606
Projet de costume féminin
Design for a Woman's Costume
Pencil
13.6 × 10.5
Z. XXIX, 394; Cooper, 210
M.P. 1703

607
Projet de costume féminin
Design for a Woman's Costume
Pencil
16.2 × 12.5
Z. XXIX, 398; Cooper, 197
M.P. 1704

608
Projet de costume féminin
Design for a Woman's Costume
Gouache, Indian ink and pencil
22.5 × 17.5
Z. XXIX, 403; Cooper (repr. in col.), 204
M.P. 1705

609
Projet de costume féminin
Design for a Woman's Costume
Gouache and pencil
22.2 × 17.4
Z. XXIX, 401; Cooper (repr. in col.), 198
M.P. 1706

610
Projet de costume féminin
Design for a Woman's Costume
Gouache and pencil
26.2 × 19.5
Inscr. verso: *2/Klementoriz/Istomina/Radnia/*
Zalesska
Z. III, 312
M.P. 1708

611
Projet de costume féminin d'une
'voisine' et détail
Design for a Costume for a Woman
Neighbour, with Detail
Gouache and pencil
26 × 20
Inscr. verso: *nº1/Memchinova Vera Olchina/*
Wassilevska/Mikoulina
Z. III, 321
M.P. 1709

612
Projet de costume féminin
Design for a Woman's Costume
Gouache
27.5 × 20.5
M.P. 1710

613
Projet de costume féminin
Design for a Woman's Costume
Gouache, Indian ink and pencil
26 × 20
Inscr. verso: *3*
M.P. 1711

614
Projet de costume féminin
Design for a Woman's Costume
Pencil
21.5 × 17.5
Z. XXIX, 372; Cooper, 208
M.P. 1713

615
Projet de costume féminin
Design for a Woman's Costume
Gouache and pencil
26.5 × 20
Inscr. verso: *nº3/Grantzeva*
Z. III, 318
M.P. 1714

616
Projet de costume féminin
Design for a Woman's Costume
Pencil
22.5 × 17.4
M.P. 1715

617
Projet de costume féminin: écuyère avec indications de couleurs
Design for a Woman's Costume: Horse-woman, with notes showing colours to be used
Pencil
22.5 × 17.4
M.P. 1716

618
Projet de costume féminin
Design for a Woman's Costume
Pencil
13.5 × 8.2
M.P. 1717(r)

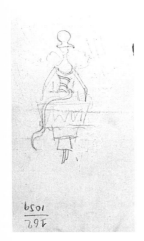

618a
Projet de costume féminin
Design for a Woman's Costume
Pencil
13.5 × 8.2
M.P. 1717(v)

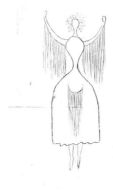

619
Projet de costume féminin
Design for a Woman's Costume
Brown ink on headed paper of the Savoy Hotel, London
31.5 × 20
M.P. 1718

620
Projet de costume féminin et croquis
Design for a Woman's Costume and Sketches
Ink and gouache on blotting paper
28.5 × 42.7
M.P. 1719

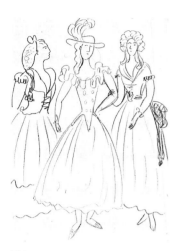

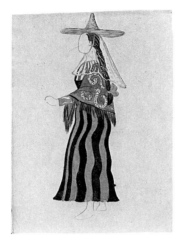

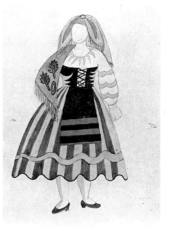

621
Projets de costumes féminins
Design for Women's Costumes
Pencil
26.5 × 20
Z. XXIX, 374; Cooper, 211
M.P. 1720

622
Projet de costume féminin
Design for a Woman's Costume
Gouache and pencil
26.8 × 20
Inscr. verso: *n°5/Kostrovskaia*
Z. III, 328
M.P. 1722

623
Projet de costume féminin
Design for a Woman's Costume
Gouache and pencil
26.5 × 19.5
Inscr. verso: *20/Pavlovska*
Z. III, 330
M.P.1725

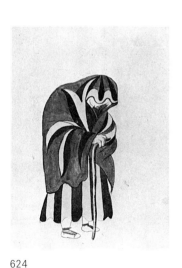

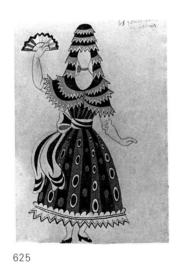

624
Projet de costume: une vieille femme
Design for a Costume: an Old Woman
Gouache and pencil
26.5 × 19.5
Inscr. verso: *13/Nemtakinova Lydia*
Z. III, 324
M.P. 1723

625
**Projet de costume: la sevillana et
indications manuscrits**
*Design for a Costume: the Woman from
Seville, with handwritten notes*
Gouache and pencil
27.5 × 19.6
Z. III, 315; T.l.o.p.(2), 931
M.P. 1707

626
Projet de costume: la femme du meunier
Design for a Costume: the Miller's Wife
Gouache and pencil
26 × 19.7
Inscr.: *19 Karsavina*
Z. III, 326
M.P. 1712

627
Projet de costume: aragonaise
Design for a Costume: Woman from Aragon
Gouache and pencil
26.5 × 19.7
Inscr. verso: *n°4/Allanova/Slavicka*
Z. III, 333; T.l.o.p.[2], 932
M.P. 1724

628
Projet de châle
Design for a Shawl
Gouache and pencil
19.5 × 26
Z. III, 336
M.P. 1727

629
Projet d'éléments de costume avec indications manuscrites
Design for Parts of a Costume, with handwritten notes
Gouache and Indian ink
27 × 19.7
Z. VI, 1378
M.P. 1728

630
Projets de costumes
Designs for Costumes
Pencil
26 × 20.9
Z. XXIX, 373; Cooper, 212
M.P. 1721

631
Projets de costumes
Designs for Costumes
Watercolour and pencil on paper cut-outs
(a) 9.5 × 6.9 (b) 8.7 × 5.7 (c) 9.7 × 7.1
Z. XXIX, 386(a), 387(b), 388(c); Cooper,
199(c), 202(a), 203(b)
M.P. 1674a, b, c

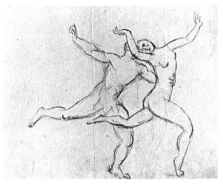

632
Portrait d'André Derain
Portrait of André Derain
[May–July] 1919
London
Pencil
39.9 × 30.8
S.D.a.l.: *Picasso/A Londres 1919*
Z. III, 300
M.P. 838

633
Léonide Massine et Lydia Lopoukova dans 'La Boutique Fantasque'
Leonid Massine and Lydia Lopukova in 'La Boutique Fantasque'
[May–July] 1919
[London]
Pencil
31.1 × 24
Z. III, 339
M.P. 842

634
Couple de danseurs
Two Dancers
[May–July] 1919
[London]
Pencil
26.5 × 39.2
Z. XXIX, 425
M.P. 852

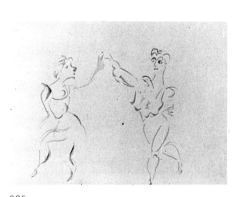

635
Léonide Massine et sa partenaire
Leonid Massine and his Partner
[May–July] 1919
[London]
Gouache
19.8 × 27.4
M.P. 843

636
Etudes pour en-tête de papier à lettre pour Paul Rosenberg et marque pour les éditions de la Sirène
Studies for Writing-paper Headings for Paul Rosenberg and Logo for 'La Sirène' Publications
Summer 1919
Pencil
26.4 × 19.5
Z. III, 259
M.P. 873

637
Etudes pour en-tête de papier à lettre pour Paul Rosenberg
Studies for Writing-paper Headings for Paul Rosenberg
Summer 1919
Indian ink
20 × 27.8
Z. III, 265
M.P. 874

638
Fenêtre ouverte sur la mer et avion dans le ciel
Window Open on to the Sea and Aeroplane in the Sky
12 October 1919
[Saint-Raphaël]
Gouache
19.5 × 11.1
D. verso in pencil: *12 oc. 1919*
M.P. 856

639
Homme au gibus assis dans un intérieur lisant son journal
Man with an Opera Hat in an Interior Reading his Newspaper
13 October 1919
[Saint-Raphaël]
Watercolour
19.8 × 10.9
D. verso in pencil: *13 oct. 1919*
M.P. 857

640
Nature morte sur une table devant une fenêtre ouverte
Still-life on a Table in front of an Open Window
26 October 1919
[Paris]
Gouache
15.9 × 10.5
D. verso in pencil: *26 octobre 1919*
M.P. 859

641
Guitare et compotier
Guitar and Fruit Bowl
7 November 1919
Paris
Gouache
11.4 × 19.6
D. verso in pencil: *7 N. 1919*
M.P. 858

642
Etude pour 'Table et guitare devant une fenêtre'
Study for 'Table and Guitar in front of a Window'
Autumn 1919
Paris
Gouache and pencil
34 × 23.7
Z. XXIX, 458
M.P. 861

643
Cinq études de guitare
Five Studies of a Guitar
Autumn 1919
Paris
Pencil
39.7 × 31
Z. III, 391
M.P. 862

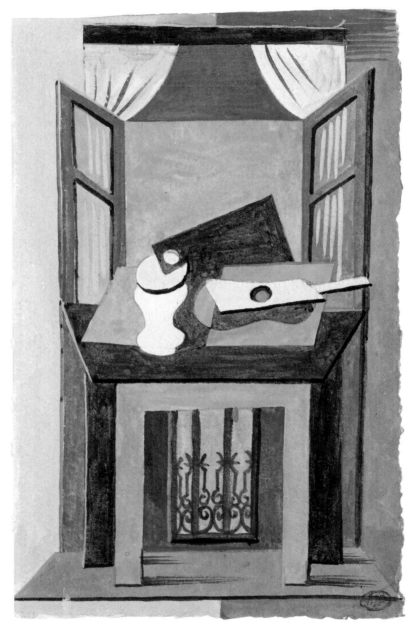

640 Still-life on a Table in front of an Open Window

644
Compotier et guitare (étude pour une construction)
Fruit Bowl and Guitar (study for a construction)
Autumn 1919
[Paris]
Pencil
32.5 × 21.9
Z. VI, 1368
M.P. 863

645
Etudes de mains et guitare sur une table devant une fenêtre ouverte
Studies of Hands and Guitar on a Table in front of an Open Window
[Autumn] 1919
[Paris]
Pencil; black chalk (for the hands)
24 × 34
Z. XXIX, 443
M.P. 860

646
Feuille d'études: nature morte et main
Various Studies: Still-life and Hand
[Autumn 1919]
Gouache and pencil
19.9 × 10.6
M.P. 865

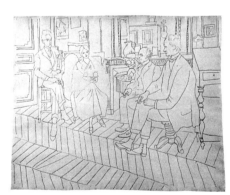

647
Nature morte sur un guéridon devant une fenêtre ouverte
Still-life on a Pedestal Table in front of an Open Window
[Autumn 1919]
Pencil with rubbing
34.2 × 23.5
Z. XXIX, 452
M.P. 864

648
Danse
Dance
18 November 1919
[Paris]
Pencil
16.4 × 11.2
D. verso: *18 n. 19*
Z. XXIX, 440
M.P. 867

649
Le salon de l'artiste rue La Boétie: Jean Cocteau, Olga, Erik Satie, Clive Bell
The Artist's Sitting-room in the Rue La Boétie: Jean Cocteau, Olga, Erik Satie, Clive Bell
21 November 1919
Paris
Pencil
49 × 61
D. verso: *21 novembre 1919/après déjeuner*
Z. III, 427; T.l.o.p.[2], 86; Cooper, 13
M.P. 869

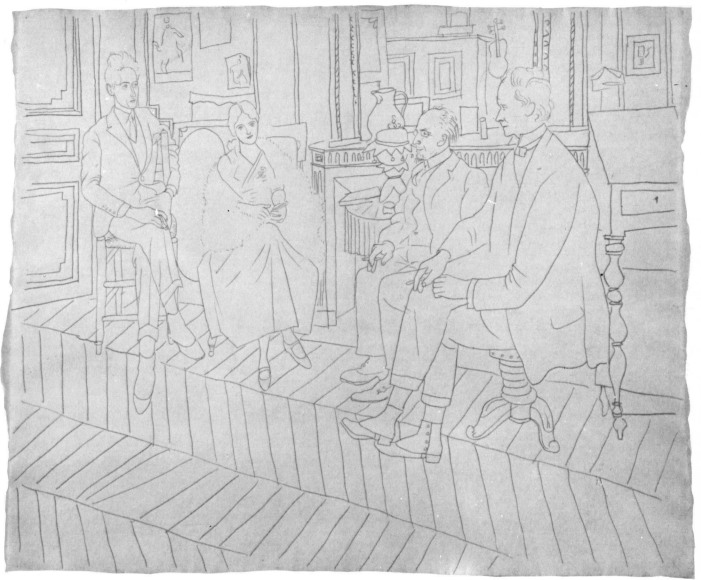

649 The Artist's Sitting-room in the Rue La Boétie: Jean Cocteau, Olga, Erik Satie, Clive Bell

650
Guitare sur une table
Guitar on a Table
22 November 1919
Paris
Gouache
11.6 × 8.7
D. verso in pencil: *22 n/19*
M.P. 870

651
Guitare sur une table
Guitar on a Table
24 November 1919
Paris
Gouache and Indian ink
11.6 × 8.9
D. verso in pencil: *24 n. 19*
M.P. 872(r)

651a
Etude de costume féminin
Study of a Woman's Costume
24 November 1919
Paris
Pencil
11.6 × 8.9
D. c. a: *24 n. 19*
M.P. 872(v)

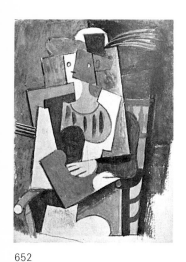

652
Femme au chapeau à plume assise dans un fauteuil
Woman with a Feathered Hat Seated in an Armchair
28 November 1919
Paris
Gouache and pencil
14.5 × 11
D. on back: *28 n. 19*
M.P. 871(r)

652a
Etudes pour une nature morte?
Studies for a Still-life?
28 November 1919
Paris
Pencil
14.5 × 11
D. a. r.: *28 n. 19*
M.P. 871(v)

653
Arlequin et Pierrot musiciens
Harlequin and Pierrot as Musicians
Late 1919
Pen and Indian ink
10.9 × 10.4
M.P. 812

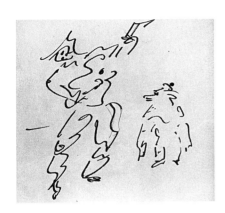

654
Arlequin à la guitare et singe
Harlequin with a Guitar and Monkey
Late 1919
Pen and Indian ink
10.9 × 11.6
M.P. 813

655
Portrait-charge d'Igor Stravinsky?
Caricature of Igor Stravinsky?
1919
Paris
Indian ink
20 × 4
M.P. 1627(r)

655a
Etude de personnage biffée
Study of a Figure, Crossed Out
1919
Paris
Indian ink
20 × 4
M.P. 1627(v)

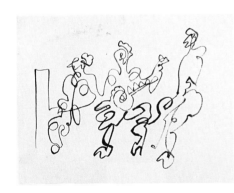

656
Etude pour la couverture de la partition de 'Ragtime' d'Igor Stravinsky: trois musiciens
Study for the Cover of the Score of Igor Stravinsky's 'Ragtime': Three Musicians
Late 1919
Paris
Gouache
19.7 × 26
M.P. 1621

657
Etude pour la couverture de la partition de 'Ragtime' d'Igor Stravinsky: pianiste et joueur de banjo
Study for the Cover of the Score of Igor Stravinsky's 'Ragtime': Pianist and Banjo Player
Late 1919
Paris
Pen and Indian ink on pencil outlines
20.5 × 27.3
M.P. 1626(r)

657a
Deux musiciens
Two Musicians
Late 1919
Paris
Pencil
20.5 × 27.3
M.P. 1626(v)

658
Etude pour la couverture de la partition de 'Ragtime' d'Igor Stravinsky: pianiste, joueur de banjo et chien
Study for the Cover of the Score of Igor Stravinsky's 'Ragtime': Pianist, Banjo Player and Dog
Late 1919
Paris
Indian ink on pencil outlines
21 × 27.4
M.P. 1624(r)

658a
Etude pour un musicien
Study for a Musician
Late 1919
Paris
Pencil
21 × 27.5
M.P. 1624(v)

659
Projet pour la couverture de la partition de 'Ragtime' d'Igor Stravinsky: violoniste et joueur de banjo
Design for the Cover of the Score of Igor Stravinsky's 'Ragtime': Violinist and Banjo Player
Late 1919
Paris
Indian ink
41 × 27.5
M.P. 1623

660
Projet pour la couverture de la partition de 'Ragtime' d'Igor Stravinsky: violoniste et joueur de banjo
Design for the Cover of the Score of Igor Stravinsky's 'Ragtime': Violinist and Banjo Player
Late 1919
Paris
Watercolour and Indian ink on pencil outlines
20 × 18
M.P. 1625

661
Projet pour la couverture de la partition de 'Ragtime' d'Igor Stravinsky: violoniste et joueur de banjo
Design for the Cover of the Score of Igor Stravinsky's 'Ragtime': Violinist and Banjo Player
Late 1919
Paris
Indian ink on pencil outlines
39.5 × 26.5
M.P. 1620(r)

661a
Deux études pour la couverture de la partition de 'Ragtime' d'Igor Stravinsky
Two Studies for the Cover of the Score of Igor Stravinsky's 'Ragtime'
Late 1919
Paris
Pencil
39.5 × 26.5
M.P. 1620(v)

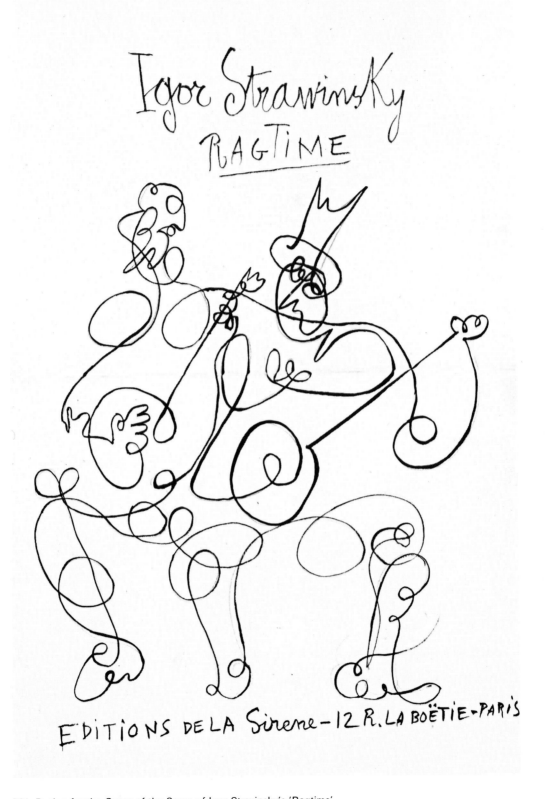

661 Design for the Cover of the Score of Igor Stravinsky's 'Ragtime'

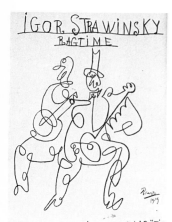

662
Projet pour la couverture de la partition de 'Ragtime' d'Igor Stravinsky: violoniste et joueur de banjo
Design for the Cover of the Score of Igor Stravinsky's 'Ragtime': Violinist and Banjo Player
Late 1919
Paris
Indian ink on pencil outlines
26 × 19.7
S. D. b. r: *Picasso/1919*
M.P. 1622

663
Nature morte au pigeon
Still-life with a Pigeon
[Late 1919]
[Paris]
Gouache
13.7 × 11
M.P. 866

664
Olga dans un fauteuil
Olga in an Armchair
[Late 1919]
Paris
Pen and black ink
26.7 × 19.7
Z. III, 295
M.P. 854

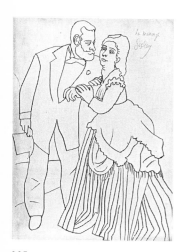

665
Le ménage Sisley d'après 'Les fiancés' d'Auguste Renoir
Sisley and his Wife after Auguste Renoir's 'Les fiancés'
Late 1919
Paris
Pencil
31.2 × 23.8
Inscr. a.r.: *Le menage/Sisley*
Z. III, 428
M.P. 868

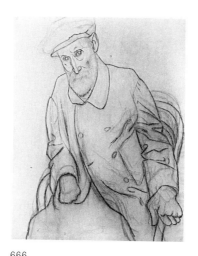

666
Portrait d'Auguste Renoir
Portrait of Auguste Renoir
(from a photograph)
1919–1920
Paris
Pencil and charcoal
61 × 49.3
Z. III, 413
M.P. 913

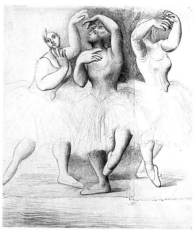

667
Trois danseuses
Three Dancers
1919–1920
Pencil on three sheets pasted together
37.5 × 32
Z. XXIX, 432; Cooper, 242
M.P. 840

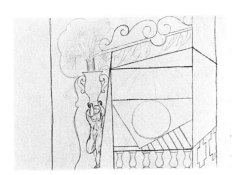

668
Etude de décor
Study of a Set
[1919–1920]
Pencil
16 × 24
M.P. 1773

669
Projet de décor
Design for a Set
[1919–1920]
Pastel and pencil on a sheet folded in two
21.7 × 27.3
M.P. 1654

670
Façade de palais (étude de décor?)
Palace Façade (study of a set?)
[1919–1921]
Pencil
11.5 × 16.2
Z. XXX, 22
M.P. 1771

671
Maquette pour un décor
Model for a Set
[1919–1921]
Pastel and pencil
15 × 23.5
Z. XXX, 157
M.P. 1823

672
Feuille d'études: Arlequin, Pierrot et femme
Various Studies: Harlequin, Pierrot and a Woman
[1919–1921]
Brown ink
17.3 × 22.2
M.P. 1731

1920

673–754
Designs for the Curtain, Sets and Costumes for

Pulcinella
Paris 1920

Ballet by Sergei Diaghilev
Music by Igor Stravinsky after Pergolese
Choreography by Leonid Massine
Ist performance: Théâtre de l'Opéra, Paris, 15 May 1920

673
Avant projet de rideau de scène:
sérénade de Pierrot et Arlequin
musiciens à une femme nue allongée; à
ses pieds un chien
Initial Design for the Drop-curtain: Pierrot and
Harlequin as Musicians Serenading a
Reclining Nude Woman with a Dog at her
Feet
Pencil
20 × 26.7
Z. III, 193; Cooper, 261
M.P. 1733

674
Avant projet de rideau de scène:
sérénade de Pierrot et Arlequin
musiciens à une femme nue allongée; à
ses pieds un chien
Initial Design for the Drop-curtain: Pierrot and
Harlequin as Musicians Serenading a
Reclining Nude Woman with a Dog at her
Feet
Pencil
18.5 × 22
Z. III, 196; Cooper, 259
M.P. 1734

675
Avant projet de rideau de scène:
sérénade de Pierrot et Arlequin
musiciens à une femme nue allongée
Initial Design for the Drop-curtain: Pierrot and
Harlequin as Musicians Serenading a
Reclining Nude Woman
Pencil
20 × 26.7
Z. III, 194; Cooper, 260
M.P. 1735

676
Projet de rideau de scène: Arlequin dans la piste avec danseuse et écuyer
Design for the Drop-curtain: Harlequin in the Ring with a Dancer and a Rider
Oil
16 × 25
Z. XXIX, 293; Cooper (repr. in col.), 264
M.P. 814

677
Etude de détail de décor avec annotations manuscrites
Study of a Detail of the Set, with handwritten notes
Pencil
27 × 18
M.P. 1764(r)

677a
Etude de décor et annotations manuscrites concernant les personnages et les musiciens
Study of a Set, and handwritten notes on the characters and musicians
Pencil
27 × 18
M.P. 1764(v)

678
Etude de décor
Study of a Set
Pencil
21 × 27.5
Cooper, 265
M.P. 1768

679
Etudes de détails de décor
Studies of Details of a Set
Pencil
20.5 × 27.6
M.P. 1766(r)

679a
Etudes de détails de décor
Studies of Details of a Set
Pencil
20.5 × 27.6
M.P. 1766(v)

680
Etudes de décor et de costumes
Studies of a Set and Costumes
Pencil
21 × 27.5
M.P. 1769(r)

680a
Etude de décor
Study of a Set
Pencil
21 × 27.5
M.P. 1769(v)

681
Trois études de détail de décor
Three Studies of Details of a Set
Pencil
19.5 × 27.2
M.P. 1777

682
Etudes de décor
Studies of a Set
Pencil
19.5 × 27.5
Z. XXX, 9
M.P. 1778

683
Etude de détails de décor
Study of Details of a Set
Pencil
21 × 27.5
M.P. 1767(r)

683a
Etude de décor
Study of a Set
Pencil
21 × 27.5
M.P. 1767(v)

684
Etude de décor
Study of a Set
Pen and Indian ink on tracing paper
9.8 × 14.2
Z. XXX, 16
M.P. 1783

685
Trois études de decor
Three Studies of a Set
Pencil
19.5 × 26.5
M.P. 1780

686
**Etudes d'éléments de décor: maison et
fontaine de Neptune**
*Studies of Parts of a Set: House and
Neptune's Fountain*
Pencil
20.5 × 27.1
Z. XXX, 18
M.P. 1781

687
**Etude de décor et études pour la
fontaine de Neptune**
*Study of a Set and Studies for Neptune's
Fountain*
Pencil
19.5 × 26.7
Z. XXX, 19
M.P. 1782

688
**Etude de décor et études pour la
fontaine de Neptune**
*Study of a Set and Studies for Neptune's
Fountain*
Pen and Indian ink on tracing paper
26 × 28.5
Z. IV, 23; Cooper, 252
M.P. 1784

689
**Trois études de décor avec indications
manuscrites sur l'éclairage**
*Three Studies of a Set, with handwritten
notes on the lighting*
Pencil
23 × 33.5
Z. XXX, 13
M.P. 1744

690
Etude de décor: instruments de musique et personnage de la loge
Study of a Set: Musical Instruments and Figure in the Box
Gouache and pencil
23.5 × 34
M.P. 1743

691
Quatre études de décor
Four Studies of a Set
Pencil
20 × 27.4
Z. XXX, 11
M.P. 1785

692
Etude de détail de décor
Study of Detail of a Set
Pencil
34 × 23.5
Z. XXX, 21
M.P. 1772

693
Etudes de détails de décor
Studies of Details of a Set
Pencil
24.5 × 32.2
Inscr. b. r: *faire un tableau représentant ensemble le facteur d'Ingres et la Odalisque de Vin Gog* (sic)
M.P. 1779

694
Etude de décor et quatres études de détails
Study of a Set and Four Studies of Details
Pencil
23.4 × 34
Z. XXX, 10
M.P. 1786

695
Etude de décor
Study of a Set
Pencil
23.5 × 17
Z. XXX, 20; Cooper, 250
M.P. 1745

696
Etude de décor et études de détails
Study of a Set and Studies of Details
Pencil
23.5 × 34.1
Z. XXX, 12; Cooper, 251
M.P. 1746

697
Etude de décor avec indications
manuscrites
Study of a Set, with handwritten notes
Pencil
22.5 × 32.3
Z. XXX, 48; Cooper, 248
M.P. 1748

698
Etude de décor
Study of a Set
Pencil
16.2 × 22
Z. XXX, 52
M.P. 1747

699
Etude pour un décor
Study for a Set
Pencil
13.5 × 16.5
M.P. 1819

700
Etude de décor: le chef d'orchestre
Study of a Set: the Conductor
Pencil
8 × 22
Z. XXX, 53
M.P. 1739(r)

700a
Cadre
Frame
Pencil
8 × 22
M.P. 1739(v)

701
Etude de décor
Study of a Set
Pencil
14.2 × 16.5
Z. XXX, 51
M.P. 1740

702
Maquette de décor
Model of a Set
Gouache and pencil
24.5 × 23
Z. XXX, 54, 55
M.P. 1738

703
Cinq études de décor
Five Studies of a Set
Pencil
23.8 × 34
M.P. 1770

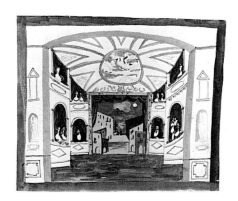

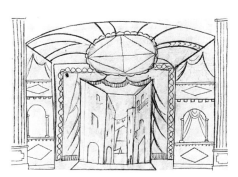

704
Etude de décor
Study of a Set
Pencil
23.7 × 33.5
Z. XXX, 39
M.P. 1776

705
Etude de décor
Study of a Set
Gouache, Indian ink and pencil
21.6 × 26
Z. XXX, 50; Cooper (repr. in col.), 258
M.P. 1749

706
Etude de décor
Study of a Set
Pencil
23.4 × 34
Z. XXX, 49
M.P. 1775

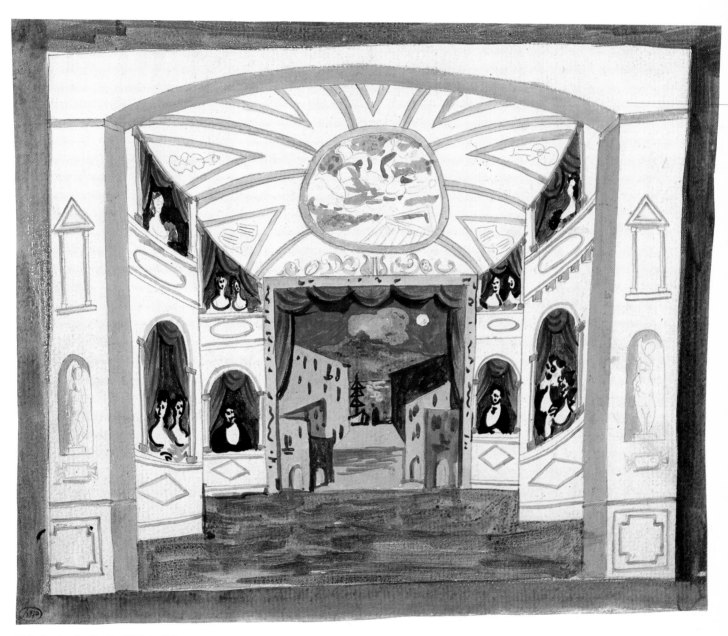

705 Study of a Set for 'Pulcinella'

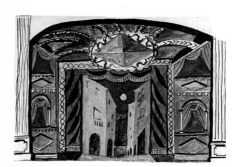

707
Etude de décor
Study of a Set
Gouache and Indian ink
24.3 × 33
Z. XXX, 1
M.P. 1750(r)

707a
Etude de décor
Study of a Set
Pencil
24.3 × 33
M.P. 1750(v)

708
Quatre études de decor
Four Studies of a Set
Pencil
21 × 34
Z. XXX, 56
M.P. 1741

709
Etude de décor
Study of a Set
Gouache, Indian ink and pencil
24 × 34
Z. XXX, 58
M.P. 1754

710
Etude de décor
Study of a Set
Gouache and Indian ink
22 × 23.2
Z. IV, 24; T.l.o.p.[(2)], 941
M.P. 1753

711
Etude de décor
Study of a Set
Pencil
10.5 × 13.5
M.P. 1765(r)

711a
Etude de décor
Study of a Set
Pencil
10.5 × 13.5
M.P. 1765(v)

712
Etude de décor
Study of a Set
Gouache and Indian ink
10.5 × 13.5
M.P. 1751

713
Etude de décor
Study of a Set
Gouache and Indian ink
10.5 × 13.5
M.P. 1752

714
**Maquette de décor avec indications
manuscrites de cotes**
*Model of a Set, with handwritten notes
indicating the dimensions*
Pencil on tracing paper
21.6 × 46.5
M.P. 1762

715
**Maquette de décor avec indications
manuscrites de cotes**
*Model of a Set, with handwritten notes
indicating the dimensions*
Pencil and ink on three cardboard cut-outs
(a) 10.7 × 3.4 (b) 9.5 × 6.8 (c) 11.8 × 3.4
M.P. 1761

716
Quatres études de décor
Four Studies of a Set
Gouache, Indian ink and pencil
23.5 × 34
M.P. 1758

717
Etude de décor
Study of a Set
Gouache
11.1 × 13.5
Z. IV, 57
M.P. 1774

718
Etude de décor
Study of a Set
Gouache, Indian ink and pencil
20 × 26.3
Z. XXX, 63
M.P. 1755

719
**Etude de décor avec indications
manuscrites de cotes**
*Study of a Set, with handwritten notes
indicating the dimensions*
Pencil and ink on tracing paper
17.9 × 20.8
M.P. 1763

720
Quatres études de décor
Four Studies of a Set
Gouache, Indian ink and pencil
20 × 26.6
M.P. 1760

721
Cinq études de décor
Five Studies of a Set
Pencil and gouache
23.5 × 34.1
Z. XXX, 57; Cooper, 268
M.P. 1756

722
**Deux études de décor et deux études de
détails**
*Two Studies of a Set and Two Studies of
Details*
Gouache, Indian ink and pencil
24 × 34.2
M.P. 1757

723
Etude de décor et deux études de détails
Study of a Set and Two Studies of Details
Gouache, Indian ink and pencil
23.4 × 33.6
Z. IV, 28; T.l.o.p.(2), 942; Cooper, 263
M.P. 1759

724
Etude du masque de Pulcinella
Study of Pulcinella Mask
Pencil on the back of a piece of an envelope
addressed to Monsieur Picasso
10 × 8.5
M.P. 1797

725
**Etudes du masque de Pulcinella et
visage féminin**
Studies of Pulcinella Mask and Woman's Face
Pencil
23.5 × 34
Z. XXX, 25
M.P. 1795

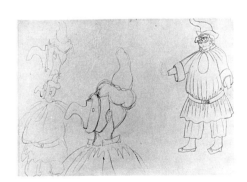

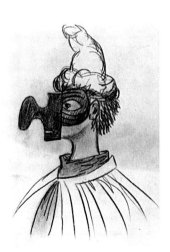

726
**Etudes du masque et du costume de
Pulcinella**
Studies of Pulcinella Mask and Costume
Pencil
23.5 × 34
Z. XXX, 26; Cooper, 279
M.P. 1794(r)

726a
Etude de personnage biffeé
Study of a Figure, Crossed Out
Pencil
23.5 × 34
M.P. 1794(v)

727
**Etude du masque et du costume de
Pulcinella**
Study of Pulcinella Mask and Costume
Pencil and coloured crayons on the back of
an invitation for the Galerie des Feuillets
d'Art, April–May 1920
14.5 × 11
Z. XXX, 41
M.P. 1798

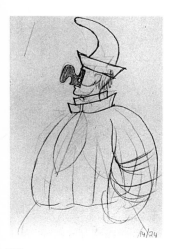

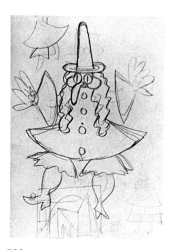

728
**Etude du masque et du costume de
Pulcinella**
Study of Pulcinella Mask and Costume
Pencil
15.5 × 10.9
M.P. 1802(r)

728a
**Etude de costume: le docteur et étude
de décor**
*Study of a Costume: the Doctor and Study of
a Set*
Pencil
15.5 × 10.9
M.P. 1802(v)

729
Etude du costume de Pulcinella
Study of Pulcinella Costume
Pencil
24 × 34
D. verso: *22-4-20-*
M.P. 1796(r)

729a
Etude du costume de Pulcinella
Study of Pulcinella Costume
Pencil
24 × 34
D. a. l.: *22-4-20-*
M.P. 1796(v)

730
Etude du personnage de Pulcinella
Study of the Character of Pulcinella
Indian ink
11.3 × 10
Z. IV, 26; Cooper, 45
M.P. 1801

731
Etude du personnage de Pulcinella
Study of the Character of Pulcinella
Pencil and gouache
16 × 10.3
M.P. 1800

734 Design for Pulcinella Costume

732
Etude du personnage de Pulcinella et annotations manuscrites
Study of the Character of Pulcinella, and handwritten notes
Pencil and watercolour
23.5 × 20.9
Z. XXX, 43
M.P. 1799

733
Projet pour le costume de Pulcinella
Design for Pulcinella Costume
Pencil
34.3 × 23.5
Z. XXX, 15
M.P. 1792

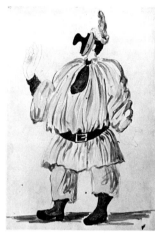

734
Projet pour le costume de Pulcinella
Design for Pulcinella Costume
Gouache and pencil
34 × 23.5
Z. IV, 21; T.l.o.p.(2), 943; Cooper, 281
M.P. 1791

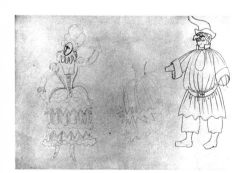

735
Etudes de costumes de Pulcinella et de personnages féminins
Studies of Costumes for Pulcinella and Female Characters
Pencil
24 × 33.9
Z. XXX, 28; Cooper, 282
M.P. 1793

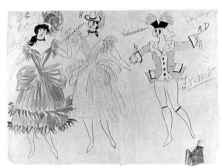

736
Etudes de costumes: Prudenza, Rosetta et Florindo avec des annotations manuscrites de noms de danseurs
Studies of Costumes: Prudenza, Rosetta and Florindo, with handwritten notes of the dancers' nàmes
Gouache and pencil
(sample of coloured paper pinned to the work)
23.6 × 34.3
Z. XXX, 46
M.P. 1788(r)

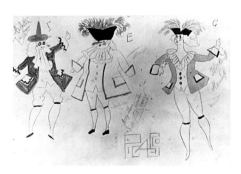

737
Etudes de costumes: Tartaglia et Caviello avec des annotations manuscrites de couleurs et de noms de danseurs
Studies of Costumes: Tartaglia and Caviello, with handwritten notes on colours and the dancers' names
Pencil and watercolour
23.8 × 34.3
Z. XXX, 44
M.P. 1787

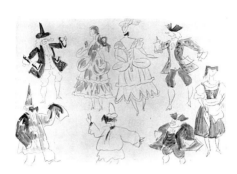

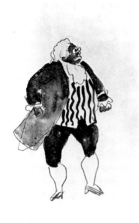

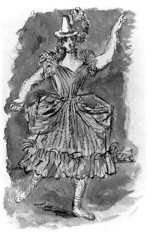

738
Etudes de costumes: le docteur, Prudenza, Rosetta, Florindo, le mage, Pulcinella, Tartaglia et Pimpinella
Studies of Costumes: the Doctor, Prudenza, Rosetta, Florindo, the Magician, Pulcinella, Tartaglia and Pimpinella
Gouache and pencil
23.5 × 33.9
Z. XXX, 45
M.P. 1789

739
Etude de costume: 'il dottore'?
Study of a Costume: the Doctor?
Gouache and pencil
16.4 × 10.5
M.P. 1807

740
Etude de costume: Prudenza
Study of a Costume: Prudenza
Gouache and Indian ink
15.7 × 10.6
Z. XXX, 42
M.P. 1809

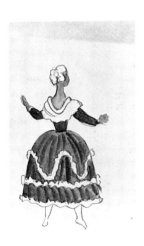

741
Etude de costume: Prudenza?
Study of a Costume: Prudenza?
Pencil
47.4 × 31
Z. XXIX, 312
M.P. 1810(r)

741a
Ebauche
Rough Outline
Charcoal
47.4 × 31
M.P. 1810(v)

742
Etude de costume: Prudenza?
Study of a Costume: Prudenza?
Gouache and pencil
16.2 × 10.2
M.P. 1812

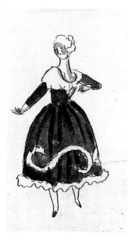

743
Etude de costume: Rosetta?
Study of a Costume: Rosetta?
Gouache and pencil
16.3 × 10
M.P. 1813

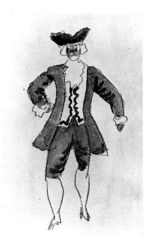

744
Etude de costume: Florindo
Study of a Costume: Florindo
Gouache and pencil
15.4 × 10.5
M.P. 1805

745
Etude de costume: Caviello
Study of a Costume: Caviello
Gouache and pencil
16.4 × 10.5
M.P. 1806

746
Etude de costume: Pimpinella?
Study of a Costume: Pimpinella?
Gouache and pencil
16 × 10.5
M.P. 1811 (r)

746a
Etude de rideau
Study of a Curtain
Pencil
10.5 × 16
M.P. 1811 (v)

747
La marchande de poissons: étude pour le costume de Pimpinella avec indications manuscrites còncernant les matériaux à utiliser
The Fish Seller: Study for Pimpinella's Costume, with handwritten indications of materials to be used
Pencil and gouache
23.5 × 17
Z. XXX, 40
M.P. 1815 (r)

747a
La marchande de poissons: étude pour le costume de Pimpinella?
The Fish Seller: Study for Pimpinella's Costume?
Pencil
23.5 × 17
M.P. 1815(v)

748
La marchande de poissons: étude pour le costume de Pimpinella avec annotations manuscrites
The Fish Seller: Study for Pimpinella's Costume, with handwritten notes
Gouache and pencil
23.6 × 34.2
Z. XXX, 38
M.P. 1816(r)

748a
La marchande de poissons: étude pour le costume de Pimpinella
The Fish Seller: Study for Pimpinella's Costume
Pencil
23.6 × 34.2
M.P. 1816(v)

749
La marchande de poissons: études pour le costume de Pimpinella
The Fish Seller: Studies for Pimpinella's Costume
Pencil
23.8 × 34
Z. XXX, 37
M.P. 1817

750
La marchande de poissons: étude pour le costume de Pimpinella
The Fish Seller: Study for Pimpinella's Costume
Pencil
34.2 × 23.7
Z. XXX, 33
M.P. 1818

751
Etude de personnage féminin
Study of a Female Character
Pencil
16.3 × 11.5
M.P. 1814

752
Etude de costume: le mage
Study of a Costume: the Magician
Pencil
31.8 × 22.2
Z. XXX, 14
M.P. 1804

753
Etude de costume: le mage
Study of a Costume: the Magician
Gouache and pencil
16.2 × 10.5
M.P. 1803

754
Etude de costume: le gendarme
Study of a Costume: the Gendarme
Gouache and pencil
23.7 × 17
M.P. 1808

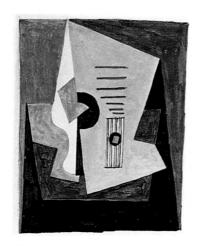

755
Guitare
Guitar
9 February 1920
Paris
Gouache and Indian ink
13.5 × 11.7
D. verso in pencil: *9 Février – 20*
M.P. 875

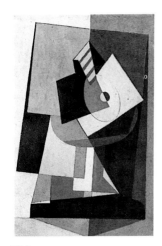

756
Mandoline sur un guéridon
Mandolin on a Pedestal Table
11 February 1920
Paris
Gouache on cardboard
30 × 20
D. verso in pencil: *11 février 1920*
M.P. 876

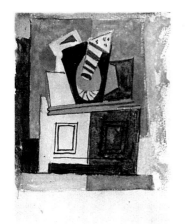

757
Compotier et mandoline sur un buffet
Fruit Bowl and Mandolin on a Sideboard
14 February 1920
Paris
Gouache and pencil
15.2 × 11.2
D. verso: *14-2-20*
Inscr. verso: *(1)*
M.P. 877

758
Compotier et mandoline sur un buffet
Fruit Bowl and Mandolin on a Sideboard
14 February 1920
Paris
Gouache and pencil
15.8 × 11.2
D. verso: *14-2-1920*
Inscr. verso: *(2)*
M.P. 878

759
Compotier et mandoline sur un buffet
Fruit Bowl and Mandolin on a Sideboard
14 February 1920
Paris
Gouache
14.4 × 11
D. verso in pencil: *14-2-1920*
Inscr. verso in pencil: *(3)*
M.P. 879

760
Compotier et mandoline sur un buffet
Fruit Bowl and Mandolin on a Sideboard
14 February 1920
Paris
Gouache
15.5 × 11.2
D. verso in pencil: *14-2-1920*
Inscr. verso in pencil: *(4)*
M.P. 880

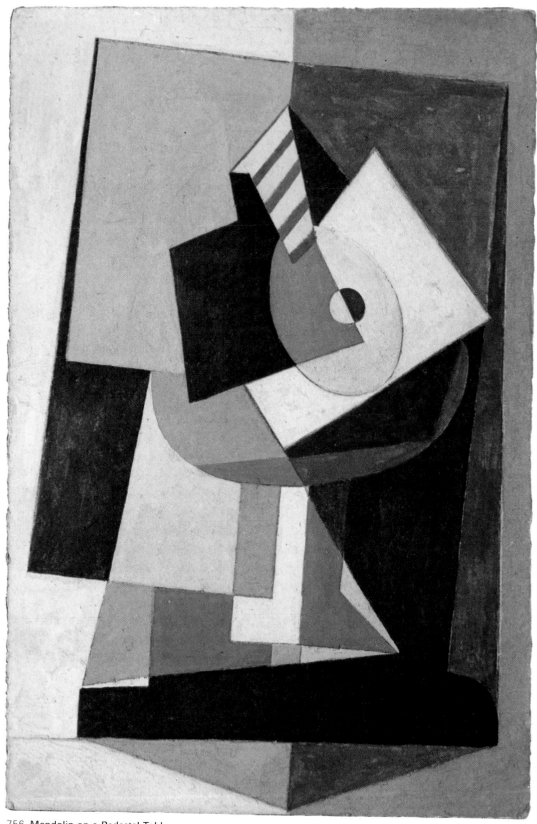

756 **Mandolin on a Pedestal Table**

761
Feuille d'études: mandoline sur un guéridon, mandoline et masque de Pulcinella
Various Studies: Mandolin on a Pedestal Table, Mandolin and Pulcinella Mask
14 February 1920
Paris
Gouache and pencil
23.7 × 17.4
D. verso: *14 F. 1920*
M.P. 881

762
Compotier et mandoline sur un buffet
Fruit Bowl and Mandolin on a Sideboard
15 February 1920
Paris
Gouache and pencil
15.2 × 10.2
D. verso: *15-2-20*
Inscr. verso: *(1)*
M.P. 882

763
Compotier et mandoline sur un buffet
Fruit Bowl and Mandolin on a Sideboard
15 February 1920
Paris
Gouache and pencil
15.5 × 10.3
D. verso: *15-2-1920*
Inscr. verso: *(2)*
M.P. 883

764
Compotier et mandoline sur un buffet
Fruit Bowl and Mandolin on a Sideboard
15 February 1920
Paris
Gouache and pencil
14 × 10.1
D. verso: *15-2-20*
Inscr. verso: *(3)*
M.P. 884

765
Compotier et mandoline sur un buffet
Fruit Bowl and Mandolin on a Sideboard
16 February 1920
Paris
Gouache
16.1 × 10.1
D. verso in pencil: *16-2-20*
M.P. 885

766
Compotier et mandoline sur un buffet
Fruit Bowl and Mandolin on a Sideboard
18 February 1920
Paris
Gouache
15.6 × 11
D. verso in pencil: *18-2-20*
Inscr. verso in pencil: *(1)*
M.P. 886

767
Compotier et mandoline sur un buffet
Fruit Bowl and Mandolin on a Sideboard
18 February 1920
Paris
Gouache
14.3 × 11.1
D. verso in pencil: *18-2-20*
Inscr. verso in pencil: *(3)*
M.P. 887

768
Compotier et mandoline sur un buffet
Fruit Bowl and Mandolin on a Sideboard
19 February 1920
Paris
Gouache
16.5 × 10.8
D. verso in pencil: *19-2-20*
M.P. 888

769
Compotier et mandoline
Fruit Bowl and Mandolin
27 February 1920
Paris
Gouache and Indian ink on pencil outlines
14.1 × 17.5
D.b.l.: *27-2-20*
M.P. 889(r)

769a
Arlequin avec masque de Pulcinella
Harlequin with Pulcinella Mask
1920
Paris
Pencil and gouache
14.1 × 17.5
M.P. 889(v)

770
Compotier et mandoline sur un guéridon
Fruit Bowl and Mandolin on a Pedestal Table
7 March 1920
Paris
Pencil with rubbing
17.8 × 12.5
D. verso: *7-3-20*
Z. IV, 40
M.P. 890

771
Compotier et mandoline sur un buffet
Fruit Bowl and Mandolin on a Sideboard
11 March 1920
Gouache
14 × 10.4
D. verso in pencil: *11-3-20-*
Inscr. verso in pencil: *(1)*
M.P. 891

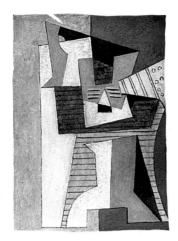

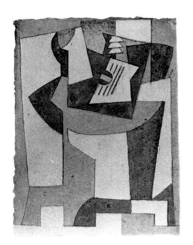

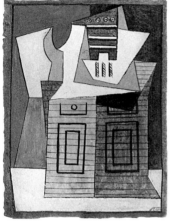

772
Compotier et mandoline sur un guéridon
Fruit Bowl and Mandolin on a Pedestal Table
11 March 1920
Paris
Gouache and Indian ink
13.5 × 10.5
D. verso in pencil: *11-3-20*
Inscr. verso in pencil: *(2)*
M.P. 892

773
Compotier et mandoline sur un guéridon
Fruit Bowl and Mandolin on a Pedestal Table
13 March 1920
Paris
Gouache and pencil
13.4 × 10.4
D. verso: *13-3-20-*
Inscr. verso: *(II)*
M.P. 893

774
Compotier et mandoline sur un buffet
Fruit Bowl and Mandolin on a Sideboard
13 March 1920
Paris
Gouache
13.5 × 10.5
D. verso in pencil: *13-3-20-*
Inscr. verso in pencil: *(IV)*
M.P. 894

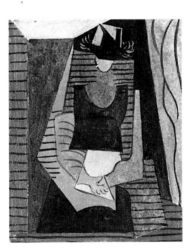

775
L'atelier de l'artiste rue La Boëtie
The Artist's Studio in the Rue La Boëtie
15 March 1920
Paris
Pencil
24 × 34.1
D.b.l.: *15 Mars 1920*
M.P. 895

776
Femme au chapeau assise
Seated Woman with a Hat
17 March 1920
Paris
Gouache and Indian ink on pencil outlines
13.3 × 10.5
D. verso: *17-3-20-*
M.P. 896

777
Un coin de l'atelier de l'artiste, rue La Boëtie
A Corner of the Artist's Studio in the Rue La Boëtie
20 March 1920
Paris
Pencil
33.9 × 23.7
D.a.r.: *20 mars–20*
M.P. 897

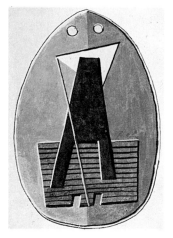

778
La salle à manger de la rue La Boëtie
The Dining-room in the Rue La Boëtie
21 March 1920
Paris
Pencil
34 × 23.3
D.b.l.: *21-3-20*
M.P. 898

779
Olga cousant
Olga Sewing
21 March 1920
Paris
Pencil
34.2 × 24
D.b.l.: *21-3-20*
Z. IV, 30
M.P. 899

780
Composition
Composition
22 April 1920
Paris
Gouache and Indian ink
15 × 11
D. verso in pencil: *22-4-20*
M.P. 904

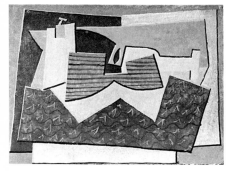

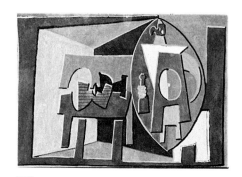

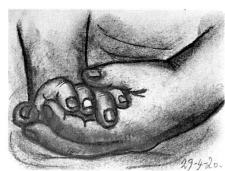

781
Nature morte à la guitare
Still-life with Guitar
24 April 1920
Paris
Gouache and Indian ink
10.7 × 15.5
D. verso in pencil: *24-4-20*
Inscr. verso in pencil: *(II)*
M.P. 903

782
Guitare sur une table et Pulcinella
Guitar on a Table and Pulcinella
26 April 1920
Paris
Gouache and Indian ink
10.9 × 15.6
D. verso in pencil: *26-4-20*
Inscr. verso in pencil: *(I)*
M.P. 905

783
Etude de mains
Study of Hands
29 April 1920
Paris
Charcoal and pastel
11.1 × 14.5
D.b.r. in pencil: *29-4-20-*
M.P. 908

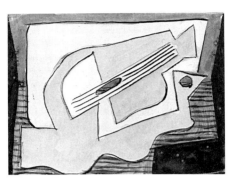

784
Guitar
Guitar
5 May 1920
Gouache and Indian ink on pencil outlines on
the back of a proof-copy of Maurice Raynal's
work on Lipchitz
10.3 × 14.5
D. verso: *5-5-20-*
M.P. 909

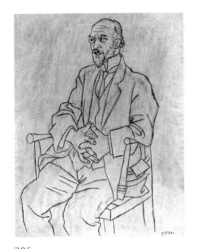

785
Portrait d'Erik Satie
Portrait of Erik Satie
19 May 1920
Paris
Pencil and charcoal
62 × 47.7
D.b.r.: *19-5-20-*
Z. IV, 59; Cooper, 245
M.P. 910

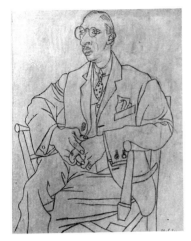

786
Portrait d'Igor Stravinsky
Portrait of Igor Stravinsky
24 May 1920
Paris
Pencil and charcoal
61.5 × 48.2
D.b.r.: *24-5-20-*
Z. IV, 60; Cooper, 273
M.P. 911

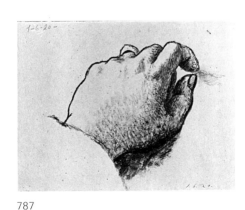

787
**Etude de main: la main gauche de
l'artiste**
Study of a Hand: the Artist's Left Hand
1 June 1920
Paris
Gouache
21.3 × 27.3
D.a.l. in pencil: *1-6-20-*
and b.r. in ink: *1.6.20.*
Z. IV, 53
M.P. 914

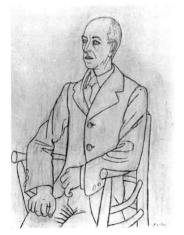

788
Portrait de Manuel de Falla
Portrait of Manuel de Falla
9 June 1920
[Paris]
Pencil and charcoal
63 × 48
D.b.r.: *9-6-20-*
Z. IV, 62; Cooper, 236
M.P. 915

789
Baigneuses et enfant
Bathers and a Child
10 June 1920
[Paris–Saint-Raphaël]
Pencil and charcoal
22 × 32
D.b.r.: *10-6-20-*
Inscr. verso: *(l)*
M.P. 916

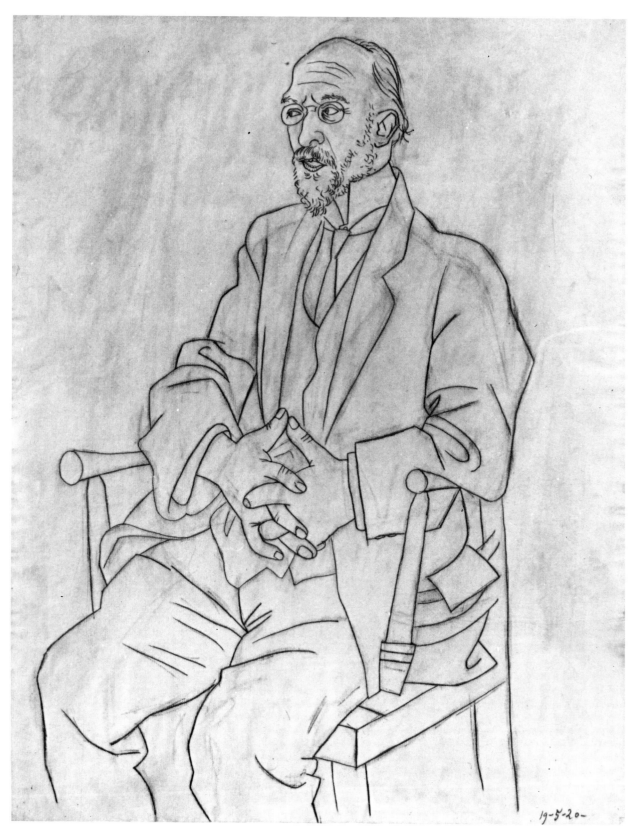

785 Portrait of Erik Satie

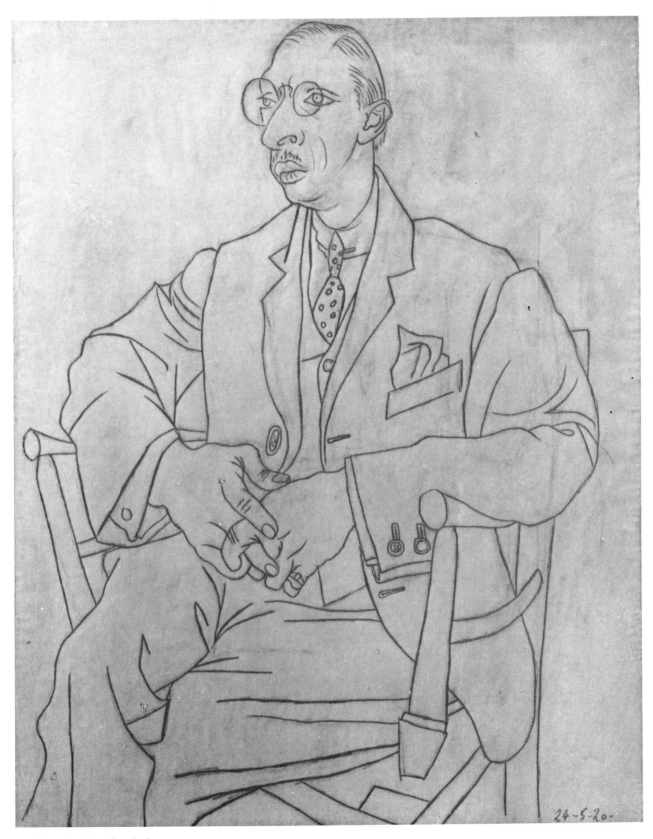

786 Portrait of Igor Stravinsky

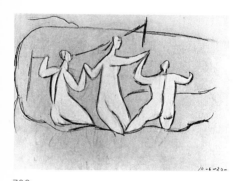

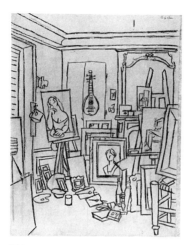

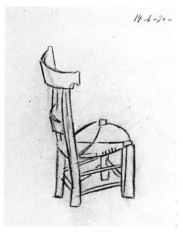

790
Trois baigneuses
Three Bathers
10 June 1920
[Paris–Saint-Raphaël]
Pencil and charcoal with eraser shading
22 × 32
D.b.r.: *10-6-20-*
Inscr. verso: *(II)*
M.P. 917

791
L'atelier de l'artiste rue La Boëtie
The Artist's Studio in the Rue La Boëtie
12 June 1920
[Paris–Saint-Raphaël]
Pencil and charcoal on grey paper
62.5 × 48
D.a.r.: *12-6-20-*
Z. IV, 78; Cooper, 10
M.P. 918

792
Chaise
Chair
14 June 1920
[Paris–Saint-Raphaël]
Pencil and charcoal
27.3 × 21.2
D.a.r.: *14-6-20-*
M.P. 919

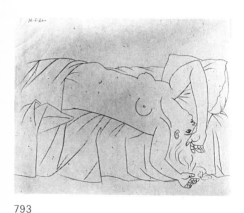

793
Nu allongé sur un lit
Nude Stretched Out on a Bed
16 June 1920
[Paris–Saint-Raphaël]
Pencil
21.5 × 27.1
D.a.l.: *16-6-20-*
Inscr. verso: *(IV)*
M.P. 920

794
Etudes de main et visage
Studies of a Hand and Face
23 June 1920
Saint-Raphaël
Pencil
27 × 13.1
D.a.r.: *23-6-20*
Inscr. verso: *M. Serge Stchoukine, Hôtel Graziella, Juan-les-Pins*
Z. XXX, 82
M.P. 921

795
Compotier et mandoline sur un guéridon
Fruit Bowl and Mandolin on a Pedestal Table
8 July 1920
Juan-les-Pins
Gouache
27.2 × 21.1
S.b.r. in pencil: *Picasso*
D. verso in ink: *8-7-20*
Inscr. verso in pencil: *(I)*
Z. IV, 100
M.P. 922

796 Leaves

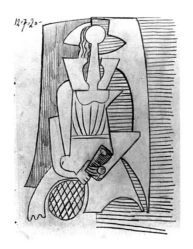

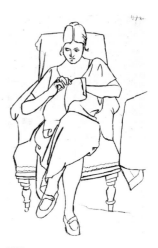

796
Feuillages
Leaves
11 July 1920
Juan-les-Pins
Pencil and charcoal
50.5 × 36.6
D.b.r.: *11-7-20-*
Z. IV, 128
M.P. 923

797
Jeune femme à la raquette
Young Woman with a Racket
12 July 1920
Juan-les-Pins
Pencil
27.4 × 21.5
D.a.l.: *12-7-20-*
Inscr. verso: *(I)*
M.P. 924

798
Olga cousant assise dans un fauteuil
Olga Sewing Seated in an Armchair
13 July 1920
Juan-les-Pins
Pencil
42.4 × 27
D.a.r.: *13-7-20-*
Z. XXX, 88
M.P. 925

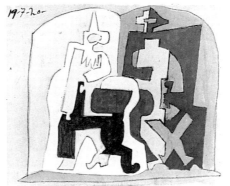

799
Etude pour une construction
Study for a Construction
17 July 1920
Juan-les-Pins
Pencil
21 × 27
D.a.r.: *17-7-20-*
Inscr. verso: *(III)*
M.P. 926

800
Pierrot et Arlequin
Pierrot and Harlequin
19 July 1920
Juan-les-Pins
Gouache and pencil
21.5 × 27
D.a.l.: *19-7-20-*
Inscr. verso: *(III)*
M.P. 1730

801
Deux baigneuses allongées sur une plage
Two Bathers Stretched Out on a Beach
21 July 1920
Juan-les-Pins
Pencil
20.4 × 27.5
D. verso: *21-7-20*
Inscr. verso: *(V)*
M.P. 927

31-7-20

802 Olga Reading Seated in an Armchair

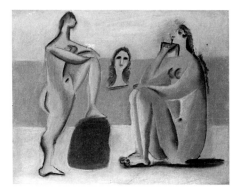

802
Olga lisant assise dans un fauteuil
Olga Reading Seated in an Armchair
31 July 1920
Juan-les-Pins
Pencil
42.5 × 27.7
D.b.r.: *31-7-20*
Z. XXX, 92
M.P. 928

803
Branches et feuillages
Branches and Leaves
1 August 1920
Juan-les-Pins
Pencil
50.5 × 36.6
D.a.l.: *1-8-20*
Z. IV, 129
M.P. 930

804
Trois baigneuses
Three Bathers
20 August 1920
Juan-les-Pins
Pastel on beige paper
50 × 65
D. verso in pencil: *20-8-20*
Z. IV, 161
M.P. 937

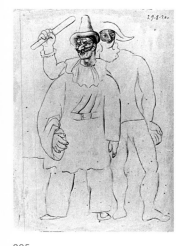

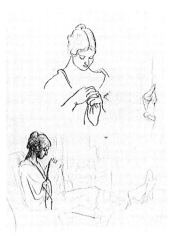

805
Polichinelle et Arlequin
Pulcinella and Harlequin
29 August 1920
Juan-les-Pins
Gouache and ink on a sheet folded in two
27 × 21.4
D.a.r.: *29-8-20-*
Inscr. verso: *(II)*
M.P. 1729

806
Juan-les-Pins
Juan-les-Pins
August 1920
Juan-les-Pins
Pencil
37 × 50
D.b.r.: *8-1920*
Z. IV, 204
M.P. 929

807
**Feuille d'études: Olga brodant et
personnage étendu sur la plage**
*Various Studies: Olga Embroidering and
Figure Stretched Out on the Beach*
Summer 1920
Juan-les-Pins
Pencil
48.5 × 32
Z. IV, 89
M.P. 900

808
Olga à la chevelure dénouée assise dans un fauteuil les mains croisées
Olga with her Hair Loose Seated in an Armchair, Hands Crossed
5 September 1920
Juan-les-Pins
Pencil
105 × 75.5
D.a.r.: *5-9-20-*
Z. XXX, 98
M.P. 931

809
Composition
Composition
10 September 1920
Juan-les-Pins
Gouache and pencil
27 × 21.7
S.b.l.: *Picasso*
D. verso in ink: *10-9-20-*
Inscr. verso in ink: *(I)*
Z. IV, 188
M.P. 932

810
Trois baigneurs
Three Bathers
10 September 1920
Juan-les-Pins
Gouache
21.2 × 27
S.b.l. in pencil: *Picasso*
D. verso in pencil: *10-9-20-*
Z. IV, 175
M.P. 933

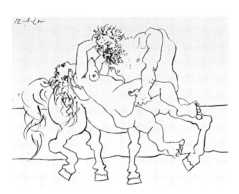

811
Homme lançant une boule
Man Throwing a Ball
10 September 1920
Juan-les-Pins
Gouache
21.3 × 27
D. verso in pencil: *10-9-20-*
M.P. 934

812
Nessus et Déjanire
Nessus and Deianira
12 September 1920
Juan-les-Pins
Brown ink on a sheet folded in two
21.3 × 27.3
D.a.l.: *12-9-20-*
Z. IV, 185
M.P. 935

813
Guitare
Guitar
18 September 1920
Juan-les-Pins
Gouache and pencil
27.5 × 21.3
S.b.l.: *Picasso*
D. verso in pencil: *18-9-20-*
Z. IV, 189
M.P. 936

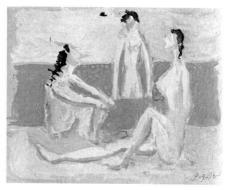

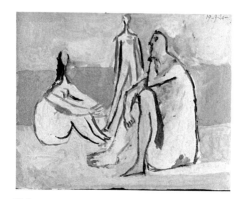

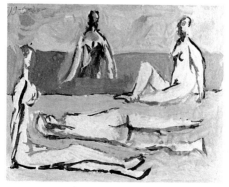

814
Trois baigneuses
Three Bathers
19 September 1920
Juan-les-Pins
Gouache on beige paper
21.3 × 27.1
D.b.r. in pencil: *19-9-20-*
Inscr. verso: *(I)*
M.P. 938

815
Trois baigneurs
Three Bathers
19 September 1920
Juan-les-Pins
Gouache
21.2 × 27.5
D.a.r. in pencil: *19-9-20-*
Inscr. verso: *(II)*
M.P. 940

816
Quatre baigneuses
Four Bathers
19 September 1920
Juan-les-Pins
Gouache
21 × 27.3
D.a.l. in pencil: *19-9-20-*
Inscr. verso: *(III)*
M.P. 941

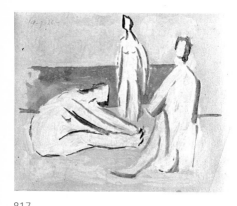

817
Trois baigneurs
Three Bathers
19 September 1920
Juan-les-Pins
Gouache on beige paper
21.5 × 27.3
D.a.l. in pencil: *19-9-20-*
Inscr. verso: *(IV)*
M.P. 939

818
Olga allongée sur un divan
Olga Stretched Out on a Couch
23 September 1920
Juan-les-Pins
Pencil on paper prepared with gouache
25 × 32.5
D.a.r.: *23-9-20*
M.P. 942

819
Piano
Piano
26 September 1920
Juan-les-Pins
Gouache on a sheet folded in two
27.4 × 21.2
D. verso in ink: *26-9-20-*
and in pencil: *(II)*
Z. XXX, 72
M.P. 943

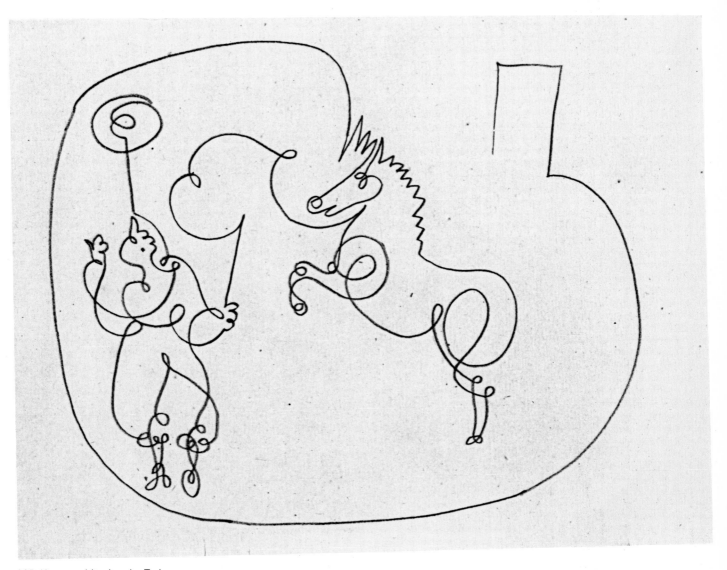

825 Horse and its Juggler Trainer

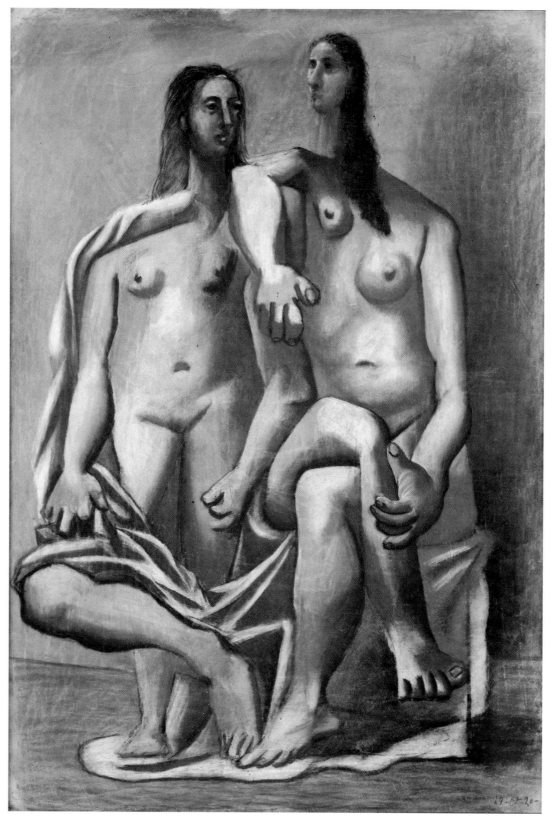

820 Two Bathers

820
Deux baigneuses
Two Bathers
24 October 1920
Paris
Pastel
108.5 × 75.8
D.l.r.: *24-oct-20-*
Z. IV, 202
M.P. 944

821
Verre et main
Glass and Hand
23 November 1920
Paris
Charcoal
27.2 × 21.2
D.a.r.: *23-11-20-*
M.P. 946

822
Cheval et son dresseur
Horse and its Trainer
23 November 1920
Paris
Pencil
21.5 × 27.1
D. verso: *23-11-20*
Inscr. verso: *VII*
M.P. 954

823
Cheval et son dresseur
Horse and its Trainer
23 November 1920
Paris
Pencil
21.3 × 27.2
D. verso: *23-11-20*
Inscr. verso: *VIII*
M.P. 953

824
Cheval et son dresseur jongleur
Horse and its Juggler Trainer
23 November 1920
Paris
Pencil
21.2 × 27.2
D. verso: *23-11-20*
Inscr. verso: *IX*
M.P. 952

825
Cheval et son dresseur jongleur
Horse and its Juggler Trainer
23 November 1920
Paris
Pencil
21.5 × 27.3
D. verso: *23-11-20*
Inscr. verso: *X*
M.P. 951

826
Cheval et son dresseur
Horse and its Trainer
23 November 1920
Paris
Pencil
21.2 × 27.1
D. verso: *23-11-20*
Inscr. verso: *XI*
M.P. 950

827
Cheval et son dresseur
Horse and its Trainer
23 November 1920
Paris
Pencil
21 × 27.5
D. verso: *23-11-20*
Inscr. verso: *XII*
M.P. 949

828
Cheval et son dresseur
Horse and its Trainer
23 November 1920
Paris
Pencil
21.3 × 27.2
D. verso: *23-11-20*
Inscr. verso: *XIII*
M.P. 948

829
Cheval et femme dresseur
Horse and Female Trainer
23 November 1920
Paris
Pencil
21 × 27
D. verso: *23-11-20*
Inscr. verso: *XV*
M.P. 947

830
Olga au chapeau à la plume
Olga with a Hat with a Feather
1920
Paris
Pencil on charcoal outlines
61 × 48.5
Z. IV, 91
M.P. 902

831
Olga au châle
Olga with a Shawl
1920
[Paris]
Pencil and charcoal
61.5 × 49
Z. IV, 113
M.P. 901

832
**Portrait d'un homme barbu accoudé à
une sellette**
*Portrait of a Bearded Man Leaning on his
Elbow against a Stand*
(from a photograph)
1920
Paris
Pencil on charcoal outlines on grey paper
48.1 × 39.1
Z. IV, 61
M.P. 912

833
**Jeune fille au chapeau les mains
croisées**
Young Girl with a Hat, Hands Crossed
[1920–1921]
Pastel and charcoal
105 × 75
Z. XXX, 262
M.P. 945

1921

834–838
Designs for the Set of
Cuadro flamenco

Sequence of Andalusian Dances
Ist performance: Théâtre de la Gaieté Lyrique, Paris, 17 May 1921

834
Feuille d'études: décor avec indications manuscrites
Various Studies: Set, with handwritten notes
Pencil
14.7 × 32
Z. IV, 22 (for the section below left); Z. XXX, 23
M.P. 1820

835
Etudes de détails d'un décor
Studies of Details of a Set
Pencil
19.5 × 26.5
Z. XXX, 27; Cooper, 254
M.P. 1742

836
Etude pour le décor: spectateurs dans une loge
Study for the Set: Spectators in a Box
Pencil
26.5 × 20
Z. IV, 247; Cooper, 300
M.P. 1822

837
**Feuille d'études: décor et spectateurs
d'une loge**
*Various Studies: Set and Spectators from a
Box*
Pencil
20 × 26
Z. XXX, 24
M.P. 1821

838
Projet de décor
Design for a Set
Gouache and pencil
23.5 × 34
Z. IV, 245; T.l.o.p.(2), 956; Cooper, 294
M.P. 1824

839
Deux mains croisées
Two Hands Crossed
17 January 1921
Paris
Pencil
21 × 27
D.a.l.: *17-1-21-*
M.P. 955

840
Deux mains croisées
Two Hands Crossed
17 January 1921
Paris
Pencil
27 × 21
D.a.l.: *17-1-21-*
M.P. 956

841
Trois baigneurs
Three Bathers
26 February 1921
Paris
Pencil
31.2 × 22
D. verso: *26-2-21-*
Z. XXX, 151
M.P. 957

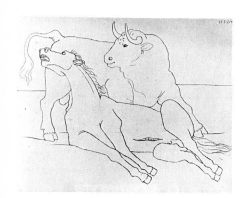

842
Taureau et cheval blessé
Bull and Wounded Horse
25 March 1921
Paris
Pencil
24.5 × 30.5
D.a.r.: *25-3-21-*
Z. IV, 250
M.P. 958

843
Femme à la baignoire
Woman in the Bath
16 April 1921
Paris
Pencil on the back of an invitation card for
the Galerie Bernheim Jeune, exhibition
Stoënesco, April
1921
16 × 12
D.a.r.: *16-4-21-*
Z. XXX, 222
M.P. 959

844
**Façade sur le jardin de la maison de
Fontainebleau**
*The House at Fontainebleau: Façade
Overlooking the Garden*
6 July 1921
Fontainebleau
Pencil
49.1 × 64.3
D.b.r.: *6-7-21-*
Z. IV, 296
M.P. 961

845
Le salon de la maison de Fontainebleau
*The Sitting-room in the House at
Fontainebleau*
5 July 1921
Fontainebleau
Pencil
49.4 × 64
D.b.r.: *5-7-21-*
Z. IV, 297; Cooper, 12
M.P. 960

846
**Le salon de Fontainebleau: Olga au
piano**
*The Sitting-room at Fontainebleau: Olga at
the Piano*
6 July 1921
Fontainebleau
Pencil
49 × 64
S.b.r.: *6-7-21-*
Z. IV, 298; Cooper, 11
M.P. 970

847
Olga donnant un biberon à Paulo
Olga Feeding Paulo with a Bottle
6 July 1921
Fontainebleau
Pencil
64.3 × 49.2
D.b.l.: *6-7-21-*
Z. IV, 290
M.P. 962

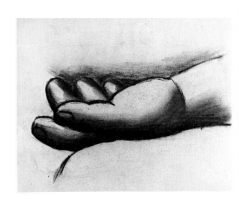

848
**Etude pour 'Trois femmes à la fontaine':
main**
*Study for 'Three Women at the Fountain':
Hand*
Summer 1921
Fontainebleau
Charcoal and red chalk, with eraser shading
24.5 × 32.1
Z. IV, 326
M.P. 967

849
**Etude pour 'Trois femmes à la fontaine':
main de la femme de gauche**
*Study for 'Three Women at the Fountain':
Hand of the Woman on the Left*
Summer 1921
Fontainebleau
Charcoal and red chalk, with eraser shading
32.1 × 24.5
Z. IV, 323
M.P. 966

850
**Etude pour 'Trois femmes à la fontaine':
main gauche de la femme de droite**
*Study for 'Three Women at the Fountain': Left
Hand of the Woman on the Right*
Summer 1921
Fontainebleau
Charcoal and red chalk, with eraser shading
24.5 × 32.1
Z. IV, 325
M.P. 968

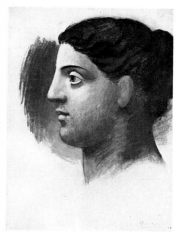

851
**Etude pour 'Trois femmes à la fontaine':
tête de la femme de droite**
*Study for 'Three Women at the Fountain':
Head of the Woman on the Right*
Summer 1921
Fontainebleau
Pastel on dark beige paper
62.6 × 47
S.b.r.: *Picasso*
Z. IV, 345
M.P. 969

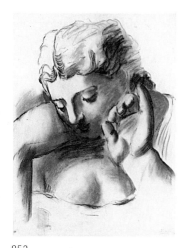

852
**Etude pour 'Trois femmes à la fontaine':
buste de la femme du centre**
*Study for 'Three Women at the Fountain':
Head and Shoulders of the Woman in the
Centre*
Summer 1921
Fontainebleau
Red chalk and charcoal
64 × 49
Z. IV, 344
M.P. 964

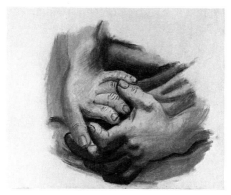

853
Etude de mains
Study of Hands
1921
Pastel and gouache
48 × 62
Z. XXX, 239
M.P. 906

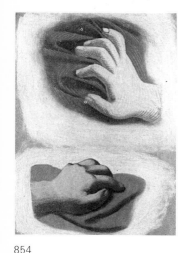

854
Etude de mains
Study of Hands
1921
Pastel on raw paper
65.2 × 50
M.P. 907

855
**Scènes de cirque: singe-écuyer, Auguste
et clown blanc dresseurs (projet pour
une timbale)**
*Circus Scenes: Monkey on Horseback, Clown
and Pierrot as Trainers (design for a
kettledrum)*
1921
Paris
Pen and ink on blue writing-paper
13.3 × 21
Z. XXX, 120
M.P. 1002

856
**Scène de cirque: clown blanc jouant de
la guitare et singe sur une boule (projet
pour une timbale)**
*Circus Scene: Pierrot Playing the Guitar and
Monkey on a Ball (design for a kettledrum)*
1921
Paris
Pen and ink on blue writing-paper
7.6 × 20.7
M.P. 1003

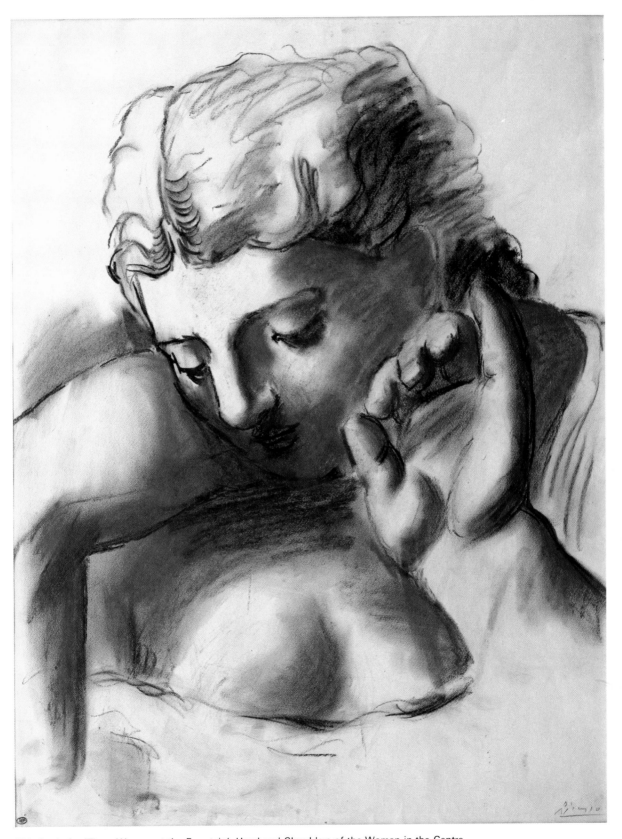

852 Study for 'Three Women at the Fountain': Head and Shoulders of the Woman in the Centre

857
Scène de cirque: clown blanc jouant de la guitare et danseuse nue (projet pour une timbale)
Circus Scene: Pierrot Playing the Guitar and Nude Dancer (design for a kettledrum)
1921
Paris
Pen and ink on blue writing-paper
7.6 × 20.7
M.P. 1004

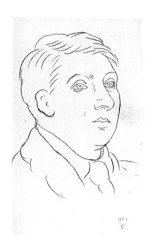

858
Portrait de Pierre Reverdy
Portrait of Pierre Reverdy
[1921]
Pencil on squared paper
16.5 × 10.5
M.P. 973(r)

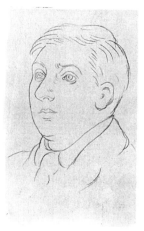

858a
Portrait de Pierre Reverdy
Portrait of Pierre Reverdy
[1921]
Pencil on squared paper
16.5 × 10.5
M.P. 973(v)

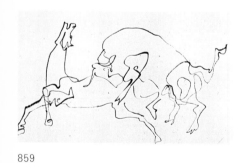

859
Cheval et taureau
Horse and Bull
[1921–1923]
Indian ink
14 × 24
M.P. 994(r)

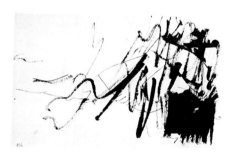

859a
Graffitis
Graffiti
[1921–1923]
Indian ink
14 × 24
M.P. 994(v)

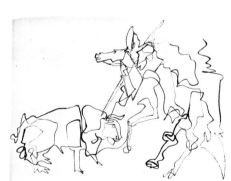

860
Picador et taureau
Picador and Bull
[1921–1923]
Indian ink
24 × 31.6
M.P. 995(r)

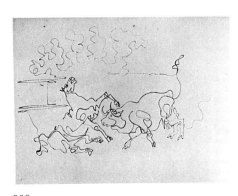

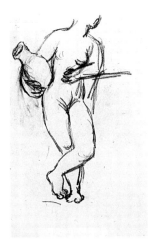

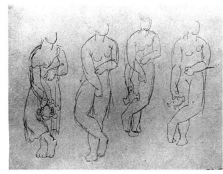

860a
Taureau étripant un cheval
Bull Disembowelling a Horse
[1921–1923]
Indian ink
24 × 31.6
M.P. 995(v)

861
Femme nue à la cruche
Female Nude with a Jug
March 1922
Paris
Pencil
18.6 × 12.2
D. verso: *mars 1922*
Z. XXX, 267
M.P. 972

862
Femme à la cruche: quatre études
Woman with a Jug: Four Studies
[March 1922]
[Paris]
Pencil
18.4 × 24.7
Z. IV, 270
M.P. 975

863
Portrait de Léon Bakst
Portrait of Leon Bakst
1 April 1922
Paris
Pencil
64 × 49
D.S.a.l.: *1-4-22/Picasso*
Z. IV, 363; Cooper, 304
M.P. 974

864
Etude pour 'Famille au bord de la mer'
Study for 'Family on the Sea-shore'
Summer 1922
Dinard
Pencil
49.2 × 64.2
S.b.r.: *Picasso*
M.P. 963

865
Acrobate
Acrobat
22 December 1922
Paris
Gouache
16.3 × 10.3
D. verso: *22 Décembre 1922*
M.P. 979

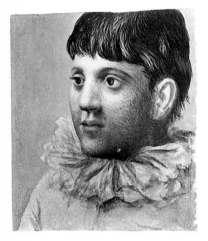

866
Portrait d'adolescent en Pierrot
Portrait of an Adolescent Dressed as a Pierrot
27 December 1922
Paris
Gouache and watercolour
11.8 × 10.5
D. verso: *27 decembre/1922*
M.P. 982

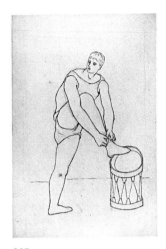

867
Acrobate le pied sur son tambour
Acrobat with his Foot on his Drum
December 1922
Paris
Ink on pencil outlines
16.4 × 11.5
D. verso in gouache: *Décembre 1922*
M.P. 976

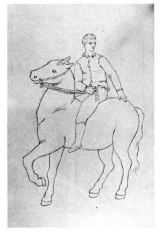

868
Acrobate à cheval
Acrobat on Horseback
December 1922
Paris
Ink on pencil outlines
18.5 × 11.2
D. verso: *Décembre 1922*
M.P 977

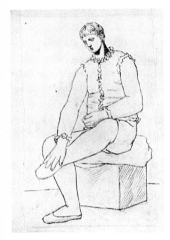

869
Acrobate au repos
Acrobat Relaxing
December 1922
Paris
Ink and pencil
16.6 × 11.4
M.P. 978

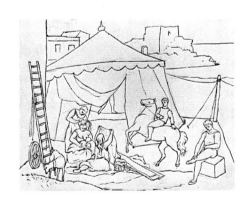

870
Cirque forain
Travelling Circus
December 1922
Paris
Ink and pencil
11.2 × 14.3
M.P. 980

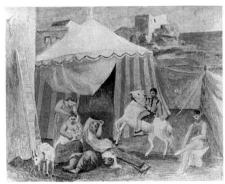

871
Cirque forain
Travelling Circus
December 1922
Paris
Gouache
11 × 14.5
M.P. 981

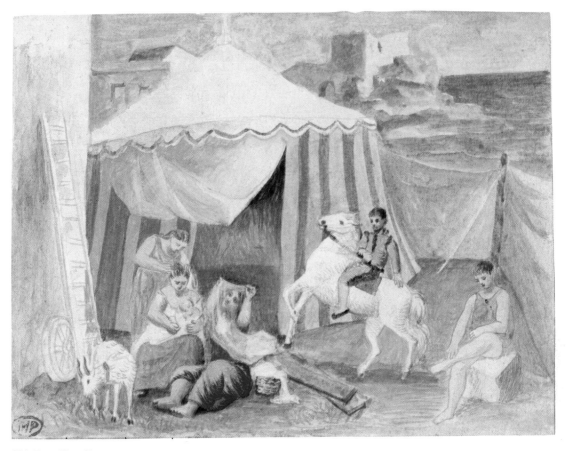

871 Travelling Circus

872
Olga et Paulo
Olga and Paulo
[1922–1923]
Pencil
11.5 × 8.4
M.P. 1007

873
BAL (projet pour un rideau pour un bal de Mardi gras chez le Comte Etienne de Beaumont)
BALL (design for a curtain for a Mardi-Gras ball given by Count Etienne de Beaumont)
Early 1923
[Paris]
Indian ink on pencil outlines
22.4 × 17.5
M.P. 1553

874
Feuille d'études: Cupidon et danse au son de la flûte de Pan
Various Studies: Cupid and Dancing to the Sound of the Pipes of Pan
4 February 1923
Paris
Pen and ink
13.2 × 20.8
D.a.r.: *4 Fevrier 1923*
M.P. 983

875
Personnages à l'antique de profil
Classical Figures in Profile
Summer 1923
Antibes
Ink on a page from the *Excelsior* newspaper, Monday 23 July 1923
33.9 × 35.5
M.P. 984

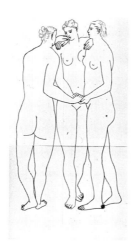

876
Trois nus
Three Nudes
Summer 1923
Antibes
Pen and Indian ink on the back of three sheets of writing-paper headed 'Hôtel du Cap d'Antibes'
47.7 × 32.1
M.P. 987

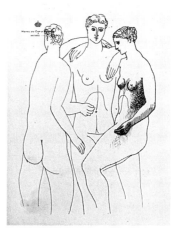

877
Trois nus
Three Nudes
Summer 1923
Antibes
Pen and Indian ink on writing-paper headed 'Hôtel du Cap d'Antibes'
27.5 × 21.6
M.P. 985

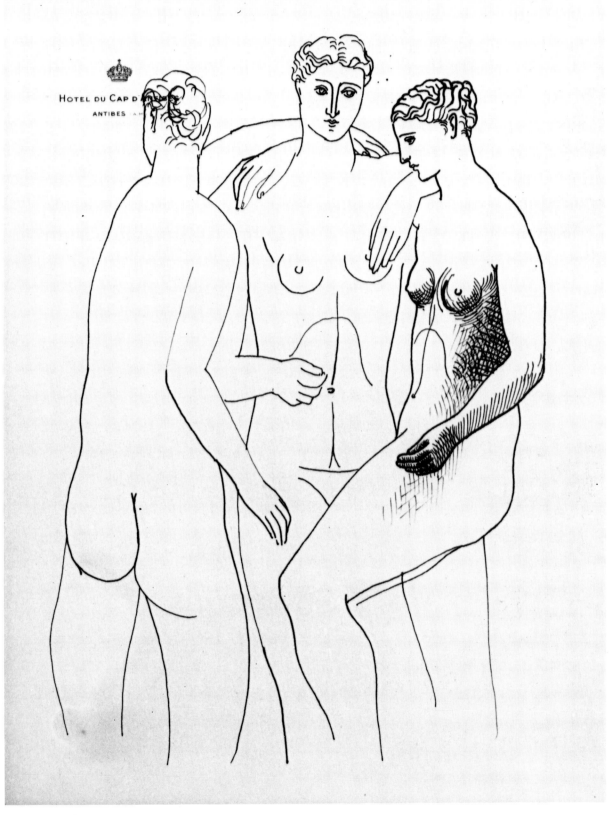

877 Three Nudes

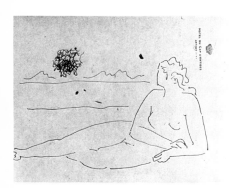

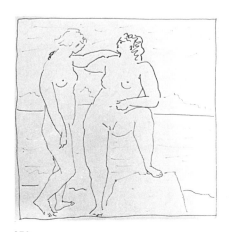

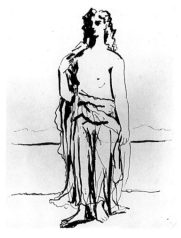

878
Nu allongé au bord de la mer
Nude Stretched Out on the Sea-shore
Summer 1923
Antibes
Pen and Indian ink on writing-paper headed
'Hôtel du Cap d'Antibes'
21 × 26.7
M.P. 986

879
Deux nus debout au bord de la mer
Two Nudes Standing on the Sea-shore
Summer 1923
Antibes
Pen and Indian ink
22.2 × 22.4
M.P. 988

880
Baigneuse drapée
Draped Bather
[Summer 1923]
[Antibes]
Pen and Indian ink
28.7 × 22.2
M.P. 989

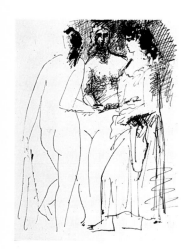

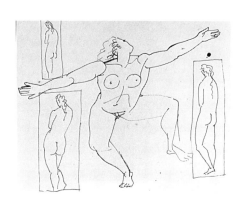

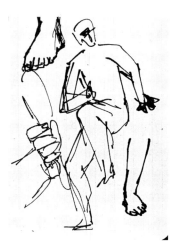

881
Trois nus
Three Nudes
[Summer 1923]
[Antibes]
Pen and Indian ink
29 × 22.5
M.P. 990

882
Etudes de nus
Studies of Nudes
[Summer 1923]
[Antibes]
Pen and Indian ink
22.4 × 28.7
M.P. 991

883
Feuille d'études: homme, main et pieds
Various Studies: Man, Hand and Feet
[Summer 1923]
[Antibes]
Pen and Indian ink on a squared sheet of
paper from a sketchbook
11.2 × 8.5
M.P. 992(r)

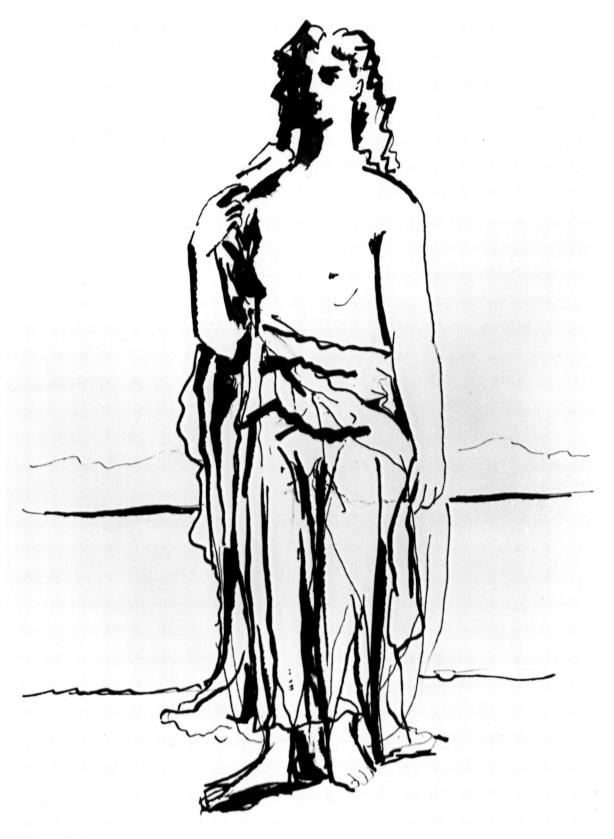

880 Draped Bather

887 Bullfight: Death of the Torero

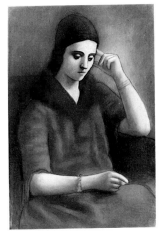

883a
Feuille d'études: homme jouant de la flûte de Pan
Various Studies: Man Playing the Pipes of Pan
[1923]
[Antibes]
Pen and Indian ink on a squared sheet of paper from a sketchbook
11.2 × 8.5
M.P. 992(v)

884
Femme et enfant
Woman and Child
1923
Indian ink and red chalk
24 × 31.2
M.P. 971

885
Olga pensive
Olga in Pensive Mood
1923
Paris
Pastel and black chalk
104 × 71
Z. V, 38; Cooper (repr. in col.), 303
M.P. 993

886
Corrida: taureau et cheval
Bullfight: Bull and Horse
1923
Pencil
24.1 × 25
Z. V, 144
M.P. 998

887
Corrida: la mort du torero
Bullfight: Death of the Torero
1923
Pencil
47.6 × 62.5
Z. V, 145; Cooper, 306
M.P. 996

888
Corrida: taureau et cheval blessé
Bullfight: Bull and Wounded Horse
[1923–1924]
Pencil on the back of an invitation card for the Galerie Briant-Robert, Stival exhibition, 26 November–15 December 1923
11.7 × 14.2
M.P. 997

1924

889–890
Designs for the Curtain for

Mercure

Ballet by Leonid Massine
Music by Erik Satie
1st performance: Théâtre de la Cigale, Paris, 18 June 1924, as part of 'Soirées de Paris'
organized by Count Etienne de Beaumont

889
Trois études
Three Studies
Pastel and pencil on beige paper
20 × 22.2
M.P. 1826

890
**Projet pour le rideau: Arlequin jouant de
la guitare et Pierrot jouant du violon**
*Design for the Curtain: Harlequin Playing the
Guitar and Pierrot Playing the Violin*
Pastel on grey paper
25 × 32
M.P. 1825

890 Design for the Curtain for 'Mercure': Harlequin Playing the Guitar and Pierrot Playing the Violin

On the Fringe of Surrealism – Boisgeloup: 1924–1936

We cannot fail to recognize the immense responsibility that Picasso assumed . . . A single failure of will-power on his part would have been sufficient for everything we are concerned with to be at least set back, if not wholly lost. But his admirable perseverance is such a precious guarantee that we have no need to call upon any other authority. Shall we ever know what awaits us at the end of this agonizing journey?

ANDRÉ BRETON[1]

Picasso's connection with the Surrealists has been much disputed. They immediately claimed him for themselves and from the very outset his works were published in their review. The artist, who had many friends among the Surrealist poets and painters, agreed to show his works in the first exhibition at the Galerie Pierre Loeb in 1925, but always refused to be categorized. As late as 1955, when reading Maurice Jardot's manuscript of the catalogue for the exhibition at the Musée des Arts Decoratifs, Picasso told Kahnweiler that there were no grounds for the claim that Surrealism had influenced his work,, although he made an exception of the drawings executed in 1933.[2]

At Juan-les-Pins during the summer of 1924, the artist filled a sketchbook with drawings that seemed to be composed of dots and lines. These have been described as 'abstract'. 'These drawings, comprising small elements not usually seen in art, create a curious spectacle in our visual associations, composed and arranged to represent now objects, now shapes; the transcendance of thought replaces lost reality,' comments Christian Zervos.[3] In *Guitare* (*Guitar*, cat. 892) we see an example of this technique. During the same summer of 1924 the bodies of the *Trois baigneuses* (*Three Bathers*, cat. 891) underwent major transformations and remodelling, as did the *Femme assise dans un fauteuil tenant un verre* (*Woman Seated in an Armchair Holding a Glass*, cat. 894). *Nature morte sur la table* (*Still-life on the Table*, cat. 893) perpetuates the theme of still-life compositions in front of a window prevailing in 1919. Stars were introduced, like those decorating the tablecloth in *Mandoline et guitare* (*Mandolin and Guitar*, fig. 3), held in the Solomon R. Guggenheim Museum, New York. *Nature morte à la tête du bélier* (*Still-life with the Head of a Ram*, cat. 898) creates a striking impact through the contrast between light and shade defined by the use of pencil. The *Etreintes* (*Embraces*, cat. 896, 897) suggest some measure of aggression, but this does not distort the figures. Picasso used a curvilinear style to depict the family scene showing Paulo playing with his rocking horse at home in the rue La Boétie (cat. 899–902). 'Undulating forms intersect and overlap a Cubist infrastructure, creating a superposition of points of vision, like a deliberately distorted stereoscope,' writes Pierre Daix.[4]

Femme dans un intérieur (*Woman in an Interior*, cat. 903) presents a study in contrasts with its vertical and horizontal lines and the priestly quality of the figure. *Le couple* (*The Couple*, cat. 905) and *Femme assise dans un fauteuil* (*Woman Seated in an Armchair*, cat. 906) display the contrast between black and white characteristic of the paintings from this period. Another drawing on the same subject, which formed an important part of Picasso's repertoire, provides us with an outstanding example of the liberties the artist took with the human form (cat. 907). The woman represented is not unlike the famous *Femme dans un fauteuil* (*Woman in an Armchair*, fig. 4) painted on 22 January 1927. She has the same elephantine feet and long arms, but here the smallness of the head contrasts with the large vagina. The same motif was used again in 1929 (cat. 918). The figure is still deformed, but in a different way, and the armchair is brought to the fore. The dislocation of the human body reaches its most extreme form in 1927, with the decapitation scenes (cat. 908, 909) heralding the painting *La femme au*

(1) A. Breton, *Surrealism and Painting*, p. 5.

(2) Cf. *Picasso. Peintures 1900–1955*, Paris, Musée des Arts Décoratifs, 1955, no. 40.

(3) C. Zervos, *Dessins de Pablo Picasso*, op. cit, p. xxvii.

(4) P. Daix, *La vie de peintre de Pablo Picasso*, p. 216.

stylet (*The Woman with a Stylet*, cat. I, 114) and the *Meurtres* (*Murders*) of 1934 (cat. 1022, 1023). During the period when Picasso was engraving the plates for *Le chef-d'œuvre inconnu* his drawings began to feature his favourite theme – the painter and his model.[5] The use of relief and the curves evident in the painting of 1926 (cat. I, 82) were replaced by a more linear style (cat. 911–913). Picasso gave the painter an amoeba-like head, similar to that of the sculpture *Tête* (*Head*, fig. 5), and devoted a whole sheet of studies to this motif (cat. 916). The composition bears a resemblance to *Peintre à la palette et au chevalet* (*Painter with Pallette and Easel*, fig. 6).

In 1927, while visiting Cannes, Picasso conceived the idea of placing a line of monuments along the Croisette. He created a series of drawings for this project – the majority are in sketchbooks – beginning in Paris during the winter and finishing in Dinard the following summer. *Baigneuses* (*Bathers*, cat. 915) forms part of that series. The artist's elaborate drawing created the moulded appearance of a colossal structure.

From 1930 onwards the reclining figure of an attractive young bather with undulating curves begins to emerge in Picasso's work (cat. 924, 956, 957, 974); this was Marie-Thérèse Walter, often shown in relaxed mood or in her sleep. She was just seventeen when Picasso met her in 1927. He kept the great love-affair secret for some time, although he could not resist writing her initials at every opportunity. We see her in an ink drawing executed in Dinard, entitled *Baigneuse au ballon* (*Bather with a Ball*, cat. 919).[6] It was Marie-Thérèse who inspired him when he was engraving the plates for Ovid's *Metamorphoses* in 1930; a study for one is held in the museum (cat. 920). The beautiful young fair-headed girl is, of course, the muse for the drawings on the theme *Le peintre et son modèle* (*The Painter and his Model*, cat. 933–938). These were produced in 1930 at Boisgeloup, the mansion near Gisors that Picasso had just purchased. The style of 1927 is no longer in evidence, and whatever the mode of expression used – simple lines or fine hatching – the people are realistically represented. The possibilty of setting up a large studio in the vast house at Boisgeloup prompted Picasso to devote himself to sculpture.[7] The image of the painter and his model was accordingly replaced by that of the sculptor and his model (cat. 940, 952). This was to be one of the motifs in the Vollard Suite. One of these drawings shows the artist at work; it is full of poetic inspiration. The other portrays him contemplating an oval-shaped face, recognizable as Marie-Thérèse from the prominent cheek-bones, full lips and the nose extending from an elongated forehead.

The *Têtes de femme* (*Heads of a Woman*, cat. 944, 945, 953–955) and the *Baigneuse allongée* (*Bather Stretched Out*, cat. 946–949) are related to the sculptures (cf. figs 7–9). A small sketch on the back of an envelope posted in December 1934 (cat. 1025) provides us with an image of *La femme au vase* (*Woman with a Vase*, fig. 12), executed in 1933. This was hung in the Spanish Pavilion at the International Exhibition in Paris, 1937.[8]

On 7 February 1930 Picasso painted a unique *Crucifixion* (fig. 1); it was done on a plywood panel and completed in one sitting. Drawings of some of the motifs done in 1929 had paved the way for the composition, which has been the subject of considerable interest to art historians. It is difficult to decipher and is open to a variety of interpretations. The painter drew inspiration from sources other than traditional Christian iconography, notably the bullfight, and autobiographical elements also lie hidden within the work. The series of crucifixions produced two years later is very different (cat. 958–965, 967–970, 972). It is based on the famous altarpiece of Issenheim in Colmar (fig. 10). Christ's leaning head and tensed hands are borrowed from this work. The theme remains the same but the specific motifs seen in the painting of 1930 are no longer in evidence. Christ alone – sometimes given an expressive face – or Christ and the two thieves are the only figures occupying the composition. There are two distinct categories of illustrations in the series. In certain drawings the sheet is not entirely covered, creating white areas which stand out from the black of the Indian ink; others show figures defined by a structure made up of delicately balanced bones. These works bear a greater resemblance to *Femme au fauteuil rouge* (*Woman in a Red Armchair*, fig. 11) than to the *Crucifixion* of 1930.

In the words of André Fermigier: 'Broadcasting the discoveries of psychoanalysis, Surealism gave Picasso a taste for exploring the world of passion, instinct and primeval eroticism.'[9] Picasso acknowledged the definition of 'Surrealist' applied to his drawings of

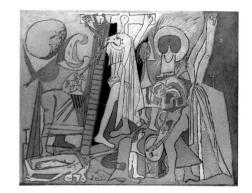

Fig. 1
La crucifixion (*The Crucifixion*), 1930
Paris, Musée Picasso

(5) Cf. M. Leiris, The Artist and his Model', *Picasso in Retrospect*, 1980, pp. 161–175.

(6) See the photograph of Marie-Thérèse on the beach at Dinard, cat. I, p. 285.

(7) Cf. cat. I, pp. 143, 144, 165–178.

(8) One of the bronzes was placed on the artist's grave at Vauvenargues; the other is now in Madrid near *Guernica*, a gift of his heirs.

(9) A. Fermigier, *Picasso*, Paris, 1969, p. 196.

1933. That same year *L'atelier* (*The Studio*, cat. 975) displayed two concurrent styles of representation. A traditional picture rests on an easel while on a table we see what Jean Leymarie calls 'the strange, functional megalith corresponding to his spiritual self'.[10] The drawings for the *Crucifixion* and the sequence *Une anatomie* (*Anatomy*, cat. 976–985) were published in the first issue of *Minotaure*. (Georges Bataille suggested the name for this review, which was edited by Tériade; Picasso drew the cover illustration.) The series[11] consists of small images drawn in pencil, featuring every possible kind of permutation; a chair is used to represent a body, two cups resting on a seat serve as breasts. These are female figures but 'each one carries within herself a powerful symbol of her male partner' (John Golding).[12] In other drawings executed that year, particularly the series of couples (cat. 989–1001), we see the culmination of the artist's distortion of various parts of the body, of differences in scale and permutations. This is also evident in the large pastel *Figure au bord de la mer* (*Figure on the Sea-shore*, cat. 1003). *Nu couché devant la fenêtre* (*Nude Reclining in front of the Window*, cat. 1019), produced early in 1934, is still in the Surrealist vein.

The boldness of the creative imagination is evident once again in 1934, with *Meutre* (*Murder*, cat. 1022, 1023); this expressed the artist's distress in the face of serious marital problems. Like the painting *La femme au stylet* (*The Woman with a Stylet*, cat. I, 114), these drawings are an interpretation of David's *Mort de Marat* (*Death of Marat*).

'If all the ways I have been along were marked on a map and joined up on a line, it might represent a minotaur.'

<div align="right">

PICASSO TO DOR DE LA SOUCHÈRE[13]

</div>

Fig. 2
La minotauromachie (*Minotauromachy*), 1935
7th state; Baer 573. Paris, Musée Picasso

The artist identified with this legendary creature, half man, half beast, born in Crete from the union between a woman and a bull and the focus of many myths and legends. He saw the minotaur as the embodiment of duality and likened it, according to Brassaï, to 'the fighting toro of Spain, charged with obscure, potentially eruptive forces'.[14] The merging of the two themes culminated in *La Minotauromachie* of 1935 (fig. 2).

The minotaur served as a recurrent motif throughout most of the thirties and is associated with Boisgeloup, where Picasso produced the majority of his important works during that period. Chief among these is the famous Vollard Suite. On his arrival in Normandy the artist interposed the drawing of a bull and a profile in a delicate pen and ink drawing (cat. 925). The same technique is used in *Sauvetage* (*The Rescue*, cat. 973). The head of the *Minotaur* (cat. 1004) is 'morphologically human and threatening', in the words of Marie-Laure Bernadac.[15] In the *Minotaure violant une femme* (*Minotaur Ravishing a Woman*, cat. 1002), we see a stamping, enraged monster hurling himself upon a female figure. Referring to another drawing in the same series, Jean Leymarie describes a 'sensual ardour unequalled even by Rubens'.[16]

Symbol of Picasso's thoughts and feelings, the blind minotaur allows himself to be guided by a small girl (cat. 1024), as seen in the engraving in the Vollard Suite. The theme of combat between a bull and a horse – embodying man and woman – was developed after a journey to Spain (cat. 1006, 1007; cat. I, 125a). These cruel scenes, so complex in iconography and significance, show Marie-Thérèse personified as a young girl holding a candle. In April 1935, there is a confrontation between the horse and the forbidding mythical creature, strangely attired in what appears to be a striped jersey. A violent, brightly coloured *Corrida* (*Bullfight*), of the type frequently depicted by Picasso at that time, ends the Boisgeloup cycle (cat. 1032).

Although the output as a whole was large and varied, one sequence stands out above all: the *Jeune fille dessinant dans un intérieur* (*Young Girl Drawing in an Interior*, cat. 1026–1030). It was produced in early February 1935 and bears direct relation to the two versions of the painting, one in Paris (fig. 13), the other in The Museum of Modern Art, New York (Zervos VIII, 263). Maurice Jardot points out that 'their distinctive feature is the mirrored reflection of an imaginary figure who represents a "seated woman drawing" depicted in the most "naturalistic" way.'[17]

(10) J. Leymarie, *Métamorphoses et unité*, Geneva, 1985, p. 55.

(11) The museum holds 27 of the 28 figures; cat. 982 has not been reproduced.

(12) J. Golding, 'Picasso and Surrealism', *Picasso in Retrospect*, p. 101.

(13) R. Dor de la Souchère, *Picasso in Antibes*, p. 54.

(14) Brassaï, *Conversations with Picasso*, p. 9.

(15) M.-L. Bernadac, *Picasso et la Méditerranée*, Athens, 1983, p. 151.

(16) J. Leymarie, *Picasso, dessins*, op. cit., p. 63.

(17) *Picasso. Peintures 1900–1955*, op. cit., no. 84.

In 1935 Picasso, tormented by the problems in his private life and troubled at the prospect of the unpleasantness surrounding his divorce, stopped painting for a few months. In the words of Jaime Sabartés:[18] 'he wanted to return to a bygone period in our lives; he neither painted nor sketched, and never went up to his studio except when it was absolutely necessary and even then he put it off from day to day.' While continuing to devote himself to engraving, the artist turned to poetry. 'Picasso's work was his life and as usual in moments of crisis his resourcefulness allowed him to discover new methods of expression,' explains Roland Penrose.[19]

Only illustrated poems appear in this catalogue.[20, 21] In 1956 Picasso showed Douglas Duncan into a room where he had been secretly keeping paintings, notably twenty-three works produced between 2 April and 2 May 1936. He allowed them to be photographed.[22] The illustrated poems (cat. 1034, 1035, 1039, 1054, 1058), together with related works from the same period, reappear in the paintings dating from that time.[23] They include fantastical heads, which look as if they have been fashioned out of wire, and curious-looking bathers.

This series also contains extremely lifelike portraits of Marie-Thérèse. The *Nu couché de profil* (*Reclining Nude in Profile*, cat. 1049) is probably a transposition of a theme Picasso held dear: *Homme contemplant une femme endormie* (*Man Gazing at a Sleeping Woman*, cat. 950). The sequence in its entirety forms a hymn of love to the artist's engaging mistress. The harmony is nonetheless disturbed by more complex autobiographical elements. Picasso departed incognito for Juan-les-Pins[24] taking Marie-Thérèse and their daughter with him. From 26 March to 14 May he tried to create a family atmosphere in the Villa Sainte-Geneviève. Paintings, drawings and poems make up an intimate – and secret – diary for this brief period.

Picasso had been overjoyed at the birth of Marie de la Concepción, known as Maya, in September 1935. He named her after his young sister, who had died when still a child. The pride and joy of her father, she appears in her cradle (cat. 1038) or in her mother's arms (cat. 1045) in two important Indian ink and tinted wash drawings depicting an interior.[25] Picasso is seen as the Minotaur, whom he unmasks: 'The stubbornness of the old man in hiding his mask opens an abyss between him and his family.' writes Sabartés.[26] This shedding of the disguise could equally be explained as a sign of rejuvenation brought about by the birth of the child. At the beginning of his stay in Juan-les-Pins Picasso had drawn (cat. 1037) and painted (fig. 14) *Minotaure emmenant une jument et son poulain dans une charrette* (*Minotaur Leading away a Mare and her Foal in a Cart*). It is not difficult to interpret the subject: the Minotaur is Picasso, an expression of tenderness on his face, taking Marie-Thérèse and Maya away. In the painting a picture forms part of the cart-load; this is an allusion to the fact that he would soon have to move and leave Boisgeloup to Olga, a prospect he did not enjoy. Three large, compelling works in gouache produced during the same stay, on 6, 8, 10 May, also portray the Minotaur. The first, *Minotaure et jument morte devant une grotte face à une jeune fille au voile* (*Minotaure and Dead Mare in front of a Cave opposite a Young Girl with a Veil*, cat. 1050), shows the same white mare as depicted in the cart seemingly in the throes of death, the Minotaur's protective arm around her. He appears to have pulled her out of the dark cave, from which two pale hands emerge in a gesture of distress. Opposite them, in the light, stands a veiled young girl garlanded with flowers. Some elements are open to easy interpretation; others relating to Picasso's personal mythology are more complex. This is also the case with the two following scenes (cat. 1051, 1052), both reminiscent of bullfights. The Minotaur is no longer a protector, but wounded and begging for help. In the first drawing his gaze is turned to a young girl in a boat: in the second the woman leans over the stabbed Minotaur as he is trampled by a horse.

On returning to Paris the artist developed his series of gouache compositions on the theme of the Minotaur. Asked to design a drop-curtain for Romain Rolland's *Quatorze Juillet*, Picasso chose a work he had recently finished: *La dépouille du Minotaure en costume d'Arlequin* (*The Remains of the Minotaur Dressed as Harlequin*, cat. 1053).[27] It combined the two heroes with whom Picasso identified. The collection in the Musée Picasso also includes an important work in gouache entitled *Faune, cheval et oiseau* (*Faun, Horse and Bird*, cat. 1057).

A large pencil drawing takes as its theme the Fourteenth of July and the Storming of the Bastille (cat. 1055). The arms of the women in the foreground herald *Guernica*. The

(18) J. Sabartés, *Picasso: an Intimate Portrait*, p. 105.

(19) R. Penrose, *Picasso*, p. 272.

(20) *Sur le dos de l'immense tranche de melon ardent* (*On the Back of an Enormous Slice of Burning Melon*, cat. 1033) is an exception. The style of writing and the use of coloured crayons bring the poem closer to a drawing.

(21) These will be studied, with the poems, in *Les manuscrits de Picasso* by Marie-Laure Bernadac and Christine Piot, due to be published in 1988.

(22) D. D. Duncan, *Picasso's Picassos*, p. 61.

(23) Several have come to the museum: see cat. I, pp. 84–88.

(24) See J. Sabartés, *Picasso: An Intimate Portrait*, pp. 127, 129.

(25) These and the following works, produced during the same period, are not entirely unknown; some appear in the Zervos catalogue, and have been previously published or exhibited.

(26) J. Sabartés, *Picasso: an Intimate Portrait*, p. 130.

(27) The enlargement was carried out by Luis Fernandez. The artist presented the curtain to the Musée des Augustins in Toulouse.

deformities seen in *La femme au piano* (*Woman at the Piano*, cat. 1059) are certainly tinged with personal or political significance. The woman has the swollen body of the figure in the Michelin advertisements; the piano displays huge gaping jaws. Do these allude to Olga or to Franco?

Principal Related Works

Cat. 893:
Mandoline et guitare (*Mandolin and Guitar*), 1924. New York, The Solomon R. Guggenheim Museum. Z. V, 220. (Fig. 3)

Cat. 907:
Femmes dans un fauteuil (*Woman in an Armchair*), 1927. New York, private collection. Z. VII, 79. (Fig. 4)

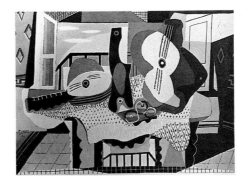

Fig. 3

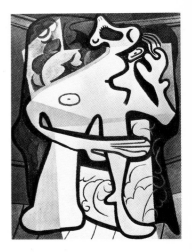

Fig. 4

Cat. 911–913
Tête (*Head*), 1928. Paris, Musée Picasso, cat.
I, 304; S. 66 A. (Fig. 5)
Peintre à la palette et au chevalet (*Painter
with Palette and Easel*), 1928. Paris, Musée
Picasso, cat. I, 90. (Fig. 6)

Cat. 944–945:
Tête de femme (*Head of a Woman*), 1931.
Paris, Musée Picasso, cat. I, 341; S. 133 (II).
(Fig. 7)

Cat. 946–949:
Baigneuse allongée (*Stretched-out Bather*),
1931. Paris, Musée Picasso, cat. I, 331; S.
109 (II). (Fig. 8)

Cat. 953–955:
Tête de femme (*Head of a Woman*), 1931.
Paris, Musée Picasso, cat. I, 337; S. 131 (II).
(Fig. 9)

Cat. 958–965, 967–970, 972:
Mathias Grünewald, Altarpiece of Issenheim,
Colmar, Musée d'Unterlinden (photo O.
Zimmerman). (Fig. 10)
Femme au fauteuil rouge (*Woman in a Red
Armchair*), 1932. Paris, Musée Picasso, cat. I,
116; Z. VII, 330. (Fig. 11)

Fig. 5

Fig. 6

Fig. 7

Fig. 8

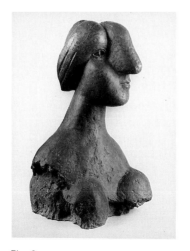

Fig. 9

Fig. 10

Cat. 1022–1023:
David, *La mort de Marat* (*The Death of Marat*). Brussels, Musées Royaux des Beaux-Arts.

Cat. 1025:
La femme au vase (*Woman with a Vase*), 1933. Vauvenargues (photo A. Gomès). (Fig. 12)

Cat. 1026–1030:
Femme dans un intérieur dit 'La Muse' (*Woman in an Interior, Known as 'The Muse'*), 1937. Paris, Musée National d'Art Moderne, gift of the artist. Z. VIII, 256. (Fig. 13)

Cat. 1037:
Minotaure à la carriole (*Minotaur with a Cart*), 1936, private collection. Duncan, p. 86. (Fig. 14)

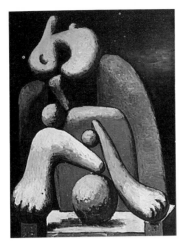

Fig. 11

Fig. 12

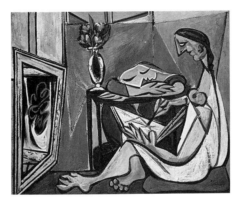

Fig. 13

Fig. 14

891
Trois baigneuses
Three Bathers
23 July 1924
Juan-les-Pins
Purple ink
15.6 × 20.1
D.b.r.: *Juan/Les Pins/23-7-24*
M.P. 999

892
Guitare
Guitar
1924
Juan-les-Pins
Oil, pen and Indian ink
30.2 × 28.8
D.b.r.: *Juan-les-Pins, 1924*
M.P. 1000

893
Nature morte sur la table
Still-life on the Table
1924
[Paris–Juan-les-Pins]
15.8 × 20.2
Oil and pencil on a sheet folded in four
Z. V, 218
M.P. 1001

894
Femme assise dans un fauteuil tenant un verre
Woman Seated in an Armchair Holding a Glass
1924
Pencil on letter-card
11.5 × 18.8
M.P. 1005(r)

894a
Baigneuse
Bather
1924
Pencil on letter-card
18.8 × 11.5
M.P. 1005(v)

895
Baigneuse
Bather
1924
Pencil and pastel on dark brown paper
26.5 × 20.5
M.P. 1006

891 Three Bathers

896
Etreinte
Embrace
[1925]
Pencil
10.9 × 11.5
M.P. 1008

897
Etreinte
Embrace
[1925]
Pencil
25.5 × 35.6
Z. V, 400
M.P. 1009

898
Nature morte à la tête du bélier
Still-life with the Head of a Ram
[1925]
Pencil
23.1 × 28.9
M.P. 1010

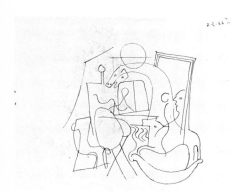

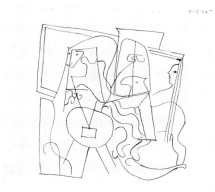

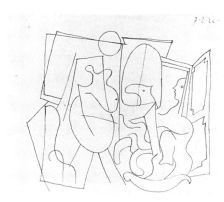

899
Composition au cheval à bascule
Composition with a Rocking Horse
7 February 1926
Paris
Indian ink on pencil outlines
40.6 × 51
D.a.r.: *7-2-26-*
Inscr.a.l.: *1*
M.P. 1011

900
Composition au cheval à bascule
Composition with a Rocking Horse
7 February 1926
Paris
Indian ink on pencil outlines
40.6 × 51
D.a.r.: *7-2-26-*
Inscr.a.l.: *2*
M.P. 1012

901
Composition au cheval à bascule
Composition with a Rocking Horse
7 February 1926
Paris
Indian ink on pencil outlines
41 × 51
D.a.r.: *7-2-26-*
Inscr.a.l.: *3*
M.P. 1013

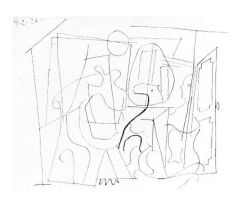

902
Composition au cheval à bascule
Composition with a Rocking Horse
7 February 1926
Paris
Indian ink on pencil outlines
40.6 × 51
D.a.l.: *7-2-26-*
Inscr.a.l.: *4*
M.P. 1014

903
Femme dans un intérieur
Woman in an Interior
September 1926
Juan-les-Pins
Indian ink
29.1 × 38.8
D. verso: *Juan les Pins Septembre 1926*
Z. VII, 34
M.P. 1017

904
Figure
Face
[1926]
Pencil
14.9 × 9.4
M.P. 1015

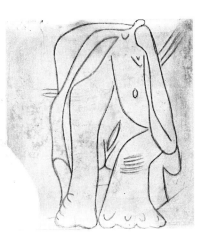

905
Couple
Couple
[1926]
Indian ink
27.7 × 20.9
M.P. 1016

906
Femme assise dans un fauteuil
Woman Seated in an Armchair
[1926–1927]
Indian ink on paper edged with blue
laminated cloth
29 × 23.1
M.P. 1018

907
Femme assise dans un fauteuil
Woman Seated in an Armchair
[January] 1927
Paris
Pencil on tracing paper
26 × 24.7
M.P. 1022

908
Scène de décollation
Decapitation Scene
Winter–spring 1927
Paris
Indian ink
28 × 22.5
M.P. 1020

909
Scène de décollation
Decapitation Scene
Winter–spring 1927
Paris
Pen and Indian ink
27.7 × 22.5
M.P. 1021

910
Joueurs de ballon
Ball Players
21 November 1927
Paris
Indian ink
23.5 × 34.2
D.b.r.: *21-11-27*
Z. VII, 114
M.P. 1019

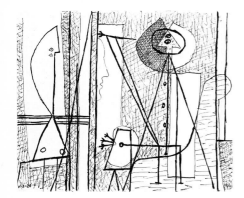

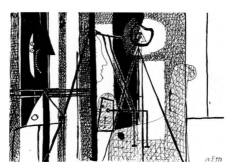

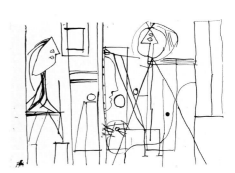

911
Le peintre et son modèle
The Painter and his Model
11 February 1928
Paris
Pen and Indian ink
21.1 × 27.1
D.b.l.: *11-2-28*
M.P. 1026

912
Le peintre et son modèle
The Painter and his Model
12 February 1928
Paris
Indian ink
23.6 × 34
D.b.r.: *12.F.928*; verso: *Février 1928*
M.P. 1027

913
Le peintre et son modèle
The Painter and his Model
February 1928
[Paris]
Indian ink
23.5 × 34
D.b.l.: *F 28*
M.P. 1029

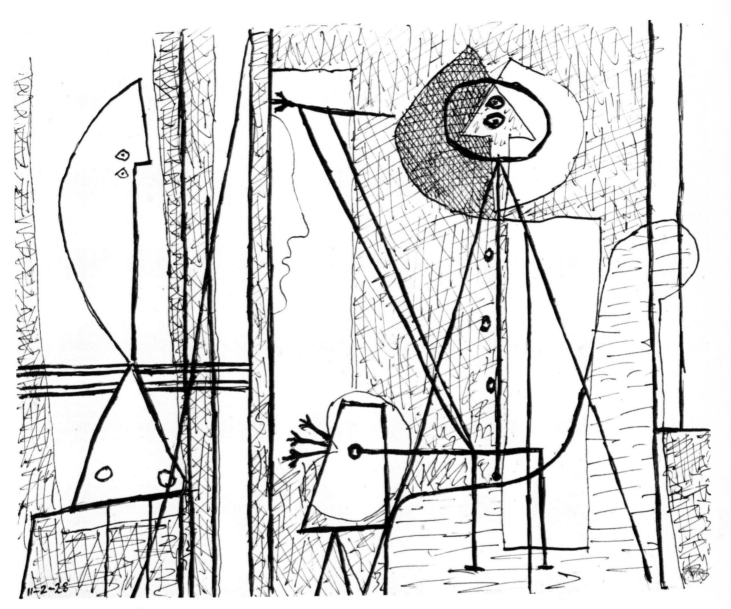

911 The Painter and his Model

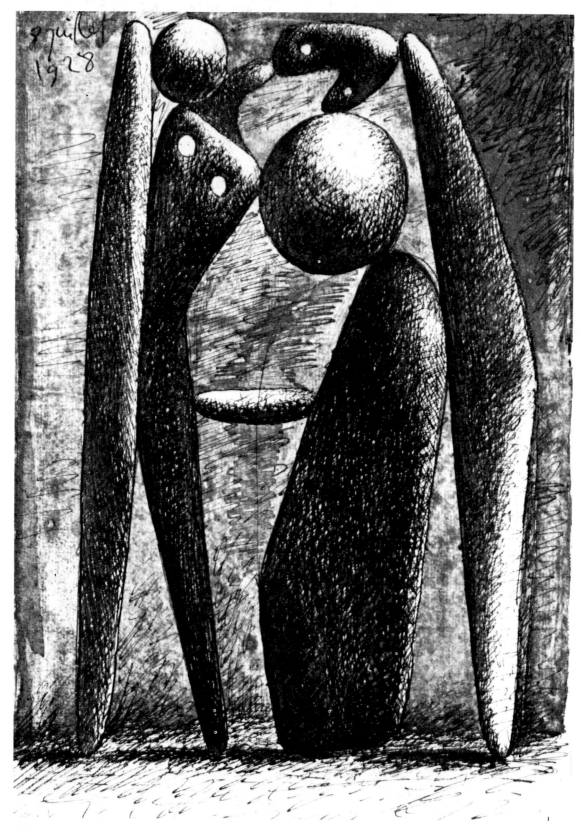

915 Bathers (design for a monument)

914
Baigneuse
Bather
22 February 1928
[Paris]
Pen and Indian ink
30.6 × 31.2
D.a.r.: *22 F. 928*
M.P. 1028

915
Baigneuses (project pour un monument)
Bathers (design for a monument)
8 July 1928
Dinard
Pen, Indian ink and tinted wash on a sheet
from a sketchbook
30.2 × 22
D.a.l.: *8 Juillet/1928*
Z. VII, 199
M.P. 1030

916
Etudes pour 'Tête'
Studies for 'Head'
[1928]
Pen and Indian ink
37 × 27
M.P. 1024(r)

916a
Cavalier
Horseman
[1928]
Pen and Indian ink
37 × 27
M.P. 1024(v)

917
Feuille d'études: femmes debout
Various Studies: Standing Women
[1928]
Pencil
34.2 × 24.2
Inscr.a.r. in pencil: *71*
M.P. 1025

918
Femme dans un fauteuil
Woman in an Armchair
29 January 1929
Paris
Pencil
27.8 × 20.8
D.b.l.: *29 janvier 1929*
Z. VII, 241
M.P. 1031

919
Baigneuse au ballon
Bather with a Ball
18 September 1929
Dinard
Pen and brown ink on a sheet folded in four
16.5 × 10.5
D.c.r.: *Dinard/18 Septembre/XXIX*
M.P. 1032

920
Etude pour 'Les métamorphoses d'Ovide', Livre XI: la mort d'Orphée
Study for Ovid's 'Metamorphoses', Book XI: The Death of Orpheus
1 September 1930
Juan-les-Pins
Pen and ink on blue writing-paper
27 × 21
D.a.l.: *1er Septembre 1930/Juan les Pins*
M.P. 1033(r)

920a
Maison
House
1930
Juan-les-Pins
Pen and ink on blue writing-paper
21 × 27
M.P. 1033(v)

921
Composition aux deux figures
Composition with Two Figures
5 September 1930
Juan-les-Pins
Indian ink on a photograph of Saturn, Mars and Venus
14 × 8.8
D. verso: *Juan les Pins/le 5 Septembre/1930*
M.P. 1035

922
Cheval couché
Horse Lying Down
5 September 1930
Juan-les-Pins
Indian ink on a photograph of the moon
8.8 × 14
D. verso: *Juan les Pins –/le 5 Septembre 1930*
M.P. 1034

923
Profils féminins sur main découpée
Female Profiles on a Cut-out Hand
6 September 1930
Juan-les-Pins
Indian ink on newspaper
15 × 17.5
D. verso in pencil on the little finger: *Juan les Pins/6 Septembre/1930*
M.P. 1036

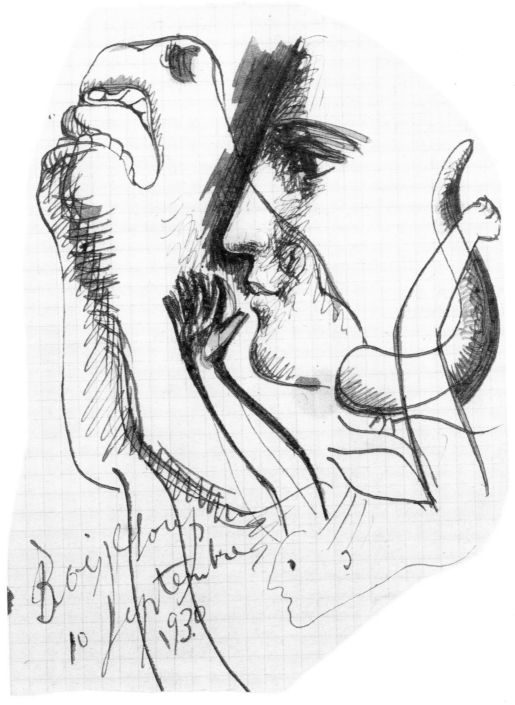

925 Composition: Woman and Bull

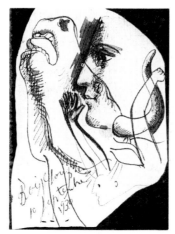

924
Baigneuse au parasol
Bather with a Parasol
[Early September] 1930
[Juan-les-Pins]
Pencil on an opened out envelope
23.5 × 28.3
Z. VIII, 186
M.P. 1068

925
Composition: femme et taureau
Composition: Woman and Bull
10 September 1930
Boisgeloup
Pen and blue ink on a squared sheet, cut out
to an irregular shape
18.2 × 13.5
D.b.l.: *Boisgeloup/10 Septembre/1930*
M.P. 1037

926
Cercles et signes, I
Circles and Signs, I
29 October 1930
[Boisgeloup]
Indian ink on the back of a page from the
catalogue for La Maison du Trousseau
35.1 × 21.9
D.c.r.: *XXIX. Octobre M.CM.XXX*
Inscr.c.r.: *(I)*
M.P. 1038

927
Cercles et signes, II
Circles and Signs, II
[Boisgeloup]
Indian ink on the back of a page from the
catalogue for La Maison du Trousseau
17.5 × 22
D.b.r.: *XXIX Octobre M.CM.XXX*
Inscr.c.b.: *(II)*
M.P. 1039

928
Cercles et signes, III
Circles and Signs, III
29 October 1930
[Boisgeloup]
Indian ink on the back of a page from the
catalogue for la Maison du Trousseau
17.5 × 22
D.b.r.: *XXIX Octobre M.CM.XXX*
Inscr.b.l.: *(III)*
M.P. 1040

929
Cercles et signes. IV
Circles and Signs, IV
29 October 1930
[Boisgeloup]
Indian ink on the back of a page from the
catalogue for La Maison du Trousseau
17.6 × 22
D.b.r.: *XXIX Octobre M.CM.XXX*
Inscr.c.l.: *(IV)*
M.P. 1041

930
Cercles et signes, V
Circles and Signs, V
29 October 1930
[Boisgeloup]
Indian ink on the back of a catalogue for La
Maison du Trousseau
18.2 × 23
D.b.r.: *XXIX Octobre M.CM.XXX*
Inscr.c.b.: *(V)*
M.P. 1042

931
Cercles et signes, VI
Circles and Signs, VI
29 October 1930
[Boisgeloup]
Indian ink on the back of a page from a
catalogue for La Maison du Trousseau
18.4 × 23
D.b.r.: *XXIX. Octobre M.CM.XXX.*
Inscr.c.l.: *(VI)*
M.P. 1043

932
Constellations
Constellations
29 October 1930
[Boisgeloup]
Indian ink on the back of a page from a
catalogue for La Maison du Trousseau
17.5 × 21.9
D.b.r.: *XXIX Octobre/M.CM.XXX*
M.P. 1044

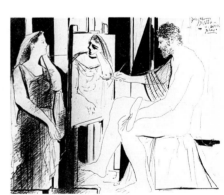

933
Le peintre et son modèle
The Painter and his Model
31 October 1930
Boisgeloup
Pen and Indian ink
23.1 × 28.9
S.D.b.r.: *Picasso/Boisgeloup 31 Octobre*
M.CM.XXX
M.P. 1045

934
Le peintre et son modèle devant le
tableau
The Painter and his Model in front of the
Picture
31 October 1930
Boisgeloup
Pen and Indian ink
23.1 × 28.8
D.S.c.b.: *31. Octobre XXX à Boisgeloup*
Picasso
M.P. 1046

935
Le peintre et son modèle devant le
tableau
The Painter and his Model in front of the
Picture
31 October 1930
Boisgeloup
Pen and Indian ink
23.1 × 28.8
D.S.a.r.: *Boisgeloup/31 octobre M.CM.XXX./*
Picasso
M.P. 1049

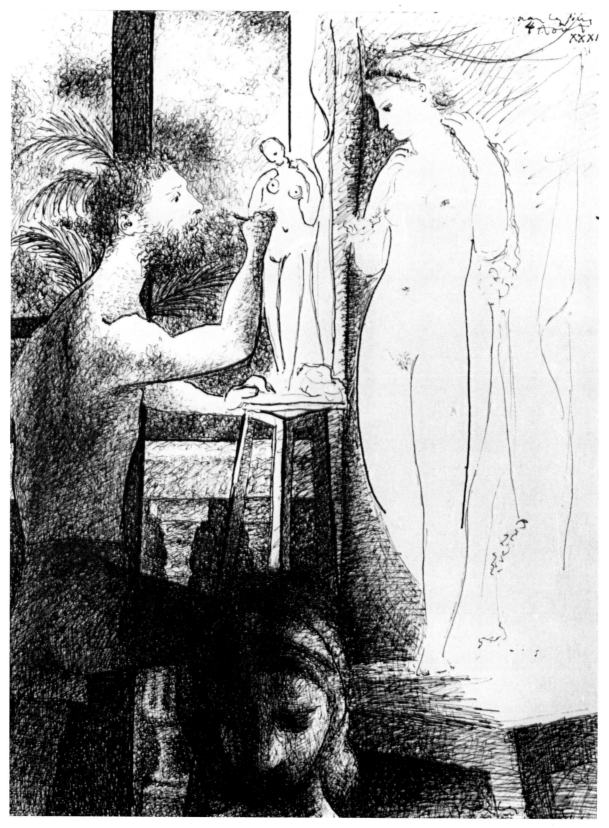

940 The Sculptor and·his Model

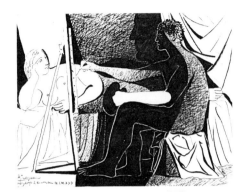

936
Le peintre et son modèle
The Painter and his Model
2 November 1930
Boisgeloup
Indian ink on a pad of watercolour paper
23.1 × 29
S.D.b.l.: *Picasso/Boisgeloup 2 Novembre*
M.CM.XXX
M.P. 1050

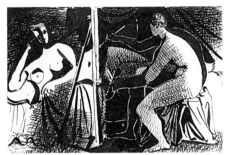

937
Le peintre et son modèle
The Painter and his Model
9 November 1930
Boisgeloup
Pen and Indian ink on cardboard
12.4 × 18.5
D.b.l. and verso: *Boisgeloup/9 Novembre/*
M.CM.XXX
M.P. 1047

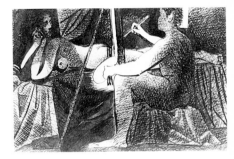

938
Le peintre et son modèle
The Painter and his Model
9 November 1930
Boisgeloup
Pen and Indian ink on cardboard
12.1 × 18.5
D. verso: *Boisgeloup/9 novembre M.CM.XXX*
M.P. 1048

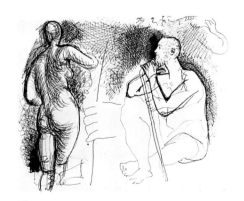

939
Le sculpteur et son modèle
The Sculptor and his Model
2 August 1931
[Juan-les-Pins]
Pen and Indian ink
25.6 × 32.6
D.a.r.: *2 Août XXXI*
M.P. 1051

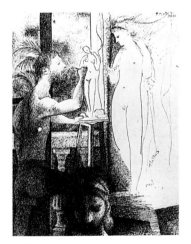

940
Le sculpteur et son modèle
The Sculptor and his Model
4 August 1931
Juan-les-Pins
Pen and Indian ink
32.4 × 25.5
D.a.r.: *Juan les Pins/4 Août/XXXI*; verso: *7/7*
Juan les Pins/4 Août XXXI
X. VII, 351
M.P. 1052

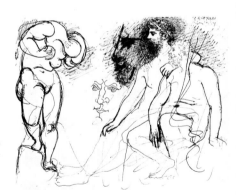

941
L'atelier du sculpteur
The Sculptor's Studio
8 August 1931
Juan-les-Pins
Pen and Indian ink
25.8 × 32.6
D.a.r.: *8 Août XXXI/ Juan les Pins*
M.P. 1053

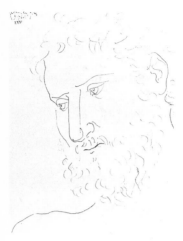

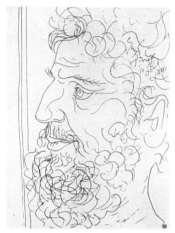

942
Le sculpteur
The Sculptor
9 August 1931
Juan-les-Pins
Pen and ink
32.6 × 25.7
D.a.l.: *Juan les Pins/9 Août/XXXI*
Inscr. verso in pencil: *5/9*
M.P. 1054

943
Le sculpteur
The Sculptor
10 August 1931
Juan-les-Pins
Pen and Indian ink
32.5 × 25.5
D.a.r.: *Juan les Pins/10 Août/XXXI*
Inscr. verso in pencil: *4*
M.P. 1055

944
Tête de femme
Head of a Woman
11 August 1931
Juan-les-Pins
Indian ink and tinted wash
33 × 25.5
D.b.r.: *Juan les Pins/11 Août XXXI*
M.P. 1056

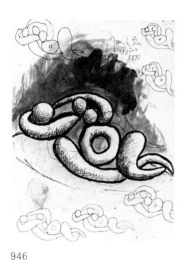

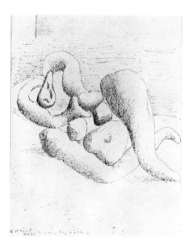

945
Tête de femme
Head of a Woman
13 August 1931
Juan-les-Pins
Pen, Indian ink and tinted wash
32.5 × 25.1
D.a.r.: *Juan les Pins/13 Août XXXI*
M.P. 1057

946
Baigneuse allongée
Bather Stretched Out
13 August 1931
Juan-les-Pins
Pen, Indian ink and tinted wash
32.5 × 25.5
D.a.r.: *Juan les Pins/13 Août/XXXI*
M.P. 1058

947
Baigneuse allongée
Bather Stretched Out
16 August 1931
Juan-les-Pins
Pen and Indian ink
32.7 × 26
D.b.l.: *16 Août/XXXI Juan les Pins*
Inscr. verso in pencil: *1/3*
M.P. 1061

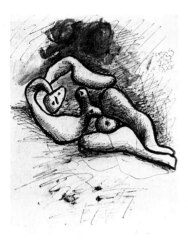

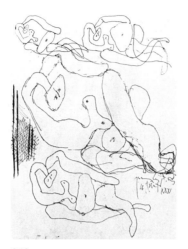

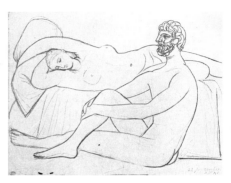

948
Baigneuse allongée
Bather Stretched Out
16 August 1931
Juan-les-Pins
Indian ink and tinted wash
32.6 × 26
D.a.r.: *Juan les/Pins/16 Août/XXXI*
Inscr. verso in pencil: *2/3*
M.P. 1060

949
Baigneuse allongée
Bather Stretched Out
16 August 1931
Juan-les-Pins
Pen and Indian ink
32.8 × 25.6
D.b.r.: *Juan-les-Pins/16 Août/XXXI*
Inscr. verso in pencil: *3/3*
M.P. 1059

950
Femme endormie et homme assis
Sleeping Woman and Seated Man
22 September 1931
[Boisgeloup–Paris]
Pencil
26 × 35
D.b.r.: *22 Septembre/XXXI*
Z. VII, 348
M.P. 1062

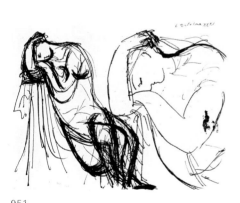

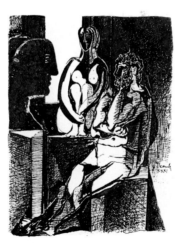

951
Femme endormie
Sleeping Woman
6 October 1931
[Boisgeloup–Paris]
Indian ink
25.2 × 33.1
D.a.r.: *6 Octobre XXXI*
M.P. 1063

952
L'atelier du sculpteur
The Sculptor's Studio
4 December 1931
[Boisgeloup–Paris]
Pen and Indian ink
33 × 26
D.b.r.: *4 Decembre/XXXI*
Z. VII, 352
M.P. 1064

953
Tête de femme de profil
Head of a Woman in Profile
5 December 1931
[Boisgeloup–Paris]
Pen and Indian ink
32.5 × 25.5
D.b.l.: *5 decembre XXXI*
M.P. 1066

954
Tête de femme de profil
Head of a Woman in Profile
5 December 1931
[Boisgeloup–Paris]
Pen and Indian ink
32.7 × 25.5
D.b.l.: *5 Decembre XXXI*
M.P. 1067

955
Tête de femme de profil
Head of a Woman in Profile
5 December 1931
[Boisgeloup–Paris]
Indian ink
33 × 25.9
D.b.l.: *5 Decembre/XXXI*
M.P. 1065

956
Femme étendue au soleil sur la plage
Woman Stretched Out in the Sun on the Beach
25 March 1932
[Boisgeloup]
Oil and charcoal on tracing paper
24.6 × 35.4
D.a.l.: *25 mars XXXII*
Z. VII, 356
M.P. 1069

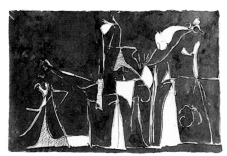

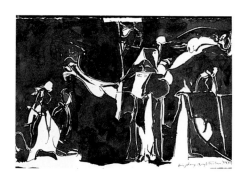

957
Nu couché
Reclining Nude
19 June 1932
Boisgeloup
Oil on an opened out envelope
26.5 × 31.5
D.b.r.: *Boisgeloup 19 juin XXXII*
Z. VII, 386
M.P. 1070

958
La Crucifixion
The Crucifixion
17 September 1932
Boisgeloup
Indian ink
34 × 51
D.b.l.: *Boisgeloup/17 septembre XXXII*
Z. VIII, 51
M.P. 1071

959
La Crucifixion
The Crucifixion
17 September 1932
Boisgeloup
Indian ink
34 × 51
D.b.r.: *Boisgeloup 17 septembre XXXII.*
Z. VIII, 52
M.P. 1072

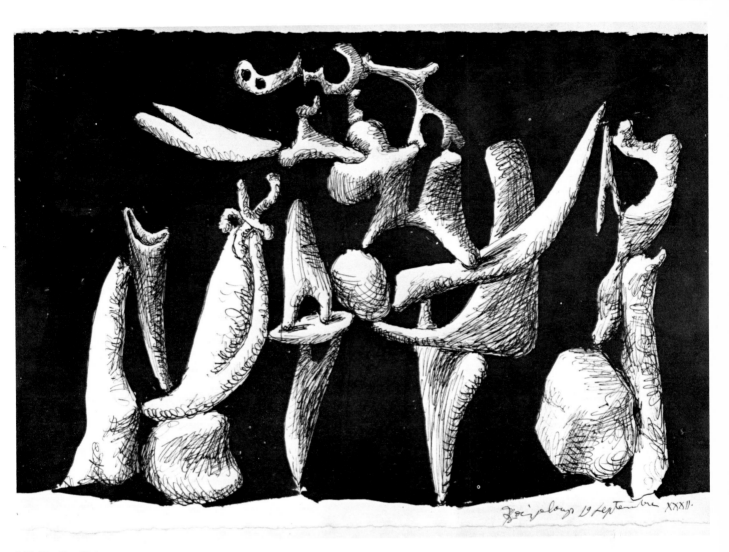

961 The Crucifixion

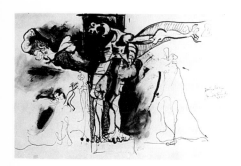

960
La Crucifixion
The Crucifixion
17 September 1932
Boisgeloup
Indian ink with rubbing
34 × 51
D.c.r.: *Boisgeloup/17 Septembre/XXXII.*
Z. VIII, 49
M.P. 1073

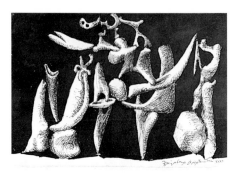

961
La Crucifixion
The Crucifixion
19 September 1932
Boisgeloup
Indian ink
34 × 51
D.b.r.: *Boisgeloup 19 septembre XXXII.*
M.P. 1074

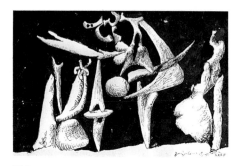

962
La Crucifixion
The Crucifixion
19 September 1932
Boisgeloup
Indian ink
34.5 × 51.2
D.b.r.: *Boisgeloup 19 septembre/XXXII.*
Z. VIII, 55
M.P. 1075

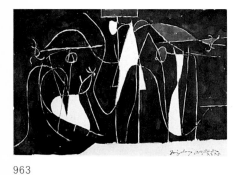

963
La Crucifixion
The Crucifixion
19 September 1932
Boisgeloup
Indian ink
34.5 × 51
D.b.r.: *Boisgeloup 19 septembre/XXXII.*
M.P. 1076

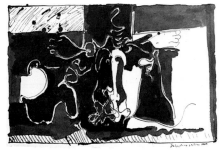

964
La Crucifixion
The Crucifixion
4 October 1932
Boisgeloup
Indian ink
34 × 51
D.b.r.: *Boisgeloup 4 Octobre XXXII.*
Z. VIII, 56
M.P. 1078

965
La Crucifixion
The Crucifixion
4 October 1932
Boisgeloup
Indian ink
34 × 51
D.b.r.: *Boisgeloup 4 octobre XXXII.*
Z. VIII, 50
M.P. 1079

966
Deux femmes nues dont l'une jouant de la diaule
Two Nude Women, One Playing the Double Flute
4 October 1932
Boisgeloup
Oil on Indian ink drawing
34.2 × 51.1
D.b.l.: *Boisgeloup 4 octobre XXXII.*
Z. VIII, 43
M.P. 1077

967
La Crucifixion
The Crucifixion
7 October 1932
Boisgeloup
Pen and Indian ink
34 × 51
D.b.r.: *Boisgeloup 7 octobre XXXII.*
M.P. 1080

968
La Crucifixion
The Crucifixion
7 October 1932
Boisgeloup
Pen and Indian ink
34 × 51
D.b.r.: *Boisgeloup 7 octobre/XXXII.*
Z. VIII, 53
M.P. 1081

969
La Crucifixion
The Crucifixion
7 October 1932
Boisgeloup
Pen and Indian ink
34 × 51
D.b.r.: *Boisgeloup 7 Octobre XXXII.*
M.P. 1082

970
La Crucifixion: études de détails
The Crucifixion: Studies of Details
7 October 1932
Boisgeloup
Pen and Indian ink
34 × 51
D.b.r.: *Boisgeloup 7 octobre/XXXII.*
M.P. 1083

971
Joueur de flûte et nu allongé
Flute Player and Nude Stretched Out
8 October 1932
Boisgeloup
Pencil on the inside of an envelope
25.2 × 37.2
D.b.r.: *Boisgeloup 8 Octobre XXXII.*
Z. VIII, 38
M.P. 1084

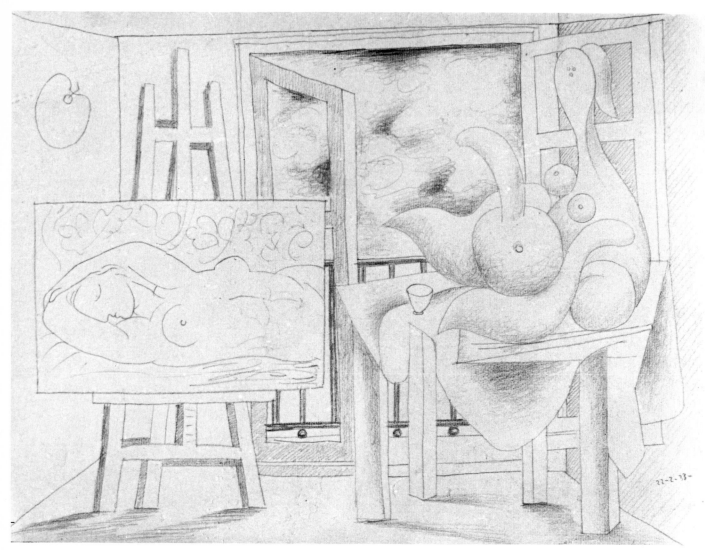

975 **The Studio**

972
La Crucifixion
The Crucifixion
21 October 1932
Paris
Pen and Indian ink
25.5 × 33
D.b.r.: *Paris 21 Octobre XXXII.*
Z. VIII, 54
M.P. 1085

973
Le sauvetage
The Rescue
December 1932
Paris
Pencil on card
11.5 × 16
D. verso: *PARis Decembre XXXII*
Z. VIII, 65
M.P. 1086(r)

973a
Silhouettes
Outline Sketches
December 1932
Paris
Pencil on card
11.5 × 16
D.a.l.: *PARis Decembre XXXII.*
M.P. 1086(v)

974
Nu allongé
Nude Stretched Out
[Spring–summer 1932]
Charcoal and coloured crayon on tissue paper
24.5 × 35.4
Z. VIII, 60
M.P. 1023

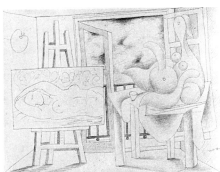

975
L'atelier
The Studio
22 February 1933
[Paris–Boisgeloup]
Pencil
26.2 × 34.3
D.b.r.: *22-2-33-*
Z. VIII, 92
M.P. 1088

976
Une Anatomie: trois femmes
Anatomy: Three Women
25 February 1933
[Paris]
Pencil
20 × 27
D.b.r.: *25-2-33-*
Inscr. verso: *II*
M.P. 1090

977
Une Anatomie: trois femmes
Anatomy: Three Women
26 February 1933
[Paris]
Pencil
20 × 27.2
D.a.r.: *26-2-33-*
Inscr. verso: *III*
M.P. 1091

978
Une Anatomie: trois femmes
Anatomy: Three Women
26 February 1933
[Paris]
Pencil
19.8 × 27.2
D.a.r.: *26-2-33-*
Inscr. verso: *IV*
M.P. 1092

979
Une Anatomie: trois femmes
Anatomy: Three Women
27 February 1933
[Paris]
Pencil
20 × 27
D.a.r.: *27-2-33-*
Inscr. verso: *V*
M.P. 1093

980
Une Anatomie: trois femmes
Anatomy: Three Women
27 February 1933
[Paris]
Pencil
20 × 27.1
D.a.r.: *27-2-33-*
Inscr. verso: *VI*
M.P. 1094

981
Une Anatomie: trois femmes
Anatomy: Three Women
27 February 1933
[Paris]
Pencil
19.8 × 27.4
D.a.r.: *27-2-33-*
Inscr. verso: *VII*
M.P. 1095

982
Une Anatomie: femme assise
Anatomy: Seated Woman
28 February 1933
[Paris]
Pencil
20 × 27
D.b.l.: *28.2.33-*
Inscr. verso: *I*
Z. VIII, 93
M.P. 1089

983
Une Anatomie: trois femmes
Anatomy: Three Women
28 February 1933
[Paris]
Pencil
19.7 × 27
D.b.r.: *28-2-33-*
Inscr. verso: *VIII*
M.P. 1096

984
Une Anatomie: trois femmes
Anatomy: Three Women
1 March 1933
[Paris]
Pencil
19.5 × 27.3
D.a.r.: *1-3-33-*
Inscr. verso: *IX*
M.P. 1097

985
Une Anatomie: trois femmes
Anatomy: Three Women
1 March 1933
[Paris]
Pencil
19.7 × 27.1
D.a.r.: *1-3-33-*
Inscr. verso: *X*
M.P. 1098

986
L'arstiste et son modèle
The Artist and his Model
12 April 1933
Boisgeloup
Pen, Indian ink and tinted wash
23 × 29
D.a.r.: *Boisgeloup 12 Avril XXXIII-*
Z. VIII, 131
M.P. 1099

987
Deux figures
Two Figures
12 April 1933
Boisgeloup
Pencil
34.5 × 47.5
D.a.r.: *Boisgeloup 12 Avril XXXIII-*
Z. VIII, 95
M.P. 1100

988
Femme se regardant dans un miroir: construction
Woman Looking at Herself in a Mirror: Construction
12 April 1933
Boisgeloup
Pencil
34.5 × 51.2
D.a.l.: *Boisgeloup 12 Avril XXXIII-*
Z. VIII, 94
M.P. 1101

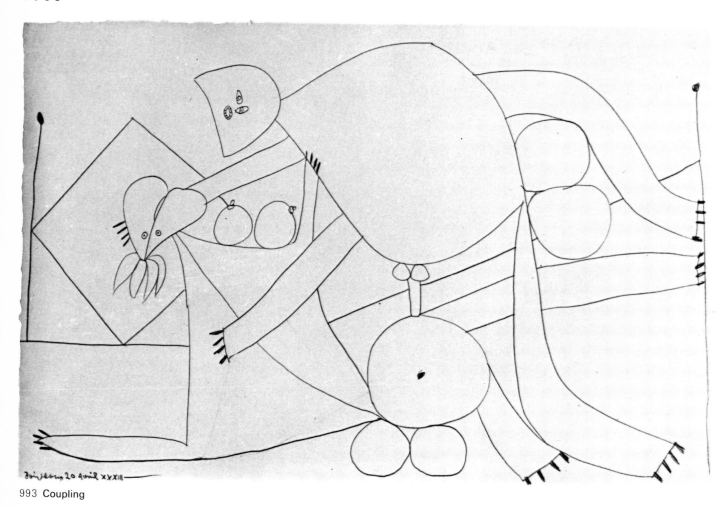

993 **Coupling**

989
Etude pour 'Accouplement': femme nue et tête
Study for 'Coupling': Nude Woman and Head
18 April 1933
Boisgeloup
Pencil
34 × 51.5
D.b.l.: *Boisgeloup 18 Avril XXXIII-*
Z. VIII, 97
M.P. 1102

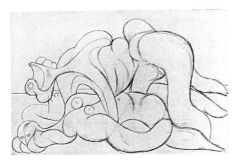

990
Accouplement
Coupling
18 April 1933
Boisgeloup
Pencil
34.4 × 51.5
D.a.r.: *Boisgeloup 18 Avril XXXIII-*
Z. VIII, 100
M.P. 1103

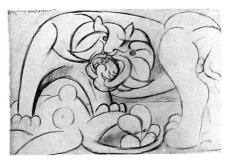

991
Animal sauvage attaquant une femme nue
Wild Animal Attacking a Nude Woman
19 April 1933
Boisgeloup
Pencil
34.1 × 51.5
D.a.l.: *Boisgeloup 19 Avril XXXIII-*
Z. VIII, 98
M.P. 1104

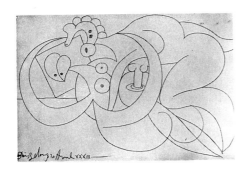

992
Accouplement
Coupling
20 April 1933
Boisgeloup
Pencil
34.5 × 51
D.b.l.: *Boisgeloup 20 Avril XXXIII-*
Inscr. verso: *(III)*
Z. VIII, 102
M.P. 1106

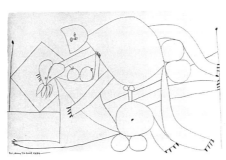

993
Accouplement
Coupling
20 April 1933
Boisgeloup
Pencil
34 × 51.5
D.b.l.: *Boisgeloup 20 Avril XXXIII-*
Inscr. verso: *(IV)*
Z. VIII, 105
M.P. 1105

994
Accouplement
Coupling
21 April 1933
Boisgeloup
Pencil
34.1 × 51.5
D.b.l.: *Boisgeloup 21 Avril XXXIII-*
Inscr. verso: *(I)*
Z. VIII, 107
M.P. 1112

995
Accouplement
Coupling
21 April 1933
Boisgeloup
Pencil
34 × 51.5
D.a.l.: *Boisgeloup 21 Avril XXXIII-*
Inscr. verso: *(II)*
Z. VIII, 111
M.P. 1111

996
Accouplement
Coupling
21 April 1933
Boisgeloup
Pencil
34 × 51.5
D.b.l.: *Boisgeloup 21 Avril XXXIII-*
Inscr. verso: *(IV)*
Z. VIII, 110
M.P. 1109

997
Accouplement
Coupling
21 April 1933
Boisgeloup
Pencil
34 × 51.4
D.b.r.: *Boisgeloup 21 Avril XXXIII-*
Inscr. verso: *(V)*
Z. VIII, 109
M.P. 1107

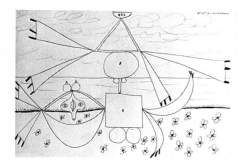

998
Accouplement
Coupling
21 April 1933
Boisgeloup
Pencil
34.5 × 51.5
D.a.r.: *Boisgeloup 21 Avril XXXIII-*
Inscr. verso: *(VI)*
Z. VIII, 104
M.P. 1108

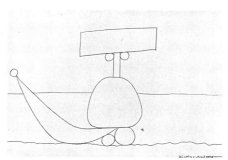

999
Accouplement
Coupling
21 April 1933
Boisgeloup
Pencil
34 × 51
D.b.r.: *Boisgeloup 21 Avril XXXIII-*
Inscr. verso: *(VII)*
Z. VIII, 106
M.P. 1113

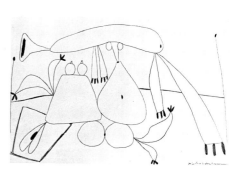

1000
Accouplement
Coupling
21 April 1933
Boisgeloup
Pencil
34.2 × 51.4
D.b.r.: *Boisgeloup 21 Avril XXXIII-*
Z. VIII, 108
M.P. 1110

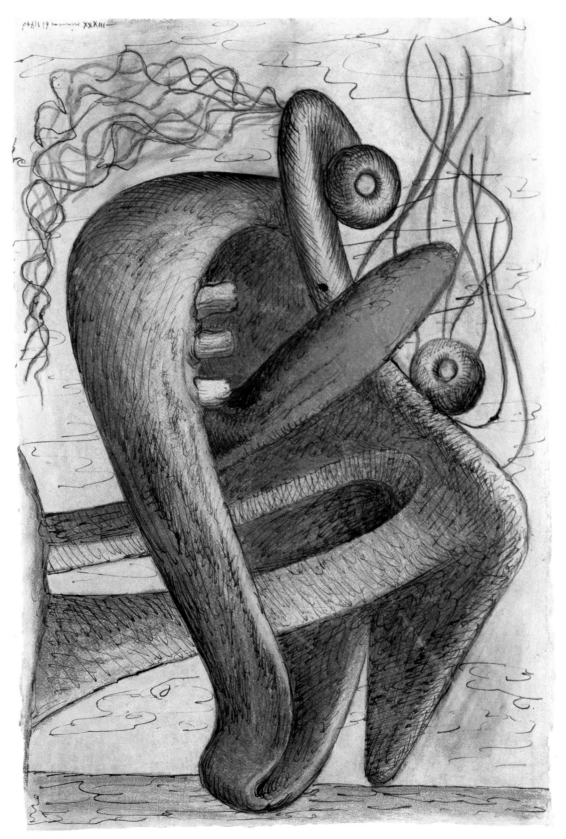

1003 Figure on the Sea-shore

1001
Accouplement
Coupling
22 April 1933
Boisgeloup
Pencil
12 × 20
D.a.l.: *Boisgeloup 22 Avril XXXIII-*
Inscr. verso: *(II)*
Z. VIII, 113
M.P. 1114

1002
Minotaure violant une femme
Minotaur Ravishing a Woman
28 June 1933
Boisgeloup
Pen, Indian ink and tinted wash
47 × 62
D.a.l.: *Boisgeloup 28 juin XXXIII-*
M.P. 1115

1003
Figure au bord de la mer
Figure on the Sea-shore
19 November 1933
Paris
Pastel, Indian ink and charcoal
51 × 34.2
D.a.l.: *PARIS 19 novembre XXXIII-*
Z. VIII, 149
M.P. 1116

1004
Minotaure
Minotaur
1933
Charcoal
51 × 34
Z. VIII, 137
M.P. 1117

1005
Tête de minotaure et bras
Head of the Minotaur and Arm
[1933]
Pencil
6.2 × 31
M.P. 853

1006
Combat entre taureau et cheval
Fight between Bull and Horse
[1933–1934]
Pencil and oil
55 × 35
Z. VIII, 135
M.P. 1118

1007
Femme à la bougie, combat entre le taureau et le cheval
Woman with a Candle, Fight between Bull and Horse
[1933–1934]
Pencil
26 × 34.5
Z. VIII, 212
M.P. 1119

1008
Il neige au soleil
It Is Snowing in the Sun
10 January 1934
Paris
Indian ink
26 × 32.5
D.b.l.: *Paris 10 janvier XXXIV*
Inscr. verso: *(I)*
M.P. 1120

1009
Il neige au soleil
It Is Snowing in the Sun
10 January 1934
Paris
Indian ink
26 × 32.5
D.b.l.: *Paris 10 janvier XXXIV*
Inscr. verso: *(II)*
M.P. 1121

1010
Il neige au soleil
It Is Snowing in the Sun
10 January 1934
Paris
Indian ink
26 × 32.5
D.b.l.: *Paris 10 janvier XXXIV*
Inscr. verso: *(III)*
M.P. 1122

1011
Il neige au soleil
It Is Snowing in the Sun
10 January 1934
Paris
Indian ink
26 × 32.5
D.b.l.: *Paris 10 janvier XXXIV*
Inscr. verso: *(IV)*
M.P. 1123

1012
Il neige au soleil
It Is Snowing in the Sun
10 January 1934
Paris
Indian ink
26 × 32.5
D.b.l.: *Paris 10 janvier XXXIV*
Inscr. verso: *(V)*
M.P. 1124

1013
Il neige au soleil
It Is Snowing in the Sun
10 January 1934
Paris
Indian ink
26 × 32.5
D.b.l.: *Paris 10 janvier XXXIV*
Inscr. verso: *(VI)*
M.P. 1125

1014
Il neige au soleil
It Is Snowing in the Sun
10 January 1934
Paris
Indian ink
26 × 32.5
D.b.l.: *Paris 10 janvier XXXIV*
Inscr. verso: *(VII)*
M.P. 1126

1015
Il neige au soleil
It Is Snowing in the Sun
10 January 1934
Paris
Indian ink
26 × 32.5
D.b.l.: *Paris 10 janvier XXXIV*
Inscr. verso: *(VIII)*
M.P. 1127

1016
Il neige au soleil
It Is Snowing in the Sun
10 January 1934
Paris
Indian ink
26 × 32.5
D.b.l.: *Paris 10 janvier XXXIV*
Inscr. verso: *(IX)*
M.P. 1128

1017
Il neige au soleil
It Is Snowing in the Sun
10 January 1934
Paris
Indian ink
26 × 32.5
D.b.l.: *Paris 10 janvier XXXIV*
Inscr. verso: *(X)*
M.P. 1129

1018
Il neige au soleil
It Is Snowing in the Sun
10 January 1934
Paris
Indian ink
26 × 32.5
D.b.l.: *Paris 10 janvier XXXIV*
Inscr. verso: *(XI)*
M.P. 1130

1019
Nu couché devant la fenêtre
Nude Reclining in front of the Window
7 February 1934
Paris
Pen and Indian ink
26.2 × 32.7
D.b.l.: *PARIS 7 F. XXXIV*
Z. VIII, 179
M.P. 1131

1020
Intérieur aux hirondelles, I
Interior with Swallows, I
10 February 1934
Paris
Indian ink and charcoal
25.7 × 32.5
D.c.b.: *PARIS 10 F. XXXIV*
Z. VIII, 175
M.P. 1132

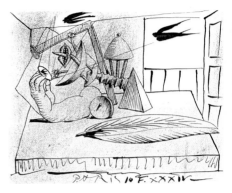

1021
Intérieur aux hirondelles, II
Interior with Swallows, II
10 February 1934
Paris
Indian ink and charcoal
26 × 32.7
D.c.b.: *PARIS 10 F. XXXIV*
Z. VIII, 173
M.P. 1133

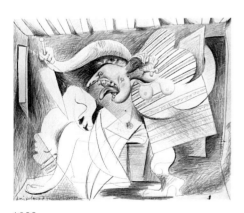

1022
Le meurtre
The Murder
7 July 1934
Boisgeloup
Pencil
39.8 × 50.4
D.b.l.: *Boisgeloup 7 juillet XXXIV*
Z. VIII, 216
M.P. 1135

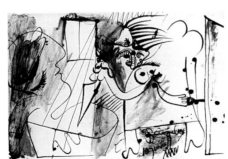

1023
Le meurtre
The Murder
10 July 1934
Boisgeloup
Indian ink
34 × 51
D.b.r.: *Boisgeloup/10 juillet/XXXIV*
Z. VIII, 222
M.P. 1134

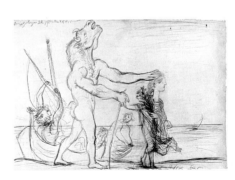

1024
**Minotaure aveugle devant la mer
conduit par une petite fille**
*Blind Minotaur before the Sea Being Guided
by a Little Girl*
22 September 1934
Boisgeloup
Pencil
34.5 × 51.4
D.a.l.: *Boisgeloup 22 Septembre XXXIV*
M.P. 1137

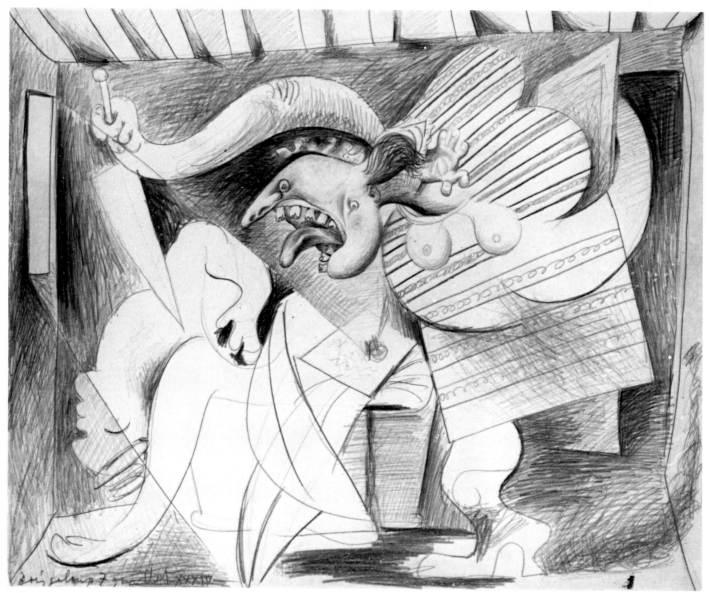

1022 **The Murder**

1025
La femme au vase
Woman with a Vase
[1934–1935]
Pencil on the back of an envelope
9.8 × 21.5
M.P. 1138

1026
Jeune fille dessinant dans un intérieur
Young Girl Drawing in an Interior
5 February 1935
[Paris]
Pencil
17 × 25.5
D.b.r.: *5 Février XXXV*
Z. VIII, 252
M.P. 1139

1027
Jeune fille dessinant dans un intérieur
Young Girl Drawing in an Interior
5 February 1935
[Paris]
Pencil
17.5 × 26.5
D.b.l.: *5 Février XXXV*
Z. VIII, 250
M.P. 1140

1028
Jeune fille dessinant dans un intérieur
Young Girl Drawing in an Interior
with notes showing colours to be used
17 February 1935
Paris
Pen and Indian ink on pencil outlines
17.1 × 25.3
D.b.r.: *Paris Dimanche 17 Fevrier XXXV*
Z. VIII, 262
M.P. 1141

1029
Feuille d'études: jeune fille assoupie
Various Studies: Young Girl Drowsing
[February] 1935
[Paris]
Pencil
21.7 × 33
Z. VIII, 255
M.P. 1142

1030
Jeune fille dessinant dans un intérieur
Young Girl Drawing in an Interior
[February] 1935
[Paris]
Pencil
17 × 25.7
Z. VIII, 249
M.P. 1143

1031
Minotaure et cheval
Minotaur and Horse
15 April 1935
Boisgeloup
Pencil
17.5 × 25.5
D.a.l.: *Boisgeloup 15 Avril XXXV*
Z. VIII, 244
M.P. 1144

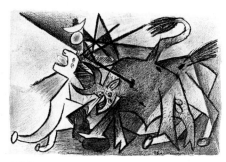

1032
Corrida
Bullfight
26 April 1935
Boisgeloup
Coloured crayons, pencil and Indian ink
17.2 × 25.8
D.b.r.: *26 avril XXXV*; verso: *Boisgeloup/26 avril/XXXV*
M.P. 1145

1033
Sur le dos de l'immense tranche de melon ardent
On the Back of the Immense Slice of Burning Melon
(poem in French)
[Paris]
Indian ink and coloured crayons
25.5 × 17.1
D.a.l.: *14 Decembre XXXV.*
M.P. 1146

1034
Feuille d'études: profils de Marie-Thérèse
Various Studies: Marie-Thérèse in Profile
2 April 1936
Juan-les-Pins
Indian ink on a sheet folded in two
26 × 17.5
D.a.l.: *J. les P./2 Avril/XXXVI.*
Page 3 features poems in Spanish and French, dated 3 April 1936 at Juan-les-Pins
M.P. 1148

1035
Etude pour 'Portrait de jeune fille'; Marie-Thérèse lisant
Study for 'Portrait of a Young Girl'; Marie-Thérèse Reading
3 April 1936
Juan-les-Pins
Pen and Indian ink on a sheet folded in two
26 × 17.5
D.a.l.: *3 Avril XXXVI.*
Page 3 features poems in Spanish, dated 3 April 1936 at Juan-les-Pins
M.P. 1149

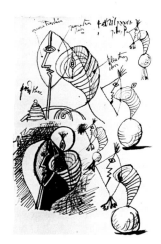

1036
'Portrait de jeune fille'
'Portrait of a Young Girl'
with handwritten notes showing colours to be used
4 April
Juan-les-Pins
Indian ink on a sheet folded in two
26 × 17.4
D.a.r.: *4 avril XXXVI./J.les P.*
M.P. 1150(r = p.1)

1032 **Bullfight**

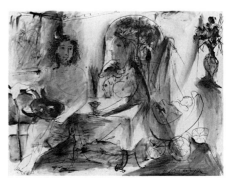

1036a
'Portrait de jeune fille sur une vieille boîte de conserve' et poème en français sur ce thème
'Portrait of a Young Girl on an Old Tin Can' and Poem in French on this Theme
4 April 1936
Juan-les-Pins
Indian ink on a sheet folded in two
28 × 17.4
D.c.r.: *J. les P. 4 avril XXXVI.*
M.P. 1150 (v = p.3)

1037
Minotaure emmenant une jument et son poulain dans une charette
Minotaur Leading away a Mare and her Foal in a Cart
5 April 1936
Juan-les-Pins
Pen and Indian ink
50.5 × 66
D.b.r.: *5 avril XXXVI.*
Z. VIII, 276
M.P. 1151

1038
Homme au masque, femme et enfant dans son berceau
Man in a Mask, Woman and Child in its Cradle
7 April 1936
Juan-les-Pins
Pen, Indian ink and tinted wash
50 × 65.5
D.b.r.: *7 avril XXXVI.*
Z. VIII, 279
M.P. 1152

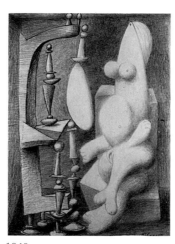

1039
Femme devant un dressoir et poèmes en français
Woman in front of a Dresser and Poems in French
10 April 1936
Juan-les-Pins
Pen and Indian ink on a sheet folded in two
25.8 × 17.4
D.a.l.: *10 avril XXXVI.*
Page 3 features a poem in French, dated 9 April 1936
M.P. 1147

1040
Nu devant un dressoir
Nude in front of a Dresser
12 April 1936
Juan-les-Pins
Pencil
65 × 50
D.b.r. in Indian ink: *12 avril XXXVI.*
Z. VIII, 275
M.P. 1153

1041
Etudes: 'Tête de femme'
Studies: 'Head of a Woman'
with handwritten notes showing colours to be used
15 April 1936
Juan-les-Pins
Indian ink on pencil outlines on a sheet folded in two
26 × 17.2
D.a.l.: *15 avril XXXVI.*
M.P. 1154 (r = p.1)

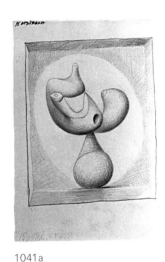

1041a
Femme
Woman
15 April 1936
Juan-les-Pins
Pencil on a sheet folded in two
26 × 17.2
D.a. in Indian ink and b.l. in pencil: *15 avril
XXXVI.*
M.P. 1154(v = p.3)

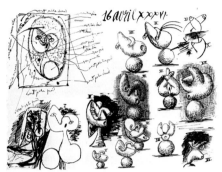

1042
Feuille d'études: 'Tête de femme'
Various Studies: 'Head of a Woman'
with handwritten notes showing colours to be
used
16 April 1936
Juan-les-Pins
Pen and Indian ink
26 × 34
D.c.a.: *16 avril XXXVI.*
Z. VIII, 283
M.P. 1155

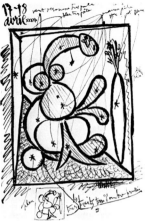

1043
Etudes: 'Femme au vase de fleurs'
Studies: 'Woman with a Vase of Flowers'
with handwritten notes showing colours to be
used
17–18 April 1936
Juan-les-Pins
Pen and Indian ink on pencil outlines on a
sheet folded in two
52.7 × 17.4
D.a.l.: *17–18/avril XXXVI.*
M.P. 1156(r = p.1)

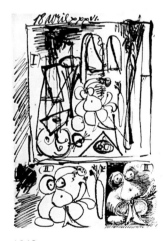

1043a
Etudes: 'Femme au vase de fleurs'
Studies: 'Woman with a Vase of Flowers'
18 April 1936
Juan-les-Pins
Pen and Indian ink on pencil outlines on a
sheet folded in two
52.7 × 17.4
D.a.l.: *18 avril XXXVI.*
M.P. 1156(v = p.3)

1044
**Baigneuse à la cabine; paysage de Juan-
les-Pins**
*Bather by a Beach-hut; Juan-les-Pins
Landscape*
19–21 April 1936
Juan-les-Pins
Indian ink and tinted wash on a sheet folded
in two
26 × 17.3
D.c.l.: *19 avril XXXVI.* and c.r.: *21 avril XXXVI.*
M.P. 1157(r = p.1)

1044a
Feuille d'études: Baigneuses à la cabine
Various Studies: Bathers by a Beach-hut
22 April 1936
Juan-les-Pins
Indian ink and tinted wash on a sheet folded
in two
26 × 17.3
D.a.r.: *22/avril/XXXVI.*
M.P. 1157(v = p.3)

1045
Homme au masque, femme et enfant dans ses bras
Man Wearing a Mask, Woman with a Child in her Arms
23 April 1936
Juan-les-Pins
Pen, Indian ink and tinted wash
65 × 50
D.b.l.: *23 avril XXXVI.*
Z. VIII, 278
M.P. 1158

1046
Etudes: Portrait de femme de profil
Studies: Portrait of a Woman in Profile
24 April 1936
Juan-les-Pins
Indian ink on a sheet folded in two
26 × 17.4
D.a.l.: *24 avril XXXVI.*
M.P. 1159(r = p.1)

1046a
Etudes: Portrait de femme de profil
Studies: Portrait of a Woman in Profile
24 April 1936
Juan-les-Pins
Indian ink on a sheet folded in two
26 × 17.4
D.a.l.: *24 avril XXXVI.*
M.P. 1159 (v = p.3)

1047
Etudes: 'Dormeuse aux persiennes'; Portrait de femme
Studies: 'Sleeping Woman with Shutters'; Portrait of a Woman
25 April 1936
Juan-les-Pins
Indian ink on a sheet folded in two
26 × 17.5
D.a.l.: *25/avril/XXXVI.*
M.P. 1160(r = p.1)

1047a
Etudes: Portrait de femme
Studies: Portrait of a Woman
26 April 1936
Juan-les-Pins
Indian ink on a sheet folded in two
26 × 17.5
D.a.l.: *26/avril/XXXVI.*
M.P. 1160(v = p.3)

1048
Feuille d'études: 'Buste de femme'; 'Tête' et 'Le chapeau de paille au feuillage bleu'
Various Studies: 'Head and Shoulders of a Woman'; 'Head' and 'The Straw Hat with Blue Leaves'
with handwritten notes showing colours to be used
1 May 1936
Juan-les-Pins
Indian ink on a sheet folded in two
26 × 17.3
D.a.l.: *1er mai XXXVI.*
M.P. 1162(r = p.1)

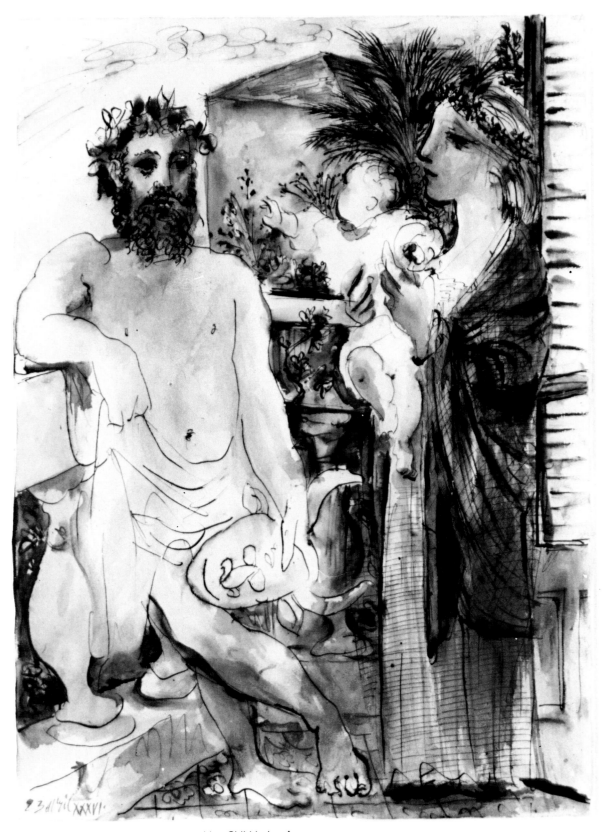

1045 Man Wearing a Mask, Woman with a Child in her Arms

1048a
Feuille d'études
Various Studies
27 April 1936
Juan-les-Pins
Indian ink on a sheet folded in two
26 × 17.3
D.a.l.: *27 avril XXXVI.*
M.P. 1162(v = p.3)

1049
Nu couché et profil
Reclining Nude and Profile
28 April 1936
Juan-les-Pins
Indian ink
17.2 × 25.5
D.a.r.: *28 avril/XXXVI.*
M.P. 1161

1050
Minotaure et jument morte devant une grotte face à une jeune fille au voile
Minotaur and Dead Mare in front of a Cave opposite a Young Girl with a Veil
6 May 1936
Juan-les-Pins
Gouache and Indian ink
50 × 65
D.b.r.: *6 mai XXXVI.*; verso: *6 mai XXXVI*
M.P. 1163

1051
Minotaure blessé, cavalier et personnages
Wounded Minotaur, Horseman and Figures
8 May 1936
[Juan-les-Pins]
Indian ink and gouache
50 × 65
D.b.r.: *8 mai XXXVI.*
Z. VIII, 285
M.P. 1164(r)

1051a
Buste de faune
Head and Shoulders of a Faun
8 May 1936
[Juan-les-Pins]
Indian ink
50 × 65
D.b.r.: *8 mai XXVI*
M.P. 1164(v)

1052
Minotaure blessé, cheval et personnages
Wounded Minotaur, Horse and Figures
10 May 1936
[Juan-les-Pins]
50 × 65
D.b.r.: *10 mai XXXVI.*
Z. VIII, 288
M.P. 1165

1054 Head of a Horse; Poems in French

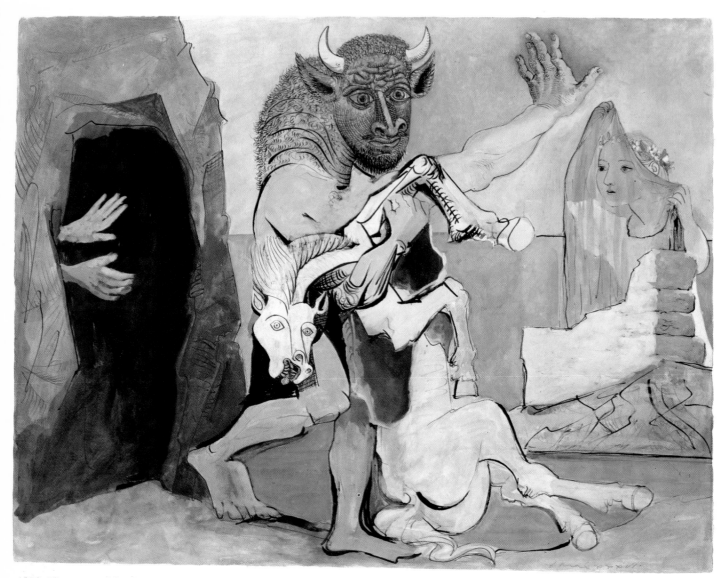

1050 Minotaur and Dead Mare in front of a Cave opposite a Young Girl with a Veil

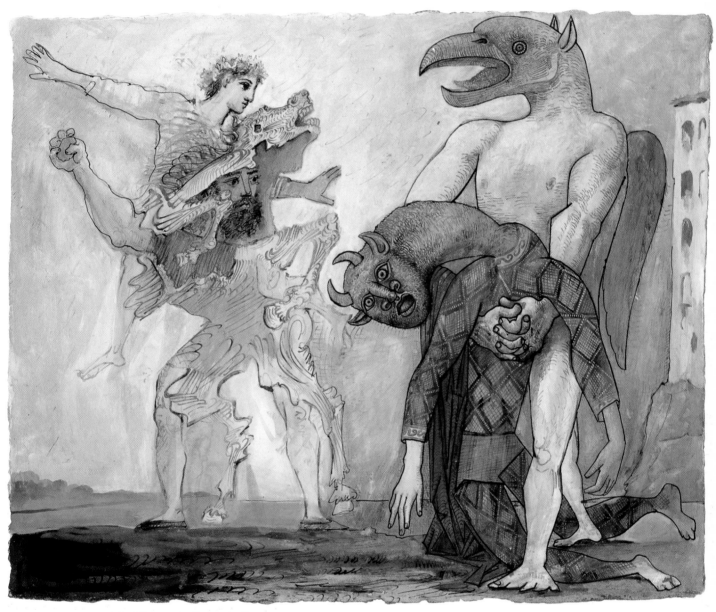

1053 The Remains of the Minotaur in Harlequin Costume

1053
La dépouille du Minotaure en costume d'Arlequin
The Remains of the Minotaur in Harlequin Costume
(the drawing was used as a model for the drop-curtain for *Quatorze Juillet* by Romain Rolland)
28 May 1936
Paris
Gouache and Indian ink
44.5 × 54.5
D. verso: *Paris 28 mai XXXVI*
Z. VIII, 287; Cooper (repr. in col.), 391
M.P. 1166

1054
Tête de cheval; poèmes en français
Head of a Horse; Poems in French
7 and 15 June 1936
Paris
Pen, Indian ink and gouache
33 × 17
D.a.l.: *7 Juin XXXVI.* and c.l.: *15 juin XXXVI.*
M.P. 1168

1055
Le 14 juillet
14 July
13 June 1936
Paris
Pencil on six sheets pieced together
68 × 67
D.a.l.: in Indian ink: *13 Juin XXXVI(I)*
M.P. 1167

1056
Feuille d'études: Faune, nus, mains et marine
Various Studies: Faun, Nudes, Hands and Sea-front
30 June 1936
[Paris]
Pen and ink
34.5 × 51.5
D.c.: *30 Juin XXXVI.*
M.P. 1169(r)

1056a
Feuille d'études: danseuses et taureaux
Various Studies: Dancers and Bulls
30 June 1936
[Paris]
34.5 × 51.5
D.c.a.: *30 Juin XXXVI.*
M.P. 1169(v)

1057
Faune, cheval et oiseau
Faun, Horse and Bird
5 August 1936
[Paris]
Gouache and Indian ink
44 × 54
D.b.r.: and verso: *5 Août XXXVI.*
M.P. 1170

1058
Etudes: Tête de femme; poèmes en français
Studies: Head of a Woman; Poems in French
9 and 11 October 1936
[Le Tremblay-sur-Mauldre]
Pen, Indian ink and tinted wash
27 × 21
D.c.a.: *9 Octobre XXXVI* and *11 octobre XXXVI.*
M.P. 1171

1059
Femme au piano
Woman at the Piano
29 December 1936
[Le Tremblay-sur-Mauldre]
Pencil on blue paper
27 × 21
D.b.r.: *29 D.XXXVI.*
M.P. 1172

Wars: 1937–1945

What do you consider an artist to be? A fool, all eyes if he is a painter, all ears if he is a musician, a lyre on every storey of his soul if he is a poet or even, if he is a boxer, all muscles? On the contrary, he is also a political being, constantly alert to the harrowing, dramatic or joyful events in the world, fashioning himself wholly in their image. How could one ever detach oneself from others, what kind of drunken insouciance would enable one to turn away from a life others offer in such abundance? No, painting is not meant for decorating apartments. It is an instrument of active and defensive war against the enemy.

PABLO PICASSO[1]

This sequence of drawings begins a few months after the outbreak of the Spanish Civil War. Picasso was shaken by the tragic drama and followed the development of events closely. The title of his poem 'Sueño y Mentira de Franco' and the engravings intended to illustrate it are particularly eloquent.[2] The bloated figure of the monster Caudillo and the phallic deformity of his head reappear with the *Baigneuses* (*Bathers*) of February 1937 (cat. 1060–1063), as noted by Ludwig Ullmann.[3] They allude to political events, in particular the fall of Malaga to Franco's forces, as suggested by the depiction of the Sierra Nevada in the background. At the beginning of the year the Spanish Government had asked Picasso to produce a mural for the Spanish Pavilion at the Paris International Exhibition to be held in late spring.

(1) *Picasso libre*, 21 paintings, 1940–1945, Paris, 1945.

(2) See fig. 1.

(3) L. Ullmann, 'Zur Vorgeschichte von Picassos 'Guernica': unbekannte und unbeachtete Arbeiten (Januar–April 1937)' *Kritische Berichte*, 1985, no. 4.

Fig. 1
Dreams and Lies of Franco, 1937
Baer 615
Paris, Musée Picasso

Fig. 2
Guernica, before its completion in the studio in the rue des Grands-Augustins, 1937 (Photo Dora Maar)

The series of drawings dated 18 and 19 April (cat. 1064–1077) could well be seen[4] as preliminary studies leading to the initial sketch on the theme of the painter and his model in the studio. From 1 May, following the German bombing of a small Spanish community on 28 April, Picasso left that theme for the great composition which the tragedy inspired him to paint. This was *Guernica*, the only work he himself named. The theory is supported by the preparatory drawings, some done on blue paper, which are exhibited in Madrid near the painting.[5] The raised arm and clenched fist in *Le peintre et son modèle dans l'atelier* (*The Painter and his Model in the Studio*, cat. 1007) figured in the initial versions of *Guernica*.[6] The mother carrying her dead child in her arms shown on the left of the mural, together with the woman falling from a blazing house depicted on the right, are 'sisters' of *La femme qui pleure* (*The Weeping Woman*, cat. 1079). Her face is heavily lined with grief and her eyes seem to have turned into tears – a theme the artist was to develop during the month of October. The work, executed in oil and Indian ink on paper, portrays the woman holding up a large white handkerchief to wipe her face.[7] This gesture is repeated in the Musée Picasso's painting of the woman which the artist had carried out the previous week. The famous painting in the Penrose Collection shows the handkerchief thrust into her mouth in order to stifle the cries. This 'universal symbol of human suffering', as Roger Garaudy describes her, was given the face of Dora Maar, who had become Picasso's mistress the year before. She was with him when he moved into the studio in the rue des Grands-Augustins and shared his political beliefs.

A sheet featuring various studies dated 24 October 1937 (cat. 1080) analyses the face and eyes. Another (cat. 1081) could be seen as a morphological study of eyes and ears.

Jean Leymarie defines Picasso's work during this period in the following way: 'The ornamental and geometric style comparable to a piece of thickly latticed basketweave on the shining structure of a spider's web is totally characteristic of the majority of works produced in 1938, paintings as well as drawings.'[8] The style is reflected in the portraits of Dora, which are the most significant works of 1938. This elegant, beautiful dark-haired woman with her sharp features, lively glance and long hands is successively depicted still, seated in her armchair, or active on the beach. She tries to open the door of a beach-hut (cat. 1093) – a common theme in Picasso's work, with Freudian connotations – or plays with her friends Inés and Nusch Eluard (cat. 1094). Throughout 1939, in Paris, in Antibes and then in Royan after the declaration of war, the two 'Muses', Marie-Thérèse Walter and Dora Maar, alternate in Picasso's repertoire.

(4) This was in fact Dominique Bozo's theory and the reason why he selected these works.

(5) Cf. *Guernica, legado Picasso*, Madrid, Museo del Prado, 1981.

(6) See fig. 2, photographed by Dora Maar, who recorded the work in all its stages of development.

(7) M.P. 165, cat. I, 143.

(8) J. Leymarie, *Picasso, dessins*, p. 71.

Fig. 3
Pigeons, a painting by Don José Ruiz Blasco
(Picasso Archives, Penrose bequest)

(9) D. Bozo, 'Le modèle en question sur quelques portraits, 1930–1940', *Le courrier de l'Unesco*, December 1980.

(10) C. Roy, *Picasso, La guerre et la paix*.

(11) See fig. 3.

(12) Cat. I, 375. One trial work was erected in the square at Vallauris, the gift of the artist. Another is held in The Philadelphia Museum of Art; Claude Picasso has the plaster cast.

Picasso frequently stated that although he did not paint the war, it was present in his work. Commenting on this, Dominique Bozo writes: 'It is natural that a classical painter who presents his own life as contemporary humanity in his paintings should seek out the expression of horror on the human face.'[9] This reflection is applicable to the two heads of women (cat. 1115, 1116) produced at the time of the German invasion. Claude Roy uses these words to describe the colours featured in the latter work:[10] 'The very colours of the Nazi columns which were to force their way into Royan on Sunday evening: the sinister, greyish green, the browns and the ashy ochres'. He adds: 'The hideous, tortured, abject faces portrayed by Picasso are really the faces of war itself and of the truly nonsensical iniquity of the tragedy . . .'

The series of paintings is completed by the four Royan sketchbooks, the artist's personal diary and a reflection of that sad era.

In August 1940 Picasso returned to Paris and his studio in the rue des Grands-Augustins. Here he was to stay throughout the Occupation. The museum's collection of works evoking the atmosphere of that time is better represented in painting than in drawing, but there are two still-life compositions (cat. 1203, 1216), the chair in the studio (cat. 1196, 1198) and the visiting pigeons (cat. 1194, 1195 and 1198), the latter doubtless evoking the memory of the artist's childhood companions and his father's paintings.[11] Besides the portraits of women alone or gazing at sleeping men (cat. 1199, 1200), the outstanding series revolve around the two major works of this period. The most notable painting is *L'Aubade*, given by the artist to the Musée National d'Art Moderne at the suggestion of Jean Cassou and Georges Salles. The second work is a sculpture, *L'homme au mouton (Man with a Sheep).*[12]

The title *Etude pour 'L'Aubade' (Study for 'L'Aubade')* given to a series of sketches markedly different from the final composition rests on an assumption. The series was begun in spring 1941. We know that the painting is dated 5 May 1942. The idea behind the hypothesis was that these pen or pencil drawings, most of them done on the same material (a sort of Japanese vellum), contain motifs which prefigure the painting. We are presented with the successive images of a woman stretched out, a head, two women in an interior and the furniture. Picasso said to Zervos in 1935: 'A painting comes to me from afar; who knows from

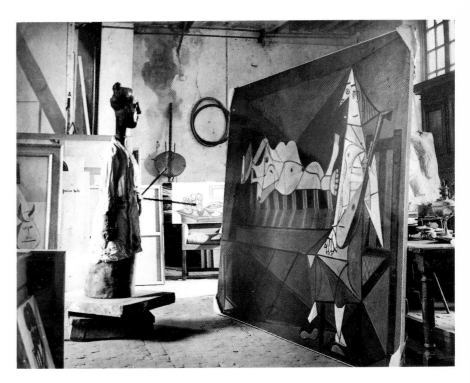

Fig. 4
L'Aubade, in the studio in the rue des Grands-Augustins, 1946
(Photo Brassaï © Gilberte Brassaï)

what distance I have divined it, seen it . . .?'[13] And to André Malraux, who expressed interest in *L'homme au mouton* when visiting Picasso's studio in 1945, he confided: 'I did this statue in a single afternoon, but not until after many months of reflections and I don't know how many sketches.'[14]

The Musée Picasso holds nineteen of these 'sketches', many of which are highly polished drawings. As Christian Zervos notes,[15] they offer 'a general, direct view of the process by which Picasso's works evolve'. The very first studies on this theme are four sketches dating from July 1942; three are executed in pencil, a fourth in pen. Nine others were produced during the course of the year.

Picasso took up the theme of the man with a sheep once more in February and March 1943. Throughout this period a woman is featured beside the two protagonists. She appeared in September when Picasso had just completed a series of bathers sketched in coloured crayons (cat. 1183–1191). The other drawings are studies presenting the sheep or the man and the sheep, the man being portrayed successively full-face or in profile, bearded or clean-shaven, young or old. The sculpture was completed in February or March 1943, although the exact date is not known; it is therefore impossible to say whether the sketches of 1943 were done prior to this work. The final drawing may well have appeared after the model, a theory suggested by its style and power, as well as its format: it was done on two sheets pieced together. Like the sculpture it presents us with a simple image, both compelling and serene, apparently rife with symbolism. This the artist denied, although the work inevitably recalls the pagan theme of Hermes bearing the ram or the Christian images of the Good Shepherd and John the Baptist.

(13) C. Zervos, 'Conversation avec Picasso', *Picasso 1930–1935, Cahiers d'Art*, Vol. X, nos 7–10, 1936, p. 42.

(14) Comment quoted by Brassaï, *Conversations with Picasso*, p. 161.

(15) C. Zervos, 'L'homme à l'agneau de Picasso', *Cahiers d'Art*, 20th–21st year, 1946, p. 85.

Principal Related Works

Cat. 1062:
La Baignade (*The Bathe*), 1937. Venice, The Peggy Guggenheim Collection. Z. VIII, 344. (Fig. 5)

Cat. 1118–1159, 1162–1171:
L'Aubade, 1942. Paris, Musée National d'Art Moderne. Z. VII, 69. (Fig. 6)

Cat. 1172–1182, 1192–1193, 1201–1206:
L'homme au mouton (*Man with a Sheep*), 1943. Paris, Musée Picasso, cat. I, 375; S. 280 (II). (Fig. 7)

Fig. 5

Fig. 6

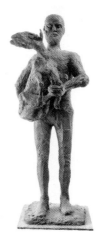

Fig. 7

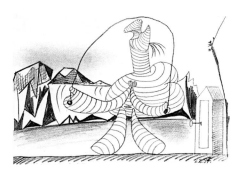

1060
Baigneuse à la cabine sautant à la corde
Bather by a Beach-hut Skipping with a Rope
6 February 1937
[Paris–Le Tremblay-sur-Mauldre]
Pencil
17.5 × 26
D.b.r.: *6.2.37.*
M.P. 1173

1061
Baigneuse
Bather
6 February 1937
[Paris–Le Tremblay-sur-Mauldre]
Pencil
17 × 25.5
D.b.l.: *6.2.37.*
M.P. 1174

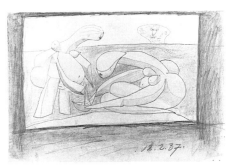

1062
Etude pour 'La baignade'
Study for 'The Bathe'
12 February 1937
[Paris–Le Tremblay-sur-Mauldre]
Pencil, charcoal and pastel
34 × 52
D.b.r.: *12.2.37.*
Z. VIII, 342
M.P. 1175

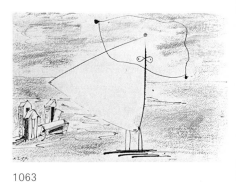

1063
Baigneuse sautant à la corde sur une plage
Bather Skipping with a Rope on a Beach
20 February 1937
[Paris–Le Tremblay-sur-Mauldre]
Indian ink and pastel
17.3 × 25.5
D.b.l.: *20.2.37.*
M.P. 1176

1064
L'atelier: le peintre et son modèle
The Studio: the Painter and his Model
18 April 1937
[Paris–Le Tremblay-sur-Mauldre]
Pencil on blue paper
18 × 28
D.a.r.: *18.A.37.*
Inscr.a.r.: *(I)*
M.P. 1178

1065
L'atelier: le peintre et son modèle
The Studio: the Painter and his Model
18 April 1937
[Paris–Le Tremblay-sur-Mauldre]
Pencil on blue paper
18 × 18.5
D.a.r.: *18.A.37.*
Inscr.a.r.: *(II)*
M.P. 1179

1066
L'atelier: le peintre et son modèle
The Studio: the Painter and his Model
18 April 1937
[Paris–Le Tremblay-sur-Mauldre]
Pencil on blue paper
18 × 28
D.a.r.: *18.A.37.*
Inscr.a.r.: *(III)*
M.P. 1180

1067
L'atelier: le peintre et son modèle
The Studio: the Painter and his Model
18 April 1937
[Paris–Le Tremblay-sur-Mauldre]
Pencil on blue paper
18 × 28
D.a.r.: *18.A.37.*
Inscr.a.r.: *(IV)*
M.P. 1181

1068
L'atelier: le peintre et son modèle
The Studio: the Painter and his Model
18 April 1937
[Paris–Le Tremblay-sur-Mauldre]
Pencil on blue paper
18 × 28
D.a.r.: *18.A.37.*
Inscr.a.r.: *(V)*
M.P. 1182

1069
L'atelier: le peintre et son modèle
The Studio: the Painter and his Model
18 April 1937
[Paris–Le Tremblay-sur-Mauldre]
Pencil on blue paper
18 × 28
D.a.r.: *18.A.37.*
Inscr.a.r.: *(VI)*
M.P. 1183

1070
L'atelier: le peintre et son modèle
The Studio: the Painter and his Model
18 April 1937
[Paris–Le Tremblay-sur-Mauldre]
Pencil on blue paper
18 × 28
D.c.a.: *18.A.37.*
Inscr.a.r.: *(VII)*
M.P. 1184

1071
L'atelier: le peintre et son modèle
The Studio: the Painter and his Model
18 April 1937
[Paris–Le Tremblay-sur-Mauldre]
Pencil on blue paper
18 × 28
D.c.a.: *18.A.37.*
Inscr.c.a.: *(VIII)*
M.P. 1185

1072
L'atelier: le peintre et son modèle
The Studio: the Painter and his Model
18 April 1937
[Paris–Le Tremblay-sur-Mauldre]
Pencil on blue paper
18 × 28
D.a.r.: *18.A.37.*
Inscr.a.r.: *(IX)*
M.P. 1186

1073
L'atelier: le peintre et son modèle
The Studio: the Painter and his Model
18 April 1937
[Paris–Le Tremblay-sur-Mauldre]
Pencil on blue paper
18 × 28
D.c.b.: *18.A.37.*
Inscr.c.b.: *(X)*
M.P. 1187

1074
L'atelier: le peintre et son modèle
The Studio: the Painter and his Model
18 April 1937
[Paris–Le Tremblay-sur-Mauldre]
Pencil on blue paper
18 × 28
D.c.b.: *18.A.37.*
Inscr.c.b.: *(XI)*
M.P. 1188

1075
L'atelier: le peintre et son modèle
The Studio: the Painter and his Model
18 April 1937
[Paris–Le Tremblay-sur-Mauldre]
Pencil on blue paper
18 × 28
D.c.: *18.A.37.*
Inscr.c.: *(XII)*
M.P. 1189

1076
L'atelier: le peintre et son modèle: la lampe
The Studio: the Painter and his Model: the Light
18–19 April 1937
[Paris–Le Tremblay-sur-Mauldre]
Pencil on blue paper
18 × 13.5
M.P. 1191

1077
L'atelier: le peintre et son modèle; bras tenant une faucille et un marteau
The Studio: the Painter and his Model; Arm Holding a Hammer and Sickle
19 April 1937
[Paris–Le Tremblay-sur-Mauldre]
Pen and Indian ink on blue paper
18 × 28
D.a.r.: *19.A.37.*
M.P. 1190

1078
Personnage tenant une faucille et un marteau
Figure Holding a Hammer and Sickle
[April] 1937
[Paris–Le Tremblay-sur-Mauldre]
Ink and pencil on *Paris-soir*, 19 April 1937
60 × 43
M.P. 1177

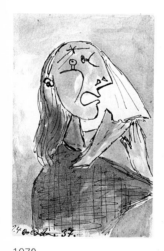

1079
La femme qui pleure
The Weeping Woman
24 October 1937
[Paris]
Oil and Indian ink
25.5 × 17.3
D.b.l.: *24 octobre 37.*
M.P. 1192

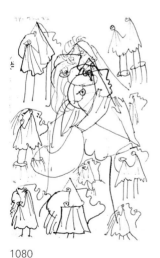

1080
Feuille d'études: la femme qui pleure
Various Studies: the Weeping Woman
24 October 1937
[Paris]
Pen and Indian ink
25.5 × 17.9
D.a.l.: *24 octobre 37*
M.P. 1193

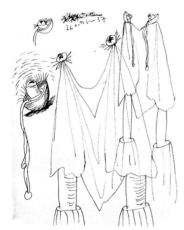

1081
Feuille d'études: larmes
Various Studies: Tears
26 October 1937
[Paris]
Pen and brown ink on the back of an envelope
20.5 × 16.6
D.c.a.: *26 octobre 37* (*24 octobre* crossed out)
M.P. 1194

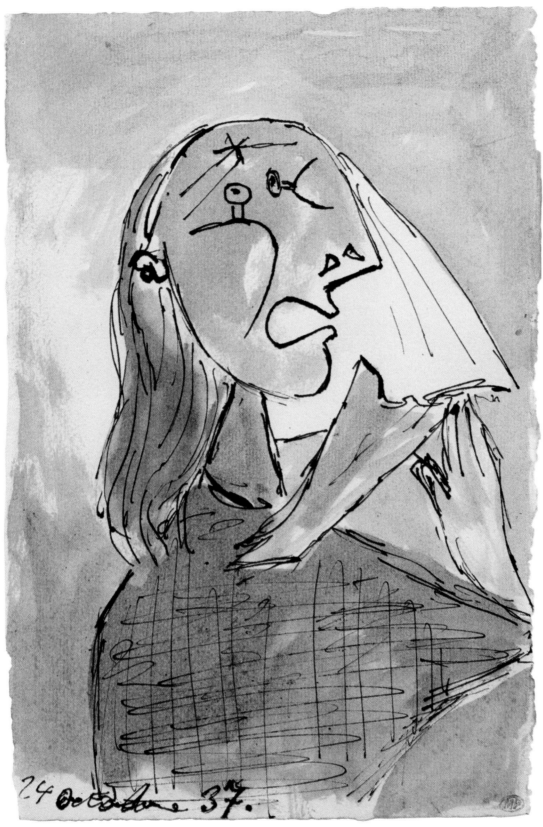

24 October 37.

1079 The Weeping Woman

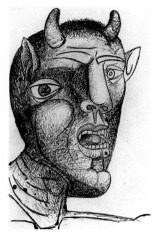

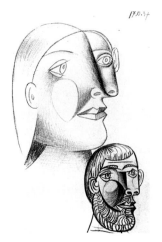

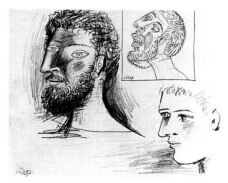

1082
Minotaure
Minotaur
7 December 1937
[Paris]
Pen, Indian ink, charcoal and pencil
57 × 38.5
D.a.l.: *7.D.37.*
M.P. 1195

1083
Profils féminin et masculin
Woman and Man in Profile
17 December 1937
[Paris]
Pencil
25.8 × 17.5
D.a.r. in gouache: *17 D. 37*
Z. IX, 88
M.P. 1196

1084
Trois têtes d'homme
Three Heads of a Man
20 December 1937
[Paris]
Pencil on squared paper
21 × 27
D.b.l.: *20 D 37.* and c.: *20 D 37.*
M.P. 1198

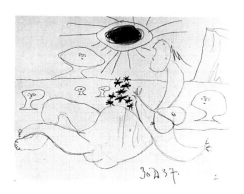

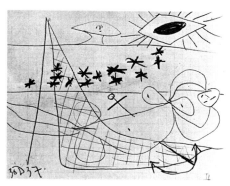

1085
Famille de pêcheurs au repos
Family of Fishermen Relaxing
20 December 1937
[Paris]
Pencil and charcoal on squared paper
21 × 27
D.b.l.: *20 D 37.*
M.P. 1197

1086
Sur la plage
On the Beach
30 December 1937
[Paris]
Pencil on squared paper
21 × 27
D.b.r.: *30 D 37*
Inscr.b.r.: *I*
M.P. 1199

1087
Sur la plage
On the Beach
30 December 1937
[Paris]
Pencil on squared paper
21 × 27
D.b.l.: *30 D 37.*
Inscr.b.r.: *II*
M.P. 1200

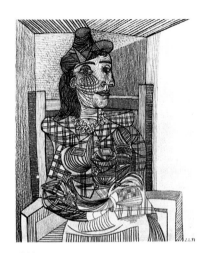

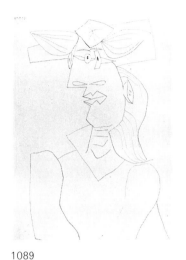

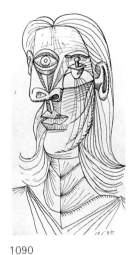

1088
Dora Maar assise
Dora Maar Seated
2 February 1938
Paris
Pastel, Indian ink and pencil on cardboard
27 × 21.9
D.b.r.: *2. 2. 38.*
Z. IX, 118
M.P. 1201

1089
Buste de femme au chapeau
Head and Shoulders of a Woman with a Hat
27 April 1938
Paris
Pen and Indian ink
77.3 × 56.5
D.a.l.: *27. 4. 38.*
Z. IX, 129
M.P. 1202

1090
Tête de femme
Head of a Woman
13 June 1938
Paris
Pen and Indian ink
46 × 24.5
D.b.r.: *13.6.38.*
Inscr. verso in pencil: *(V)*
Z. IX, 156
M.P. 1203

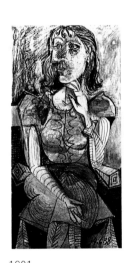

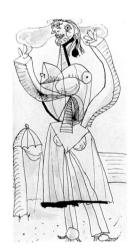

1091
Femme assise
Seated Woman
14 June 1938
Paris
Indian ink, pastel and coloured crayons
45.5 × 24
D.b.r.: *14.6.38*; verso in Indian ink: *PARIS/ 14.6.38.*
Z. IX, 149
M.P. 1204

1092
Femme debout sur la plage
Woman Standing on the Beach
20 June 1938
Paris
Indian ink and tinted wash
45.5 × 24.2
D.b.l.: *20.6.38.*
Z. IX, 166
M.P. 1205(r)

1092a
Femme sacrifiant une chèvre
Woman Sacrificing a Goat
1938
Paris
Pencil
24.2 × 45.5
Z. IX, 116
M.P. 1205(v)

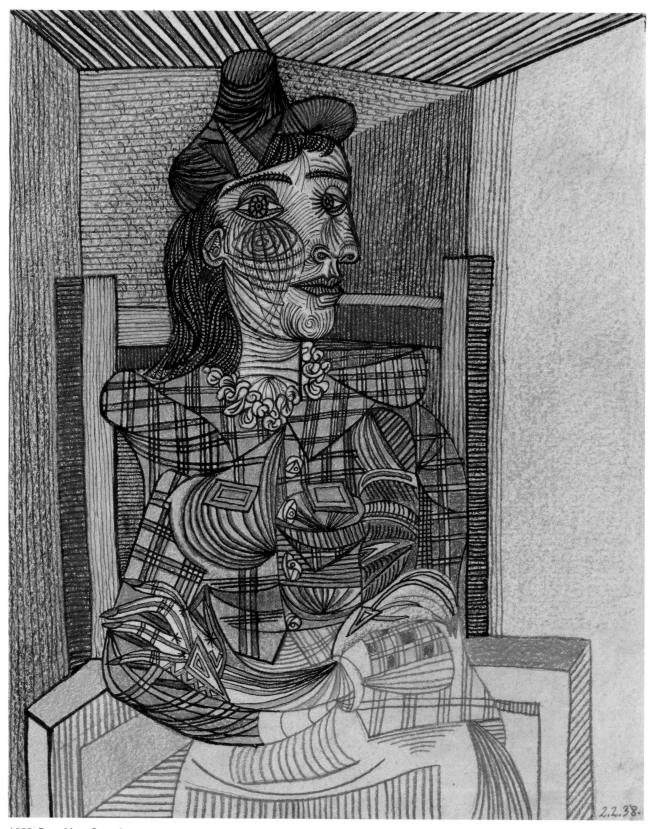

1088 Dora Maar Seated

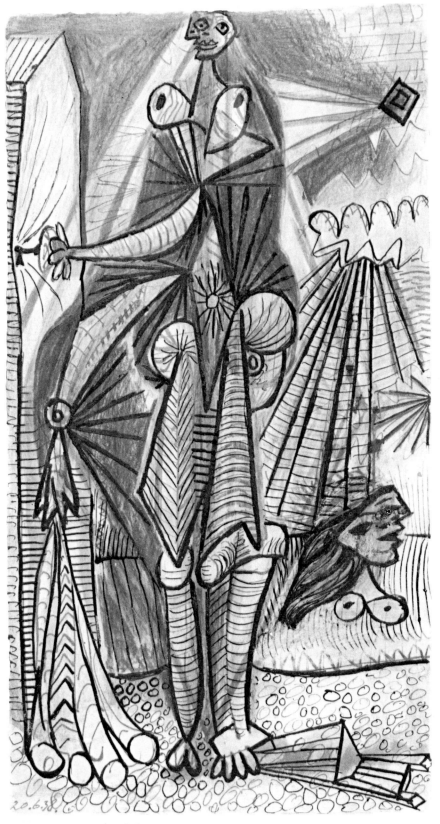

1093 Bathers by a Beach-hut

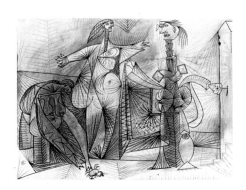

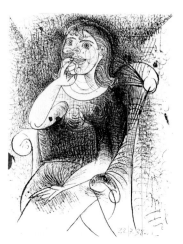

1093
Baigneuses à la cabine
Bathers by a Beach-hut
20 June 1938
Paris
Indian ink, coloured crayons and pencil
43.5 × 24.2
D.b.l.: *20.6.38.*; verso in Indian ink: *20.6.38.*
Z. IX, 164
M.P. 1206

1094
Baigneuses au crabe
Bathers with a Crab
10 July 1938
Mougins
Indian ink, gouache and rubbed petals
36.5 × 50.5
D.a.l.: *10.7.38.*
Z. IX, 172
M.P. 1207

1095
Femme dans un fauteuil
Woman in an Armchair
22 July 1938
Mougins
Pen and Indian ink on pencil outlines
27 × 20
D.b.r.: *22.7.38.*
Z. IX, 184
M.P. 1208

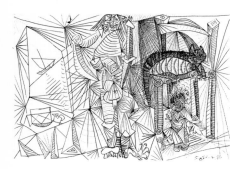

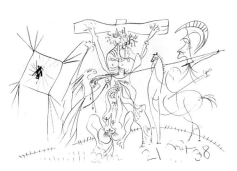

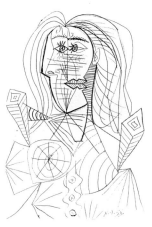

1096
Femme, chat sur une chaise et enfant sous la chaise
Woman, Cat on a Chair and Child under the Chair
5 August 1938
Pen and Indian ink
44.3 × 68
D.b.r.: *5.Août 38.*
Z. IX, 194
M.P. 1209

1097
La Crucifixion
The Crucifixion
21 August 1938
Mougins
Pen and Indian ink
44.5 × 67
D.b.r.: *21 Août 38*
Z. IX, 193
M.P. 1210

1098
Femme assise
Seated Woman
8 September 1938
Mougins
Pen and Indian ink
68 × 44.4
D.b.r.: *8.9.38.*
Z. IX, 221
M.P. 1211

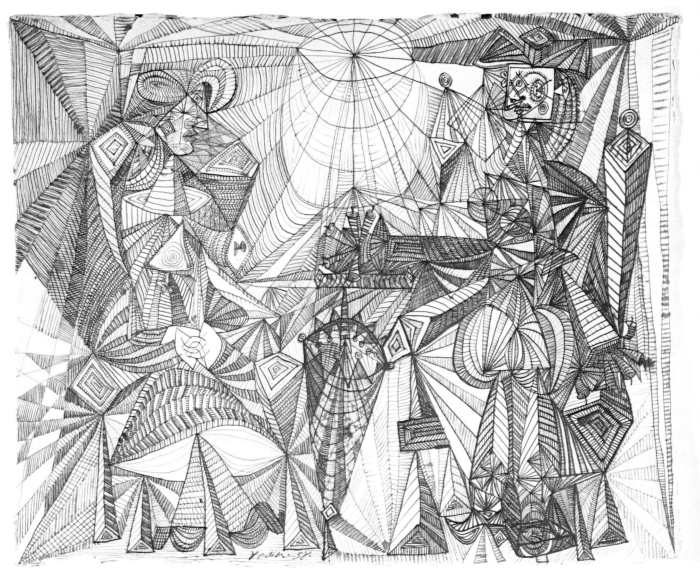

1100 Two Women with a Parasol

1099
Femme au chapeau assise
Seated Woman with a Hat
8 September 1938
Mougins
Pen and Indian ink
68 × 45.5
D.c.l.: *8.9.38.*
Z. IX, 219
M.P. 1212

1100
Deux femmes à l'ombrelle
Two Women with a Parasol
8 October 1938
[Mougins–Paris]
Pen, Indian ink and blue ink
44 × 54
D.c.b.: *8 octobre 38.*
Z. IX, 227
M.P. 1213

1101
Tête de femme
Head of a Woman
Paris
18 October 1938
Pencil
24.3 × 45.3
D.c.b.: *18 Octobre/38.*
M.P. 1214

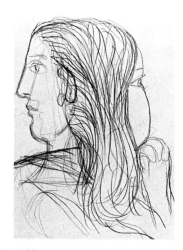

1102
Scène de plage
Beach Scene
24 December 1938
Paris
Pen, ink and pencil outlines on an opened-out cardboard box
15.3 × 12
D.c.b.l.: *24.12.38.*
M.P. 1215(r)

1102a
Paysage
Landscape
1938
Paris
Pen, ink and pencil outlines on an opened-out cardboard box
15.3 × 12
M.P. 1215(v)

1103
Tête de femme à double profil
Head of a Woman with Double Profile
[1938–1941]
Pencil on an invitation card for the Galerie Pierre, 1938
13.5 × 10.2
Z. IX, 278
M.P. 1239

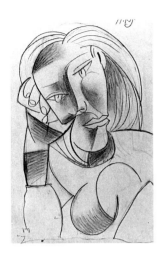

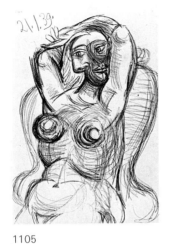

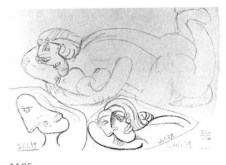

1104
Tête de femme appuyée sur une main
Woman Resting her Head on her Hand
14 January 1939
Paris
Pencil
43 × 29
D.a.r.: *14. 1. 39.*
Z. IX, 258
M.P. 1216

1105
Femme les bras croisés au-dessus de la tête
Woman with her Arms Crossed above her Head
21 January 1939
Paris
Pencil and black chalk
43 × 29
D.a.l.: *21.1.39.*
Z. IX, 259
M.P. 1217(r)

1105a
Etude pour 'Femme couchée lisant'
Study for 'Reclining Woman Reading'
20–21 January 1939
Paris
Pencil and black chalk
29 × 43
D.b.l.: *21.1.39* and b.r.: *21.1.39./20.1.39*
Z. IX, 246
M.P. 1217(v)

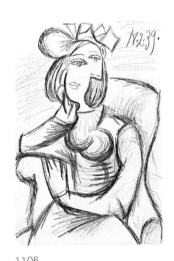

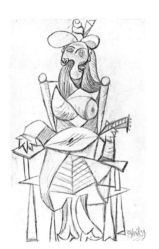

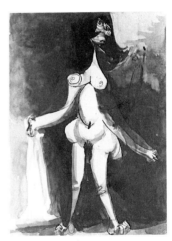

1106
Femme au chapeau assise dans un fauteuil
Woman with a Hat Seated in an Armchair
18 February 1939
Paris
Pencil
43 × 29
D.a.r.: *18.2.39.*
Z. IX, 254
M.P. 1218

1107
Femme assise à l'instrument de musique
Seated Woman Holding a Musical Instrument
1 April 1939
Paris
Pencil on cream paper
46 × 32
D.b.r.: *1er Avril 39.*
Z. IX, 285
M.P. 1219

1108
Nu debout
Standing Nude
19 July 1939
Antibes
Indian ink wash
64.5 × 45.5
D.a.r.: *19.7.39–*
Z. IX, 317
M.P. 1220

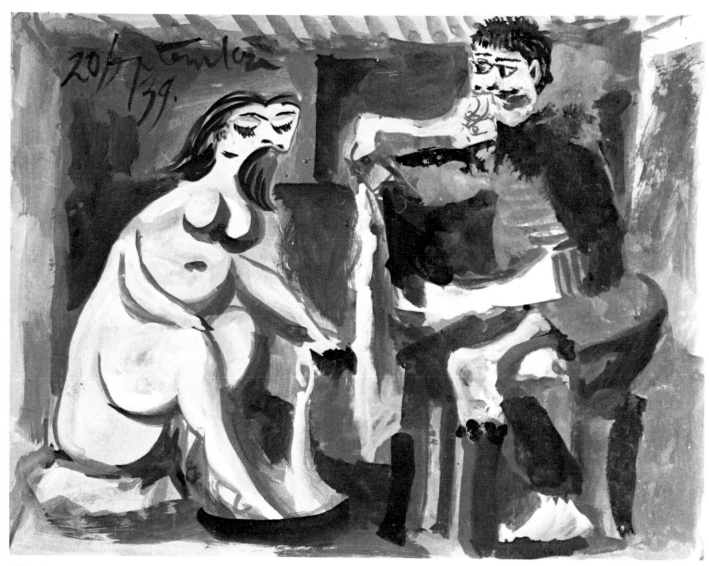

1109 Seated Man and Woman at her Toilette

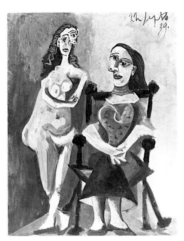

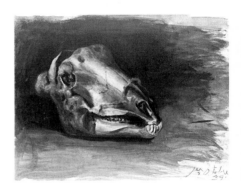

1109
Homme assis et femme à sa toilette
Seated Man and Woman at her Toilette
20 September 1939
Royan
Gouache and Indian ink on lined paper
21 × 27
D.a.l.: *20 Septembre/39.*; verso: *Royan/20 Septembre/39/(I)*
Z. IX, 331
M.P. 1221

1110
Femme nue debout et femme assise
Nude Woman Standing and Seated Woman
22 September 1939
Royan
Gouache
26.8 × 21
D.a.r.: *22 Septb/39.*
Z. IX, 339
M.P. 1222

1111
Crâne de mouton
Sheep's Skull
1 October 1939
Royan
Oil and Indian ink
46.2 × 65
D.b.r.: *1er Octobre/39.*
Z. IX, 348
M.P. 1223

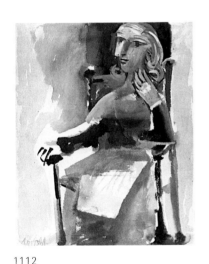

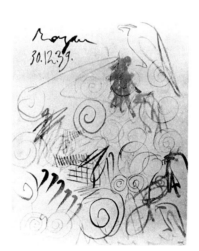

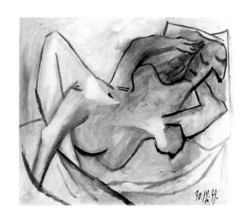

1112
Femme assise la main gauche sur la joue
Seated Woman, her Left Hand on her Cheek
30 December 1939
Royan
Indian ink and gouache
46.2 × 38.3
D.b.l.: *30.12.39.*
Z. IX, 385
M.P. 1224(r)

1112a
Feuille d'études: entrelacs et oiseaux
Various Studies: Interlaced Designs and Birds
30 December 1939
Royan
Indian ink and gouache
46.2 × 38.3
D.a.l.: *Royan/30.12.39.*
M.P. 1224(v)

1113
Nu allongé
Nude Stretched Out
30 December 1939
Royan
Gouache and tinted wash
38.3 × 46.1
D.b.r.: *30.12.39.*; verso: *Royan/30.12.39.*
M.P. 1225

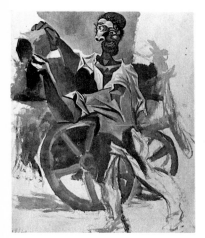

1114
L'éboueur
The Road-sweeper
8 January 1940
Royan
Gouache and pencil
46 × 38
D.b.l.: *8.1.40.*
Z. X, 196
M.P. 1227

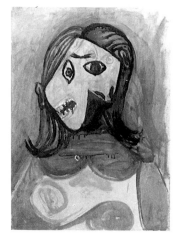

1115
Tête de femme
Head of a Woman
10 June 1940
Royan
Oil
63.5 × 45
D.c.r.: 10.6.40
Z. X, 525
M.P. 1228

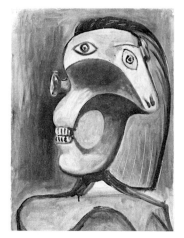

1116
Tête de femme
Head of a Woman
11 June 1940
Royan
Oil
64.8 × 45
D.a.l.: *11.6.40.*
Z. X, 526
M.P. 1229

1117
Ouvrières au travail
Women at Work
1940
[Paris]
Pencil on newspaper photographs
24.5 × 18
M.P. 1226

1118
Etude pour 'L'Aubade': femme nue étendue
Study for 'L'Aubade': Nude Woman Stretched Out
19 May 1941
Paris
Pencil
21 × 27
D.a.r.: *19.Mai.41.*
Z. XI, 121
M.P. 1230

1119
Etude pour 'L'Aubade': femme nue étendue
Study for 'L'Aubade': Nude Woman Stretched Out
19 May 1941
Paris
Pencil
21 × 27
D.a.r.: *19.Mai.41.*
Z. XI, 130
M.P. 1231

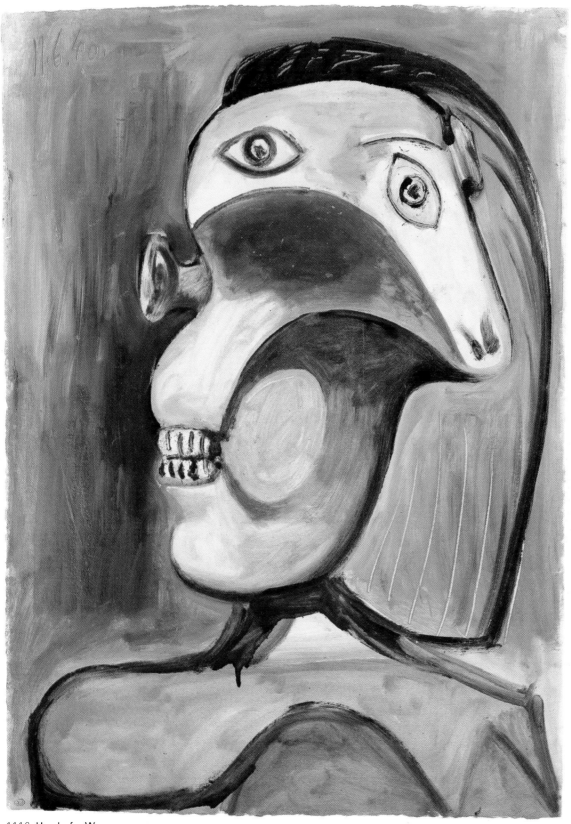

1116 Head of a Woman

1120
Etude pour 'L'Aubade': femme nue étendue
Study for 'L'Aubade': Nude Woman Stretched Out
19 May 1941
Paris
Pencil
21 × 27
D.a.r.: *19.Mai.41.*
Z. XI, 123
M.P. 1232

1121
Etude pour 'L'Aubade': femme nue étendue
Study for 'L'Aubade': Nude Woman Stretched Out
19 May 1941
Paris
Pencil
21 × 27
D.a.r.: *19.Mai.41.*
Z. XI, 127
M.P. 1233

1122
Etude pour 'L'Aubade': femme nue étendue
Study for 'L'Aubade': Nude Woman Stretched Out
20 May 1941
Paris
Pencil
21 × 27
D.b.l.: *20.Mai.41.*
Z. XI, 137
M.P. 1241

 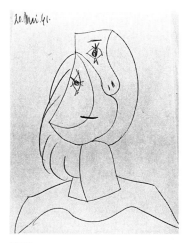

1123
Etude pour 'L'Aubade': tête
Study for 'L'Aubade': Head
20 May 1941
Paris
Pencil
27 × 21
D.a.l.: *20.Mai.41.*
Z. XI, 115
M.P. 1234

1124
Etude pour 'L'Aubade': tête
Study for 'L'Aubade': Head
20 May 1941
Paris
Pencil
27 × 21
D.a.l.: *20.Mai.41.*
Z. XI, 118
M.P. 1235

1125
Etude pour 'L'Aubade': tête
Study for 'L'Aubade': Head
20 May 1941
Paris
Pencil
27 × 21
D.a.l.: *20.Mai.41.*
Z. XI, 116
M.P. 1236

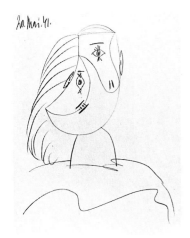

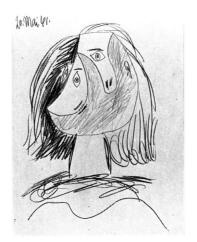

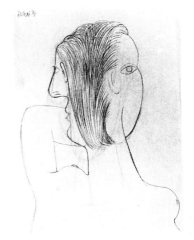

1126
Etude pour 'L'Aubade': tête
Study for 'L'Aubade': Head
20 May 1941
Paris
Pencil
27 × 21
D.a.l.: *20.Mai.41.*
Z. XI, 117
M.P. 1237

1127
Etude pour 'L'Aubade': tête
Study for 'L'Aubade': Head
20 May 1941
Paris
Pencil
27 × 21
D.a.l.: *20.Mai.41.*
Z. XI, 120
M.P. 1238

1128
Etude pour 'L'Aubade': tête de femme à double profil
Study for 'L'Aubade': Head of a Woman with Double Profile
20 May 1941
Paris
Pencil
27 × 21
D.a.l.: *20.mai.41.*
Z. XI, 119
M.P. 1240

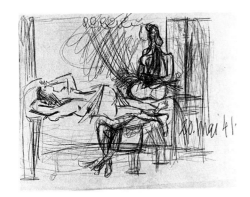

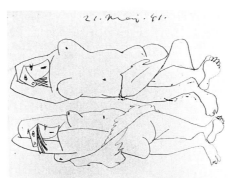

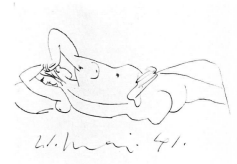

1129
Etude pour 'L'Aubade': femme nue étendue et femme nue assise
Study for 'L'Aubade': Nude Woman Stretched Out and Nude Woman Seated
20 May 1941
Paris
Pencil
21 × 27
D.b.r.: *20.Mai 41.*
Z. XI, 138
M.P. 1242

1130
Etude pour 'L'Aubade': deux femmes nues étendues
Study for 'L'Aubade': Two Nude Women Stretched Out
21 May 1941
Paris
Pen and black ink
21 × 27
D.c.a.: *21.Mai.41.*
Z. XI, 140
M.P. 1243

1131
Etude pour 'L'Aubade': femme nue étendue
Study for 'L'Aubade': Nude Woman Stretched Out
21 May 1941
Paris
Pen and black ink
21 × 27
D.c.b.: *21.Mai.41.*
Z. XI, 133
M.P. 1244

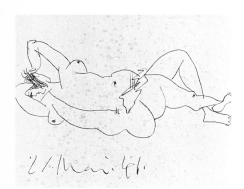

1132
Etude pour 'L'Aubade': femme nue étendue
Study for 'L'Aubade': Nude Woman Stretched Out
21 May 1941
Paris
Pen and black ink
21 × 27
D.b.l.: *21.Mai.41.*
Z. XI, 132
M.P. 1245

1133
Etude pour 'L'Aubade': femme nue étendue
Study for 'L'Aubade': Nude Woman Stretched Out
21 May 1941
Paris
Pen and black ink
21 × 27
D.a.r.: *21.Mai.41.*
Z. XI, 139
M.P. 1246

1134
Etude pour 'L'Aubade': deux femmes dans un intérieur
Study for 'L'Aubade': Two Women in an Interior
26 August 1941
Paris
Pencil
21 × 27
D.b.l.: *26 Août 41.*
Z. XI, 254
M.P. 1247

1135
Etude pour 'L'Aubade': deux femmes dans un intérieur
Study for 'L'Aubade': Two Women in an Interior
28 August 1941
Paris
Pencil
21 × 27
D.a.r.: *28 Août 41.*
Z. XI, 253
M.P. 1248

1136
Etude pour 'L'Aubade': le miroir
Study for 'L'Aubade': the Mirror
18 September 1941
Paris
Pen and black ink
21 × 27
D.c.a.: *18 septembre 41.*
Inscr.a.l.: *1*
Z. XI, 295
M.P. 1249

1137
Etude pour 'L'Aubade': le miroir
Study for 'L'Aubade': the Mirror
18 September 1941
Paris
Pen and black ink
21 × 27
D.b.: *18 septembre 41.*
Inscr.b.l.: *2*
Z. XI, 296
M.P. 1250

1138
Etude pour 'L'Aubade': le miroir
Study for 'L'Aubade': the Mirror
18 September 1941
Paris
Pen and black ink
21 × 27
D.b.l.: *18 septembre 41.*
Inscr.b.l.: *3*
Z. XI, 297
M.P. 1251

1139
Etude pour 'L'Aubade': le miroir
Study for 'L'Aubade': the Mirror
18 September 1941
Paris
Pen and black ink
21 × 27
D.b.l.: *18 septembre 41.*
Inscr.b.l.: *4*
Z. XI, 298
M.P. 1252

1140
Etude pour 'L'Aubade': le miroir
Study for 'L'Aubade': the Mirror
18 September 1941
Paris
Pen and black ink
21 × 27
D.b.l.: *18 septembre 41.*
Inscr.b.l.: *5*
Z. XI, 291
M.P. 1253

1141
Etude pour 'L'Aubade': le miroir
Study for 'L'Aubade': the Mirror
18 September 1941
Paris
Pen and black ink
21 × 27
D.b.l.: *18 septembre 41.*
Inscr.b.l.: *6*
Z. XI, 292
M.P. 1254

1142
Etude pour 'L'Aubade': le miroir
Study for 'L'Aubade': the Mirror
18 September 1941
Paris
Pen and black ink
21 × 27
D.b.l.: *18 septembre 41.*
Inscr.b.l.: *7*
Z. XI, 293
M.P. 1255

1143
Etude pour 'L'Aubade': le miroir
Study for 'L'Aubade': the Mirror
18 September 1941
Paris
Pen and black ink
21 × 27
D.b.l.: *18 septembre 41.*
Inscr.b.l.: *8*
Z. XI, 294
M.P. 1256

1144
Etude pour 'L'Aubade': le miroir
Study for 'L'Aubade': the Mirror
18 September 1941
Paris
Pen and black ink
21 × 27
D.b.l.: *18 septembre 41.*
Inscr.b.l.: *9*
Z. XI, 299
M.P. 1257

1145
Etude pour 'L'Aubade': le miroir
Study for 'L'Aubade': the Mirror
18 September 1941
Paris
Pen and black ink
21 × 27
D.b.l.: *18 septembre 41.*
Inscr.b.l.: *10*
Z. XI, 300
M.P. 1258

1146
Etude pour 'L'Aubade': le miroir
Study for 'L'Aubade': the Mirror
18 September 1941
Paris
Pen and black ink
21 × 27
D.b.l.: *18 septembre 41.*
Inscr.b.l.: *11*
Z. XI, 301
M.P. 1259

1147
Etude pour 'L'Aubade': le miroir
Study for 'L'Aubade': the Mirror
19 September 1941
Paris
Pen and black ink
21 × 27
D.b.l.: *19 septembre 41.*
Inscr.b.l.: *1*
Z. XI, 302
M.P. 1260

1148
Etude pour 'L'Aubade': le miroir
Study for 'L'Aubade': the Mirror
19 September 1941
Paris
Pen and black ink
21 × 27
D.b.l.: *19 septembre 41.*
Inscr.b.l.: *2*
Z. XI, 303
M.P. 1261

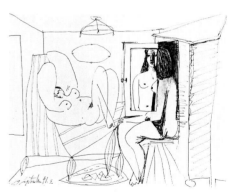

1149
Etude pour 'L'Aubade': le miroir
Study for 'L'Aubade': the Mirror
19 September 1941
Paris
Pen and black ink
21 × 27
D.b.l.: *19 septembre 41.*
Inscr.b.l.: *3*
Z. XI, 304
M.P. 1262

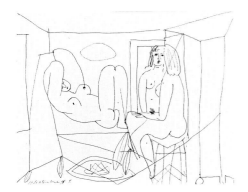

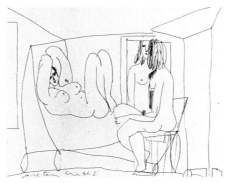

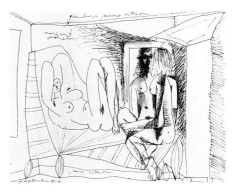

1150
Etude pour 'L'Aubade': le miroir
Study for 'L'Aubade': the Mirror
19 September 1941
Paris
Pen and black ink
21 × 27
D.b.l.: *19 septembre 41.*
Inscr.b.l.: *4*
Z. XI, 305
M.P. 1263

1151
Etude pour 'L'Aubade': le miroir
Study for 'L'Aubade': the Mirror
19 September 1941
Paris
Pen and black ink
21 × 27
D.b.l.: *19 septembre 41.*
Inscr.c.b.: *5*
Z. XI, 307
M.P. 1264

1152
Etude pour 'L'Aubade': le miroir
Study for 'L'Aubade': the Mirror
with handwritten notes showing colours to be used
19 September 1941
Paris
Pen and black ink
21 × 27
D.b.l.: *19 septembre 41.*
Inscr.b.l.: *6*
Z. XI, 306
M.P. 1265

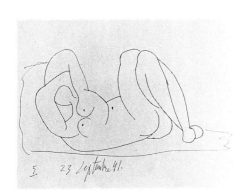

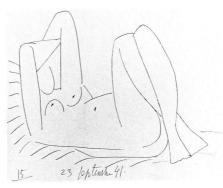

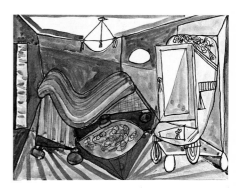

1153
Etude pour 'L'Aubade': femme nue étendue
Study for 'L'Aubade': Nude Woman Stretched Out
23 September 1941
Paris
Pen and black ink
21 × 27
D.b.l.: *23 septembre 41.*
Inscr.b.l.: *5*
Z. XI, 310
M.P. 1266

1154
Etude pour 'L'Aubade': femme nue étendue
Study for 'L'Aubade': Nude Woman Stretched Out
23 September 1941
Paris
Pen and black ink
21 × 27
D.b.l.: *23 septembre 41.*
Inscr.b.l.: *15*
Z. XI, 313
M.P. 1267

1155
Etude pour 'L'Aubade': intérieur à l'armoire à glace
Study for 'L'Aubade': Interior and Wardrobe with a Mirror
November 1941
Paris
Watercolour, Indian ink and pencil on a sheet from a sketchbook
30.5 × 41
Z. XI, 358
M.P. 1268

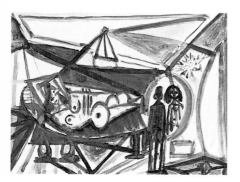

1156
Etude pour 'L'Aubade': deux femmes dans un intérieur
Study for 'L'Aubade': Two Women in an Interior
28 November 1941
Paris
Watercolour, Indian ink and pencil on a sheet from a sketchbook
30.5 × 41
Z. XI, 362
M.P. 1269

1157
Etude pour 'L'Aubade': deux femmes dans un intérieur
Study for 'L'Aubade': Two Women in an Interior
28 November 1941
Paris
Watercolour and Indian ink
24.5 × 30.5
D.b.l.: *28.11.41.*
Z. XI, 363
M.P. 1270

1158
Etude pour 'L'Aubade': femme nue étendue les bras derrière la tête
Study for 'L'Aubade': Nude Woman Stretched Out, Arms behind her Head
12 December 1941
Paris
Pastel, coloured crayons and pencil
27.2 × 35.3
D.c.a.: *12.D.41.*
M.P. 1278(r)

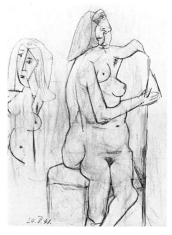

1158a
Etude pour 'L'Aubade': femme nue étendue
Study for 'L'Aubade': Nude Woman Stretched Out
12 December 1941
Paris
Pencil
27.2 × 35.3
D.c.a.: *12 Decembre/41.*
M.P. 1278(v)

1159
Etude pour 'L'Aubade': femme nue étendue
Study for 'L'Aubade': Nude Woman Stretched Out
12 December 1941
Paris
Pastel
27.5 × 35
D.a.r.: *12. D.41.*
M.P. 1279

1160
Nu assis et nu debout
Seated and Standing Nudes
24 December 1941
Paris
Pencil on a sheet from a sketchbook
41 × 30.5
D.b.l.: *24.D.41.*
M.P. 1280

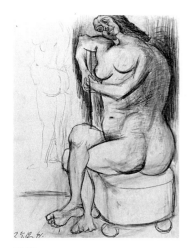

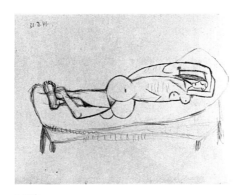

1161
Nu assis et nu debout
Seated and Standing Nudes
25 December 1941
Paris
Pencil on a sheet from a sketchbook
41 × 30.5
D.b.l.: *25.12.41.*
M.P. 1281

1162
**Etude pour 'L'Aubade': femme nue
étendue les bras derrière la tête**
*Study for 'L'Aubade': Nude Woman Stretched
Out, Arms behind her Head*
31 December 1941
Paris
Black chalk
21 × 27
D.a.l.: *31.D.41.*
Z. XI, 367
M.P. 1282

1163
Etude pour 'L'Aubade': intérieurs
Study for 'L'Aubade': Interiors
1941
Paris
Pencil
27 × 21
Inscr.a.l.: *1*
M.P. 127$\overline{1}$(r)

1163a
Poêle
Stove
1941
Paris
Pencil
27 × 21
M.P. 1271(v)

1164
Etude pour 'L'Aubade': méridiennes
Study for 'L'Aubade': Sofas
1941
Paris
Pencil
21 × 27
Inscr.a.l.: *2*
M.P. 127$\overline{2}$

1165
Etude pour 'L'Aubade': méridiennes
Study for 'L'Aubade': Sofas
1941
Paris
Pencil
21 × 27
Inscr.a.l.: *3*
M.P. 127$\overline{3}$

1166
Etude pour 'L'Aubade': méridiennes
Study for 'L'Aubade': Sofas
1941
Paris
Pencil
21 × 27
Inscr.a.l.: *4*
M.P. 1274

1167
Etude pour 'L'Aubade': armoire à glace, méridienne et femme nue étendue
Study for 'L'Aubade': Wardrobe with Mirror, Sofa and Nude Woman Stretched Out
1941
Paris
Pencil
21 × 27
Inscr.a.l.: *5*
M.P. 1275

1168
Etude pour 'L'Aubade': nus et méridienne
Study for 'L'Aubade': Nudes and Sofa
1941
Paris
Gouache on an envelope addressed to Picasso by Jean Paulhan
17.1 × 30.3
M.P. 1276(r)

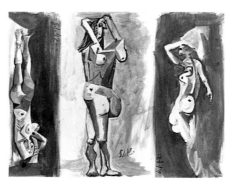

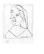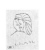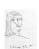

1168a
Etude pour 'L'Aubade': intérieur et méridiennes
Study for 'L'Aubade': Interior and Sofas
1941
Paris
Pencil and coloured crayon on a beige envelope
17.1 × 30.3
M.P. 1276(v)

1169
Etude pour 'L'Aubade': trois femmes nues
Study for 'L'Aubade': Three Nude Women
5, 6 and 8 January 1942
Paris
Gouache on a sheet from a sketchbook
30.3 × 40.5
D.a.l.: *8.1.42.*; b.r.: *5.1.42.*; a.l.: *6.1.42.*
(corresponding to the three drawings)
Z. XII, 2
M.P. 1283

1170
Etude pour 'L'Aubade': têtes de femme
Study for 'L'Aubade': Heads of a Woman
3 May 1942
Paris
10 studies in pen and ink, 13.3 × 10.7, dated *3 mai 42* and numbered from *(I)* to *(X)*
M.P. 1284

1170 Study for 'L'Aubade': Heads of a Woman

1171
'L'Aubade'
'L'Aubade'
5 May 1942
Paris
Pen and ink on lined paper
10.7 × 13.2
D.c.a.: *5 mai 42*
Z. XII, 67
M.P. 1285

1172
Etude pour 'L'homme au mouton'
Study for 'Man with a Sheep'
15 July 1942
Paris
Pencil
D.b.r.: *15 juillet 42.*
Z. XII, 89
M.P. 1286

1173
Etude pour 'L'homme au mouton'
Study for 'Man with a Sheep'
16 July 1942
Paris
Pencil
33.5 × 21.5
D.b.r.: *16 juillet 42*
Z. XII, 91
M.P. 1287

1174
Etude pour 'L'homme au mouton'
Study for 'Man with a Sheep'
16 July 1942
Paris
Pencil
33.5 × 22
D.b.r.: *16 juillet 42.*
Z. XII, 93
M.P. 1288

1175
Etude pour 'L'homme au mouton'
Study for 'Man with a Sheep'
16 July 1942
Paris
Indian ink
33.5 × 21.5
D.a.l.: *16 Juillet 42.*
Z. XII, 87
M.P. 1289

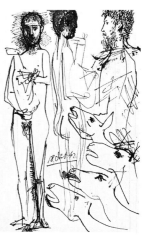

1176
Etudes pour 'L'homme au mouton'
Studies for 'Man with a Sheep'
18 August 1942
Paris
Pen and Indian ink
33.3 × 21.5
D.c.: *18.Août.42.*
Z. XII, 117
M.P. 1290

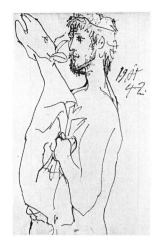

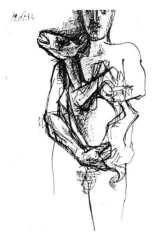

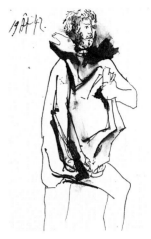

1177
Etude pour 'L'homme au mouton'
Study for 'Man with a Sheep'
19 August 1942
Paris
Pen and Indian ink
33.5 × 21.7
D.c.r.: *19 Ât/42.*
Z. XII, 116
M.P. 1292

1178
Etude pour 'L'homme au mouton'
Study for 'Man with a Sheep'
19 August 1942
Paris
Pen and Indian ink
33.5 × 21.5
D.a.l.: *19 Ât/42.*
Z. XII, 118
M.P. 1293

1179
Etude pour 'L'homme au mouton'
Study for 'Man with a Sheep'
19 August 1942
Paris
Pen, Indian ink and tinted wash
33.5 × 21.6
D.a.l.: *19 Ât 42.*
Z. XII, 120
M.P. 1291

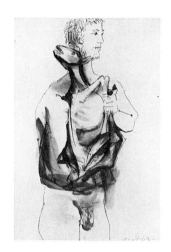

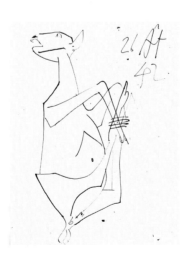

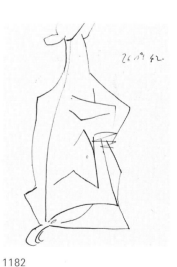

1180
Etude pour 'L'homme au mouton'
Study for 'Man with a Sheep'
20 August 1942
Paris
Indian ink and tinted wash
68 × 44.5
D.b.r.: *20 Ât 42.*
Z. XII, 127
M.P. 1294

1181
Etude pour 'L'homme au mouton': le mouton
Study for 'Man with a Sheep': the Sheep
26 August 1942
Paris
Pen and Indian ink on squared paper
27 × 21
D.a.r.: *26 Ât/42.*
M.P. 1295

1182
Etude pour 'L'homme au mouton': le mouton
Study for 'Man with a Sheep': the Sheep
26 August 1942
Paris
Pen and Indian ink on squared paper
27 × 21
D.a.r.: *26 Ât 42.*
M.P. 1296

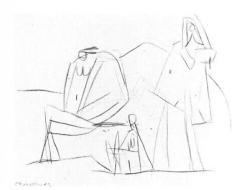

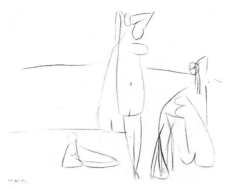

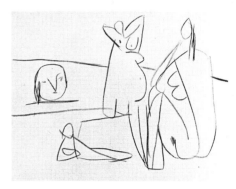

1183
Baigneuses
Bathers
14 September 1942
Paris
Coloured crayons on squared paper
21 × 27
D.b.l. in pencil: *14 Septbre 42*
Inscr. verso: *1*
Z. XII, 151
M.P. 1297

1184
Baigneuses
Bathers
14 September 1942
Paris
Coloured crayons on squared paper
21 × 27
D.a.l. in pencil: *14 Sept 42*
Inscr. verso: *2*
Z. XII, 146
M.P. 1298

1185
Baigneuses
Bathers
14 September 1942
Paris
Coloured crayons on squared paper
21 × 27
D.b.l. in pencil: *14 Sept 42*
Inscr. verso: *3*
Z. XII, 147
M.P. 1299

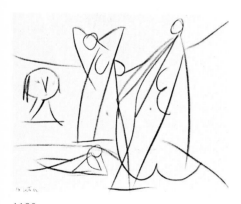

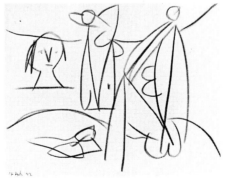

1186
Baigneuses
Bathers
14 September 1942
Paris
Coloured crayons on squared paper
27 × 27
D.b.l. in pencil: *14 Sept 42*
Inscr. verso: *4*
Z. XII, 143
M.P. 1300

1187
Baigneuses
Bathers
14 September 1942
Paris
Coloured crayons on squared paper
21 × 27
D.b.l. in pencil: *14 Sept 42*
Inscr. verso: *5*
Z. XII, 149
M.P. 1301

1188
Baigneuses
Bathers
14 September 1942
Paris
Coloured crayons on squared paper
21 × 27
D.b.l.: *14 Sept 42*
Inscr. verso: *6*
Z. XII, 148
M.P. 1302

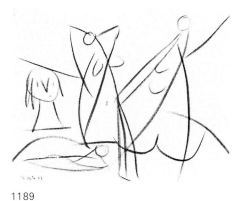

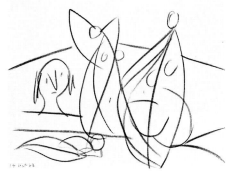

1189
Baigneuses
Bathers
14 September 1942
Paris
Coloured crayons on squared paper
21 × 27
D.b.l. in pencil: *14 Sept 42*
Inscr. verso: *7*
Z. XII, 142
M.P. 1303

1190
Baigneuses
Bathers
14 September 1942
Paris
Coloured crayons on squared paper
21 × 27
D.b.l.: *14 Sept 42*
Inscr. verso: *8*
Z. XII, 144
M.P. 1304

1191
Baigneuses
Bathers
14 September 1942
Paris
Coloured crayons on squared paper
21 × 27
D.b.l.: *14 Sept 42*
Inscr. verso: *9*
Z. XII, 145
M.P. 1305

1192
Femme nue; Etude pour 'L'homme au mouton'
Nude Woman; Study for 'Man with a Sheep'
19 September 1942
Paris
Indian ink
68 × 44.6
D.c.b: *Samedi 19 Septembre 42.*
Z. XII, 152
M.P. 1306

1193
Etude pour 'L'homme au mouton'
Study for 'Man with a Sheep'
6 October 1942
Paris
Indian ink and gouache on parchment
28.4 × 21.5
D.a.r.: *6.Octobre/42*
Z. XII, 139
M.P. 1307

1194
Pigeon
Pigeon
4 December 1942
Paris
Indian ink and gouache
64 × 45.9
D.b.r.: *4 D 42*
Z. XII, 179
M.P. 1308

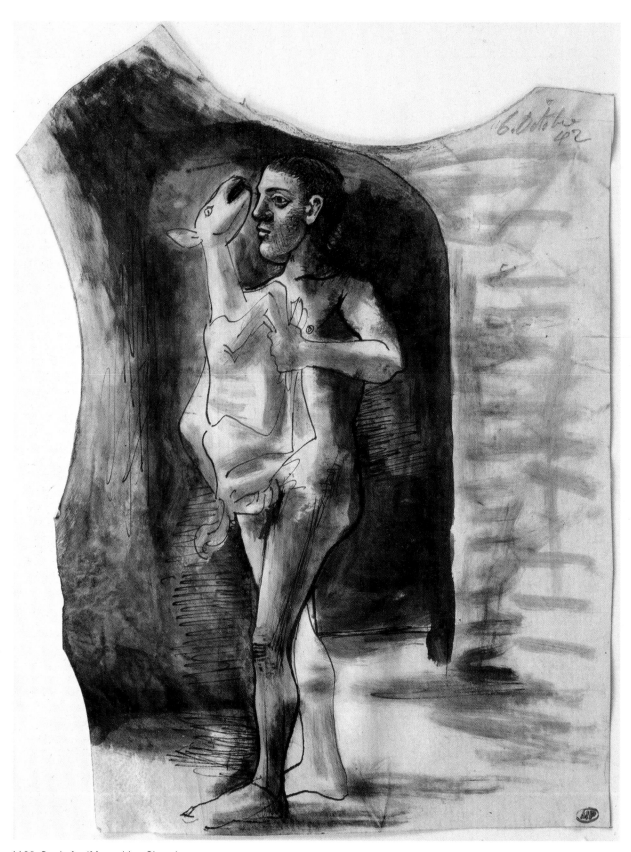

1193 Study for 'Man with a Sheep'

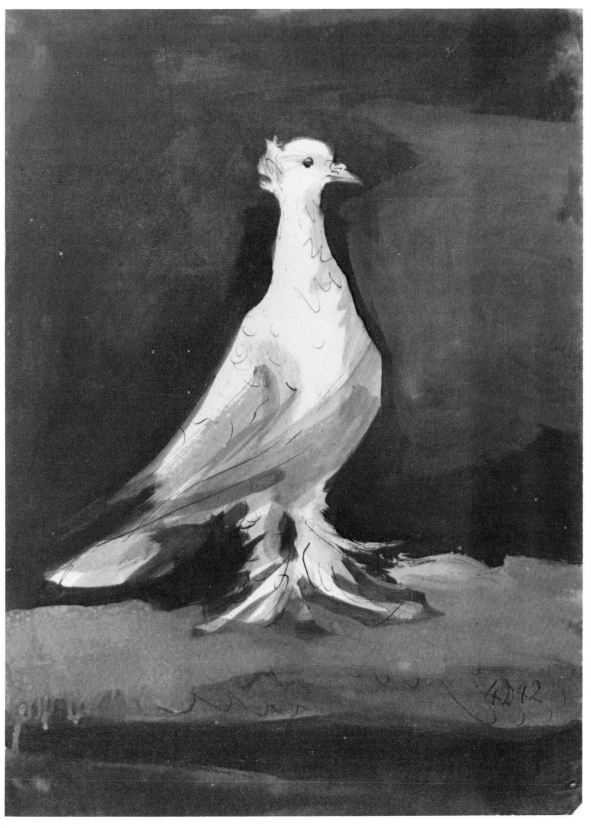

1194 Pigeon

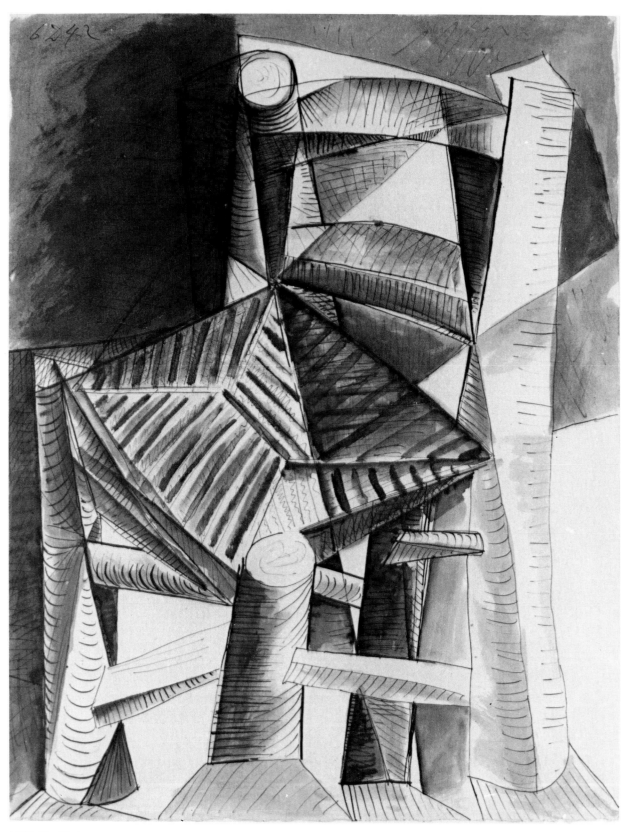

1196 **The Chair**

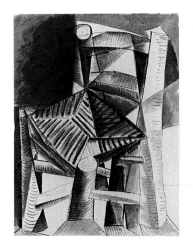

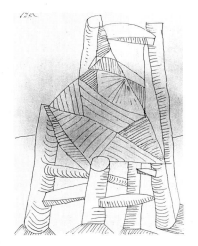

1195
Pigeons
Pigeons
4 December 1942
Paris
Indian ink and tinted wash
64 × 45.8
D.a.r.: *4 D 42*
Z. XII, 180
M.P. 1309

1196
La chaise
The Chair
6 December 1942
Paris
Indian ink
65.5 × 50.5
D.a.l.: *6 D 42*
Z. XII, 177
M.P. 1310

1197
La chaise
The Chair
6 December 1942
Paris
Pen and Indian ink
65.5 × 50.5
D.a.l.: *6 D 42*
Z. XII, 176
M.P. 1311

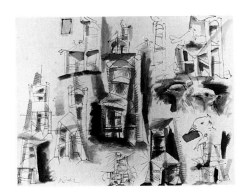

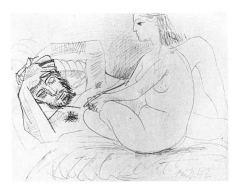

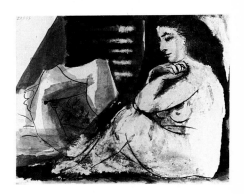

1198
Feuille d'études: chaises et pigeons
Various Studies: Chairs and Pigeons
8 December 1942
Paris
Pen, Indian ink and tinted wash
55 × 65.7
D.b.l.: *8 D 42*
Z. XII, 178
M.P. 1312

1199
Femme nue assise contemplant un homme endormi
Seated Nude Woman Gazing at a Sleeping Man
16 December 1942
Paris
Pen and Indian ink wash
50.7 × 65.7
D.b.r.: *16.D.42.*
Z. XII, 197
M.P. 1313

1200
Femme nue assise contemplant un homme endormi
Seated Nude Woman Gazing at a Sleeping Man
20 January (?) 1943
Indian ink with scraping
49 × 65
D.a.l.: *20 j. 43*
Z. XII, 219
M.P. 1327

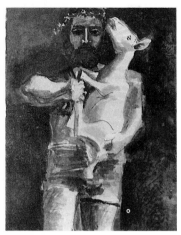

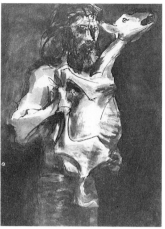

1201
Etude pour 'L'homme au mouton'
Study for 'Man with a Sheep'
13 February 1943
Paris
Indian ink and gouache
65.2 × 49.6
D.b.r.: *13. F 43*
Z. XII, 240
M.P. 1314(r)

1201a
Etude pour 'L'homme au mouton'
Study for 'Man with a Sheep'
1943
Paris
Indian ink and gouache
65.2 × 49.6
M.P. 1314(v)

1202
Etude pour 'L'homme au mouton'
Study for 'Man with a Sheep'
13 February 1943
Paris
Indian ink and tinted wash
66 × 50.2
D. verso: *19 F 43*
Z. XII, 238
M.P. 1315

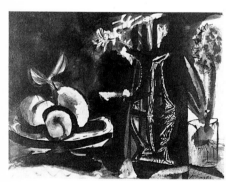

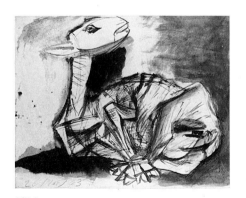

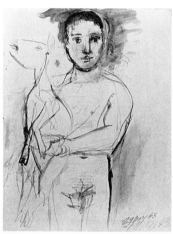

1203
Nature morte aux fruits et aux fleurs
Still-life with Fruit and Flowers
1 March 1943
Paris
Indian ink wash
50.5 × 65.5
D.b.r.: *1er Mars 43*
Z. XII, 254
M.P. 1316

1204
Etude pour 'L'homme au mouton': le mouton
Study for 'Man with a Sheep': the Sheep
26 March 1943
Paris
Indian ink with scraping
50.5 × 66
D.b.l.: *26 Mars 43*
Z. XII, 299
M.P. 1317

1205
Etude pour 'L'homme au mouton'
Study for 'Man with a Sheep'
27–29 March 1943
Paris
Indian ink wash with rubbing
66 × 50
D.b.r.: *29 Mars 43/27 Mars 43*
Z. XII, 298
M.P. 1318

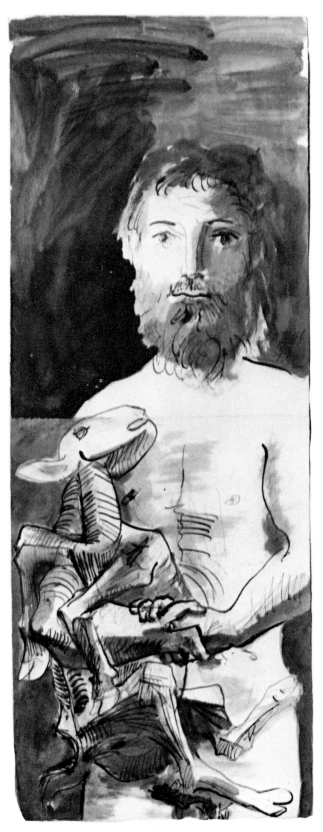

1206 Study for 'Man with a Sheep'

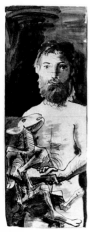

1206
Etude pour 'L'homme au mouton'
Study for 'Man with a Sheep'
30 March 1943
Paris
Indian ink and tinted wash on two sheets
pieced together
130.5 × 50.7
D.b.l.: *30 Mars/43*
Z. XII, 241
M.P. 1319

1207
Femme au chapeau
Woman with a Hat
30 March 1943
Paris
Indian ink wash and gouache
66 × 50.5
D.b.r.: *30 Mars/43*
Z. XII, 312
M.P. 1320

1208
Femme au chapeau
Woman with a Hat
31 March 1943
Paris
Pen and Indian ink
66 × 50.5
D.b.r.: *31 Mars 43*
Z. XII, 308
M.P. 1321

1209
Femme au chapeau
Woman with a Hat
31 March 1943
Paris
Indian ink and tinted wash
66 × 50.5
D.a.r.: *31 Mars 43*
Z. XII, 318
M.P. 1322

1210
Etude pour 'L'homme au mouton': le mouton
Study for 'Man with a Sheep': the Sheep
31 March 1943
Paris
Gouache, Indian ink and Indian ink wash
65.6 × 50.5
D.b.r.: *31 Mars 43*
Z. XII, 306
M.P. 1323

1211
Tête de femme
Head of a Woman
3 June 1943
Paris
Oil
66 × 50.5
D.b.l.: *3 Juin 43*
Inscr.b.l.: *I*
Z. XIII, 29
M.P. 1324

1212
Tête de femme
Head of a Woman
3 June 1943
Paris
Oil
66 × 50.5
D.b.r.: *3 Juin 43*
Inscr.b.r.: *II*
Z. XIII, 30
M.P. 1325

1213
Tête de femme
Head of a Woman
3 June 1943
Paris
Oil
66 × 50.5
D.b.r.: *3 Juin 43*
Inscr.b.l.: *III*
Z. XIII, 31
M.P. 1326

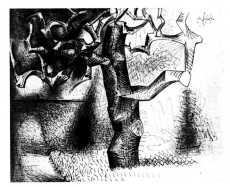

1214
L'arbre
The Tree
4 January 1944
Paris
Indian ink and tinted wash
50.5 × 65.5
D.a.r.: *4 Jr 44*
Z. XIII, 211
M.P. 1331

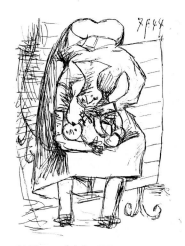

1215
Femme allaitant son enfant
Woman Breastfeeding her Child
7 February 1944
Paris
Black ink on brown paper
32.5 × 25.3
D.a.r.: *7.F.44.*
Z. XIII, 231
M.P. 1328

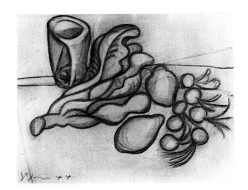

1216
Nature morte
Still-life
8 June 1944
Paris
Charcoal
50.5 × 65.5
D.b.l.: *8 juin 44*
M.P. 1329

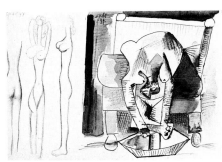

1217
Nus et femme se lavant les pieds
Nudes and Woman Washing her Feet
6 and 8 July 1944
Paris
Indian ink, tinted wash and pencil
33 × 50.5
D.a.l.: *8 juillet 44*; and c.a.: *6 Juillet/44*
Z. XII, 325
M.P. 1330

1214 The Tree

1218
Coq
Cockerel
[Spring] 1945
Paris
Pen and Indian ink on the back of an
invitation card for the Galerie René Drouin,
February 1945
14 × 11.5
M.P. 1335

1219
Tête de coq
Head of a Cockerel
[Spring] 1945
Paris
Pen and Indian ink on the back of an
invitation card for the Galerie René Drouin,
February 1945
14 × 11.5
M.P. 1334

1220
Tête de coq à la croix de Lorraine
Head of a Cockerel with the Cross of Lorraine
[Spring] 1945
Paris
Indian ink on the back of an invitation card
for the Galerie René Drouin, February 1945
14 × 11.5
M.P. 1332

1221
Tête de coq à la croix de Lorraine
Head of a Cockerel with the Cross of Lorraine
[Spring] 1945
Paris
Indian ink on the back of an invitation card
for the Galerie René Drouin, February 1945
14 × 11.5
M.P. 1333

1222
Coq tricolore à la croix de Lorraine
*Tricoloured Cockerel with the Cross of
Lorraine*
[Spring] 1945
Paris
Pen, Indian ink and watercolour, with tracing
paper pasted down the centre
32.5 × 26
D.verso in pencil: *1945*
M.P. 1336

La femme fleur, la joie de vivre
1945–1954

Fig. 1
La femme fleur (*Flower-woman*),
1946. New York,
Françoise Gilot Collection

'The Bacchanalia after Poussin (unknown collection), painted on 24 and 29 August 1944, expresses an outburst of joy doubtless intended to mark the end of an era of war and the gateway to another world of rediscovered *Joie de vivre*. The youthful beauty and physique of Françoise are evident in the undeniably Matisse-like cycle of the *Femme fleur*.' Thus wrote Dominique Bozo.[1] *La femme-fleur* (*Flower-woman*) is the title of the superb portrait of Françoise Gilot painted on 5 May 1946,[2] the genesis of which she herself has described.[3] *La joie de vivre* is a large fresco at Antibes. It is these works which distinguish the post-war period, a time when Picasso was also obliged to confront distressing political and emotional problems. The young artist whom he met in the spring of 1943 gradually became part of his life, as told in her own story.[4] Françoise played a prominent role from April 1946, although her presence can be detected in certain drawings dating from the end of the Occupation.

Regrettably the museum holds very few portraits of the children Françoise bore Picasso; Claude was born in May 1947 and Paloma (cat. 1303) in April 1949. It does, however, possess an exceptionally rich collection of portraits of their mother. Picasso used fine lines to trace Françoise's beautiful oval face framed by curling hair in a drawing dated 21 April 1946 (cat. 1227). The well-proportioned mouth, aquiline nose and large eyes are all clearly defined. Her gaze is given extra intensity and diversity by the use of crayon encircling the iris and extending differently into each upper lid. Picasso noted the exact times of completion[5] on a series of rapidly drawn sketches produced the following day (cat. 1228–1234). A more detailed drawing done in coloured crayons (cat. 1236) shows Françoise lost in thought, her face resting on her hand. The model is depicted the following month (cat. 1252) in a different style, but the well-moulded features are once more in evidence, together with the free, decorative design accompanying her portrait. The series *Françoise au bandeau* (*Françoise with a Bandage*, cat. 1253–1257) should also be mentioned at this point. It was drawn at a time when she was wearing a dressing on an abscess which threatened to disfigure her face. At the same time Picasso produced a series of nudes, using coloured crayons on large sheets of Arches paper

(1) Picasso, *Œuvres reçues en paiement des droits de succession*, Paris, 1979, p. 197.

(2) Zervos XIV, 167. See fig. 1.

(3) F. Gilot and Carlton Lake, *Life with Picasso*, pp. 110–113.

(4) Ibid.

(5) Claude Picasso questioned his mother on this subject and was then able to explain that the two painters had held a competition that day to compare how long it took each of them to complete a drawing.

Fig. 2
Françoise Gilot in front
of her portrait in the
museum in Antibes,
1952
(Photo Denise Colomb)

Fig. 3
Picasso in front of *Nature morte à l'aiguière*
(*Still-life with Ewer*) in the museum in
Antibes, 1946
(Photo Michel Sima)

(cat. 1240–1251). In each work the model's anatomy is strongly defined with a minimum of lines and marks, like those depicting the face. The image of the woman he loved is also present in other drawings such as *La femme au vase de fleurs* (*Woman with a Vase of Flowers*, cat. 1262–1265) and those carried out during the stay in Antibes.

'Surfaces! Do you want surfaces? I can let you have them!'[6] With these words Romuald Dor de la Souchère, Curator of the Château d'Antibes, offered Picasso rooms which could potentially be transformed into vast studios. For six months the artist laboured there day and night, leaving the museum paintings and drawings from the Antibes series produced during that period.[7]

'Just imagine – he [Picasso] has bought a ewer. I don't know what he wants to do with it, or where he dug it out. It's completely worthless . . . but you wouldn't believe what a marvel he's produced from it,' wrote Marie Cuttoli to Jaime Sabartés.[8] The vessel is one of the objects featured in the large *Nature morte à la bouteille, à la sole et à l'aiguière* (*Still-life with Bottle, Sole and Ewer*) held in the Musée Picasso, Antibes, in front of which Michel Sima photographed the artist (fig. 3). The origin of the star-spangled design, appearing on two of the drawings in the museum's collection (cat. 1266, 1267) is also suggested by Marie Cuttoli:[9]

(6) Dor de la Souchère, *Picasso*, Paris, 1962.

(7) See D. Giraudy, *L'œuvre de Picasso à Antibes, catalogue raisonné du Musée*, Antibes, 1981.

(8) J. Sabartés, 'Picasso au travail' in *Picasso à Antibes*, photographs by Michel Sima with text by Paul Eluard and an introduction by Jaime Sabartés, Paris, 1948, pp. 17–18.

(9) Ibid., p. 18.

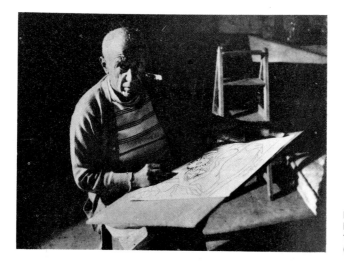

Fig. 4
Picasso drawing in the Château d'Antibes,
1946
(Photo Michel Sima)

'Picture it – everything in his room is painted: the walls, the wardrobe, the bedside table. It's an absolute nightmare, nothing but stars and little flowers everywhere.'[10]

The wounded owl which Michel Sima found in the garden[11] appears in various studies as a shrivelled ball with a piercing gaze (cat. 1275). It also makes its way into still-life compositions and is used as a subject for pottery (cat. I, 443). 'It's strange – in Paris I never draw fauns, centaurs or heroes from mythology, like these. It's as if they only live here,' declared the artist in Antibes.[12]

During his stay there the previous year Picasso had drawn a *Faune musicien et danseus* (*Faun Musician and Dancer*, cat. 1223). In the summer of 1946 he created a series of female centaurs and fauns, mythical beings from the Mediterranean which are associated with Françoise. Like the Musée d'Antibes, the Paris collection includes drawings on these themes (cat. 1268–1273).

'Landscapes are rarely represented in Picasso's work, which is fundamentally humanist, but his personal intervention is unfailingly well judged, usually in direct relation to his existence and activities of the moment,' writes Jean Leymarie.[13] He is referring to *La Galloise à Vallauris* (*La Galloise at Vallauris*, cat. 1283). La Galloise was the house in which Picasso lived from 1948 to 1954. It was situated near the workshops where he began to devote himself to ceramics, and so 'resurrected the ancient tradition of the all-round artist', in the words of Hélène Seckel.[14] These works are presented in the first volume of the catalogue.[15] The collection of graphic art does not contain studies directly related to the ceramics, although it does feature drawings which are unquestionably linked to them. *Le chevalier et le page* (*The Knight and the Page*, cat. 1291) was drawn the day before Picasso dated a ceramic plate on the same theme (fig. 10). Like the plate, the finely executed Indian ink drawing forms part of a series carried out during the same week (cat. 1289, 1290). *Le Jugement de Paris* (*The Judgment of Paris*, cat. 1293) took the artist eight days to complete; the dates are noted on the work. It is drawn in a style similar to *Le chevalier et le page*, but minutely detailed down to the very last touches. Did Picasso's encounter with Cranach's *David and Bathsheba* inspire him to take an interest in tournaments and dress his figures in period costume, one wonders.

One of the collection's examples of a composition created from a reworked, embellished lithograph is *La femme au miroir* (*Woman with a Mirror*, cat. 1288), a theme dear to the artist since his Rose Period. Picasso's confrontation with the Old Masters is exemplified by *Le portement de croix d'après le retable de Saint Thomas de Maître Francke* (*Bearing the Cross, after the Saint Thomas Altarpiece by Master Francke* (cat. 1292), a work given to the museum by Marina Ruiz-Picasso.

This period sees Picasso returning to sculpture in an intense bout of renewed activity, which resulted in such works as *La chèvre* (*The Goat*), *La femme à la poussette* (*Woman with a Pushchair*) and *La petite fille sautant à la corde* (*Little Girl Skipping*).[16] Drawings preceding the sculptures or recording their image are less numerous than in the Boisgeloup period. The fine Indian ink lines used to define the form of *La grue* (*The Crane*) do, however, suggest a link with the sculpture (fig. 11).

Picasso's affiliation to the Communist Party in the autumn of 1944 had attracted much publicity. No drawing immediately related to the event is held in the museum, although the portraits of Paul Langevin at the time of his death provide evidence of the artist's connection with that circle (cat. 1225, 1226).

At this point mention should be made of the homage to Stalin for his seventieth birthday (cat. 1284–1286). 'He drew a hand raising a glass, a hand such as he alone can draw, and wrote *Your Health, Comrade Stalin*. Believers winced at such lack of respect but Thorez and Casanova delight in the artist's good will, which is quite sufficient for them,' wrote Pierre Daix.[17] A drawing produced in September with Françoise's features, entitled *Le visage de la paix* (*The Face of Peace*, cat. 1294), was used to illustrate Eluard's work of the same name.[18]

During this period Picasso embarked upon the preparatory work for two large compositions intended for a deconsecrated chapel in Vallauris. He filled notebooks with sketches and rough drawings of this hymn to war and peace, only to improvise and alter his plans on the actual site. Before being installed in 1954 the enormous panels, measuring over 10 metres wide and 4 metres high, were put on show at the big retrospective exhibition held in Rome and Milan in 1953 (see fig. 5).

(10) Ibid.

(11) Ibid., pp. 33–34.

(12) Quoted by Jean Leymarie, *Picasso, Métamorphoses et unité*, p. 141.

(13) J. Leymarie, *Picasso, dessins*, p. 81.

(14) H. Seckel, 'Ceramics', cat. I, p. 199.

(15) Cat. I, pp. 198–227.

(16) See cat. I, p. 145 and pp. 180–187.

(17) P. Daix, *La vie de peintre de Pablo Picasso*, p. 343. He adds a footnote: 'Published by *La Défense*, the newspaper championing the people's rights, on 21 December 1949. The disrespect contrasted strongly with the adoration expressed by the party as a whole.'

(18) P. Eluard, *Le visage de la paix*, Paris, 1951.

'I have always sought for the real in reality. If someone wants to depict war it would be more elegant, more poetic to use a bow and spade because this is more aesthetic, but when I want to show war, I use a machine-gun.' These words attributed to Picasso[19] could be applied to his images of war (cat. 1295, 1296), while the little girls dancing (cat. 1300, 1301) are a harbinger of peace.

The small composition entitled *Chat devorant un coq (Cat Devouring a Cockerel)* drawn in December 1953 bears the same characteristics as the work produced on the eve of the war in 1939 (see cat. I, 155), and appears to express political or emotional anxieties.

(19) 'Conversations with Picasso' by Jérôme Seckler, *New Masses Magazine*, New York, March 1945.

Fig. 5
Picasso exhibition in Milan, 1953: *La guerre et la paix* (*War and Peace*)
(Photo Mario Perotti)

Principal Related Works

Cat. 1266–1267
Nature morte à la bouteille, à la sole et à l'aiguière (*Still-life with Bottle, Sole and Ewer*), 1946. Antibes, Musée Picasso. Z. XIV, 287. (Fig. 6)

Cat. 1275:
Nature morte à la chouette et aux trois oursins (*Still-life with an Owl and Three Sea-urchins*), 1946. Antibes, Musée Picasso. Z. XIV, 255. (Fig. 7)
Chouette dans un intérieur (*Owl in an Interior*), 1946. Paris, Musée Picasso, cat. I, 173 (Fig. 8)
Chouette (*Owl*) [1947–1953]. Paris, Musée Picasso, cat. I, 443. (Fig. 9)

Cat. 1291:
Assiette décorée d'une scène de tournoi (*Plate Decorated with a Jousting Scene*), 1951. Paris, Musée Picasso, cat. I, 478. (Fig. 10)

Cat. 1292:
Francke, *Retable de Saint Thomas* (*Saint Thomas Altarpiece*), Hamburg, Kunsthalle.

Cat. 1304a:
La grue (*The Crane*), 1951. Paris, Musée Picasso, cat. I, 386; S. 461 (I). (Fig. 11)

Fig. 6

Fig. 7

Fig. 8

Fig. 9

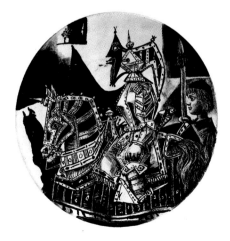

Fig. 10

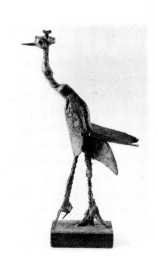

Fig. 11

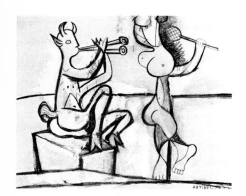

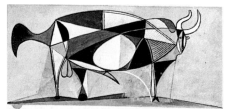

1223
Faune musicien et danseuse
Faun Musician and Dancer
24 September 1945
Antibes
Black chalk and gouache on a trial print
25 × 33.5
D.b.r.: *ANTIBES-24-9-45*
M.P. 1338

1224
Taureau
Bull
24–25 December 1945
[Paris]
Gouache and Indian ink on the bottom of a
cardboard box
15 × 31
D. verso in pencil: *24 Décembre/25 1945*
Z. XIV, 130
M.P. 1339

1225
Portrait de Paul Langevin
Portrait of Paul Langevin
[1945–1946]
Paris
Charcoal
66 × 50.5
S.b.r. in red crayon: *Picasso*
M.P. 1340

1226
Portrait de Paul Langevin
Portrait of Paul Langevin
[1945–1946]
Paris
Charcoal
66 × 50.5
Inscr.a.l.: *V*
M.P. 1341

1227
Portrait de Françoise
Portrait of Françoise
21 April 1946
Paris
Pencil
66 × 50.5
D.a.l.: *dimanche 21 Avl. 46*
M.P. 1342

1228
Portrait de Françoise
Portrait of Françoise
22 April 1946
Paris
Pencil
66 × 50.5
D.b.l.: *3 Hs 1/4/Lundi 22 Avl. 46*
M.P. 1343

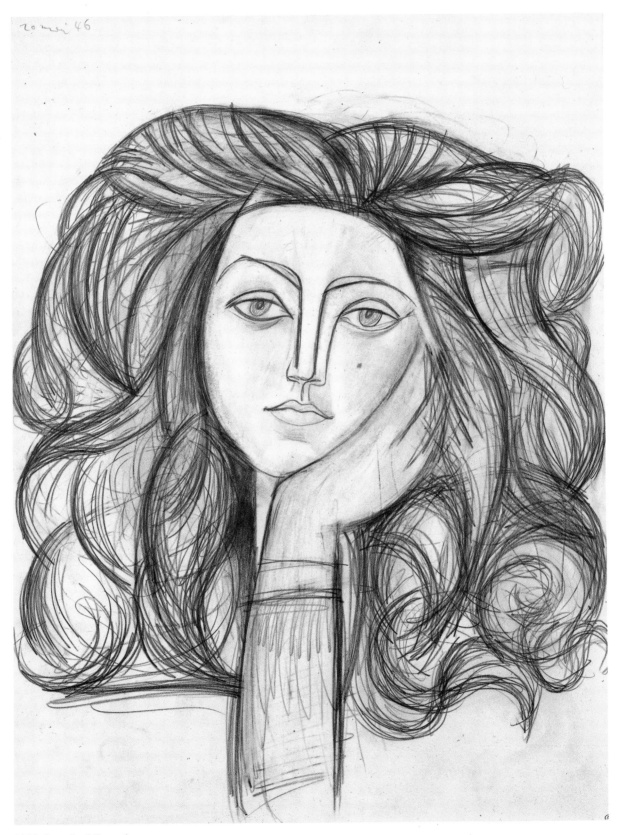

1236 Portrait of Françoise

1229
Portrait de Françoise
Portrait of Françoise
22 April 1946
Paris
Pencil
66 × 50.5
D.a.l.: *3 Hs 20/Lundi 22 Avl. 46*
M.P. 1344

1230
Portrait de Françoise
Portrait of Françoise
22 April 1946
Paris
Pencil
66 × 50.5
D.a.l.: *3 Hs 1/2 Lundi 22 Avl. 46*
M.P. 1345

1231
Portrait de Françoise
Portrait of Françoise
22 April 1946
Paris
Pencil
66 × 50.5
D.a.l.: *4 Hs 10/lundi 22 Avril 46*
M.P. 1346

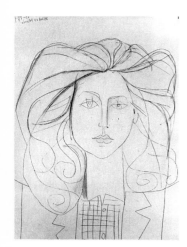

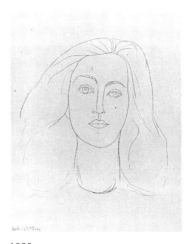

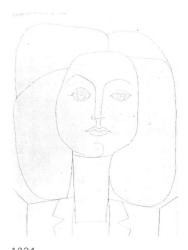

1232
Portrait de Françoise
Portrait of Françoise
22 April 1946
Paris
Pencil with shading
65.8 × 50.6
D.a.l.: *4 Hs-20/Lundi 22 Avl. 46*
M.P. 1347

1233
Portrait de Françoise
Portrait of Françoise
22 April 1946
Paris
Pencil
66 × 50.5
D.b.l.: *lundi 22 Avril 46/(avant 7 Hs)*
M.P. 1348

1234
Portrait de Françoise
Portrait of Françoise
22 April 1946
Paris
Pencil
66 × 50.5
D.a.l.: *Lundi 22 Avril 46 (après 7 Hs)*
M.P. 1349

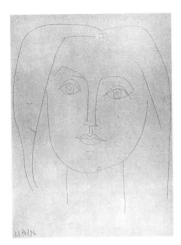

1235
Portrait de Françoise
Portrait of Françoise
22 April 1946
Paris
Pencil
66 × 50.5
D.b.l.: *23 Avl 46*
M.P. 1350

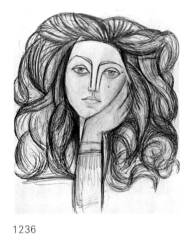

1236
Portrait de Françoise
Portrait of Françoise
20 May 1946
Paris
Pencil and charcoal with coloured crayon
shading
66 × 50.5
D.a.l.: *20 mai 46*
M.P. 1351

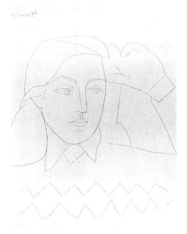

1237
Portrait de Françoise
Portrait of Françoise
25 May 1946
Paris
Pencil
66 × 50.5
D.a.l.: *25 mai 46*
M.P. 1352

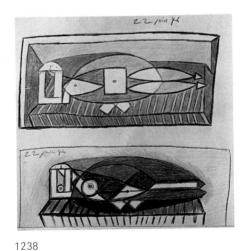

1238
Femme sur un canapé
Woman on a Sofa
22 June 1946
Paris
Pastel
50.5 × 66
D.c.a. and c.b.l.: *22 juin 46*
Z. XIV, 191, 188
M.P. 1353

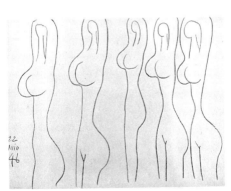

1239
Nus de profil
Nudes in Profile
22 June 1946
Paris
Coloured crayon
51 × 65.5
D.b.l.: *22/juin/46*
Z. XIV, 165
M.P. 1354

1240
**Etudes de nu debout les bras au-dessus
de la tête**
*Studies of a Standing Nude, Arms above her
Head*
22 June 1946
Paris
Blue crayon
51 × 65.5
D.a.l.: *22/juin/46*
Z. XIV, 169
M.P. 1355

1240 Studies of a Standing Nude, Arms above her Head

1241 Standing Nude

1241
Nu debout
Standing Nude
28 June 1946
Paris
Coloured crayons
51 × 32.5
D.b.l. in pencil: *28 juin 46*
Inscr. verso: *10*
M.P. 1356

1242
Nu debout
Standing Nude
28 June 1946
Coloured crayons
66 × 50.5
D.a.l. in pencil: *28 juin 46*
Inscr. verso: *11*
M.P. 1357

1243
Nu debout
Standing Nude
28 June 1946
Paris
Coloured crayons
66 × 50.5
D.b.l. in pencil: *28 juin 46*
Inscr. verso: *13*
M.P. 1358

1244
Nu debout
Standing Nude
28 June 1946
Paris
Coloured crayons
66 × 50.5
D.b.l. in pencil: *28 juin 46*
Inscr. verso: *14*
M.P. 1359

1245
Nu debout
Standing Nude
28 June 1946
Paris
Coloured crayons
66 × 50.5
D.b.l. in pencil: *28 juin 46*
Inscr. verso: *15*
Z. XIV, 172
M.P. 1360

1246
Nu debout
Standing Nude
28 June 1946
Paris
Coloured crayons
66 × 50.5
D.b.l. in pencil: *28 juin 46*
Inscr. verso: *16*
M.P. 1361

1247
Nu debout
Standing Nude
28 June 1946
Paris
Coloured crayons
66 × 50.5
D.b.l. in pencil: *28 juin 46*
Inscr. verso: *17*
M.P. 1362

1248
Nu debout
Standing Nude
28 June 1946
Paris
Coloured crayons
65.5 × 50.5
D.b.l. in pencil: *28 juin 46*
Inscr. verso: *19*
M.P. 1363

1249
Nu debout
Standing Nude
28 June 1946
Paris
Coloured crayons
65.5 × 50.5
D.b.l. in pencil: *28 juin 46*
Inscr. verso: *20*
M.P. 1364

1250
Nu debout
Standing Nude
28 June 1946
Paris
Coloured crayons
66 × 50.5
D.b.l. in pencil: *28 juin 46*
Inscr. verso: *21*
M.P. 1365

1251
Nu debout
Standing Nude
28 June 1946
Paris
Coloured crayons
65.5 × 50.5
D.b.l. in pencil: *28 juin 46*
Inscr. verso: *22*
M.P. 1366

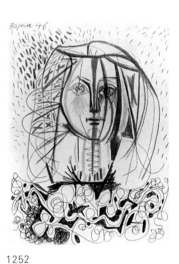

1252
Portrait de Françoise
Portrait of Françoise
30 June 1946
Paris
Pastel
66 × 50.5
D.a.l.: *30 juin 46*
Z. XIV, 183
M.P. 1367

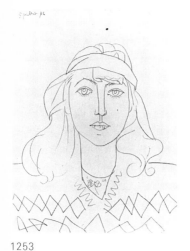

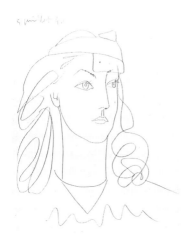

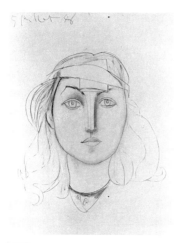

1253
Françoise au bandeau
Françoise with a Bandage
5 July 1946
Paris
Pencil
66 × 50.4
D.a.l.: *5 juillet 46*
M.P. 1368

1254
Françoise au bandeau
Françoise with a Bandage
5 July 1946
Paris
Pencil
66 × 50.5
D.a.l.: *5 juillet 46*
M.P. 1369

1255
Françoise au bandeau
Françoise with a Bandage
5 July 1946
Paris
Pencil
65.5 × 50.5
D.a.l.: *5 juillet 46*
M.P. 1370

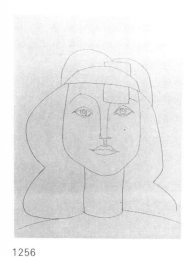

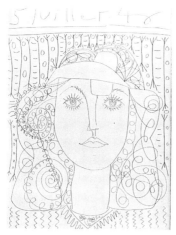

1256
Françoise au bandeau
Françoise with a Bandage
5 July 1946
Paris
Pencil
66 × 50.5
Inscr. verso: *7*
M.P. 1371

1257
Françoise au bandeau
Françoise with a Bandage
5 July 1946
Paris
Pencil
66 × 50.5
D.a.: *5 juillet 46*
Inscr. verso: *8*
Z. XIV, 192
M.P. 1372

1258
Femme assise devant sa table
Woman Seated at her Table
18 July 1946
[Ménerbes]
Pencil
50.5 × 66
D.a.r.: *18 juillet 46*
Z. XIV, 190
M.P. 1373

1257 Françoise with a Bandage

1262 Various Studies: Woman with a Vase of Flowers Seated at her Table

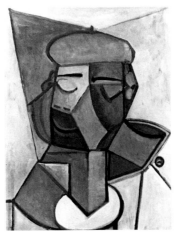

1259
Nature morte
Still-life
29 July 1946
[Antibes]
Gouache
50.5 × 66
D. verso: *29 juillet/46*
M.P. 1374

1260
Homme au béret basque
Man in a Basque Beret
30 July 1946
[Antibes]
Gouache
66 × 50.5
D. verso: *30/juillet/46*
M.P. 1375(r)

1260a
Fleurs et papillons
Flowers and Butterflies
30 July 1946
[Antibes]
Gouache and pencil
66 × 50.5
D.c.l.: *30/juillet/46*
M.P. 1375(v)

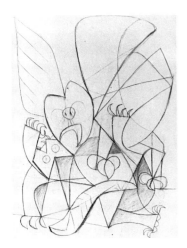

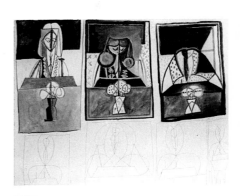

1261
Chouette attaquant un chat
Owl Attacking a Cat
3 August 1946
[Golfe-Juan]
Pencil and charcoal
66 × 50.5
D. verso: *3 Août 46*
Z. XIV, 199
M.P. 1376

1262
Feuille d'études: femme au vase de fleurs assise devant sa table
Various Studies: Woman with a Vase of Flowers Seated at her Table
7 August 1946
[Golfe-Juan]
Gouache and pencil
66 × 50.5
D.a.l.: *7 août 46*
M.P. 1337

1263
Feuille d'études: femme au vase de fleurs assise devant sa table
Various Studies: Woman with a Vase of Flowers Seated at her Table
7 August 1946
[Golfe-Juan]
Gouache and pencil
51 × 66
D. verso: *7 août 46*
M.P. 1378

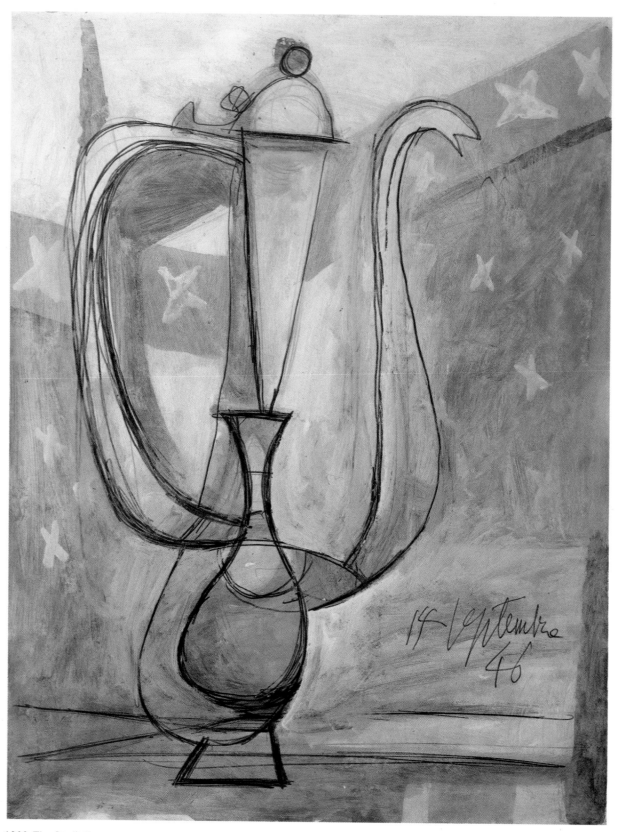

1266 **The Starlit Ewer**

1264
Femme au vase de fleurs
Woman with a Vase of Flowers
7 August 1946
[Golfe-Juan]
Gouache and pencil
66 × 50.5
D. verso: *7 Août/46*
M.P. 1379

1265
Femme assise les pieds sur la table
Woman Seated with her Feet on the Table
7 August 1946
[Golfe-Juan]
Gouache and pencil
66 × 50.5
D.a.l.: *7 Août/46*
M.P. 1377

1266
L'aiguière étoilée
The Starlit Ewer
14 September 1946
Golfe-Juan
Oil and pencil
65 × 50.5
D.b.r.: *14 Septembre/46*
M.P. 1380

1267
L'aiguière étoilée
The Starlit Ewer
15 September 1946
Golfe-Juan
Oil and pencil
66 × 50.5
D.b.l.: *15 Septembre/46*
Inscr. verso: (*II*)
M.P. 1381

1268
Femme et centaure tenant un petit faune
Woman and Centaur Holding a Little Faun
5 November 1946
Antibes
Pencil
51 × 66
D. verso: *antibes/5 novembre/46*
Inscr. verso: *III*
Z. XIV, 270
M.P. 1382

1269
Femme et centaure tenant un petit faune
Woman and Centaur Holding a Little Faun
5 November 1946
Antibes
Pencil
50.5 × 66
D. verso: *antibes/5 novembre/46*
Inscr. verso: *IV*
Z. XIV, 273
M.P. 1383

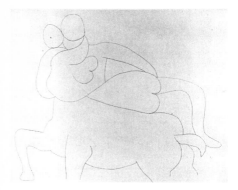

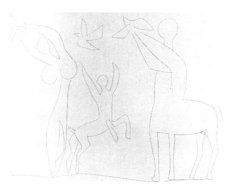

1270
Femme enlevée par un centaure
Woman Being Carried off by a Centaur
5 November 1946
Antibes
Pencil
51 × 65.7
D. verso: *antibes/5 novembre/46*
Inscr. verso: *V*
Z. XIV, 275
M.P. 1384

1271
Centaures, femme et oiseaux
Centaurs, a Woman and Birds
5 November 1946
Antibes
Pencil
51 × 66
D. verso: *antibes/5 novembre/46*
Inscr. verso: *VIII*
Z. XIV, 274
M.P. 1385

1272
Centaures, femme et oiseau
Centaurs, a Woman and a Bird
5 November 1946
Antibes
Pencil
51 × 66
D. verso: *antibes/ 5 novembre/46*
Inscr. verso: *XI*
Z. XIV, 278
M.P. 1386

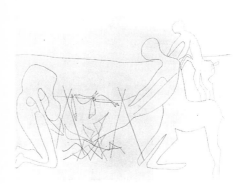

1273
Centaures et femme faisant griller des poissons
Centaurs and a Woman Grilling Fish
6 November 1946
Antibes
Pencil
51 × 66
D. verso: *antibes/6 novembre/46*
Z. XIV, 280
M.P. 1387

1274
Chouette
Owl
11 November 1946
Antibes
Pencil
66 × 50.6
D. verso: *Antibes/11 novembre/46*
Inscr. verso: *VII*
Z. XIV, 315
M.P. 1388

1275
Feuille d'études: chouette
Various Studies: Owl
11 November 1946
Antibes
Pen and Indian ink
66 × 50.6
D. verso in pencil: *antibes/11 novembre/46*
Inscr. verso: *XIV*
Z. XIV, 316
M.P. 1389

1273 Centaurs and a Woman Grilling Fish

1276
Portrait de Françoise
Portrait of Françoise
1947
Charcoal
66 × 51
D. verso in pencil: *1947*
M.P. 1390

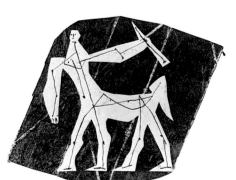

1277
Centaure tenant une arme
Centaur Holding a Weapon
[1947–1948]
Black ink on paper cut out and stuck to black
corrugated wrapping-paper
16.5 × 15
Gift of Paloma Picasso-Lopez, 1983
M.P. 1983–5

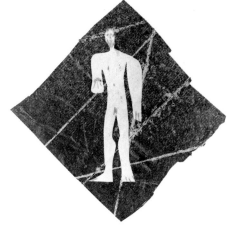

1278
Homme nu debout
Standing Nude Man
[1947–1948]
Coloured crayons on paper cut out and stuck
to black corrugated wrapping-paper
13.9 × 14
Gift of Paloma Picasso-Lopez, 1983
M.P. 1983–3

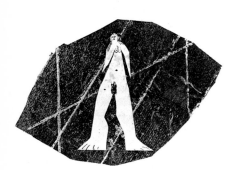

1279
Femme nue debout
Standing Nude Woman
[1947–1948]
Black ink on paper cut out and stuck to black
corrugated wrapping-paper
15.2 × 15
Gift of Paloma Picasso-Lopez, 1983
M.P. 1983–4

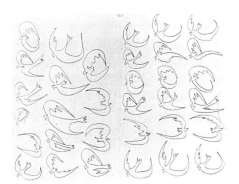

1280
**Projet de couverture pour la revue
'Europe'**
Cover Design for the Review 'Europe'
18 November 1949
Vallauris
Pencil
51 × 66
D.c. in ink: *18.11.49*
M.P. 1394

1281
**Projet de couverture pour la revue
'Europe'**
Cover Design for the Review 'Europe'
18 November 1949
Vallauris
Pencil
50.5 × 66
D.c.a. in ink: *18.11.49*
M.P. 1395

1282
Projet de couverture pour le numéro de décembre 1949 de la revue 'Europe'
Cover Design for the December 1949 Issue of the Review 'Europe'
18 November 1949
Pen, Indian ink and pencil with traces of red chalk
32.5 × 25.5
D.a.l.: *18.11.49.*
M.P. 1397

1283
La Galloise à Vallauris
La Galloise at Vallauris
25 November 1949
Vallauris
Pencil shading
51 × 66
D.b.r.: *25.11.49*; verso: *Vallauris/2[5] novembre 49*
Inscr. verso: *XII*
M.P. 1396

1284
Staline à ta santé
Your Health, Stalin
November 1949
Pen and Indian ink
21 × 15
S.D.b.r.: *Picasso/novembre 1949*
M.P. 1391

1285
Staline à ta santé
Your Health, Stalin
November 1949
Pen and Indian ink
21.7 × 14.2
S.D.b.r.: *Picasso/novembre 1949*
M.P. 1393

1286
Staline à ta santé
Your Health, Stalin
[November] 1949
Pen and Indian ink
21.5 × 14
S.D.b.r.: *Picasso/1949*
M.P. 1392

1287
Femme accoudée
Woman Leaning on her Elbow
31 August 1950
Pencil with blue crayon shading
66 × 50.5
D.a.l.: *31.8.50.*
M.P. 1398

1283 La Galloise at Vallauris

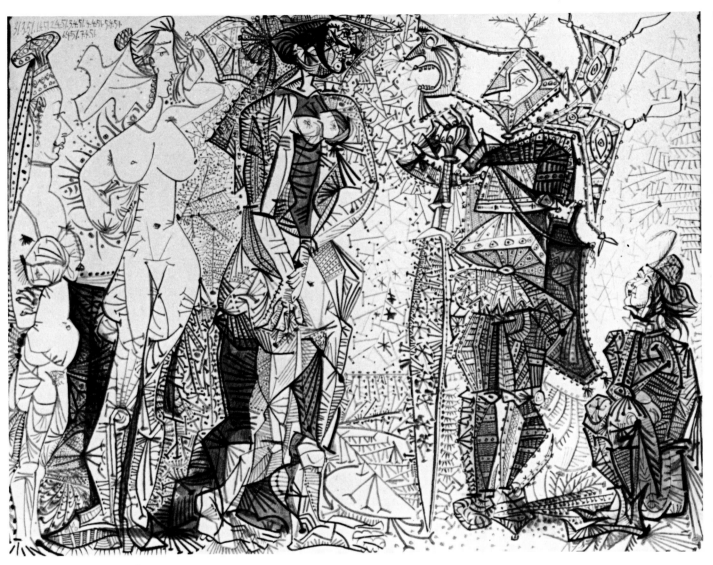

1293 The Judgment of Paris

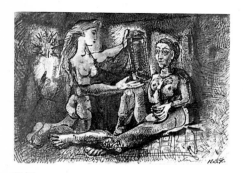

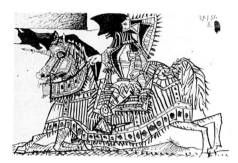

1288
La femme au miroir
Woman with a Mirror
12 December 1950
Paris
Indian ink and gouache on a lithograph dated
26.11.50 and 10.12.50 M.197
38.5 × 56
D.b.r.: *12.12.50.*
M.P. 1399

1289
Chevalier en armure
Knight in Armour
21 January 1951
Pen, Indian ink and tinted wash
27 × 21
D.a.r.: *21.1.51.*
Inscr.a.r.: *VIII*
M.P. 1400

1290
Cheval caparaçonné et cavalier en armure
Caparisoned Horse and Horseman in Armour
24 January 1951
Pen, Indian ink and tinted wash
13.5 × 21
D.a.r.: *24.1.51.*
Inscr.a.r.: *III*
M.P. 1401

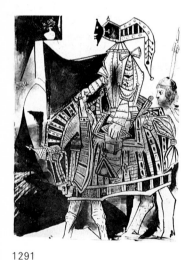

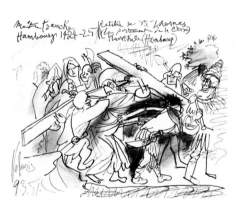

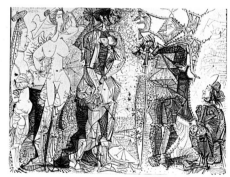

1291
Le chevalier et le page
The Knight and the Page
25 January 1951
Pen, Indian ink and tinted wash
32 × 24
D.a.l.: *25.1.51.*
M.P. 1402

1292
Le portement de croix d'après le retable de Saint-Thomas de Maître Francke
Bearing the Cross, after the Saint Thomas Altarpiece by Master Francke
9 March 1951
Vallauris
Black ink and tinted wash
21 × 26.8
D.b.l.: *Vallauris/9.3.51.*
Inscr.a.l.: *Maître Francke/Hambourg 1424-25*
and a.r.: *Retable de St Thomas/ (Le portement de la croix)/Kunsthale* (sic) *(Hambourg)*
Gift of Marina Ruiz-Picasso, 1982
M.P. 1982–161

1293
Le Jugement de Pâris
The Judgment of Paris
31 March–7 April 1951
Pen, Indian ink and tinted wash
50.6 × 65.6
D.a.l.: *31.3.51.; 1.4.51.; 2.4.51.; 3.4.51.; 4.4.51.; 5.4.51./6.4.51.; 7.4.51.*
M.P. 1403

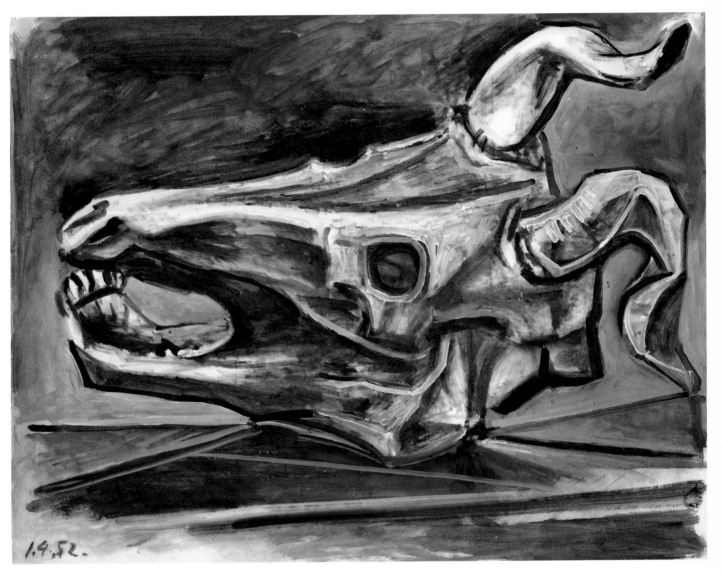

1.4.52.

1299 Ram's Skull

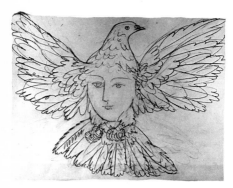

1294
Le visage de la Paix
The Face of Peace
[September] 1951
Vallauris
Pencil
51 × 66
M.P. 1416

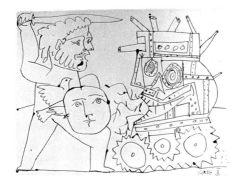

1295
Guerre et Paix
War and Peace
5 October 1951
Pen and Indian ink
50.5 × 65.5
D.b.r.: *5.10.51.*
Inscr.b.r.: *II*
M.P. 1405

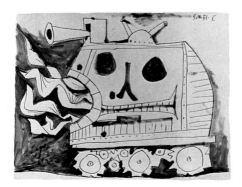

1296
La Guerre
War
5 October 1951
Indian ink
50.5 × 65.5
D.a.r.: *5.10.51.*
Inscr.a.r.: *V*
M.P. 1404

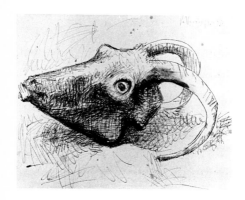

1297
Tête de chèvre
Head of a Goat
19 October 1951
Vallauris
Pen and Indian ink
51 × 65.2
D.a.r.: *Vallauris 19.10.51.*
M.P. 1406

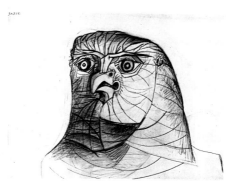

1298
Chouette
Owl
30 March 1952
Pencil
50.5 × 66
D.a.l.: *30.3.52.*
M.P. 1407

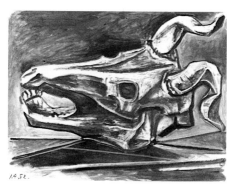

1299
Crâne de bélier
Ram's Skull
1 April 1952
Oil
51 × 66
D.b.l.: *1.4.52.*
M.P. 1408

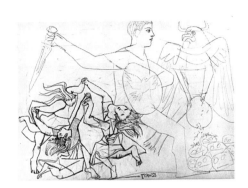

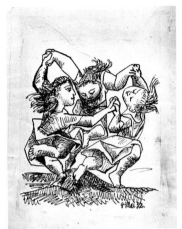

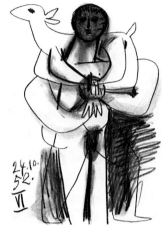

1300
Etude pour 'La Guerre et la Paix'
Study for 'War and Peace'
1 May 1952
Pencil
25.7 × 35.6
D.c.b.: *1er Mai 52.*
M.P. 1409

1301
Etude pour 'La Guerre et la Paix'
Study for 'War and Peace'
4 May 1952
Pen and Indian ink on tracing paper stuck to the centre
26 × 20
D.b.r.: *4 mai 52.*
M.P. 1410

1302
Homme au mouton
Man with a Sheep
24 October 1952
Black chalk and tinted wash
27 × 21
D.b.l.: *24.10./52.*
Inscr.b.l.: *VI*
M.P. 1411

1303
Portrait de Paloma
Portrait of Paloma
21 December 1952
Pencil and coloured crayons
66 × 51
D.a.l.: *21.12.52.*
M.P. 1412

1304
Au Quartier latin
In the Latin Quarter
[May] 1953
Pen and Indian ink
21 × 27
M.P. 1413(r)

1304a
'La grue'
'The Crane'
[1953]
Pen and Indian ink
27 × 21
M.P. 1413(v)

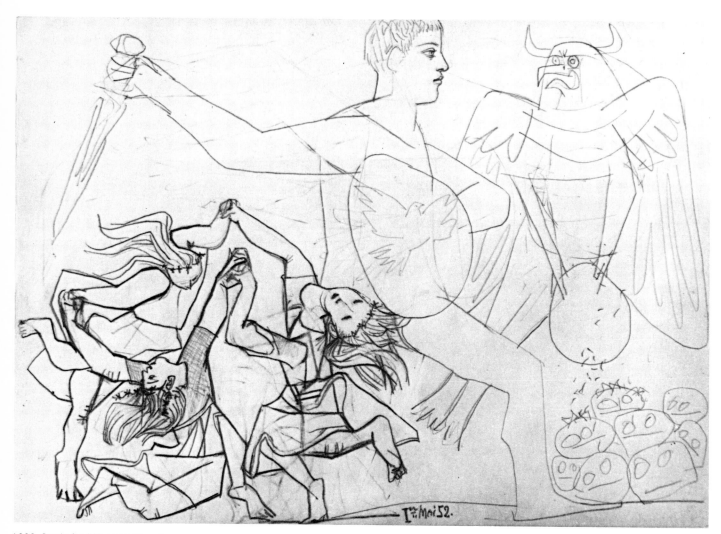

1300 Study for 'War and Peace'

1305
Chat dévorant un coq
Cat Devouring a Cockerel
15 December 1953
Purple felt-pen and Indian ink
18 × 24
D.a.r.: *15.12./53.*
M.P. 1414

1306
La Paix
Peace
16 December 1953
Vallauris
Indian ink
50.5 × 66
D.b.r.: *Vallauris le 16.12.53.*
Inscr.b.r.: *III*
M.P. 1415

The Final Years: 1954–1973

'Vallauris 1954; 28 November 1953–3 February 1954, 180 drawings by Picasso': this was the announcement carried on the covers of issues 29 and 30 of *Verve*, published by Tériade in 1955. In the text accompanying these drawings Michel Leiris writes of the 'visual diary of an appalling period spent in hell, a personal crisis which led to questions of the most fundamental nature.'[1]

These were the works Picasso produced after Françoise had left him, taking their children Claude and Paloma with her. He remained at Vallauris, alone. The drawings are the fruit of the artist's reflections on human relationships, 'set down in the light of truth, rich with haunting presences, compelling sensuality and striking observations'.[2] Several treat the theme of the painter and his model in an obsessive and erotic fashion, emphasizing their difference in age.

The majority of works were executed in Indian ink and tinted wash. From late January onwards Picasso used coloured crayons, thus introducing a more cheerful note. Six hitherto unpublished drawings kept by the artist are included in this series (cat. 1307–1312).[3] Two show a dancer in a lascivious pose facing a bearded old man as he gazes at her (cat. 1308, 1309). The solitary image of the artist with palette and brush featured in the painting could perhaps be seen as an expression of the rigours of creative effort (cat. 1307, 1312). The painter portrayed himself masked in a work dated 1 February (cat. 1311). Describing these 180 drawings Michel Leiris wrote: 'We are struck by the great quantity of masked characters. The overriding idea of metamorphosis has reappeared but in ludicrous form: when a disguise reveals itself as such it surely becomes nothing more than the caricature of a miracle, an abortive attempt to transform oneself into something one is not.'[4]

Most of the works in the series produced in March 1954 depicting seated nudes doing their hair are drawn on sheets taken from sketchbooks (cat. 1314–1317). The recurring theme of the woman with a mirror is also in evidence (cat. 1314, 1317), and we have examples of a motif treated in a similar fashion using different mediums – pencil and Indian ink (cat. 1314, 1318).

The following month, April, Picasso met Sylvette David in the streets of Vallauris. This young and slender woman, with long blond hair cascading over her shoulders, agreed to pose for him and he resumed his work with relentless abandon. Forty portraits of her, drawn and painted, were produced in one month.[5] The museum holds two characteristic works executed in pencil.

We now come to the arrival of Jacqueline, the beloved model whose all-pervading presence was henceforth to dominate his work. This was the case even when she did not appear, for example in certain drawings of the studio.

(1) M. Leiris, 'Picasso et la comédie humaine ou les avatars de Gros Pied', *Verve*, nos 29–30.

(2) Tériade, Introduction, *Verve*, nos 29–30.

(3) After *Verve*, the others were published in Volume XVI of Zervos.

(4) M. Leiris, 'Picasso et la comédie humaine', op cit.

(5) See Z. XVI, nos 274–315.

(6) H. Parmelin, *Picasso: Women, Cannes and Mougins*, 1965, p. 66.

People say of Jacqueline that she
Is Picasso's model.
A model poses.
Jacqueline does not pose
But she is there all the time.
She does not pose,
She lives.

Hélène Parmelin[6]

Jacqueline Roque, who became Mme Picasso in 1961, first appeared in a painting by the artist in 1954, under the name of Mme Z. (fig. 1). 'Thus, without knowing she was loved she made her entrance into Picasso's life and work. Her attitude was still calm, but the expectant look in her eyes suggested that she had a premonition of the exciting days to come,' wrote Antonina Vallentin.[7]

Although the museum unfortunately possesses only one portrait of Jacqueline, it is an extremely moving work, *Jacqueline dans l'atelier* (*Jacqueline in the Studio*, cat. 1446). From the beginning of winter 1954, however, with '*Les femmes d'Alger' d'après Delacroix* ('*The Women of Algiers' after Delacroix*) right up to the last nudes of 1972, she dominates Picasso's work. Her dark hair, superb carriage and 'Serene eye of an Egyptian goddess'[8] are all instantly recognizable in a study for *The Women of Algiers* drawn on 21 December (cat. 1322) and in the works which follow.

Picasso had always been interested in Delacroix. Hélène Parmelin describes how he kept a small notebook of the painter's open in his print-room, next to the press.[9] He found *The Women of Algiers* especially fascinating and had a perfect knowledge of the two versions of the work. These were painted in 1834 and 1849, and are held in the Louvre and the Musée Fabre in Montpellier respectively. Referring to the period when the artist was working on variations of the theme, Hélène Parmelin informs us that Picasso 'would in no circumstances look even at a reproduction of Delacroix's *Femmes d'Alger* and carried them everywhere in his head.'[10] It appears that Picasso had decided to challenge Delacroix and rob him of his harem, as Jacqueline seemed to him to have stepped straight out of *The Women of Algiers*. In fact he had long been influenced by the theme. Certain art historians, Robert Rosenblum in particular, have noted its influence in *Les Demoiselles d'Avignon*.[11] The first papers of a sketchbook begun in Royan on 10 January 1940 refer to the composition (figs 2 and 3). At the time of Picasso's donation to the Musée National d'Art Moderne in 1949 Georges Salles, Director of the Musées de France, invited the artist to hang his works in the Louvre one Tuesday. *The Women of Algiers* was one of the paintings near which he chose to exhibit.[12]

The fifteen erotic paintings produced between 13 December 1954 and 14 February 1955 were shown in Paris on only one occasion, at the retrospective exhibition organized by Maurice Jardot which was held in the Musée des Arts Décoratifs in 1955. The works, together with descriptions, were published in the catalogue.[13] An equivalent analysis could also be made of the drawings now held in the Musée Picasso (cat. 1321–1329, 1441). The artist not only dated but also numbered the sketches, enabling us to follow the various stages of development. The studies were executed in Indian ink and tinted wash, pen, pencil or blue crayon, and in certain instances simple pen outlines were used, particularly for a single figure. This is most often the sleeping woman, usually depicted with raised legs which are sometimes resting against the edge of a small table. Much emphasis is given to the navel and the breasts, their asymmetrical positioning and the nipples, which Antonina Vallentin saw as 'two small open eyes'.[14]

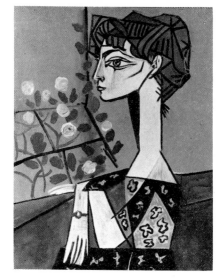

Fig. 1
Portrait de Mme Z. (*Portrait of Mme Z.*), 1954
Jacqueline Picasso Collection
(Photo Hélène Adant)

Figs 2 and 3
Les femmes d'Alger d'après Delacroix (*The Women of Algiers after Delacroix*)
sheets from a sketchbook, Royan 1940
Paris, Musée Picasso

(7) A. Vallentin, op. cit,, p. 251.

(8) R. Penrose, *The Eye of Picasso*, p. 26.

(9) H. Parmelin, *Picasso Plain*, p. 78.

(10) Ibid., p. 77.

(11) R. Rosenblum, 'The Demoiselles d'Avignon Revisited', *Art News*, no. 4, April 1973.

(12) F. Gilot and C. Lake, op. cit., p. 192.

(13) *Picasso, peintures, 1900–1955*, op. cit., no. 127.

(14) A. Vallentin, op. cit., p. 254.

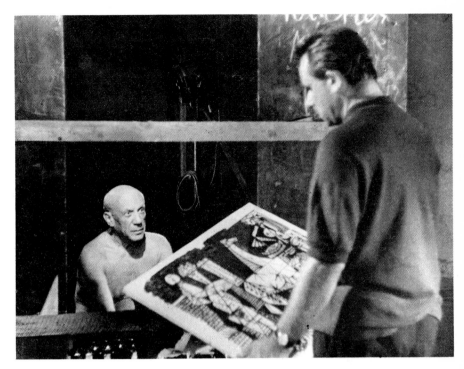

Fig. 4
Picasso and Henri-Georges Clouzot during the filming of *Le mystère Picasso*, 1955
(Photo Filmsonor)

Picasso did not set out to imitate Delacroix but to be his equal, to gain inspiration from him and in some way to re-create him. He treated the painter's works 'with as much liberty as any other subject', to use Michel Leiris's words when describing *Las Meninas*.[15]

The setting in which the women are developed has a distinctly Matisse-like air. 'I sometimes tell myself it could have been inherited from Matisse. And why shouldn't we inherit things from our friends?' Picasso observed to Kahnweiler.[16]

In the spring of 1955 Picasso decided to return to the South of France. In La Californie district of Cannes he bought a villa of the same name. During the summer he decided to comply with Henri-Georges Clouzot's suggestion of letting himself be filmed at work. A new technical process had led to his agreement: he had received some colured inks from the United States which could soak through paper without smudging. The development of a work could thus be filmed by placing a camera behind a sheet of translucent paper serving as a support. Werner Spies gives an extremely detailed account of the creative process, showing 'how the drawing combines spontaneity and experience'.[17] *Le mystère Picasso*, released in 1956, enables us to witness the way in which a picture is brought into being.

The drawings were kept by the artist and subsequently presented to the museum by his heirs (cat. 1393–1430).[18,19] They feature a range of familiar themes – the painter and his model, the couple, faces of sleeping women, beach scenes, mythological elements, fauns, bullfights and the circus. Animals also make an appearance: a horse, a goat, a cockerel, a fish and a bull.

La Californie, the turn-of-the-century villa where Picasso settled in 1955, was close to the sea and stood in a luxuriant garden with mimosas, eucalyptus trees and palms. These trees could be seen from the large bay windows of the ground-floor rooms, all of which opened out into each other and were used in turn by Picasso as a workplace.'We can try to imagine what happened in the studio in October 1955. Picasso has just moved into the newly purchased villa. He is now at peace in this enchanting place and fortune is smiling upon him. He feels a desire to paint the source of his happiness and reaffirm mastery of his surroundings by introducing them to the realm of his dreams, his world of art. Here he paints his first *Atelier . . .*' wrote Georges Limbour.[20] The drawings of the studios in La Californie (cat. 1431–1440) are linked

(15) Introduction to the catalogue, *Picasso, Les Ménines, 1957*, Paris, Galerie Louise Leiris, 1959.

(16) D.-H. Kahnweiler, 'Entretriens avec Picasso au sujet des Femmes d'Alger', *Aujourd'hui*, no. 4, September 1955.

(17) W. Spies, *Picasso: Pastels – Dessins – Aquarelles*, op. cit. p. 46.

(18) Their fragile state creates difficult problems with regard to preservation.

(19) We are particularly indebted to Maya Ruiz-Picasso who took part in the film and was able to provide us with extremely valuable information.

to the series of paintings on the same theme, begun on 23 October 1955 and exhibited in the spring of 1957 to inaugurate the new premises of the Galerie Louise Leiris.[21] Like the studies for *The Women of Algiers*, they bear signs of homage to Matisse, who had died the previous year.

A sense of rhythm and flow predominates in these works; Picasso himself used the term 'interior landscapes' to describe the views of the studio opening out on to a patch of garden. Details abound, varying according to the version; we see a chair, a palette and a ceramic head placed on a stool. The most striking feature is the large, still untouched canvas on its easel. The series on the studio at La Californie (cat. 1434–1440) depicting the fireplace and the mirror above it is linked to the Californie sketchbook which Picasso began the same day.[22] The works, identical in style and technique, show the same room and are executed on loose sheets bearing numbers which preceded those in the sketchbook. The studio scenes quickly come to life as the woman Picasso loved makes her appearance. A painting from this series, *Femme dans l'atelier* (*Woman in the Studio*, fig. 14), reproduced on stencil by Guy Spitzer, was used as a foundation for the gouache and Indian ink work *Jacqueline dans l'atelier* (*Jacqueline in the Studio*, cat. 1446). A photograph by Edward Quinn (fig. 5) illustrates this process, and Roland Penrose comments: 'the reproduction of a painting becomes the basis for new ideas . . . Picasso has often remarked that he never really knows exactly when a painting or drawing is finished: "One can always imagine an improvement, a colour to be added or accentuated; or the style of the original work can be changed so that it then becomes only the starting point of something new."'[23] The collection contains examples of a similar process using a linocut (cat. 1452) and lithographs (cat. 1463, 1464).

Drawings carried out after 1956 are less well represented in the museum's collection. A sequence produced in December 1957 and January 1958 takes as its theme *L'atelier: la femme couchée et le tableau* (*The Studio: the Reclining Woman and the Picture*, cat. 1447–1451). The subject is known to have been the basis for the large composition created for UNESCO entitled *La chute d'Icare* (*The Fall of Icarus*). *UNESCO* is in fact written on the covers of

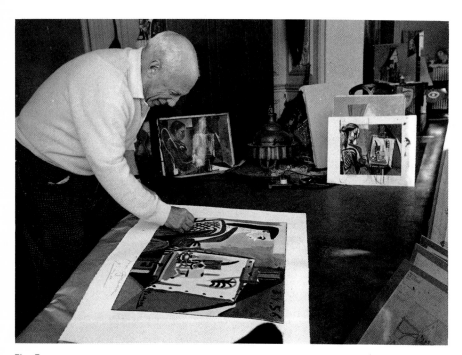

Fig. 5
Picasso uses a reproduction of the painting *Femme dans l'atelier* (*Woman in the Studio*) as a starting point for a new composition
(Photo Edward Quinn)

(20) G. Limbour, 'Picasso à La Californie', *L'œil*, no. 30, June 1957, pp. 14–23.

(21) *Picasso, Peintures 1955–1956*, Paris, Galerie Louise Leiris, March–April 1957. Cf. also Zervos XVI.

(22) See Picasso, *Carnet de La Californie*, in facsimile, introduction by Georges Boudaille, Paris, 1959.

(23) E. Quinn, *Picasso at Work. An Intimate Photographic Study*, introduction and text by R. Penrose, New York, 1964.

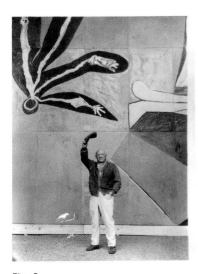

Fig. 6
Picasso in front of *La chute d'Icare*
(*The Fall of Icarus*)
(Photo Edward Quinn)

Fig. 7
UNESCO sketchbook
Paris, Musée Picasso

Fig. 8
UNESCO sketchbook
Paris, Musée Picasso

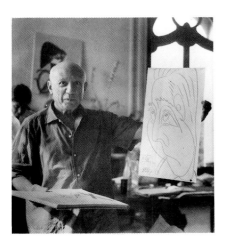

Fig. 9
Picasso presenting his newly finished
portrait of Jacques Prévert
(Photo Edward Quinn)

(24) G. Picon, *Pablo Picasso, La chute
d'Icare au Palais de l'Unesco*, Geneva, 1971,
p. 69.

(25) See figs 13 and 15.

(26) D. Cooper, *Les Déjeuners*, Paris, 1962,
pp. 35–36.

certain sketchbooks (see figs 7, 8). Gaëtan Picon comments on the link between the studies and the final composition. 'Even if . . . we take the entire series placed within such dramatically contrasting titles, a connection would clearly suggest itself. If the theme of the studio vanishes, the remaining space becomes the sea and the beach, the presence of the nude being the linking factor.'[24] As the author subsequently notes, the painting seen in the studio depicts bathers on the diving-board and is itself 'connected to the figures standing on the springboard, being the only vertical form in the entire work.' *Les baigneurs* (*The Bathers*, cat. 1442) could be seen as a distant forerunner to these works, although its date (September 1956) suggests it is more directly related to the sculpture (cat. I, 394, 399). We cannot be entirely sure, however, if the drawing in question is a study or a sketch intended to record the image of the sculpture. This is also true of *Tête de femme* (*Head of a Woman*, cat. 1445) and *Pierrot assis* (*Seated Pierrot*, cat. 1456) with regard to the sculptures of the same name.[25] At this point we should mention the portraits of the artist's friends, Jacques Prévert (cat. 1443), Francis Poulenc (cat. 1444), Marcel Cachin (cat. 1470) and the caricatures of Jaime Sabartés (cat. 1453, 1454). In 1961 Picasso also paid homage to the first man in space, Yuri Gagarin (cat. 1457, 1458).

Variations on works by Old Masters are one of the chief characteristics of this period. After Delacroix, Picasso confronted Velázquez and *Las Meninas* in 1957, followed by Manet's *Déjeuner sur l'herbe* in 1959. He presented the whole *Las Meninas* series to the Museo Picasso in Barcelona. Of the more important *Déjeuner sur l'herbe* sequence, three paintings are held in Paris (cat. I, 189–191), together with a notebook containing drawings, linocuts and a major work executed in coloured chalks and pencil on paper (cat. 1462), in which the idyllic atmosphere is particularly well brought out. In measuring himself against Manet, 'Picasso embraces the whole nineteenth-century tradition and triumphantly establishes his independence and supremacy,' writes Douglas Cooper.[26]

In 1962 Picasso turned his attention to Poussin's *Rape of the Sabines* (cat. 1465). This afforded him a fresh opportunity to express his horror of war, coinciding exactly with the Cuban crisis.

The collection closes with the works produced in 1972 (cat. 1474–1481). As with the paintings, the predominant themes are musketeers and female nudes suggesting a complex eroticism. The artist's remarkable energy, his undiminished vigour and imagination are all confirmed by the force of these drawings, which also serve as a symbol of his incomparable powers of renewal.

Principal Related Works

Cat 1321–1391:
Eugène Delacroix, *Les femmes d'Alger* (*The Women of Algiers*). Paris, Musée du Louvre. (Fig. 10)

Cat. 1442:
Les baigneurs (*The Bathers*), 1956. Paris, Musée Picasso, cat. I, 394–399; S. 503(II)–508(II). (Fig. 11)

Cat. 1447–1451:
La chute d'Icare (*The Fall of Icarus*), 1969. Paris, UNESCO (photo UNESCO R. Lesage). (Fig. 12)

Cat. 1445:
Tête de femme (*Head of a Woman*), 1957, project for a sculpture suggested as an idea for a monument at Barcarés. Paris, Musée Picasso, cat. I, 402; S. 495(2). (Fig. 13)

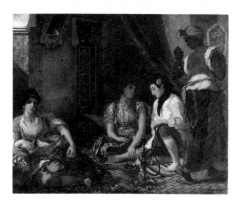

Fig. 10

Fig. 11

Fig. 12

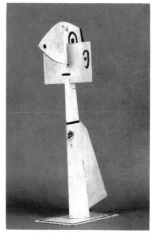

Fig. 13

Cat. 1446:
Femme dans l'atelier (*Woman in the Studio*), 1956 (photo Galerie Lousie Leiris). (Fig. 14)

Cat. 1456:
Pierrot assis (*Seated Pierrot*), 1961. Paris, Musée Picasso, cat. I, 441; S. 604(2). (Fig. 15)
Edouard Manet: *Le déjeuner sur l'herbe*. Paris, Musée d'Orsay. (Fig. 16)

Cat. 1465:
Nicolas Poussin: *L'enlèvement des Sabines* (*The Rape of the Sabines*). Paris, Musée du Louvre. (Fig. 17)
L'enlèvement des Sabines d'après Poussin (*The Rape of the Sabines after Poussin*), 1962. Paris. Musée National d'Art Moderne, gift of D.-H. Kahnweiler. Z. XXIII, 69. (Fig. 18)

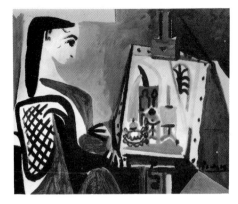

Fig. 14

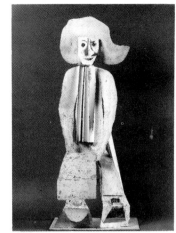

Fig. 15

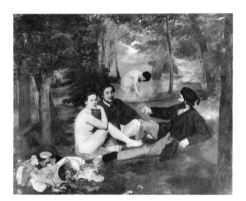

Fig. 16

Fig. 17

Fig. 18

1307
Le modèle dans l'atelier
The Model in the Studio
2 January 1954
Coloured crayons
24 × 32
D.b.l. in ink: *11.1.54.*
Inscr.b.l. in ink: *III*
M.P. 1421

1308
Danseuse et vieillard musicien
Dancer and an Old Man Musician
28 January 1954
Coloured crayons
24 × 32
D.b.r. in ink: *28.1.54.*
Inscr.b.r. in ink: *III*
M.P. 1417

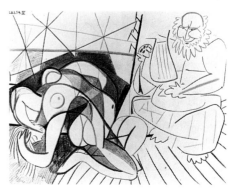

1309
Danseuse et vieillard musicien
Dancer and an Old Man Musician
28 January 1954
Coloured crayons
24 × 32
D.a.l. in ink: *28.1.54*
Inscr.a.l. in ink: *IV*
M.P. 1418

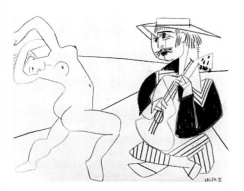

1310
Danseuse et guitariste
Dancer and Guitar Player
29 January 1954
Coloured crayons
24 × 32
D.b.r. in ink: *29.1.54.*
Inscr.b.r. in ink: *VI*
M.P. 1419

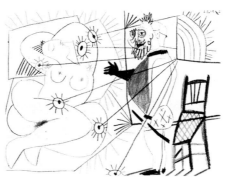

1311
Le peintre masqué et son modèle
The Masked Painter and his Model
1 February 1954
Coloured crayons
24 × 32
D.a.r. in ink: *I.II.54.*
Inscr.a.r. in ink: *II*
M.P. 1420

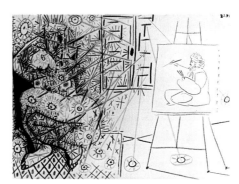

1312
Le modèle dans l'atelier
The Model in the Studio
2 February 1954
Coloured crayons
24 × 32
D.a.r. in ink: *2.2.54.*
M.P. 1422

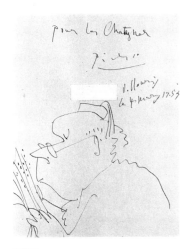

1313
Portrait-charge de Jaime Sabartés
Caricature of Jaime Sabartés
4 March 1954
Vallauris
Black ink on the back of a page from a book;
above the drawing is a piece of cardboard
covered in white gouache pasted to the page
S. and dedicated c.a.: *Pour les Chatagner/
Picasso*; D.c.a.: *Vallauris/Le 4 mars 1954*
Assigned by the Customs House, 1982
M.P. 1982–1

1314
Nu assis se coiffant
Seated Nude Doing her Hair
7 March 1954
Pencil with shading on a sheet from a
sketchbook
31.5 × 23.5
D.a.r.: *7.3/54.*
Z. XVI, 251
M.P. 1423

1315
Nu assis se coiffant
Seated Nude Doing her Hair
7 March 1954
Pencil on a sheet from a sketchbook
31.5 × 23.5
D.a.r.: *7.3.54.*
Inscr.a.r.: *II*
Z. XVI, 252
M.P. 1424

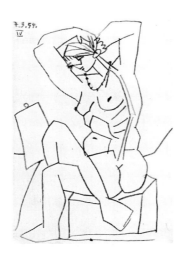

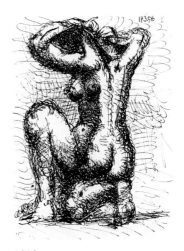

1316
Nu assis se coiffant
Seated Nude Doing her Hair
7 March 1954
Pencil on a sheet from a sketchbook
31.5 × 23.5
D.a.r.: *7.3.54.*
Inscr.a.r.: *III*
Z. XVI, 253
M.P. 1425

1317
Nu assis se coiffant
Seated Nude Doing her Hair
7 March 1954
Pencil on a sheet from a sketchbook
31.5 × 23.5
D.a.l.: *7.3.54.*
Inscr.a.l.: *IV*
Z. XVI, 254
M.P. 1426

1318
Nu se coiffant
Nude Doing her Hair
17 March 1954
Pen and Indian ink
32 × 24
D.a.r.: *17.3.54.*
Inscr.a.r. in blue ink: *I*
Z. XVI, 256
M.P. 1427

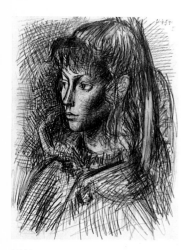

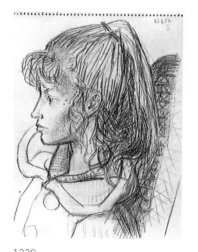

1319
Portrait de Sylvette
Portrait of Sylvette
21 April 1954
Pencil on a sheet from a sketchbook
31 × 24
D.a.r.: *21.4.54.*
Inscr.a.r.: *I*
Z. XVI, 278
M.P. 1428

1320
Portrait de Sylvette
Portrait of Sylvette
21 April 1954
Pencil on a sheet from a sketchbook
31 × 24
D.a.r.: *21.4.54*
Inscr.a.r.: *II*
Z. XVI, 277
M.P. 1429

1321
Etude pour 'Les femmes d'Alger' d'après Delacroix
Study for 'The Women of Algiers' after Delacroix
1 December 1954
Paris
Pen and brown ink
35.5 × 43.5
D.a.l.: *1er décembre 1954.*
Inscr.a.l.: *IV*
Z. XVI, 341
M.P. 1430

1322
Etude pour 'Les femmes d'Alger' d'après Delacroix
Study for 'The Women of Algiers' after Delacroix
21 December 1954
Paris
Indian ink
34.5 × 43.5
D.b.l.: *21.12.54.*
Inscr.b.l.: *II*
Z. XVI, 344
M.P. 1431

1323
Etude pour 'Les femmes d'Alger' d'après Delacroix
Study for 'The Women of Algiers' after Delacroix
25 December 1954
Paris
Blue crayon
21 × 27
D.a.r.: *25./12./54.*
Inscr.a.r.: *I*
M.P. 1432

1324
Etude pour 'Les femmes d'Alger' d'après Delacroix
Study for 'The Women of Algiers' after Delacroix
25 December 1954
Paris
Blue crayon
27 × 21
D.b.r.: *25.12./54.*
Inscr.b.r.: *II*
M.P. 1433

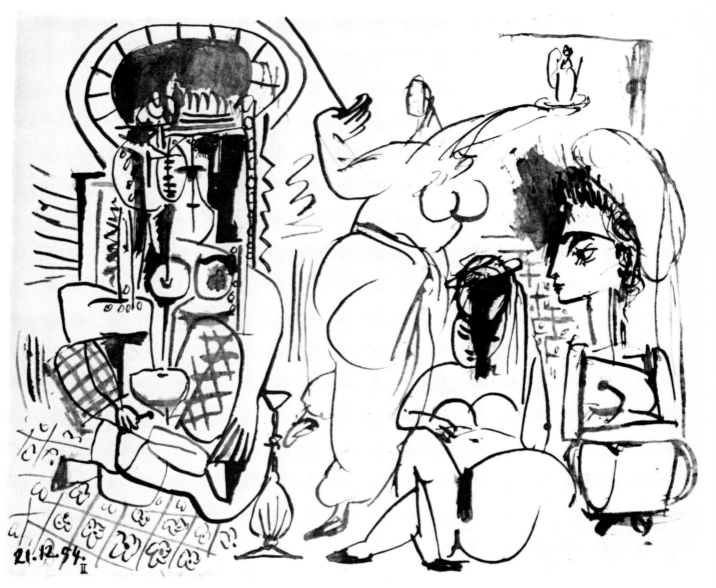

1322 Study for 'The Women of Algiers' after Delacroix

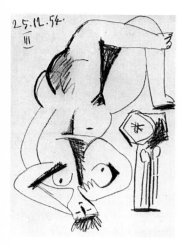

1325
Etude pour 'Les femmes d'Alger' d'après Delacroix
Study for 'The Women of Algiers' after Delacroix
25 December 1954
Paris
Blue crayon
27 × 21
D.a.l.: *25.12.54.*
Inscr.a.l.: *III*
M.P. 1434

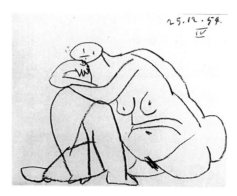

1326
Etude pour 'Les femmes d'Alger' d'après Delacroix
Study for 'The Women of Algiers' after Delacroix
25 December 1954
Paris
Blue crayon
21 × 27
D.a.r.: *25.12.54.*
Inscr.a.r.: *IV*
M.P. 1435

1327
Etude pour 'Les femmes d'Alger' d'après Delacroix
Study for 'The Women of Algiers' after Delacroix
26 December 1954
Paris
Pen and Indian ink on squared paper
21 × 27
D.a.r.: *26.12.54.*
Inscr.a.r.: *II*
M.P. 1436

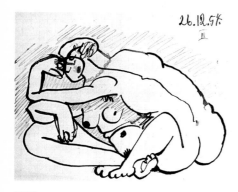

1328
Etude pour 'Les femmes d'Alger' d'après Delacroix
Study for 'The Women of Algiers' after Delacroix
Paris
Pen and Indian ink on squared paper
21 × 27
D.a.r.: *26.12.54.*
Inscr.a.r.: *III*
M.P. 1437

1329
Etude pour 'Les femmes d'Alger' d'après Delacroix
Study for 'The Women of Algiers' after Delacroix
26 December 1954
Paris
Pen and Indian ink on squared paper
21 × 27
D.a.r.: *26.12.54.*
Inscr.a.r.: *IV*
M.P. 1438

1330
Etude pour 'Les femmes d'Alger' d'après Delacroix
Study for 'The Women of Algiers' after Delacroix
26 December 1954
Paris
Pen and Indian ink on squared paper
21 × 27
D.a.r.: *26.12.54.*
Inscr.a.r.: *V*
M.P. 1439

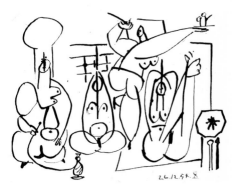

1331
Etude pour 'Les femmes d'Alger' d'après Delacroix
Study for 'The Women of Algiers' after Delacroix
26 December 1954
Paris
Pen and Indian ink on squared paper
21 × 27
D.a.r.: *26.12.54.*
Inscr.a.r.: *VI*
M.P. 1440

1332
Etude pour 'Les femmes d'Alger' d'après Delacroix
Study for 'The Women of Algiers' after Delacroix
26 December 1954
Paris
Pen and Indian ink on squared paper
21 × 27
D.a.r.: *26.12.54.*
Inscr.b.r.: *IX*
M.P. 1441

1333
Etude pour 'Les femmes d'Alger' d'après Delacroix
Study for 'The Women of Algiers' after Delacroix
26 December 1954
Paris
Pen and Indian ink on squared paper
21 × 27
D.b.r.: *26.12.54.*
Inscr.b.r.: *X*
M.P. 1442

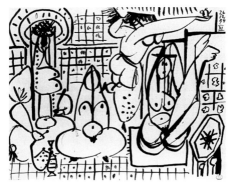

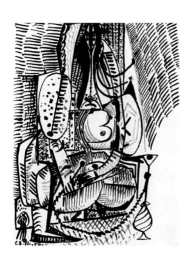

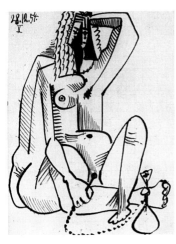

1334
Etude pour 'Les femmes d'Alger' d'après Delacroix
Study for 'The Women of Algiers' after Delacroix
26 December 1954
Paris
Pen and Indian ink on squared paper
21 × 27
D.a.r.: *26./12./54.*
Inscr.a.r.: *XI*
M.P. 1443

1335
Etude pour 'Les femmes d'Alger' d'après Delacroix
Study for 'The Women of Algiers' after Delacroix
28 December 1954
Paris
Indian ink on squared paper
27 × 21
D.b.l.: *28.12.54.*
Inscr.b.l.: *I*
M.P. 1444

1336
Etude pour 'Les femmes d'Alger' d'après Delacroix
Study for 'The Women of Algiers' after Delacroix
28 December 1954
Paris
Indian ink on squared paper
27 × 21
D.a.l.: *28.12.54.*
Inscr.a.l.: *II*
M.P. 1445

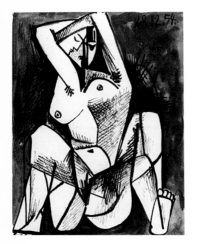

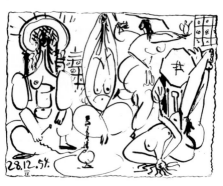

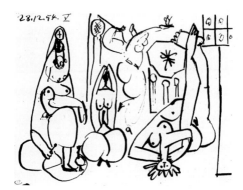

1337
Etude pour 'Les femmes d'Alger' d'après Delacroix
Study for 'The Women of Algiers' after Delacroix
28 December 1954
Paris
Pen, Indian ink and tinted wash on squared paper
27 × 21
D.a.r. and verso: *28.12.54.*
Inscr.a.r. and verso: *III*
M.P. 1446

1338
Etude pour 'Les femmes d'Alger' d'après Delacroix
Study for 'The Women of Algiers' after Delacroix
28 December 1954
Paris
Pen and Indian ink on squared paper
21 × 27
D.b.l.: *28.12.54.*
Inscr.b.l.: *IV*
M.P. 1447

1339
Etude pour 'Les femmes d'Alger' d'après Delacroix
Study for 'The Women of Algiers' after Delacroix
28 December 1954
Paris
Pen and Indian ink on squared paper
21 × 27
D.a.l.: *28.12.54.*
Inscr.a.l.: *V*
M.P. 1448

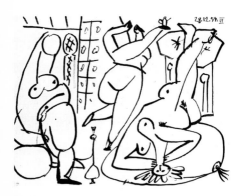

1340
Etude pour 'Les femmes d'Alger' d'après Delacroix
Study for 'The Women of Algiers' after Delacroix
28 December 1954
Paris
Pen and Indian ink on squared paper
21 × 27
D.a.r.: *28.12.54.*
Inscr.a.r.: *VI*
M.P. 1449

1341
Etude pour 'Les femmes d'Alger' d'après Delacroix
Study for 'The Women of Algiers' after Delacroix
28 December 1954
Paris
Pen and Indian ink on squared paper
21 × 27
D.b.r.: *28.12.54.*
Inscr.b.r.: *VII*
M.P. 1450

1342
Etude pour 'Les femmes d'Alger' d'après Delacroix
Study for 'The Women of Algiers' after Delacroix
28 December 1954
Paris
Pen and Indian ink on squared paper
21 × 27
D.a.l.: *28.12.54.*
Inscr.a.l.: *VIII*
M.P. 1451

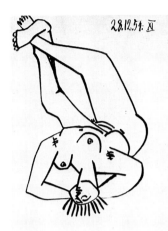

1343
Etude pour 'Les femmes d'Alger' d'après Delacroix
Study for 'The Women of Algiers' after Delacroix
28 December 1954
Paris
Pen and Indian ink on squared paper
27 × 21
D.a.l.: *28.12.54.*
Inscr.a.l.: *IX*
M.P. 1452

1344
Etude pour 'Les femmes d'Alger' d'après Delacroix
Study for 'The Women of Algiers' after Delacroix
28 December 1954
Paris
Pen and Indian ink on squared paper
27 × 21
D.a.l.: *28.12.54.*
Inscr.a.l.: *X*
M.P. 1453

1345
Etude pour 'Les femmes d'Alger' d'après Delacroix
Study for 'The Women of Algiers' after Delacroix
28 December 1954
Pen and Indian ink on squared paper
27 × 21
D.a.r.: *28.12.54.*
Inscr.a.r.: *XI*
M.P. 1454

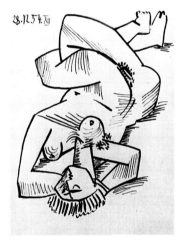

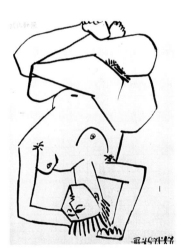

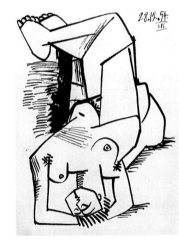

1346
Etude pour 'Les femmes d'Alger' d'après Delacroix
Study for 'The Women of Algiers' after Delacroix
28 December 1954
Paris
Pen and Indian ink on squared paper
27 × 21
D.a.l.: *28.12.54.*
Inscr.a.l.: *XII*
M.P. 1455

1347
Etude pour 'Les femmes d'Alger' d'après Delacroix
Study for 'The Women of Algiers' after Delacroix
28 December 1954
Paris
Pen and Indian ink on squared paper
27 × 21
D.a.l.: *28.12.54.* and b.r.: *28.12.54*
Inscr.a.l.: *XIII* and b.l. *XIII*
M.P. 1456

1348
Etude pour 'Les femmes d'Alger' d'après Delacroix
Study for 'The Women of Algiers' after Delacroix
28 December 1954
Paris
Indian ink on squared paper
27 × 21
D.a.r.: *28.12.54.*
Inscr.a.r.: *XIV*
M.P. 1457

1349
Etude pour 'Les femmes d'Alger' d'après Delacroix
Study for 'The Women of Algiers' after Delacroix
28 December 1954
Paris
Pen and Indian ink on squared paper
27 × 21
D.a.l.: *28.12.54.*
Inscr.a.l.: *XV*
M.P. 1458

1350
Etude pour 'Les femmes d'Alger' d'après Delacroix
Study for 'The Women of Algiers' after Delacroix
28 December 1954
Paris
Pen and Indian ink on squared paper
27 × 21
D.a.l.: *28.12.54.*
Inscr.a.l.: *XVI*
M.P. 1459

1351
Etude pour 'Les femmes d'Alger' d'après Delacroix
Study for 'The Women of Algiers' after Delacroix
29 December 1954
Paris
Pen and Indian ink on squared paper
21 × 27
D.b.l.: *29.12.54.*
Inscr.b.l.: *I*
M.P. 1460

1352
Etude pour 'Les femmes d'Alger' d'après Delacroix
Study for 'The Women of Algiers' after Delacroix
29 December 1954
Paris
Pen and Indian ink on squared paper
21 × 27
D.b.r.: *29.12.54.*
Inscr.b.r.: *II*
M.P. 1461

1353
Etude pour 'Les femmes d'Alger' d'après Delacroix
Study for 'The Women of Algiers' after Delacroix
29 December 1954
Paris
Pen and Indian ink on squared paper
21 × 27
D.b.r.: *29.12.54.*
Inscr.b.r.: *III*
M.P. 1462

1354
Etude pour 'Les femmes d'Alger' d'après Delacroix
Study for 'The Women of Algiers' after Delacroix
31 December 1954
Paris
Indian ink and blue crayon on squared paper
27 × 21
D.a.r.: *31.12.54.*
Inscr.a.r.: *I*
M.P. 1463

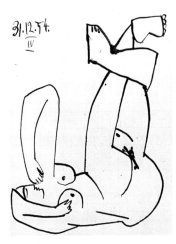

1355
Etude pour 'Les femmes d'Alger' d'après Delacroix
Study for 'The Women of Algiers' after Delacroix
31 December 1954
Paris
Indian ink and blue crayon on squared paper
27 × 21
D.a.r.: *31.12.54.*
Inscr.a.r.: *II*
M.P. 1464

1356
Etude pour 'Les femmes d'Alger' d'après Delacroix
Study for 'The Women of Algiers' after Delacroix
31 December 1954
Paris
Pen and Indian ink on squared paper
27 × 21
D.a.l.: *31.12.54.*
Inscr.a.l.: *III*
M.P. 1465

1357
Etude pour 'Les femmes d'Alger' d'après Delacroix
Study for 'The Women of Algiers' after Delacroix
31 December 1954
Paris
Pen and Indian ink on squared paper
27 × 21
D.a.l.: *31.12.54.*
Inscr.a.l.: *IV*
M.P. 1466

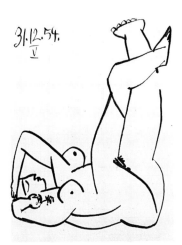

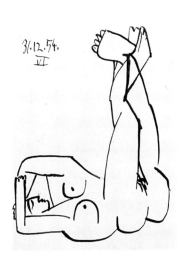

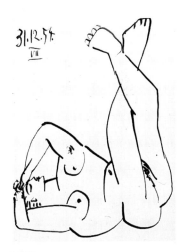

1358
Etude pour 'Les femmes d'Alger' d'après Delacroix
Study for 'The Women of Algiers' after Delacroix
31 December 1954
Paris
Pen and Indian ink on squared paper
27 × 21
D.a.l.: *31.12.54.*
Inscr.a.l.: *V*
M.P. 1467

1359
Etude pour 'Les femmes d'Alger' d'après Delacroix
Study for 'The Women of Algiers' after Delacroix
31 December 1954
Paris
Pen and Indian ink on squared paper
27 × 21
D.a.l.: *31.12.54.*
Inscr.a.l.: *VI*
M.P. 1468

1360
Etude pour 'Les femmes d'Alger' d'après Delacroix
Study for 'The Women of Algiers' after Delacroix
31 December 1954
Paris
Pen and Indian ink on squared paper
27 × 21
D.a.l.: *31.12.54.*
Inscr.a.l.: *VII*
M.P. 1469

1361
Etude pour 'Les femmes d'Alger' d'après Delacroix
Study for 'The Women of Algiers' after Delacroix
2 January 1955
Paris
Pen and Indian ink on squared paper
21 × 27
D.a.l.: *2.1.55.*
Inscr.a.l.: *I*
M.P. 1472

1362
Etude pour 'Les femmes d'Alger' d'après Delacroix
Study for 'The Women of Algiers' after Delacroix
2 January 1955
Paris
Pen and Indian ink on squared paper
21 × 27
D.b.r.: *2.1.55.*
Inscr.b.r.: *II*
M.P. 1473

1363
Etude pour 'Les femmes d'Alger' d'après Delacroix
Study for 'The Women of Algiers' after Delacroix
2 January 1955
Paris
Pen and Indian ink on squared paper
21 × 27
D.a.l.: *2.1.55.*
Inscr.a.l.: *III*
M.P. 1474

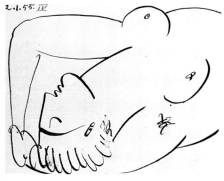

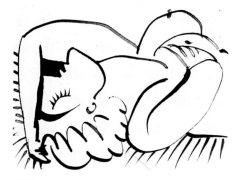

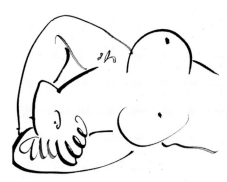

1364
Etude pour 'Les femmes d'Alger' d'après Delacroix
Study for 'The Women of Algiers' after Delacroix
2 January 1955
Paris
Pen and Indian ink on squared paper
21 × 27
D.a.l.: *2.1.55.*
Inscr.a.l.: *IV*
M.P. 1475

1365
Etude pour 'Les femmes d'Alger' d'après Delacroix
Study for 'The Women of Algiers' after Delacroix
[2–3] January 1955
Paris
Pen and Indian ink on the back of an invitation card for a National Committee of Writers book sale on Saturday 24 October [1953] at the Winter cycle-racing track
10 × 12.5
M.P. 1470

1366
Etude pour 'Les femmes d'Alger' d'après Delacroix
Study for 'The Women of Algiers' after Delacroix
[2–3] January 1955
Paris
Pen and Indian ink on the back of an invitation card for a National Committee of Writers book sale on Saturday 24 October [1953] at the Winter cycle-racing track
10 × 12.5
M.P. 1471

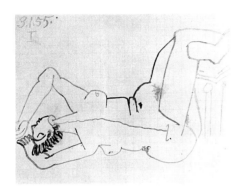

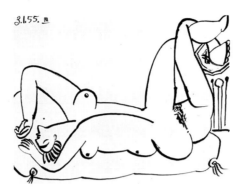

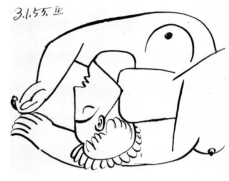

1367
Etude pour 'Les femmes d'Alger' d'après Delacroix
Study for 'The Women of Algiers' after Delacroix
3 January 1955
Paris
Pen and Indian ink on squared paper
21 × 27
D.a.l.: *3.1.55.*
Inscr.a.l.: *I*
M.P. 1476

1368
Etude pour 'Les femmes d'Alger' d'après Delacroix
Study for 'The Women of Algiers' after Delacroix
3 January 1955
Paris
Pen and Indian ink on squared paper
21 × 27
D.a.l.: *3.1.55.*
Inscr.a.l.: *III*
M.P. 1477

1369
Etude pour 'Les femmes d'Alger' d'après Delacroix
Study for 'The Women of Algiers' after Delacroix
3 January 1955
Paris
Indian ink on squared paper
21 × 27
D.a.l.: *3.1.55.*
Inscr.a.l.: *IV*
M.P. 1478

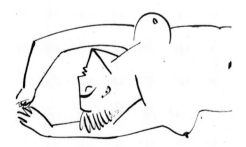

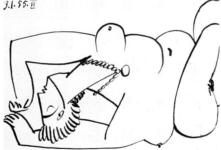

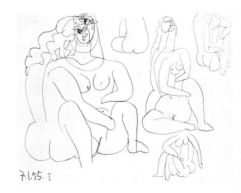

1370
Etude pour 'Les femmes d'Alger' d'après Delacroix
Study for 'The Women of Algiers' after Delacroix
3 January 1955
Paris
Pen and Indian ink on squared paper
21 × 27
D.a.l.: *3.1.55.*
Inscr.a.l.: *V*
M.P. 1479

1371
Etude pour 'Les femmes d'Alger' d'après Delacroix
Study for 'The Women of Algiers' after Delacroix
3 January 1955
Paris
Indian ink on squared paper
21 × 27
D.a.l.: *3.1.55.*
Inscr.a.l.: *VI*
M.P. 1480

1372
Etude pour 'Les femmes d'Alger' d'après Delacroix
Study for 'The Women of Algiers' after Delacroix
7 January 1955
Paris
Pencil
21 × 27
D.b.l.: *7.1.55.*
Inscr.b.l.: *I*
M.P. 1481

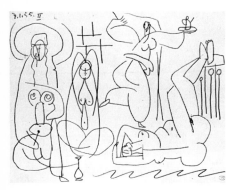

1373
Etude pour 'Les femmes d'Alger' d'après Delacroix
Study for 'The Women of Algiers' after Delacroix
7 January 1955
Paris
Pencil
21 × 27
D.b.l.: *7.1.55.*
Inscr.b.l.: *II*
M.P. 1482

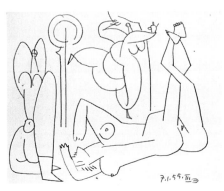

1374
Etude pour 'Les femmes d'Alger' d'après Delacroix
Study for 'The Women of Algiers' after Delacroix
7 January 1955
Paris
Pencil
21 × 27
D.b.r.: *7.1.55.*
Inscr.b.r.: *III*
M.P.1483

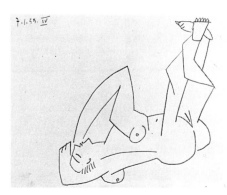

1375
Etude pour 'Les femmes d'Alger' d'après Delacroix
Study for 'The Women of Algiers' after Delacroix
7 January 1955
Paris
Pencil
21 × 27
D.a.l.: *7.1.55.*
Inscr.a.l.: *IV*
M.P. 1484

1376
Etude pour 'Les femmes d'Alger' d'après Delacroix
Study for 'The Women of Algiers' after Delacroix
7 January 1955
Paris
Pencil
21 × 27
D.a.l.: *7.1.55.*
Inscr.a.l.: *V*
M.P. 1485

1377
Etude pour 'Les femmes d'Alger' d'après Delacroix
Study for 'The Women of Algiers' after Delacroix
7 January 1955
Paris
Pencil
21 × 27
D.a.l.: *7.1.55.*
Inscr.a.l.: *VI*
M.P. 1486

1378
Etude pour 'Les femmes d'Alger' d'après Delacroix
Study for 'The Women of Algiers' after Delacroix
7 January 1955
Paris
Pencil
21 × 27
D.a.l.: *7.1.55.*
Inscr.a.l.: *VII*
M.P. 1487

1379
Etude pour 'Les femmes d'Alger' d'après Delacroix
Study for 'The Women of Algiers' after Delacroix
7 January 1955
Paris
Pencil
21 × 27
D.a.l.: *7.1.55.*
Inscr.a.l.: *VIII*
M.P. 1488

1380
Etude pour 'Les femmes d'Alger' d'après Delacroix
Study for 'The Women of Algiers' after Delacroix
7 January 1955
Paris
Pencil
21 × 27
D.a.l.: *7.1.55.*
Inscr.a.l.: *IX*
M.P. 1489

1381
Etude pour 'Les femmes d'Alger' d'après Delacroix
Study for 'The Women of Algiers' after Delacroix
7 January 1955
Paris
Pencil
21 × 27
D.a.l.: *7.1.55.*
Inscr.a.l.: *X*
M.P. 1490

1382
Etude pour 'Les femmes d'Alger' d'après Delacroix
Study for 'The Women of Algiers' after Delacroix
8 January 1955
Paris
Pen and Indian ink on the back of an invitation card for a National Committee of Writers book sale on Saturday 24 October [1953] at the Winter cycle-racing track
10 × 12.5
D.b.r.: *8.1.55.*
Inscr.b.r.: *I*
M.P. 1491

1383
Etude pour 'Les femmes d'Alger' d'après Delacroix
Study for 'The Women of Algiers' after Delacroix
8 January 1955
Paris
Pen and Indian ink on the back of an invitation card for a National Committee of Writers book sale on Saturday 24 October [1953] at the Winter cycle-racing track
10 × 12.5
D.a.r.: *8.1.55.*
Inscr.a.r.: *II*
M.P. 1492

1384
Etude pour 'Les femmes d'Alger' d'après Delacroix
Study for 'The Women of Algiers' after Delacroix
8 January 1955
Paris
Pen and Indian ink on the back of an invitation card for a National Committee of Writers book sale on Saturday 24 October [1953] at the Winter cycle-racing track
10 × 12.5
D.b.r.: *8.1.55.*
Inscr.b.r.: *III*
M.P. 1493

1385
Etude pour 'Les femmes d'Alger' d'après Delacroix
Study for 'The Women of Algiers' after Delacroix
8 January 1955
Paris
Pen and Indian ink on the back of an invitation card for a National Committee of Writers book sale on Saturday 24 October [1953] at the Winter cycle-racing track
10 × 12.5
D.b.r.: *8.1.55.*
Inscr.b.r.: *IV*
M.P. 1494

1386
Etude pour 'Les femmes d'Alger' d'après Delacroix
Study for 'The Women of Algiers' after Delacroix
8 January 1955
Paris
Pen and Indian ink on the back of an invitation card for a National Committee of Writers book sale on Saturday 24 October [1953] at the Winter cycle-racing track
10 × 12.5
D.b.r.: *8.1.55.*
Inscr.b.r.: *V*
M.P. 1495

1387
Etude pour 'Les femmes d'Alger' d'après Delacroix
Study for 'The Women of Algiers' after Delacroix
8 January 1955
Paris
Pen and Indian ink on the back of an invitation card for a National Committee of Writers book sale on Saturday 24 October [1953] at the Winter cycle-racing track
10 × 12.5
D.b.l.: *8.1.55.*
Inscr.b.l.: *VI*
M.P. 1496

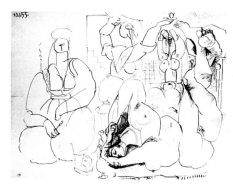

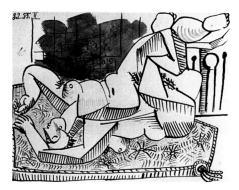

1388
Etude pour 'Les femmes d'Alger' d'après Delacroix
Study for 'The Women of Algiers' after Delacroix
8 January 1955
Paris
Pen and Indian ink on the back of an invitation card for a National Committee of Writers book sale on Saturday 24 October [1953] at the Winter cycle-racing track
10 × 12.5
D.b.l.: *8.1.55.*
Inscr.b.l.: *VII*
M.P. 1497

1389
Etude pour 'Les femmes d'Alger' d'après Delacroix
Study for 'The Women of Algiers' after Delacroix
23 January 1955
Paris
Pen and Indian ink
42.1 × 55
D.a.l.: *23.1.55.*
Z. XVI, 350
M.P. 1498

1390
Etude pour 'Les femmes d'Alger' d'après Delacroix
Study for 'The Women of Algiers' after Delacroix
3 February 1955
Paris
Indian ink on squared paper
21 × 27
D.a.l.: *3.2.55.*
Inscr.a.l.: *II*
M.P. 1499

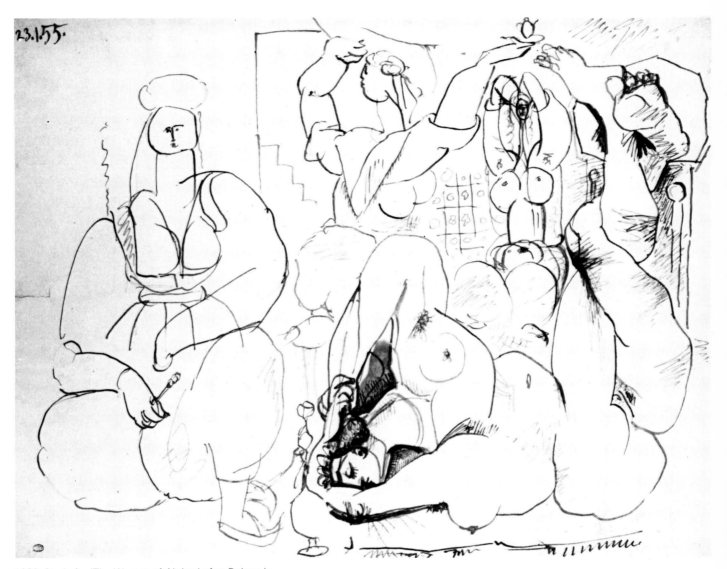

1389 Study for 'The Woman of Algiers' after Delacroix

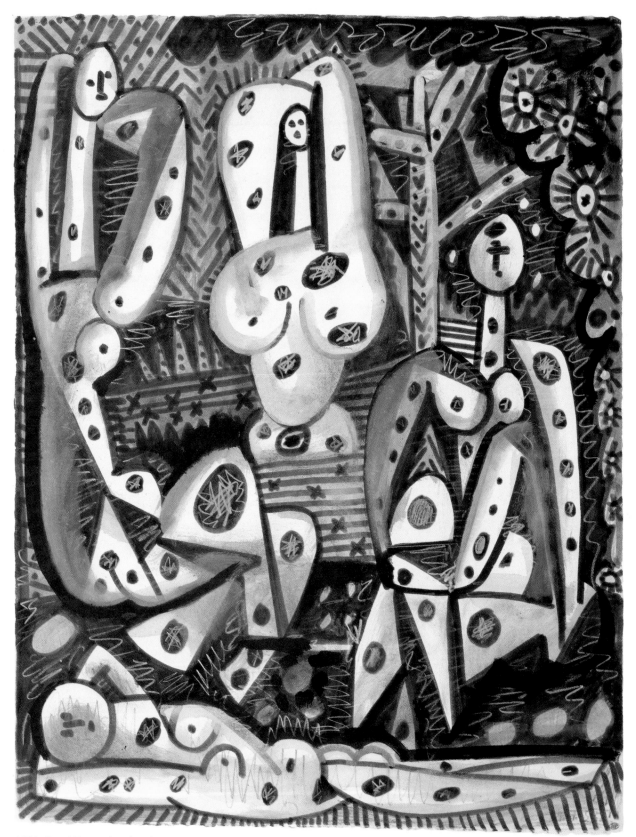

1392 Four Women in a Landscape

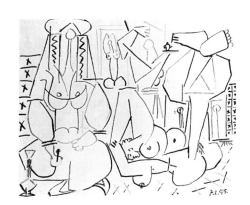

1391
Etude pour 'Les femmes d'Alger' d'après Delacroix
Study for 'The Women of Algiers' after Delacroix
7 February 1955
Paris
Pen and Indian ink
35 × 43.5
D.b.r.: *7.2.55.*
Z. XVI, 351
M.P. 1500

1392
Quatre femmes dans un paysage
Four Women in a Landscape
4 July 1955
Cannes
Indian ink, coloured crayons and gouache
65 × 50.5
D.b.r.: *4.7.55.*
Inscr. verso: *XIX*
Z. XVI, 400
M.P. 1501

1393
Paysage
Landscape
Summer 1955
Nice
Coloured inks on transparent paper mounted on a stretcher
55 × 73
Gift of the artist's heirs, 1983
M.P. 1983–8

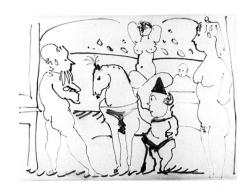

1394
Scène de cirque
Circus Scene
Summer 1955
Nice
Ink on transparent paper mounted on a stretcher
55 × 73
Gift of the artist's heirs, 1983
M.P. 1983–9

1395
Corrida
Bullfight
Summer 1955
Nice
Coloured inks on transparent paper mounted on a stretcher
55 × 73
Gift of the artist's heirs, 1983
M.P. 1983–10

1396
Couple
Couple
Summer 1955
Nice
Coloured inks on transparent paper mounted on a stretcher
55 × 73
Gift of the artist's heirs, 1983
M.P. 1983–11

1397
A l'atelier
In the Studio
Summer 1955
Nice
Coloured inks on transparent paper mounted
on a stretcher
55 × 73
Gift of the artist's heirs, 1983
M.P. 1983–12

1398
La mariée
The Bride
Summer 1955
Nice
Ink on transparent paper mounted on a
stretcher
55 × 73
Gift of the artist's heirs, 1983
M.P. 1983–13

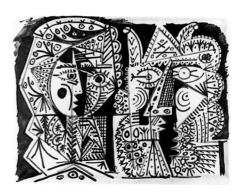

1399
Femme et bouffon
Woman and Clown
Summer 1955
Ink on transparent paper mounted on a
stretcher
55 × 73
Gift of the artist's heirs, 1983
M.P. 1983–14

1400
Tête de chèvre
Head of a Goat
Summer 1955
Nice
Ink and oil on transparent paper mounted on
a stretcher
55 × 73
Gift of the artist's heirs, 1983
M.P. 1983–15

1401
**Femme, faune et chèvre sur la plage de
La Garoupe**
*Woman, Faun and Goat on the Beach at La
Garoupe*
Summer 1955
Nice
Coloured inks and Indian ink on transparent
paper mounted on a stretcher
55 × 73
Gift of the artist's heirs, 1983
M.P. 1983–16

1402
Visage féminin
Female Face
Summer 1955
Nice
Ink on transparent paper mounted on a
stretcher
55 × 73
Gift of the artist's heirs, 1983
M.P. 1983–17

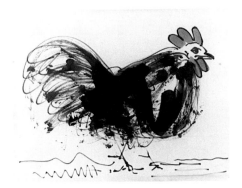

1403
Coq
Cockerel
Summer 1955
Nice
Inks on transparent paper mounted on a stretcher
55 × 73
Gift of the artist's heirs, 1983
M.P. 1983–18

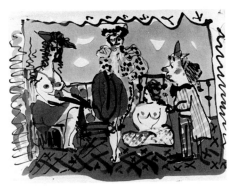

1404
Sur le balcon
On the Balcony
Summer 1955
Nice
Coloured inks on transparent paper mounted on a stretcher
55 × 73
Gift of the artist's heirs, 1983
M.P. 1983–19

1405
Nature morte à la cafetière
Still-life with Coffee-pot
Summer 1955
Nice
Coloured inks on transparent paper mounted on a stretcher
55 × 73
Gift of the artist's heirs, 1983
M.P. 1983–20

1406
Scene de plage
Beach Scene
Summer 1955
Nice
Ink on transparent paper mounted on a stretcher
55 × 73
Gift of the artist's heirs, 1983
M.P. 1983–21

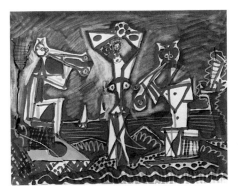

1407
Danseuse et faunes musiciens
Dancers and Faun Musicians
Summer 1955
Nice
Coloured inks and white pastel on transparent paper mounted on a stretcher
55 × 73
Gift of the artist's heirs, 1983
M.P. 1983–22

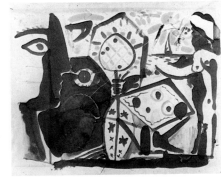

1408
Profil féminin et scène de plage
Female in Profile and Beach Scene
Summer 1955
Nice
Coloured inks on transparent paper mounted on a stretcher
55 × 73
Gift of the artist's heirs, 1983
M.P. 1983–23

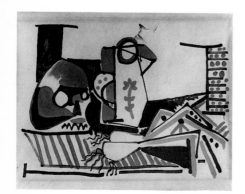

1409
Nature morte
Still-life
Summer 1955
Nice
Coloured inks on transparent paper mounted
on a stretcher
55 × 73
Gift of the artist's heirs, 1983
M.P. 1983–24

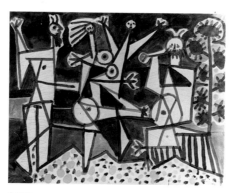

1410
Danse sur la plage
Dance on the Beach
Summer 1955
Nice
Coloured inks, coloured crayon and Indian ink
on transparent paper mounted on a stretcher
55 × 73
Gift of the artist's heirs, 1983
M.P. 1983–25(r)

1410a
Danse sur la plage
Dance on the Beach
Summer 1955
Nice
Indian ink on transparent paper mounted on a
stretcher
55 × 73
Gift of the artist's heirs, 1983
M.P. 1983–25(v)

1411
La guerre de Troie?
The Trojan War?
Summer 1955
Nice
Ink on transparent paper mounted on a
stretcher
55 × 73
Gift of the artist's heirs, 1983
M.P. 1983–26

1412
Le soleil et le faune
The Sun and the Faun
Summer 1955
Nice
Ink on transparent paper mounted on a
stretcher
73 × 55
Gift of the artist's heirs, 1983
M.P. 1983–27

1413
Corrida
Bullfight
Summer 1955
Nice
Coloured inks on transparent paper mounted
on a stretcher
55 × 73
Gift of the artist's heirs, 1983
M.P. 1983–28

1414
Corrida
Bullfight
Summer 1955
Nice
Coloured inks on transparent paper mounted on a stretcher
55 × 73
Gift of the artist's heirs, 1983
M.P. 1983–29

1415
Etudes de visages
Studies of Faces
Summer 1955
Nice
Ink on transparent paper mounted on a stretcher
55 × 73
Gift of the artist's heirs, 1983
M.P. 1983–30

1416
La dormeuse
Sleeping Woman
Summer 1955
Nice
Ink on transparent paper mounted on a stretcher
55 × 73
Gift of the artist's heirs, 1983
M.P. 1983–31

1417
A l'atelier
In the Studio
Summer 1955
Nice
Ink on transparent paper mounted on a stretcher
55 × 73
Gift of the artist's heirs, 1983
M.P. 1983–32

1418
La Célestine (?)
La Célestine (?)
Summer 1955
Nice
Coloured inks on transparent paper mounted on a stretcher; on one side is a small piece of *papier collé*
55 × 73
Gift of the artist's heirs, 1983
M.P. 1983–33

1419
Tête de chèvre
Head of a Goat
Summer 1955
Nice
Oil on transparent paper mounted on a stretcher
55 × 73
Gift of the artist's heirs, 1983
M.P. 1983–34

1420
Tête de femme
Head of a Woman
Summer 1955
Nice
Coloured inks on transparent paper mounted
on a stretcher
55 × 73
Gift of the artist's heirs, 1983
M.P. 1983–35

1421
A l'atelier
In the Studio
Summer 1955
Nice
Ink on transparent paper mounted on a
stretcher
55 × 73
Gift of the artist's heirs, 1983
M.P. 1983–36

1422
Deux têtes de faunes
Two Fauns' Heads
Summer 1955
Nice
Coloured inks on transparent paper mounted
on a stretcher
55 × 73
Gift of the artist's heirs, 1983
M.P. 1983–37

1423
Scène de plage
Beach Scene
Summer 1955
Nice
Ink on transparent paper mounted on a
stretcher
55 × 73
Gift of the artist's heirs, 1983
M.P. 1983–38

1424
Corrida
Bullfight
Summer 1955
Nice
Coloured inks on transparent paper mounted
on a stretcher
55 × 73
Gift of the artist's hairs, 1983
M.P. 1983–39

1425
Tête de taureau
Head of a Bull
Summer 1955
Nice
Coloured inks on transparent paper mounted
on a stretcher
55 × 73
Gift of the artist's heirs, 1983
M.P. 1983–40

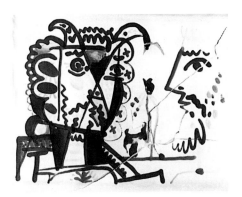

1426
Le roi et son bouffon
The King and his Jester
Summer 1955
Nice
Ink on transparent paper mounted on a
stretcher
55 × 73
Gift of the artist's heirs, 1983
M.P. 1983–41

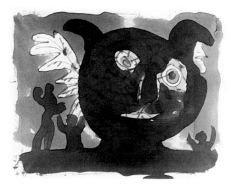

1427
Tête de faune
Head of a Faun
Summer 1955
Nice
Coloured inks on transparent paper mounted
on a stretcher
55 × 73
Gift of the artist's heirs, 1983
M.P. 1983–42

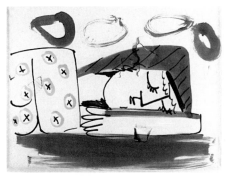

1428
La dormeuse
Sleeping Woman
Summer 1955
Nice
Coloured inks on transparent paper mounted
on a stretcher
55 × 73
Gift of the artist's heirs, 1983
M.P. 1983–43

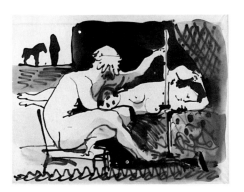

1429
Le peintre et son modèle
The Painter and his Model
Summer 1955
Nice
Ink on transparent paper mounted on a
stretcher
55 × 73
Gift of the artist's heirs, 1983
M.P. 1983–44

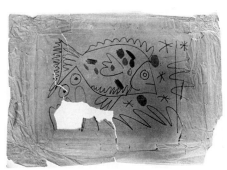

1430
Poisson
Fish
Summer 1955
Nice
Coloured inks on transparent paper
55 × 73
Gift of the artist's heirs, 1983
M.P. 1983–45

1431
Atelier de La Californie
The Studio at La Californie
25 October 1955
Cannes
Pencil
27 × 21
D.b.r.: *25./10./55.*
Inscr.b.r.: *II*
M.P. 1503

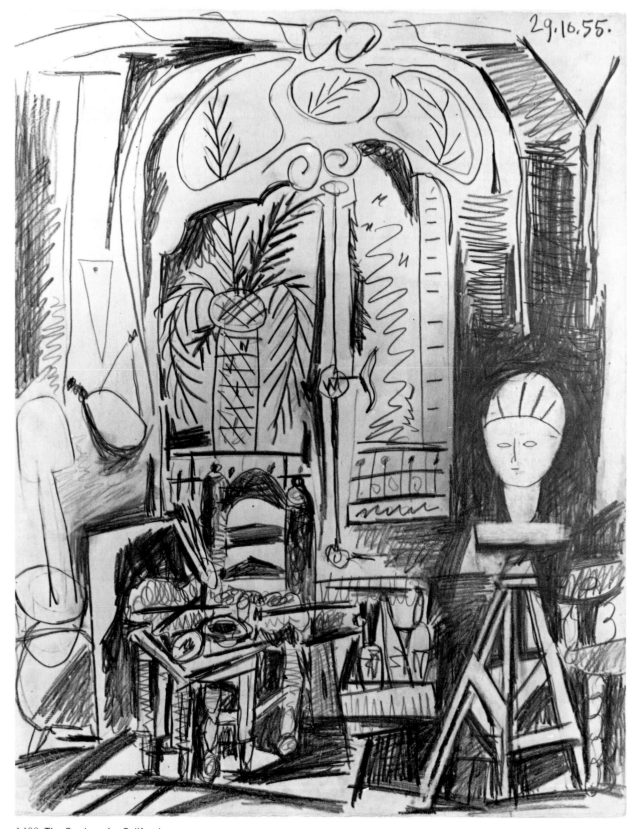

1432 **The Study at La Californie**

1432
Atelier de La Californie
The Studio at La Californie
29 October 1955
Cannes
Pencil
65 × 50.5
D.a.r.: *29.10.55.*
Z. XVI, 475
M.P. 1504

1433
Un coin de l'atelier
A Corner of the Studio
29 October 1955
Cannes
Pencil
27 × 21
D.a.l.: *29.10.55.*
Inscr.a.l.: *V*
M.P. 1505

1434
Atelier de La Californie
The Studio at La Californie
1 November 1955
Cannes
Indian ink
21 × 27
D.b.l.: *1.11.55.*
Inscr.b.l.: *I*
M.P. 1506

1435
Atelier de La Californie
The Studio at La Californie
1 November 1955
Cannes
Indian ink
21 × 27
D.b.r.: *1.11.55.*
Inscr.b.r.: *II*
M.P. 1507

1436
Atelier de La Californie
The Studio at La Californie
1 November 1955
Cannes
Indian ink
21 × 27
D.b.l.: *1.11.55.*
Inscr.b.l.: *III*
M.P. 1508

1437
Atelier de La Californie
The Studio at La Californie
1 November 1955
Cannes
Indian ink
21 × 27
D.b.l.: *1.11.55.*
Inscr.b.l.: *IV*
M.P. 1509

1438
Atelier de La Californie
The Studio at La Californie
1 November 1955
Cannes
Indian ink
21 × 27
D.a.l.: *1.11.55.*
Inscr.a.l.: *V*
M.P. 1510

1439
Atelier de La Californie
The Studio at La Californie
1 November 1955
Cannes
Indian ink
21 × 27
D.b.r.: *1.11.55.*
Inscr.b.r.: *VI*
M.P. 1511

1440
Atelier de La Californie
The Studio at La Californie
1 November 1955
Cannes
Indian ink
21 × 27
D.b.r.: *1.11.55.*
Inscr.b.r.: *VII*
M.P. 1512

1441
Etude pour 'Les femmes d'Alger' d'après Delacroix
Study for 'Women of Algiers' after Delacroix
with handwritten notes showing colours to be used
[1955]
Indian ink and blue crayon on glassine paper
39.3 × 38
M.P. 1502

1442
Etude pour 'Les baigneurs': le tremplin
Study for 'The Bathers': the Diving-board
8 September 1956
Cannes
Indian ink on pencil outlines
21 × 27
D.a.r.: *8.9.56.*
Z. XVII, 164
M.P. 1513(r)

1442a
Etude pour 'Les baigneurs'
Study for 'The Bathers'
8 September 1956
Cannes
Indian ink on pencil outlines
27 × 21
D.c.l.: *8.9.56.*
Z. XVII, 163
M.P. 1513(v)

1443
Portrait de Jacques Prévert
Portrait of Jacques Prévert
26 September 1956
Red and blue crayon on a sheet from a
sketchbook
50.7 × 33
D.b.l.: *26.9.56.*
Inscr.b.l.: *V*
M.P. 1514(r)

1443a
Portrait de Jacques Prévert
Portrait of Jacques Prévert
26 September 1956
Blue crayon on a sheet from a sketchbook
50.7 × 33
D.a.l.: *26.9.56.*
Inscr.a.l.: *VI*
M.P. 1514(v)

1444
Portrait de Francis Poulenc
Portrait of Francis Poulenc
13 March 1957
Pencil on a sheet from a sketchbook
54 × 37
D.a.l.: *13.3.57.*
Z. XVII, 327
M.P. 1515

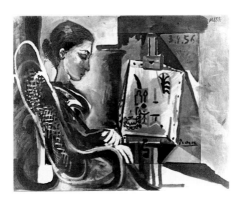

1445
Etude pour 'Tête de femme'
Study for 'Head of a Woman'
(for a sculpture project planned as an idea for
a monument to Barcarés)
13 June 1957
Cannes
Pencil
27 × 21
D.b.l.: *13.6.57.*
Inscr.b.l.: *I*
M.P. 1516

1446
Jacqueline dans l'atelier
Jacqueline in the Studio
13 November 1957
Cannes
Gouache and Indian ink on a Spitzer
reproduction on the stencil-plate of the
picture *La femme dans l'atelier*, 3 April 1956
63.5 × 80.8
D.a.r.: *13.11.57.*
Z. XVII, 403
M.P. 1517

1447
L'atelier: la femme couchée et le tableau
*The Studio: the Reclining Woman and the
Picture*
15 December 1957
Cannes
Pencil on two sheets pinned together
42.5 × 50.5
D.b.l.: *15.12.57.*
Inscr. b.l.: *unesco IV*
Z. XVII, 415
M.P. 1518

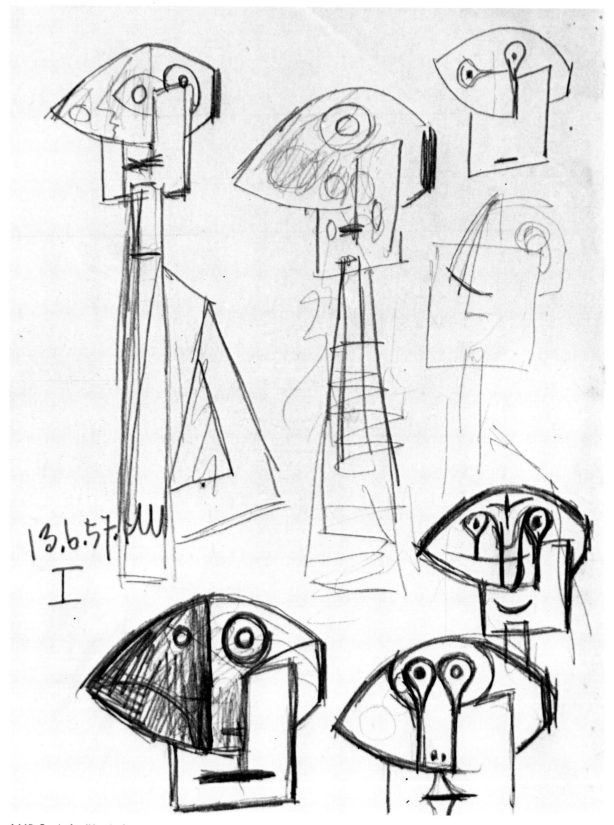

1445 Study for 'Head of a Woman'

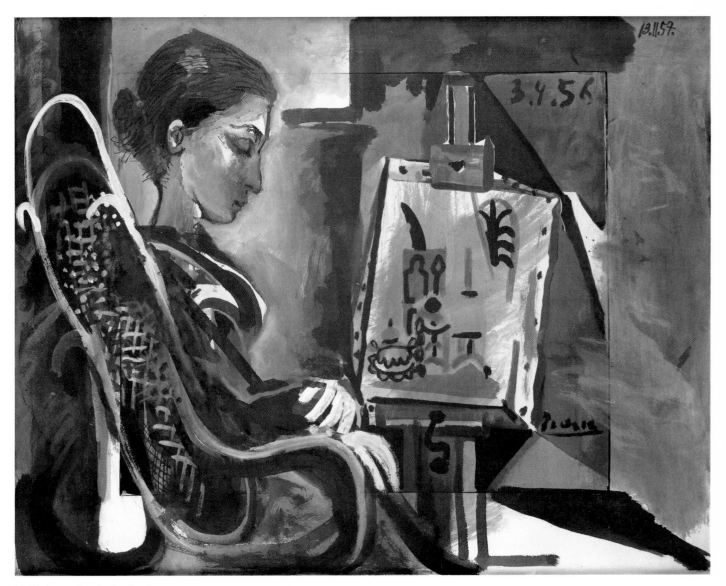

1446 Jacqueline in the Studio

1448
L'atelier: la femme couchée et le tableau
*The Studio: the Reclining Woman and the
Picture*
15 December 1957
Cannes
Pencil and blue crayon
53 × 66.5
D.a.r.: *15.12.57.*
Inscr.a.r.: *Unesco/V*
Z. XVII, 416
M.P. 1519

1449
L'atelier: la femme couchée et le tableau
*The Studio: the Reclining Woman and the
Picture*
December 1957
Cannes
Indian ink on blue crayon and pencil outlines
50.5 × 66
Z. XVII, 417
M.P. 1523

1450
L'atelier: la femme couchée et le tableau
*The Studio: the Reclining Woman and the
Picture*
December 1957
Cannes
Pencil and blue crayon
51 × 66
Z. XVII, 418
M.P. 1522

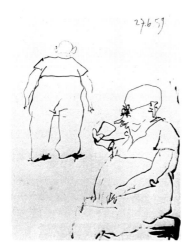

1451
**L'atelier: la femme couchée, le tableau
et le peintre**
*The Studio: the Reclining Woman, the Picture
and the Painter*
4 January 1958
Cannes
Pencil
50.5 × 65.5
D.a.r.: *4.1.58.*
Inscr.a.r.: *II*
M.P. 1520

1452
**Affiche pour une exposition de
céramiques à Vallauris**
*Poster for an Exhibition of Ceramics at
Vallauris*
1958
Cannes
Coloured chalks on a linocut
(Bloch 1279, Czwiklitzer 29)
67 × 51
Z. XVIII, 80
M.P. 1521

1453
Portrait-charge de Jaime Sabartés
Caricature of Jaime Sabartés
27 June 1959
Indian ink
27 × 21
D.a.r.: *27.6.59.*
Z. XVIII, 498
M.P. 1524

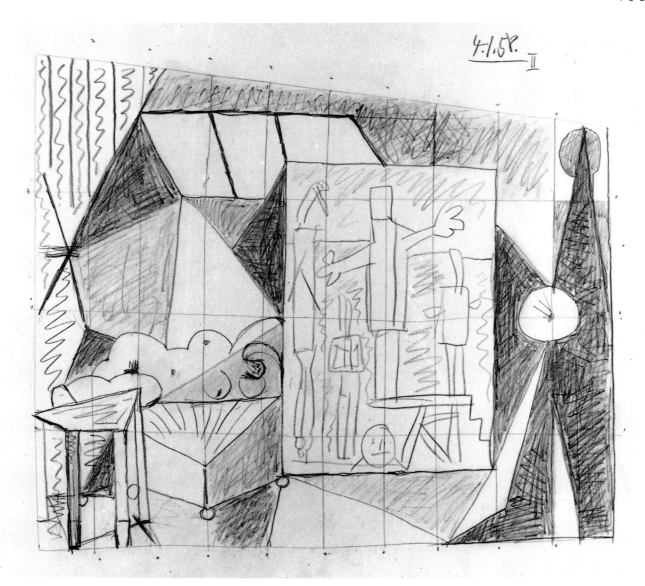

1451 The Studio: the Reclining Woman, the Picture and the Painter

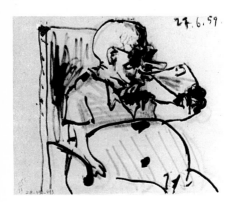

1454
Portrait-charge de Jaime Sabartés
Caricature of Jaime Sabartés
27 June 1959
Indian ink and black chalk
21 × 27
D.a.r. in pencil: *27.6.59.*
Z. XVIII, 492
M.P. 1525(r)

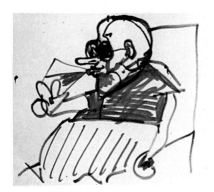

1454a
Portrait-charge de Jaime Sabartés
Caricature of Jaime Sabartés
1959
Red and black felt pen
21 × 27
Z. XVIII, 493
M.P. 1525(v)

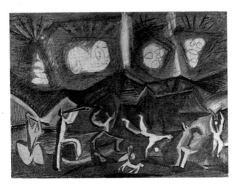

1455
Concert champêtre
Rustic Concert
10 December 1959
Coloured crayons, chalks and watercolour on
cardboard
60 × 81
D.a.r. and verso: *10.12.59* and *10.12/11/59*
Inscr.a.r.: *II*
Z. XIX, 105
M.P. 1526

1456
Pierrot assis
Seated Pierrot
9 March 1961
Mougins
Black chalk, pencil and coloured crayons
27 × 21
D.a.l.: *9.3.61.*
M.P. 1527

1457
Hommage à Youri Gagarine
Homage to Yuri Gagarin
16 April 1961
Pencil on a sheet from a sketchbook
33 × 42
S.D.a.r.: *Picasso/16.4.61.*
Inscr.a.l.: *Youri Gagarine*
Z. XIX, 447
M.P. 1531

1458
Portrait de Youri Gagarine
Portrait of Yuri Gagarin
[16] April 1961
Pencil on a sheet from a sketchbook
33 × 42
Inscr.a.l.: *Youri/Gagarine*
Z. XIX, 448
M.P. 1530

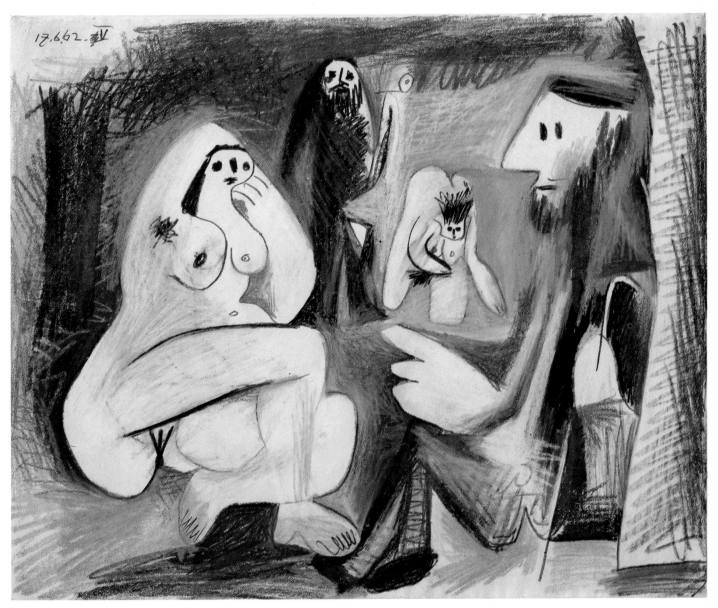

1462 'Le déjeuner sur l'herbe' after Manet

1459
Footballeur et croquis de têtes
Football Player and Sketches of Heads
2 May 1961
Mougins
Pencil, ballpoint pen and coloured chalks
50.5 × 66
D.a.l.: *2.5.61.*
Z. XX, 5
M.P. 1528(r)

1459a
Footballeurs
Football Players
2 May 1961
Mougins
Pencil and coloured chalks
50.5 × 66
D.a.r.: *2.5.61.*
Z. XX, 3
M.P. 1528(v)

1460
Footballeurs
Football Players
3 May 1961
Mougins
Coloured chalks
51 × 66
D.b.l.: *3.5.61.*
Z. XX, 4
M.P. 1529

1461
Tête de faune
Head of a Faun
12 December 1961
Pen and ink on the flyleaf of David Douglas
Duncan's book *Les Picasso de Picasso*
29 × 23
S.D.a.r.: *Picasso/le 12.12./61.*
Dedicated a: *Pour Louis Cane*
Assigned by the Customs House, 1982
M.P. 1982–2

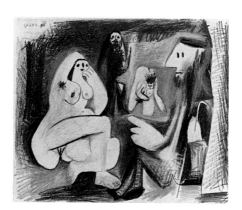

1462
'Le déjeuner sur l'herbe' d'apres Manet
'Le Déjeuner sur l'Herbe' after Manet
17 June 1962
Mougins
Coloured chalks and pencil
42.5 × 52
D.a.l.: *17.6.62.*
Inscr.a.l.: *V*
M.P. 1534

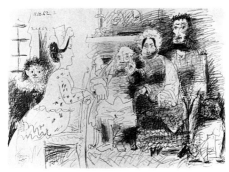

1463
Portrait de famille, II
Family Portrait, II
11 October 1962
Mougins
Pencil on a lithograph dated 21 June 1962
(M. 384)
56 × 76
D.a.l.: *11.10.62.*
Inscr.a.l.: *I*
M.P. 1277

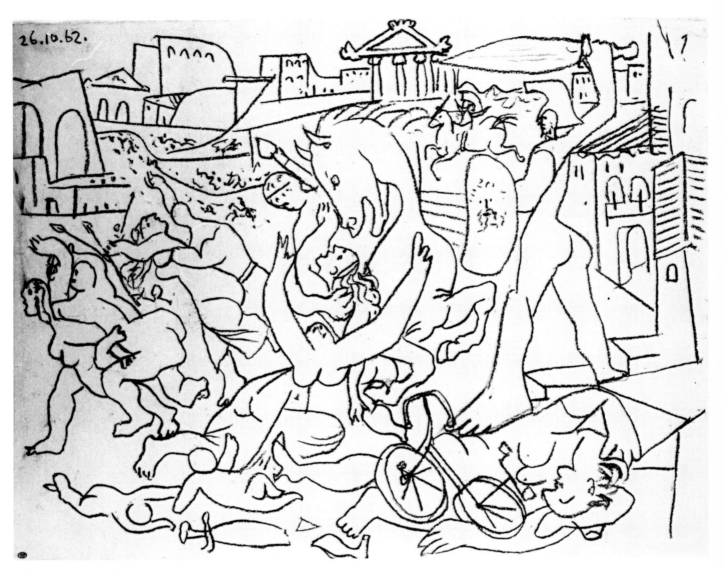

26.10.62.

1465 Study for 'The Rape of the Sabines' after Poussin

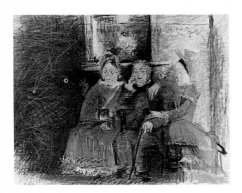

1464
Portrait de famille, I
Family Portrait, I
15–19 October 1962
Mougins
Soft coloured crayon and pencil on a
lithograph dated 23 June 1962, unlisted
56 × 76
D.a.l. in pencil: *15.10.62./16.17.18.19*
Z. XXIII, 4
M.P. 1532

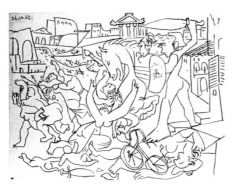

1465
**Etude pour 'L'enlèvement des Sabines'
d'après Poussin**
*Study for 'The Rape of the Sabines' after
Poussin*
26 October 1962
Mougins
Charcoal
50.5 × 66
D.a.l.: *26.10.62.*
Z. XXIII, 33
M.P. 1533

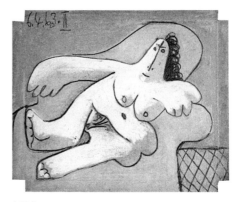

1466
Nu couché
Reclining Nude
6 April 1963
Mougins
Pastel and pencil inside an opened-out box of
colours by Lefranc
17 × 21
D.a.l.: *6.4.63.*
Inscr.a.l.: *II*
Z. XXIII, 192
M.P. 1537

1467
Homme courant (footballeur?)
Man Running (Football Player?)
13 May 1963
Mougins
Pencil on cardboard
19.8 × 26.6
D.a.r.: *13.5.63.*
Inscr.a.r.: *I*
Z. XXIII, 261
M.P. 1851

1468
Homme courant (footballeur?)
Man Running (Football Player?)
13 May 1963
Mougins
Pencil on cardboard
24.5 × 31
D.a.r.: *13.5.63.*
Inscr.a.r.: *II*
Z. XXIII, 262
M.P. 1852(r)

1468a
Homme nu
Nude Man
13 May 1963
Mougins
Pencil
24.5 × 31
D.a.l.: *13.5.63.*
M.P. 1852(v)

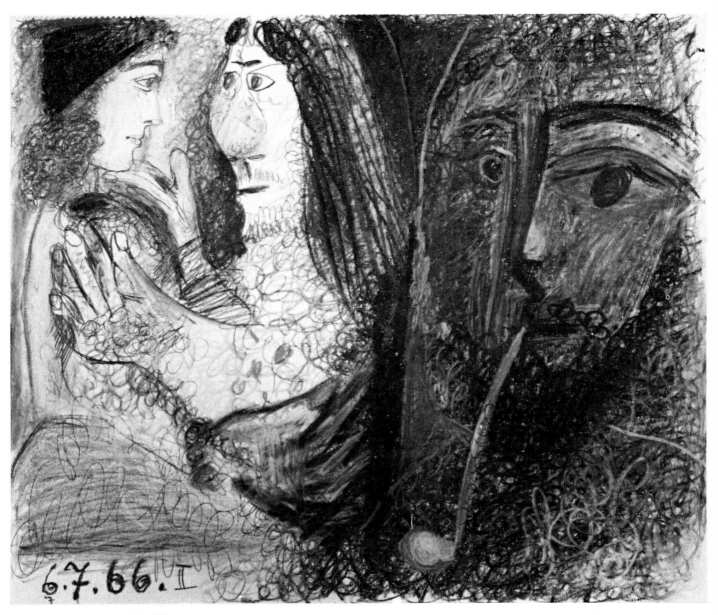

1472 Couple and Man with a Pipe

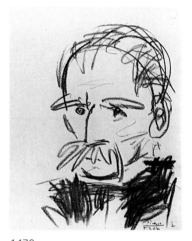

1469
Homme nu courant (footballeur?)
Nude Man Running (Football Player?)
14 May 1963
Mougins
Pencil on cardboard
19.8 × 27
D.b.r.: *14.5.63.*
Inscr.b.r.: *I*
Z. XXIII, 263
M.P. 1853(r)

1469a
Homme courant (footballeur?)
Man Running (Football Player?)
14 May 1963
Mougins
Pencil on cardboard
19.8 × 27
D.b.l.: *14.5.63*
Inscr.b.l.: *II*
Z. XXIII, 264
M.P. 1853(v)

1470
Portrait de Marcel Cachin
Portrait of Marcel Cachin
5 March 1964
Mougins
Charcoal
64 × 49
S.D.b.r.: *Picasso/5.3.64.*
Inscr.b.r.: *I*
M.P. 1535

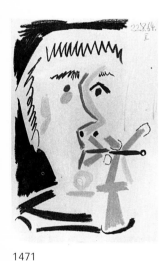

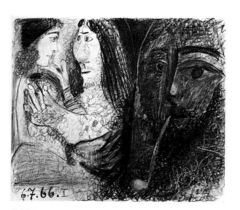

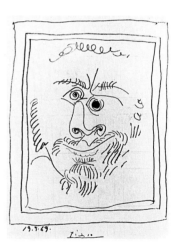

1471
Buste d'homme à la cigarette
Head and Shoulders of a Man with a Cigarette
22 August 1964
Mougins
Coloured chalks and crayons
65 × 50
D.a.r. in pencil: *22.8.64.*
Inscr.a.r. in pencil: *II*
M.P. 1536

1472
Couple et homme à la pipe
Couple and Man with a Pipe
6 July 1966
Mougins
Coloured chalks and crayons and pencil on a sheet from a sketchbook
50 × 61
D.b.l.: *6.7.66.*
Inscr.b.l.: *II*
M.P. 1538

1473
Tête d'homme barbu
Head of a Bearded Man
19 May 1969
Mougins
Felt pen on a sheet from a sketchbook
27 × 21
S.c.b. in pencil: *Picasso*
D.b.l.: *19.5.69.*
Z. XXXI, 203
Assigned by the Customs House, 1977
M.P. 1977–1

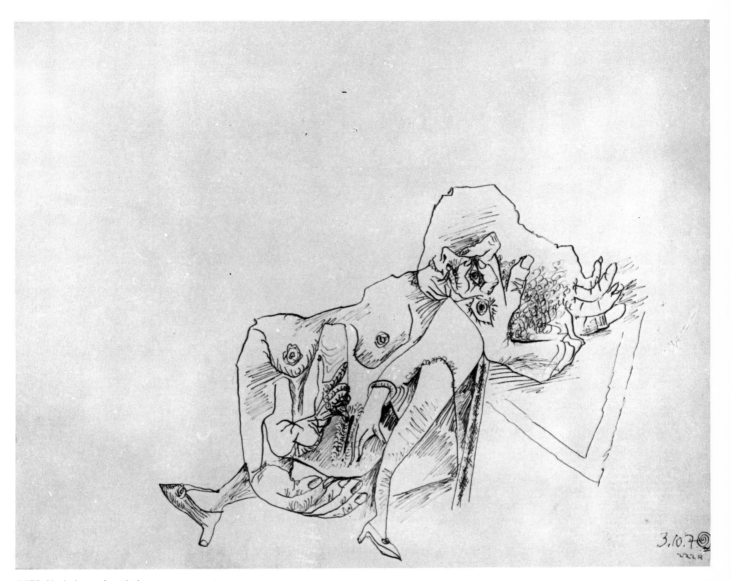

1476 Nude in an Armchair

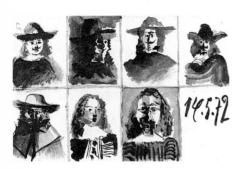

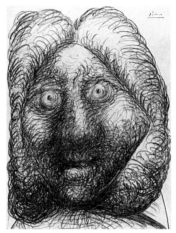

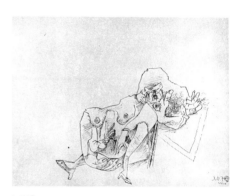

1474
Sept mousquetaires
Seven Musketeers
14 May 1972
Mougins
Indian ink wash on a sheet from a register
numbered 37
23 × 35.5
D.b.r. and verso: *14.5.72*
Inscr. verso: *III*
Z. XXXIII, 387
M.P. 1539

1475
Tête d'homme
Head of a Man
4 July 1972
Mougins
Black chalk
65.8 × 50.3
S.a.r.: in pencil: *Picasso*
D. verso: *mardi 4 Juillet 1972*
Z. XXXIII, 439
Assigned by the Fonds National d'Art
Contemporain, 1982
M.P. 1982–160

1476
Nu dans un fauteuil
Nude in an Armchair
3 October 1972
Mougins
Pen and Indian ink
59 × 75.5
D.b.r.: *3.10.72.*
Z. XXXIII, 513
M.P. 1544

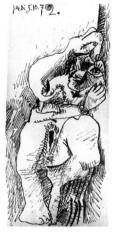

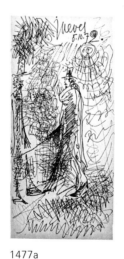

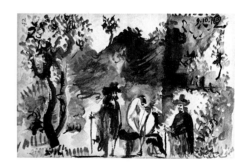

1477
Nu
Nude
5 October 1972
Mougins
Indian ink and felt pen on cardboard
34 × 16
Z. XXXIII, 514
M.P. 1542(r)

1477a
Deux hommes sous le soleil
Two Men in the Sun
5 October 1972
Mougins
Indian ink and felt pen on cardboard
34 × 16
D.a.: *Jueves/5.10.72.*
Z. XXXIII, 516
M.P. 1542(v)

1478
**Nu et deux mousquetaires dans un
paysage**
Nude and Two Musketeers in a Landscape
9 October 1972
Mougins
Watercolour on a sheet from a register
numbered 42
22.5 × 35.5
D.a.r. and verso: *9.10.72.*
Z. XXXIII, 518
M.P. 1543

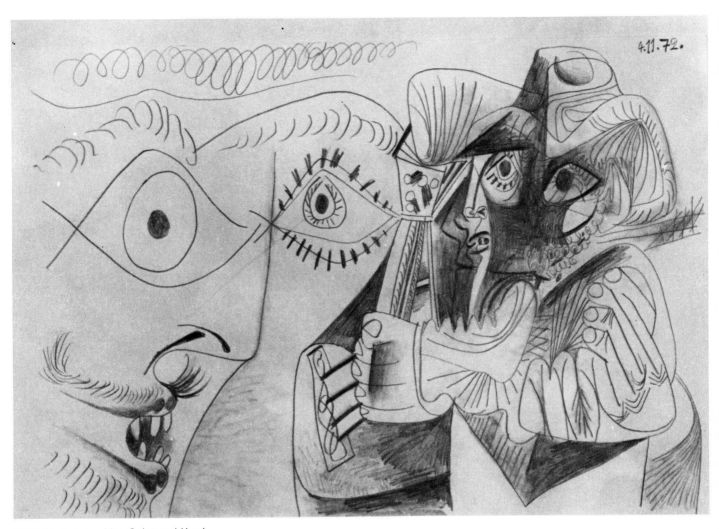

1480 Musketeer with a Guitar and Head

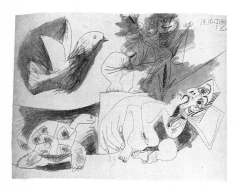

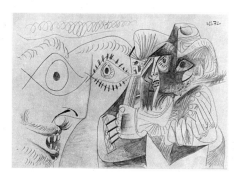

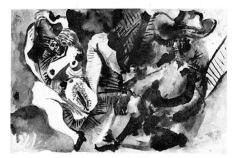

1479
Colombe, amour, tortue et nu couché
Dove, Cupid, Tortoise and Reclining Nude
13 October 1972
Mougins
Pencil, black chalk and Indian ink wash
57 × 77.5
D.a.r.: *13.10.72.*
Z. XXXIII, 521
M.P. 1541

1480
Mousquetaire à la guitare et tête
Musketeer with a Guitar and Head
4 November 1972
Mougins
Pencil
32.5 × 50
D.a.r.: *4.11.72.*
Z. XXXIII, 529
M.P. 1545

1481
Mousquetaire et femme nue
Musketeer and Nude Woman
1972
Mougins
Indian ink, tinted wash and watercolour
22.5 × 35.2
Z. XXXIII, 267
M.P. 1540

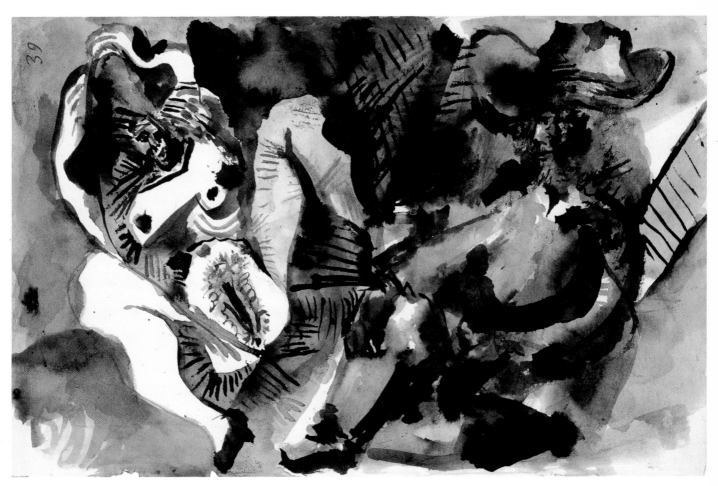

1481 Musketeer and Nude Woman

Exhibitions

Select Bibliography

Concordances

Exhibitions

Supplement to the list in Vol. I, pp. 258–266

1984

Pablo Picasso, Zeichnungen und Collagen, Hamburg, Galerie Levy, 9 April–19 May 1984.

Picasso, Suite Vollard, 1930–1937, Geneva, Galerie Patrick Cramer, June–July 1984.

Original Ceramics by Pablo Picasso, texts by Sir Richard Attenborough and Marilyn McCully, London, Nicola Jacobs Gallery, 6 June–11 August 1984.

Picasso, Els cent cinquanta-sis illustrats, Barcelona, Museo Picasso, 21 September–30 November 1984.

Pablo Picasso, A Retrospective Exhibition of the Artist's Graphic Work, Chicago, R. S. Johnson International, autumn 1984.

1985

Picasso, 34 Originals, Barcelona, Sala Gaspar, 1985.

Picasso's Picassos, Paintings, Drawings and Sculpture from the Artist's Estate, Chicago, Richard Gray Gallery, 3 April–9 May 1985.

Picasso, Sidste grafiske arbejder 1970–72, Aalborg, Nordjyllands Kunstmuseum, 6 June–1 September 1985.

Pablo Picasso, Rencontre à Montréal, catalogue by Louise d'Argencourt and Pierre Théberge, Montreal, Musée des Beaux-Arts, 21 June–10 November 1985.

Picasso Keramiek, 's-Hertogenbosch, Museum Het Kruithuis, 22 June–11 August 1985.

Picasso, mille et une nuits de la gravure, Montpellier, Musée Fabre, summer 1985.

Picasso, Zeichnungen, Radierungen, Lithographien, Salzburg, Galerie Welz, 24 July–1 September 1985.

Pablo Picasso, 1881–1973, Druckgrafik von 1931 bis 1965, Sammlung Marina Picasso Hoechst, Jahrhunderthalle, 6 October–10 November 1985; Leverkusen, Erholungshaus der Bayer AG, 17 November 1985–5 January 1986.

Through the Eye of Picasso, 1928–1934, The Dinard Sketchbook and Related Paintings and Sculpture, text by John Richardson, New York, William Beadleston, Inc., 31 October–14 December 1985.

Picasso At Work At Home, Selections from the Marina Picasso Collection, catalogue by Gert Schiff, Miami, Center for the Fine Arts, 19 November 1985–9 March 1986.

1986

Picasso Drawings 1906–1920, on loan from Maya Ruiz-Picasso, catalogue by Brigitte Baer, New York, Stephen Mazoh, spring 1986.

Picasso, Pastelle, Zeichnungen, Aquarelle, catalogue by Werner Spies, Tübingen, Kunsthalle, 5 April–1 June 1986; Düsseldorf, Kunstsammlung Nordrhein-Westfalen, 14 June–27 July 1986.

Picasso, Œuvres cubistes de la collection Marina Picasso, Geneva, Galerie Jan Krugier, 18 April–18 June 1986.

Je suis le cahier / The Sketchbooks of Picasso, edited by Arnold Glimcher and Marc Glimcher, New York, The Pace Gallery, 2 May–1 August 1986; London, Royal Academy of Arts, 20 September–19 November 1986.

Pablo Picasso / Suite Vollard, As Linoleogravuras, As 156 últimas Gravuras, Rio de Janeiro, Paço Imperial, 28 May–6 July 1986.

Mon ami Picasso, Limoges, Le Mazeau, June 1986.

Picasso, Sculptures en tôle découpée pliée, assemblée et peinte, text by Claude Fournet, Nice, Galerie Sapone, June–July 1986.

Pablo Picasso, céramiques, Collection Jacqueline Picasso, Vallauris, Atelier Sassi-Milici, summer 1986.

Picasso, der Maler und seine Modelle, preface and commentaries by Pierre Daix, Basle, Galerie Beyeler, July–October 1986.

Picasso: The Development and Transformation of an Image, introduction by Alan Cristea, London, Waddington Graphics, 9 September–25 October 1986.

Picasso, catalogue by Brigitte Baer, Barcelona, Galeria Paco Rebés, October 1986.

Picasso, 60 Originals, Barcelona, Sala Gaspar, October 1986.

Picasso en Madrid, Colección Jacqueline Picasso, Madrid, Museo Español de Arte Contemporáneo, 25 October 1986–10 January 1987.

Parade pour Parade, brief guide by Jean-Paul Ameline, Paris, Centre Georges Pompidou, Musée National d'Art Moderne, 18 December 1986–3 February 1987.

Select Bibliography

Partially reprinted from Vol. I of the catalogue, supplemented by recent publications and revised with respect to the drawings.

Bibliographies

Gaya Nuño, Juan Antonio, *Bibliografia critica y antologica de Picasso*, San Juan, Puerto Rico, 1966.
Kibbey, Ray Anne, *Picasso, A Comprehensive Bibliography*, New York, London, 1977.
Matarasso, Henri, *Bibliographie des livres illustrés par Pablo Picasso/Œuvres graphiques 1905–1945*, Nice, 1956.

Picasso the Man

Brassaï, *Picasso & Co.*, New York, 1966, London, 1967.
Champris, Pierre de, *Picasso, ombre et soleil*, Paris, 1960.
Cocteau, Jean, *Le rappel à l'ordre*, Paris, 1926.
Connaître Picasso, Paris, 1974.
Crespelle, Jean-Paul, *Picasso and his Women*, London, 1969.
Duncan, David Douglas, *The Private World of Pablo Picasso*, New York, 1958.
Duncan, David Douglas, *Goodbye Picasso*, Paris, 1975.
Duncan, David Douglas, *The Silent Studio*, New York, London, 1976.
Duncan, David Douglas, *Viva Picasso, a Centennial Celebration 1881–1981*, New York, 1980.
Eluard, Paul, *A Pablo Picasso*, Geneva, 1944.
Gilot, Françoise and Lake, Carlton, *Life with Picasso*, New York, 1964, London, 1965.
Jacob, Max, 'Souvenirs sur Picasso', Paris, *Cahiers d'Art*, 1927, Vol. VI, pp. 199–203.
Kahnweiler, Daniel-Henry, *Mes galeries et mes peintres, Entretiens avec Francis Crémieux*, Paris, 1961.
Kahnweiler, Daniel-Henry, *Confessions esthétiques*, Paris, 1963.
Laporte, Geneviève, *Sunshine at Midnight*, London, 1975.
Malraux, André, *La tête d'obsidienne*, Paris, 1974.
Mili, Gjon, *Picasso et la troisième dimension*, Paris, 1970.
Mourlot, Fernand, *Gravés dans ma mémoire*, Paris, 1979.
Olivier, Fernande, *Picasso and his Friends*, London, 1964.
Otero, Roberto, *Forever Picasso*, New York, 1974.
Parmelin, Hélène, *Picasso Plain: an Intimate Portrait*, London, 1963.
Parmelin, Hélène, *Picasso Says . . .*, London, 1968.
Parmelin, Hélène, *Voyage en Picasso*, Paris, 1980.

Penrose, Roland, *Portrait of Picasso*, London, 1956, New York, 1957.
Ponge, Francis and Descargues, Pierre, *Picasso*, photographs by Edward Quinn, Paris, 1974.
Prévert, Jacques, *Portraits de Picasso*, photographs by André Villers, Paris, 1981.
Quinn, Edward, *Picasso at Work, an Intimate Photographic Study*, introduction and text by Roland Penrose, London, New York, 1965.
Sabartés, Jaime, *Picasso: an Intimate Portrait*, London, 1949.
Sabartés, Jaime, *Picasso. Documents iconographiques*, Geneva, 1954.
Salmon, André, *Souvenirs sans fin*, 2 vols., Paris, 1955–1956.
Stein, Gertrude, *The Autobiography of Alice B. Toklas*, New York, London, 1933.
Tzara, Tristan, *Picasso et les chemins de la connaissance*, Paris, 1948.
Verdet, André, *Pablo Picasso*, photographs by Roger Hauert, Geneva, 1956.
Weill, Berthe, *Pan! Dans l'œil! ou trente ans dans les coulisses de la peinture contemporaine 1900–1930*, Paris, 1933.

Reference Works

Bloch, Georges, *Pablo Picasso, Catalogue of the Graphic Work 1904–67*, Berne, 1968.
Cachin, Françoise and Minervino, Fiorella, *Tout l'œuvre peint de Picasso, 1907–1916*, Paris, 1977.
Czwiklitzer, Christophe, *Les affiches de Pablo Picasso*, Basle, Paris, 1970.
Daix, Pierre and Boudaille, Georges, *Picasso 1900–1906, catalogue raisonné de l'œuvre peint*, Neuchâtel, 1966.
Daix, Pierre and Rosselet, Joan, *Picasso: The Cubist Years 1907–1916*, London, 1979.
Duncan, David Douglas, *Picasso's Picassos*, London, New York, 1961.
Fairweather, Sally, *Picasso's Concrete Sculptures*, New York, 1982.
Geiser, Bernhard, *Picasso peintre-graveur*, 2 vols., Berne, 1933 and 1968.
Goeppert, Sebastian, Goeppert-Frank, Herma and Cramer, Patrick *Pablo Picasso, catalogue raisonné des livres illustrés*, Geneva, 1983.
Moravia, Alberto, Lecaldano, Paolo and Daix, Pierre, *Tout l'œuvre peint de Picasso, périodes bleue et rose*, Paris, 1980.
Mourlot, Fernand, *Picasso lithographe*, 4 vols., Monte Carlo, 1949–1964.
Palau i Fabre, Josep, *Picasso, 1881–1907: Life and Work of the Early Years*, Oxford, 1981.
Ramié, Georges, *Céramique de Picasso*, Paris, 1974.
Spies, Werner, *Picasso Sculpture*, London, 1972.

Spies, Werner, *Picasso, Das plastische Werk* (sculpture catalogue in collaboration with Christine Piot), Stuttgart, 1983.
Zervos, Christian, *Pablo Picasso*, Paris, Vol. I, 1932, to Vol. XXXIII, 1978.

Monographs

Ashton, Dore, *Picasso on Art: A Selection of Views*, London, 1972.
Barr, Alfred Hamilton, *Picasso, Fifty Years of his Art*, New York, 1946, London, 1967.
Berger, John, *The Success and Failure of Picasso*, Harmondsworth, Baltimore, 1965.
Boeck, Wilhelm and Sabartés, Jaime, *Picasso*, London, New York, 1955.
Boudaille, Georges and Moulin, Raoul-Jean, *Picasso*, Paris, 1971.
Buchheim, Lothar Gunther, *Picasso. A Pictorial Biography*, New York, London, 1959.
Cabanne, Pierre, *Le siècle de Picasso*, 2 vols., Paris, 1975.
Cabanne, Pierre, *Picasso*, Neuchâtel, 1981.
Cassou, Jean, *Picasso*, New York, 1940, London, 1959.
Cassou, Jean, *Pablo Picasso*, Paris, 1975.
Chiari, Joseph, *Picasso. L'homme et son œuvre*, Paris, 1981.
Cocteau, Jean, *Picasso*, 1923.
Cocteau, Jean, *Picasso de 1916 à 1961*, Paris, 1962.
Daix, Pierre, *Picasso. The Man and his Work*, New York, 1964, London, 1965.
Daix, Pierre, *La vie de peintre de Pablo Picasso*, Paris, 1977.
Dale, Maud, *Picasso*, New York, 1930.
Damase, Jacques, *Pablo Picasso*, London, 1965.
Descargues, Pierre, *Picasso*, Paris, 1956.
Diehl, Gaston, *Picasso*, New York, 1960.
Dmitrieva, Nina Alexandrovna, *Pikasso*, Moscow, 1971.
Elgar, Frank and Maillard, Robert, *Picasso*, London, New York, 1956.
Elgar, Frank, *Picasso*, London, 1972.
Falkman, Kaj, *Picasso och hjärnan*, Stockholm, 1976.
Fermigier, André, *Picasso*, Paris, 1969.
Gaya Nuño, Juan Antonio, *Picasso*, Barcelona, 1957.
George, Waldemar, *Picasso*, Rome, 1924.
Gieure, Maurice, *Initiation à l'œuvre de Picasso*, Paris, 1951.
Guillén, Mercedes, *Picasso*, Madrid, 1973.
Hilton, Timothy, *Picasso*, New York, 1975, London, 1976.
Homage to Pablo Picasso, special issue of the review *XXᵉ siècle*, New York, 1971.
Jaffé, Hans Ludwig C., *Pablo Picasso*, New York, London, 1964.
Krestev, Kiril, *Picasso*, Sofia, 1982.
Lassaigne, Jacques, *Picasso*, London, 1955.

Level, André, *Picasso*, Paris, 1928.
Leymarie, Jean, *Picasso. Métamorphoses et Unité*, Geneva, 1985.
Lipton, Eunice, *Picasso Criticism, 1901–1939: the Making of an Artist-Hero*, New York, London, 1976.
Mahaut, Pierre, *Picasso*, Paris, 1930.
Martini, Alberto, *Picasso*, Milan, 1965.
McCully, Marilyn, *A Picasso Anthology: Documents, Criticism, Reminiscences*, London, 1981.
Merli, Juan, *Picasso, el artista y la obra de nuestro tiempo*, Buenos Aires, 1948.
Micheli, Mario de, *Picasso*, London, New York, 1967.
O'Brian, Patrick, *Pablo Ruiz Picasso*, London, 1976
Ors, Eugenio d', *Pablo Picasso*, Paris, 1930.
Palau i Fabre, Josep, *Picasso*, Barcelona, 1965.
Penrose, Roland, *Picasso: His Life and Work*, London, 1958, New York, 1962.
Penrose, Roland, *Portrait of Picasso*, London, 1981.
Perry, Jacques, *Yo Picasso*, Paris, 1982.
Picasso, coll. Génies et Réalités, Paris, 1967.
Picasso 1881–1973, London, 1973 (new ed. *Picasso in Retrospect*, New York, 1980).
Raboff, Ernest, *Pablo Picasso. Art for Children*, New York, 1968.
Raynal, Maurice, *Picasso*, Munich, 1921, Paris, 1922.
Raynal, Maurice, *Picasso*, Geneva, 1959.
Reverdy, Pierre, *Pablo Picasso*, Paris, 1924.
Ripley, Elizabeth, *Picasso: a Biography*, Philadelphia, London, 1959.
Schiff, Gert (editor), *Picasso in Perspective*, Englewood Cliffs, London, 1976.
Schürer, Oscar, *Pablo Picasso*, Leipzig, 1927.
Stein, Gertrude, *Picasso*, London, 1939, New York, 1946.
Sutton, Keith, *Pablo Picasso*, New York, 1962, London, 1963.
Sweetman, D., *Picasso*, London, 1973.
Thomas, Denis, *Picasso and his Art*, New York, London, 1975.
Uhde, Wilhelm, *Picasso et la tradition française*, Paris, 1928.
Vallentin, Antonina, *Pablo Picasso*, Paris, 1957.
Walter, Gerhard, *Picasso*, Stuttgart, 1949.
Wiegand, Wilfried, *Picasso*, Hamburg, 1973.
Zennström, Per-Olov, *Pablo Picasso*, Stockholm, 1948.
Zervos, Christian, *Pablo Picasso*, Milan, 1937.

Supplement to the Bibliography in Vol. I

Baer, Brigitte, *Picasso peintre-graveur* (continuation of the catalogues by Bernhard Geiser, Vol. III, 1935–1945), Berne, 1986.
Bernadac, Marie-Laure and du Bouchet, Paule, *Picasso, le sage et le fou*, Paris, 1986.
Besnard-Bernadac, Marie-Laure, *Le Musée Picasso, Paris*, Paris, Réunion des Musées Nationaux, 1985.
Betz, Gerd, *Pablo Picasso, Leben und Werk*, Stuttgart and Zurich, 1985.
Boudaille, Georges, Bernadac, Marie-Laure and Gauthier, Marie-Pierre, *Picasso*, Paris, 1985.
Daix, Pierre, *Picasso créateur / La vie intime et l'œuvre*, Paris, 1987.

Ferrier, Jean-Louis, *De Picasso à Guernica*, Paris, 1985.
Fournet, Claude, *Picasso, Terre-Soleil*, Paris, 1985.
Gallwitz, Klaus, *Picasso 1945–1973*, Paris, 1985.
Giraudy, Danièle, *Picasso, La mémoire du regard*, Paris, 1986.
Imdahl, Max, *Picassos Guernica*, Frankfurt, 1985.
Moeller, Magdalena M., *Picasso: Druckgraphic illustrierte Bücher, Zeichnungen, Collagen und Gemälde aus dem Sprengel Museum Hannover*, Hanover, 1986.
Museu Picasso, Catáleg de pintura i dibuix, Barcelona, 1984.
Passeron, Roger, *Maîtres de la gravure, Picasso*, Paris, 1984.
Petrová, Eva, *Picasso V ceskoslovensku*, Prague, 1981.
Puente, Joaquín de la, *El Guernica, historia de un cuadro*, Madrid, 1985.
Ramié, Georges, *Céramique de Picasso*, Paris, 1984.
Rojas, Carlos, *El mundo mítico y mágico de Picasso*, Barcelona, 1984.
Sebastian Lopez, Santiago, *El 'Guernica' y otras obras de Picasso: Contextos iconograficos*, Murcie, 1984.
Seckel, Hélène, *Musée Picasso, Guide*, Paris, Réunion des Musées Nationaux, 1985.
Somlyo, György, *Picasso*, Budapest, 1981.
Sopeña Ibañez, Federico, *Picasso y la musica*, Madrid, 1982.
Spies, Werner, *Picasso, pastels, dessins, aquarelles*, Paris, 1986.

Bibliography to the Drawings

Adrian, Dennis, 'Picasso the Draughtsman', exhibition *Picasso in Chicago*, Chicago, The Art Institute, 1968.
Aragon, Louis, 'La verve de Picasso', *Les Lettres françaises*, series of articles appearing in Nos. 543 to 547, 18 November–17 December 1954.
Aragon, *Picasso, Shakespeare*, Paris, 1965.
Boeck, Wilhelm, *Picasso: Zeichnungen*, Cologne, 1973.
Boudaille, Georges, introduction, *Pablo Picasso, Carnet de la Californie*, Paris, 1959.
Boudaille, Georges and Dominguin, Luis Miguel, *Pablo Picasso, Toros y Toreros*, Paris, 1961.
Bouret, Jean, *Picasso / Dessins*, Paris, 1950.
Carlson, Victor I., *Drawings and Watercolors, 1899–1907, in the Collection of the Baltimore Museum of Art*, Baltimore, 1976.
Carmean, E.A., 'The *Saltimbanques*, Sketchbook No. 35, 1905', *Je suis le cahier, The Sketchbooks of Picasso*, New York and London, 1986, pp. 9–50.
Le carnet des carnets, pour Marcel Duhamel, Ateliers Daniel Jacomet, 1965.
Carnet Royan, 30.5.40, Paris, Cahiers d'Art, 1948.
Carrieri, Raffaele, 'Drawing Is Like Singing', *Homage to Pablo Picasso*, special issue of the review *XXe siècle*, New York, 1971, pp. 78–85.
Cassou, Jean, 'Derniers dessins de Picasso', *Cahiers d'Art*, 1927, II, pp. 49–54.
Char, René and Feld, Charles, *Picasso. Dessins du 27-3-66 au 15-3-68*, Paris, 1969.

Cooper, Douglas, *Pablo Picasso, Carnet catalan*, Paris, 1958.
Cooper, Douglas, *Pablo Picasso, Pour Eugenia*, Paris, 1976.
'Crucifixions – Dessins de Picasso, d'après la Crucifixion de Grünewald' and 'Une Anatomie – Dessins de Picasso', *Minotaure*, No. 1, 15 February 1933, pp. [30–37].
Daix, Pierre, 'Des dessins pour tout dire', exhibition *Picasso, Gouaches, Lavis et Dessins, 1966–1972*, Paris, Galerie Berggruen, 1981.
Dessins de Picasso, époques bleue et rose, preceded by a letter by Francis Ponge and a biography by Jacques Chessex, Lausanne, 1960.
Eluard, Paul, *Picasso, Dessins*, Paris, 1952.
Faure, Elie, 'Les dessins de Picasso', *Feuillets d'Art*, No. 6, 1922, pp. 267–270.
George, Waldemar, *Picasso, Dessins*, Paris, 1926.
Granz, Norman, *Para Pablo* [no place, n.d.].
Hunter, Sam, 'Picasso at War: Royan, 1940, Sketchbook No. 110, 1940', *Je suis le cahier, The Sketchbooks of Picasso*, New York and London, 1986, pp. 141–177.
Jardot, Maurice, introduction, exhibition *Picasso, Dessins d'un demi-siècle*, Paris, Galerie Berggruen, 1956.
Jardot, Maurice, *Pablo Picasso, Dessins*, Paris, 1959.
Je suis le cahier, The Sketchbooks of Picasso, edited by Arnold Glimcher and Marc Glimcher, New York and London, 1986. Catalogue of exhibition, New York, Pace Gallery, and London, Royal Academy of Arts, 1986.
Kahnweiler, Daniel-Henry, introduction, exhibition *Pablo Picasso, gouaches en tekeningen*, Amsterdam, Galerie d'Eendt, 1965.
Karmel, Pepe, 'Picasso in Process', *Art in America*, September 1986, No. 9, pp. 108–115.
Keller, Horst, 'Picasso dessinant', exhibition *Picasso, 90 dessins et œuvres en couleurs*, Winterthur, Kunstmuseum; Basle, Galerie Beyeler; Cologne, Wallraf-Richartz Museum, 1971–1972.
Krauss, Rosalind E., 'Life with Picasso, Sketchbook No. 92, 1926', *Je suis le cahier, The Sketchbooks of Picasso*, New York and London, 1986, pp. 113–139.
Lambert, Jean-Clarence, *Picasso, Dessins de Tauromachie, 1917–1960*, Paris, 1960.
Lasarte, Juan Aynaud de, *Carnet Picasso, La Coruña, 1894–1895*, Barcelona, 1971.
Leiris, Michel, 'Romancero du Picador', exhibition *Picasso, dessins 1959–1960*, Paris, Galerie Louise Leiris, 1960.
Leiris, Michel, introduction, exhibition *Picasso, dessins 1966–1967*, Paris, Galerie Louise Leiris, 1968.
Leymarie, Jean, *Picasso, dessins*, Geneva, 1967.
Longstreet, Stephen, introduction, *The Drawings of Picasso*, Alhambra, 1974.
Mammel, Gerhard, 'Zu späten Zeichnungen Picassos', exhibition *Picasso: dessins 1970–1972*, Nuremberg, Pilatushaus, 1973.
Marcenac, Jean, *Picasso, Le goût du bonheur, Trois carnets d'atelier*, Paris, 1970.
Migel, Parmenia, *Designs for The Three-Cornered Hat (Le Tricorne)/Pablo Picasso*, New York, 1978.
Millier, Arthur, *The Drawings of Picasso*, Los Angeles, 1961.

Ocaña, Maria Teresa, introduction, *Picasso, Viatge a Paris*, Barcelona, 1979.

Palau i Fabre, Josep, *Picasso, Dessins pour ses enfants*, Paris, 1979.

Parmelin, Hélène, *Picasso, La flûte double*, Saint-Paul-de-Vence, 1967.

Penrose, Roland, 'Drawings of Picasso', exhibition *Homage to Picasso: Drawings and Watercolours since 1893*, London, The Institute of Contemporary Arts, 1951.

Penrose, Roland, 'Dessins récents de Picasso, 1966–1967', *L'Œil*, No. 157, January 1968, pp. 18–23.

Penrose, Roland, 'The drawings of Picasso', exhibition *Picasso's Picassos*, London, Hayward Gallery, 1981, pp. 90–100.

'Picasso / Arles, musée Réattu', *Portrait d'un musée* / 5, [1986].

Picasso, 145 dessins pour la presse et les organisations démocratiques, Paris, 1973.

Picasso, Der Zeichner, Zurich, 1982, 3 vols.: 1893–1929, text by Werner Spies; 1930–1954, text by Maurice Jardot; 1955–1972, text by Richard Häsli.

Picasso, dessins inédits du 31.XII.70 au 4.11.71, catalogue of the collection of drawings presented by Pablo Picasso to the City of Arles, Arles, Musée Réattu, 1971.

Picasso, Fifteen Drawings, New York, 1946.

Podoksik, A., 'On an Entry in Picasso's "Carnet Catalan"', *Bulletin du Musée de l'Ermitage*, 1982, XXII, pp. 147–161.

Pozner, Vladimir, 'Picasso comme il travaille', *La nouvelle critique*, No. 130, special issue on Picasso, 1961, pp. 61–67.

40 dessins en marge du Buffon, Paris, 1957.

Rathke, Ewald, 'Zu den Zeichnungen Picassos', exhibition *Picasso, 150 Handzeichnungen aus sieben Jahrzehnten*, Hamburg, Kunstverein, 1965.

Reff, Theodore, 'Picasso at the Crossroads, Sketchbook No. 59, 1916', *Je suis le cahier, The Sketchbooks of Picasso*, New York and London, 1986, pp. 81–111.

Richardson, John, *Pablo Picasso, Aquarelles et gouaches*, Basle, 1954.

Rosenberg, Alexandre P., introduction, exhibition *The primary of design, major drawings in black and colored media, from the Marina Picasso Collection*, New York, Galerie Paul Rosenberg & Co., 1983.

Rosenblum, Robert, 'The *Demoiselles*, Sketchbook No. 42, 1907', *Je suis le cahier, The Sketchbooks of Picasso*, New York and London, 1986, pp. 53–79.

Sabartés, Jaime, *A los toros avec Picasso*, Monte Carlo, 1961.

Salas, Xavier de, introduction, *Carnet Picasso, Madrid, 1898*, Barcelona, 1976.

Salles, Georges, *Picasso, Mes dessins d'Antibes*, Paris, 1958.

Salmon, André, introduction, exhibition *Dessins et aquarelles par Picasso*, Paris, Galerie Paul Rosenberg, 1919.

Schiff, Gert, 'The *Sabines*, Sketchbook No. 163, 1962', *Je suis le cahier, The Sketchbooks of Picasso*, New York and London, 1986, pp. 179–209.

Serullaz, Maurice, introduction, *Picasso's Private Drawings*, New York, 1969.

Solmi, Sergio, *Disegni di Picasso*, Milan, 1945.

Spies, Werner, 'Carnet Paris – Carnet Dinard', exhibition *Pablo Picasso, Werke aus der Sammlung Marina Picasso*, Munich, 1981, pp. 95–131.

Spies, Werner, *Picasso: Pastels – Dessins – Aquarelles*, Paris, 1986.

Taillandier, Yvon, 'Les profils proliférants', *XXe siècle*, special issue, 'Hommage à Pablo Picasso', 1971, pp. 86–92.

Tardieu, Jean, *L'espace et la flûte, Variations sur douze dessins de Picasso*, Paris, 1958.

Tinterow, Gary, exhibition *Master Drawings by Picasso*, Cambridge, Mass., Fogg Art Museum, 1981.

Verve, special number, Nos. 29–30, 'Suite de 180 dessins de Picasso, 28 novembre 1953 au 3 février 1954' with texts by Tériade, Michel Leiris and Rebecca West, 1954.

Zambraro, Maria, 'L'Amour et la Mort dans les dessins de Picasso', *Cahiers d'Art*, 1951, pp. 29–56.

Zervos, Christian, 'Die Zeichnungen Picassos', *der Querschnitt*, 1927, Vol. 11, pp. 819–821.

Zervos, Christian, 'Projets de Picasso pour un monument', *Cahiers d'Art*, 1929, VIII–IX, pp. 341–353.

Zervos, Christian, 'L'homme à l'agneau de Picasso, juillet 1942–octobre 1943', *Cahiers d'Art*, 1945–1946, pp. 84–112.

Zervos, Christian, *Dessins de Pablo Picasso, 1892–1948*, Paris, 1949.

Concordances

Concordance between the inventory numbers (M.P.) and the present catalogue numbers

M.P. inventory numbers	Catalogue numbers	M.P. inventory numbers	Catalogue numbers	M.P. inventory numbers	Catalogue numbers	M.P. inventory numbers	Catalogue numbers	M.P. inventory numbers	Catalogue numbers
12	136	433	31	478r	38	524v	125a	570	163
13	135	434r	40	478v	38a	525	131	571	164
399	367	434v	40a	479	80	526r	126	572	205
401r	3	435	76	480	78	526v	126a	573	169
401v	3a	436r	29	481	81	527	132	574	170
402r	4	436v	29a	482	82	528r	130	575r	204
402v	4a	437	41	483	79	528v	130a	575v	204a
403r	5	438r	39	484	83	529r	134	576	171
403v	5a	438v	39a	485	84	529v	134a	577	172
404	2	439	32	486	85	530	140	578	173
405	1	440r	27	487r	112	531	141	579	175
406	6	440v	27a	487v	112a	532	207	580	176
407r	7	441	47	488	87	533	143	581	153
407v	7a	442	35	489	121	534	144	582	178
408	9	443	46	490	124	535	139	583	177
409r	8	444	45	491r	86	536	137	584	190
409v	8a	445	49	491v	86a	537	138	585	191
410r	12	446	54	492	88	538	145	586	192
410v	12a	447	44	493r	97	539	148	587	193
411r	13	448	43	493v	97a	540r	147	588	179
411v	13a	449	67	494	102	540v	147a	589	183
412r	11	450	77	495	107	541	146	590	184
412v	11a	451r	50	496	103	542r	142	591	185
413r	22	451v	50a	497	494	542v	142a	592	186
413v	22a	452	111	498	100	543	150	593	187
414r	17	453	62	499	94	544	149	594	188
414v	17a	454r	36	500	89	545	151	595	189
415r	14	454v	36a	501	96	546	206	596	180
415v	14a	455	74	502	95	547	152	597	181
416r	19	456	57	503	99	548	208	598	182
416v	19a	457	59	504	98	549	209	599	203
417	33	458	58	505	90	550	154	600	202
418	23	459	48	506	91	551	210	601	201
419	24	460r	51	507	92	552	211	602	200
420r	20	460v	51a	508r	101	553r	213	603	199
420v	20a	461	75	508v	101a	553v	213a	604	198
421	15	462	63	509	110	554	195	605	197
422	21	463	53	510	115	555	174	606r	214
423	25	464	60	511	113	556	196	606v	214a
424	26	465	56	512	93	557	194	607	231
425	10	466	61	513	114	558	155	608	212
426r	16	467	66	514	116	559	156	609	234
426v	16a	468	64	515	117	560	168	610	235
427r	18	469	55	516	118	561	166	611	233
427v	18a	470	65	517	120	562	158	612	230
428	30	471	72	518	119	563	157	613	232
429	28	472	73	519	129	564	161	614	229
430r	42	473	69	520	123	565	160	615r	219
430v	42a	474	68	521	127	566	167	615v	219a
431r	34	475	52	522	128	567	159	616	220
431v	34a	476	70	523	133	568	165	617	223
432	37	477	71	524r	125	569	162	618r	228

M.P. inventory numbers	Catalogue numbers	M.P. inventory numbers	Catalogue numbers	M.P. inventory numbers	Catalogue numbers	M.P. inventory numbers	Catalogue numbers	M.P. inventory numbers	Catalogue numbers
618v	228a	679	293	735	319	792	473	852	634
619r	215	680	295	736	326	793	483	853	1005
619v	215a	681r	299	737	314	794	489	854	664
620r	221	681v	299a	738	368	795	484	855	488
620/621v	221a/217a	682r	298	739	364	796	496	856	638
621r	217	682v	298a	740	351	797	495	857	639
622	222	683	304	741	350	798	497	858	641
623	216	684	280	742	349	799	485	859	640
624	247	685	274	743	365	800	482	860	645
625	218	686	278	744	361	801	492	861	642
626	237	687	287	745	360	802	491	862	643
627	236	688	301	746	359	803	379 (Vol. I)	863	644
628	226	689	296	747	362	804	380 (Vol. I)	864	647
629	227	690	297	748	370	805	405	865	646
630	225	691	277	749	372	806	403	866	663
631	224	692	306	750	363	807	404	867	648
632	238	693	316	751	379	808	516	868	665
633	241	694	302	752	375	809	487	869	649
634	242	695	305	753	376	810r	498	870	650
635	243	696	300	754	377	810v	498a	871r	652
636	239	697	271	755	374	811	515	871v	652a
637	240	698	307	756	373	812	653	872r	651
638	257	699	308	757	371	813	654	872v	651a
639	249	700	310	758r	358	814	676	873	636
640	246	701	313	758v	358a	815	499	874	637
641	245	702	311	759	357	816	500	875	755
642	244	703	312	760	354	817	501	876	756
643	255	704	315	761	355	818	502	877	757
644	250	705r	309	762	356	819	503	878	758
645	251	705v	309a	763r	353	820	504	879	759
646	252	706	333	763v	353a	821	505	880	760
647	253	707	332	764r	369	822	506	881	761
648	248	708	323	764v	369a	823	508	882	762
649	254	709	348	765	352	824	507	883	763
650	262	710	335	766	321	825	514	884	764
651	259	711r	337	767	322	826r	509	885	765
652	258	711v	337a	768	380	826v	509a	886	766
653	264	712	336	769	385	827	510	887	767
654	265	713r	338	770r	386	828	511	888	768
655	266	713v	338a	770v	386a	829	512	889r	769
656	289	714	340	771r	381	830	513	889v	769a
657	256	715	341	771v	381a	831	490	890	770
658	260	716r	342	772	387	832	493	891	771
659	268	716v	342a	773	382	833	282	892	772
660	261	717	344	774	383	834	531	893	773
661	263	718r	343	775	388	835	391	894	774
662	269	718v	343a	776	393	836	527	895	775
663	267	719	346	777	389	837	528	896	776
664	270	720	345	778	390	838	632	897	777
665	272	721	329	779	392	839	530	898	778
666	286	722	325	780	384	840	667	899	779
667	290	723	347	781	401	841	529	900	807
668	291	724	328	782	402	842	633	901	831
669	320	725	324	783r	475	843	635	902	830
670	288	726	327	783v	475a	844	517	903	781
671	283	727	317	784	476	845r	518	904	780
672	284	728	281	785	477	845v	518a	905	782
673	285	729	303	786	478	846	519	906	853
674	279	730	334	787	479	847	520	907	854
675	275	731	330	788	480	848	521	908	783
676	276	732	331	789	481	849	522	909	784
677	273	733	292	790	472	850	523	910	785
678	294	734	318	791	474	851	524	911	786

M.P. inventory numbers	Catalogue numbers	M.P. inventory numbers	Catalogue numbers	M.P. inventory numbers	Catalogue numbers	M.P. inventory numbers	Catalogue numbers	M.P. inventory numbers	Catalogue numbers
912	832	974	863	1032	919	1093	979	1154v	1041a
913	666	975	862	1033r	920	1094	980	1155	1042
914	787	976	867	1033v	920a	1095	981	1156r	1043
915	788	977	868	1034	922	1096	983	1156v	1043a
916	789	978	869	1035	921	1097	984	1157r	1044
917	790	979	865	1036	923	1098	985	1157v	1044a
918	791	980	870	1037	925	1099	986	1158	1045
919	792	981	871	1038	926	1100	987	1159r	1046
920	793	982	866	1039	927	1101	988	1159v	1046a
921	794	983	874	1040	928	1102	989	1160r	1047
922	795	984	875	1041	929	1103	990	1160v	1047a
923	796	985	877	1042	930	1104	991	1161	1049
924	797	986	878	1043	931	1105	993	1162r	1048
925	798	987	876	1044	932	1106	992	1162v	1048a
926	799	988	879	1045	933	1107	997	1163	1050
927	801	989	880	1046	934	1108	998	1164r	1051
928	802	990	881	1047	937	1109	996	1164v	1051a
929	806	991	882	1048	938	1110	1000	1165	1052
930	803	992r	883	1049	935	1111	995	1166	1053
931	808	992v	883a	1050	936	1112	994	1167	1055
932	809	993	885	1051	939	1113	999	1168	1054
933	810	994r	859	1052	940	1114	1001	1169r	1056
934	811	994v	859a	1053	941	1115	1002	1169v	1056a
935	812	995r	860	1054	942	1116	1003	1170	1057
936	813	995v	860a	1055	943	1117	1004	1171	1058
937	804	996	887	1056	944	1118	1006	1172	1059
938	814	997	888	1057	945	1119	1007	1173	1060
939	817	998	886	1058	946	1120	1008	1174	1061
940	815	999	891	1059	949	1121	1009	1175	1062
941	816	1000	892	1060	948	1122	1010	1176	1063
942	818	1001	893	1061	947	1123	1011	1177	1078
943	819	1002	855	1062	950	1124	1012	1178	1064
944	820	1003	856	1063	951	1125	1013	1179	1065
945	833	1004	857	1064	952	1126	1014	1180	1066
946	821	1005r	894	1065	955	1127	1015	1181	1067
947	829	1005v	894a	1066	953	1128	1016	1182	1068
948	828	1006	895	1067	954	1129	1017	1183	1069
949	827	1007	896	1068	924	1130	1018	1184	1070
950	826	1008	897	1069	956	1131	1019	1185	1071
951	825	1009	898	1070	957	1132	1020	1186	1072
952	824	1010	899	1071	958	1133	1021	1187	1073
953	823	1011	899	1072	959	1134	1023	1188	1074
954	822	1012	900	1073	960	1135	1022	1189	1075
955	839	1013	901	1074	961	1136	125a (Vol. I)	1190	1077
956	840	1014	902	1075	962	1137	1024	1191	1076
957	841	1015	904	1076	963	1138	1025	1192	1079
958	842	1016	905	1077	966	1139	1026	1193	1080
959	843	1017	903	1078	964	1140	1027	1194	1081
960	845	1018	906	1079	965	1141	1028	1195	1082
961	844	1019	910	1080	967	1142	1029	1196	1083
962	847	1020	908	1081	968	1143	1030	1197	1085
963	864	1021	909	1082	969	1144	1031	1198	1084
964	852	1022	907	1083	970	1145	1032	1199	1086
965	68 (Vol. I)	1023	974	1084	971	1146	1033	1200	1087
966	849	1024r	916	1085	972	1147	1039	1201	1088
967	848	1024v	916a	1086r	973	1148	1034	1202	1089
968	850	1025	917	1086v	973a	1149	1035	1203	1090
969	851	1026	912	1087	339	1150r	1036	1204	1091
970	846	1027	914	1088	975	1150v	1036a	1205r	1092
971	884	1028	914	1089	982	1151	1037	1205v	1092a
972	861	1029	913	1090	976	1152	1038	1206	1093
973r	858	1030	915	1091	977	1153	1040	1207	1094
973v	858a	1031	918	1092	978	1154r	1041	1208	1095

M.P. inventory numbers	Catalogue numbers	M.P. inventory numbers	Catalogue numbers	M.P. inventory numbers	Catalogue numbers	M.P. inventory numbers	Catalogue numbers	M.P. inventory numbers	Catalogue numbers
1209	1096	1269	1156	1328	1215	1390	1276	1452	1343
1210	1097	1270	1157	1329	1216	1391	1284	1453	1344
1211	1098	1271r	1163	1330	1217	1392	1286	1454	1345
1212	1099	1271v	1163a	1331	1214	1393	1285	1455	1346
1213	1100	1272	1164	1332	1220	1394	1280	1456	1347
1214	1101	1273	1165	1333	1221	1395	1281	1457	1348
1215r	1102	1274	1166	1334	1219	1396	1283	1458	1349
1215v	1102a	1275	1167	1335	1218	1397	1282	1459	1350
1216	1104	1276r	1168	1336	1222	1398	1287	1460	1351
1217r	1105	1276v	1168a	1337	1262	1399	1288	1461	1352
1217v	1105a	1277	1463	1338	1223	1400	1289	1462	1353
1218	1106	1278r	1158	1339	1224	1401	1290	1463	1354
1219	1107	1278v	1158a	1340	1225	1402	1291	1464	1355
1220	1108	1279	1159	1341	1226	1403	1293	1465	1356
1221	1109	1280	1160	1342	1227	1404	1296	1466	1357
1222	1110	1281	1161	1343	1228	1405	1295	1467	1358
1223	1111	1282	1162	1344	1229	1406	1297	1468	1359
1224r	1112	1283	1169	1345	1230	1407	1298	1469	1360
1224v	1112a	1284	1170	1346	1231	1408	1299	1470	1365
1225	1113	1285	1171	1347	1232	1409	1300	1471	1366
1226	1117	1286	1172	1348	1233	1410	1301	1472	1361
1227	1114	1287	1173	1349	1234	1411	1302	1473	1362
1228	1115	1288	1174	1350	1235	1412	1303	1474	1363
1229	1116	1289	1175	1351	1236	1413r	1304	1475	1364
1230	1118	1290	1176	1352	1237	1413v	1304a	1476	1367
1231	1119	1291	1179	1353	1238	1414	1305	1477	1368
1232	1120	1292	1177	1354	1239	1415	1306	1478	1369
1233	1121	1293	1178	1355	1240	1416	1294	1479	1370
1234	1123	1294	1180	1356	1241	1417	1308	1480	1371
1235	1124	1295	1181	1357	1242	1418	1309	1481	1372
1236	1125	1296	1182	1358	1243	1419	1310	1482	1373
1237	1126	1297	1183	1359	1244	1420	1311	1483	1374
1238	1127	1298	1184	1360	1245	1421	1307	1484	1375
1239	1103	1299	1185	1361	1246	1422	1312	1485	1376
1240	1128	1300	1186	1362	1247	1423	1314	1486	1377
1241	1122	1301	1187	1363	1248	1424	1315	1487	1378
1242	1129	1302	1188	1364	1249	1425	1316	1488	1379
1243	1130	1303	1189	1365	1250	1426	1317	1489	1380
1244	1131	1304	1190	1366	1251	1427	1318	1490	1381
1245	1132	1305	1191	1367	1252	1428	1319	1491	1382
1246	1133	1306	1192	1368	1253	1429	1320	1492	1383
1247	1134	1307	1193	1369	1254	1430	1321	1493	1384
1248	1135	1308	1194	1370	1255	1431	1322	1494	1385
1249	1136	1309	1195	1371	1256	1432	1323	1495	1386
1250	1137	1310	1196	1372	1257	1433	1324	1496	1387
1251	1138	1311	1197	1373	1258	1434	1325	1497	1388
1252	1139	1312	1198	1374	1259	1435	1326	1498	1389
1253	1140	1313	1199	1375r	1260	1436	1327	1499	1390
1254	1141	1314r	1201	1375v	1260a	1437	1328	1500	1391
1255	1142	1314v	1201a	1376	1261	1438	1329	1501	1392
1256	1143	1315	1202	1377	1265	1439	1330	1502	1441
1257	1144	1316	1203	1378	1263	1440	1331	1503	1431
1258	1145	1317	1204	1379	1264	1441	1332	1504	1432
1259	1146	1318	1205	1380	1266	1442	1333	1505	1433
1260	1147	1319	1206	1381	1267	1443	1334	1506	1434
1261	1148	1320	1207	1382	1268	1444	1335	1507	1435
1262	1149	1321	1208	1383	1269	1445	1336	1508	1436
1263	1150	1322	1209	1384	1270	1446	1337	1509	1437
1264	1151	1323	1210	1385	1271	1447	1338	1510	1438
1265	1152	1324	1211	1386	1272	1448	1339	1511	1439
1266	1153	1325	1212	1387	1273	1449	1340	1512	1440
1267	1154	1326	1213	1388	1274	1450	1341	1513r	1442
1268	1155	1327	1200	1389	1275	1451	1342	1513v	1442a

M.P. inventory numbers	Catalogue numbers	M.P. inventory numbers	Catalogue numbers	M.P. inventory numbers	Catalogue numbers	M.P. inventory numbers	Catalogue numbers	M.P. inventory numbers	Catalogue numbers
1514r	1443	1572	468	1630	535	1683	587	1743	690
1514v	1443a	1573	469	1631	541	1684	588	1744	689
1515	1444	1574	464	1632	562	1685	589	1745	695
1516	1445	1575	465	1633	568	1686r	590	1746	696
1517	1446	1576	462	1634	569	1686v	590a	1747	698
1518	1447	1577	463	1635	564	1687	579	1748	697
1519	1448	1578	461	1636	556	1688	591	1749	705
1520	1451	1579	460	1637	557	1689	592	1750r	707
1521	1452	1580	444	1638	550	1690	593	1750v	707a
1522	1450	1581	436	1639	554	1691	594	1751	712
1523	1449	1582	438	1640	567	1692	584	1752	713
1524	1453	1583	437	1641	565	1693	595	1753	710
1525r	1454	1584	440	1642	563	1694	597	1754	709
1525v	1454a	1585	439	1643r	559	1695	598	1755	718
1526	1455	1586	441	1643v	559a	1696	599	1756	721
1527	1456	1587	447	1644r	560	1697	600	1757	722
1528r	1459	1588	443	1644v	560a	1698	601	1758	716
1528v	1459a	1589	448	1645	547	1699	602	1759	723
1529	1460	1590	445	1646r	548	1700	603	1760	720
1530	1458	1591	455	1646v	548a	1701	604	1761	715
1531	1457	1592	457	1647	555	1702	605	1762	714
1532	1464	1593	446	1648r	566	1703	606	1763	719
1533	1465	1594	451	1648v	566a	1704	607	1764r	677
1534	1462	1595	471	1649	549	1705	608	1764v	677a
1535	1470	1596	450	1650r	572	1706	609	1765r	711
1536	1471	1597	456	1650v	572a	1707	625	1765v	711a
1537	1466	1598	449	1651	552	1708	610	1766r	679
1538	1472	1599	458	1652r	546	1709	611	1766v	679a
1539	1474	1600	459	1652v	546a	1710	612	1767r	683
1540	1481	1601	427	1653	532	1711	613	1767v	683a
1541	1479	1602	421	1654	669	1712	626	1768	678
1542r	1477	1603	425	1655	538	1713	614	1769r	680
1542v	1477a	1604	426	1656	537	1714	615	1769v	680a
1543	1478	1605	434	1657	539	1715	616	1770	703
1544	1476	1606r	428	1658	534	1716	617	1771	670
1545	1480	1606v	428a	1659	540	1717r	618	1772	692
1546	394	1607	424	1660	542	1717v	618a	1773	668
1547	398	1608	433	1661	543	1718	619	1774	717
1548	395	1609	429	1662r	536	1719	620	1775	706
1549	399	1610	431	1662v	536a	1720	621	1776	704
1550	397	1611	423	1663	533	1721	630	1777	681
1551	400	1612	432	1664	558	1722	622	1778	682
1552	396	1613	422	1665	561	1723	624	1779	693
1553	873	1614	430	1666	553	1724	627	1780	685
1554	406	1615	435	1667	571	1725	623	1781	686
1555	407	1616	452	1668	551	1726	596	1782	687
1556	408	1617	453	1669	570	1727	628	1783	684
1557	409	1618	442	1670	573	1728	629	1784	688
1558	410	1619	454	1671	574	1729	805	1785	691
1559	470	1620r	661	1672	576	1730	800	1786	694
1560	415	1620v	661a	1673	575	1731	672	1787	737
1561	414	1621	656	1674/a	631	1732	486	1788r	736
1562	416	1622	662	1674/b	631	1733	673	1789	738
1563	417	1623	659	1674/c	631	1734	674	1790	299 (Vol. I)
1564r	418	1624r	658	1675r	577	1735	675	1791	734
1564v	418a	1624v	658a	1675v	577a	1736	526	1792	733
1565	420	1625	660	1676	580	1737	525	1793	735
1566	419	1626r	657	1677	582	1738	702	1794r	726
1567	413	1626v	657a	1678	581	1739r	700	1794v	726a
1568	411	1627r	655	1679	578	1739v	700a	1795	725
1569	412	1627v	655a	1680	583	1740	701	1796r	729
1570	466	1628	544	1681	586	1741	708	1796v	729a
1571	467	1629	545	1682	585	1742	835	1797	724

M.P. inventory numbers	Catalogue numbers	M.P. inventory numbers	Catalogue numbers	M.P. inventory numbers	Catalogue numbers	M.P. inventory numbers	Catalogue numbers	M.P. inventory numbers	Catalogue numbers
1798	727	1815r	747	1853r	1469	1983-17	1402	1983-36	1421
1799	732	1815v	747bis	1853v	1469a	1983-18	1403	1983-37	1422
1800	731	1816r	748	1977-1	1473	1983-19	1404	1983-38	1423
1801	730	1816v	748bis	1980-108	378	1983-20	1405	1983-39	1424
1802r	728	1817	749	1982-1	1313	1983-21	1406	1983-40	1425
1802v	728a	1818	750	1982-2	1461	1983-22	1407	1983-41	1426
1803	753	1819	699	1982-160	1475	1983-23	1408	1983-42	1427
1804	752	1820	834	1982-161	1292	1983-24	1409	1983-43	1428
1805	744	1821	837	1983-3	1278	1983-25r	1410	1983-44	1429
1806	745	1822	836	1983-4	1279	1983-25v	1410a	1983-45	1430
1807	739	1823	671	1983-5	1277	1983-26	1411	1985-72	366
1808	754	1824	838	1983-8	1393	1983-27	1412	1985-74	122
1809	740	1825	890	1983-9	1394	1983-28	1413	1986-40r	104
1810r	741	1826	889	1983-10	1395	1983-29	1414	1986-40v	104a
1810v	741a	1827	409 (Vol. I)	1983-11	1396	1983-30	1415	1986-41	106
1811r	746	to	to	1983-12	1397	1983-31	1416	1986-42	105
1811v	746a	1850	433 (Vol. I)	1983-13	1398	1983-32	1417	1986-43r	108
1812	742	1851	1467	1983-14	1399	1983-33	1418	1986-43v	108a
1813	743	1852r	1468	1983-15	1400	1983-34	1419	1986-44	109
1814	751	1852v	1468a	1983-16	1401	1983-35	1420		

Concordance between the Zervos catalogue numbers and the present catalogue numbers

Zervos numbers	Catalogue numbers	Zervos numbers	Catalogue numbers	Zervos numbers	Catalogue numbers	Zervos numbers	Catalogue numbers	Zervos numbers	Catalogue numbers
I,211	82	III,99	392	III,317	595	III,380	527	IV,161	804
II¹,39	204	III,100	485	III,318	615	III,391	643	IV,175	810
II²,737	272	III,106	484	III,319	597	III,413	666	IV,185	812
II²,841	356	III,110	437	III,320	579	III,427	649	IV,188	809
II²,946	420	III,153	491	III,321	611	III,428	665	IV,189	813
II²,947	480	III,193	673	III,322	587	IV,21	734	IV,202	820
II²,948	481	III,194	675	III,323	588	IV,22	834	IV,204	806
II²,949	408	III,196	674	III,324	624	IV,23	688	IV,245	838
II²,950	409	III,198	493	III,325	590	IV,24	710	IV,247	836
II²,952	436	III,201	525	III,326	626	IV,26	730	IV,250	842
II²,953	433	III,203	492	III,327	584	IV,28	723	IV,270	862
II²,954	432	III,259	636	III,328	622	IV,30	779	IV,290	847
II²,955	435	III,265	637	III,329	585	IV,40	770	IV,296	844
II²,956	449	III,295	664	III,330	623	IV,53	787	IV,297	845
II²,957	422	III,300	632	III,331	589	IV,57	717	IV,298	846
II²,958	423	III,301	530	III,332	602	IV,59	785	IV,323	849
II²,959	448	III,304	542	III,333	627	IV,60	786	IV,325	850
II²,960	431	III,305	543	III,334	593	IV,61	832	IV,326	848
II²,961	430	III,306	544	III,335	601	IV,62	788	IV,344	852
III,4	486	III,307	568	III,336	628	IV,78	791	IV,345	851
III,7	482	III,311	594	III,337	586	IV,89	807	IV,363	863
III,9	475	III,312	610	III,339	633	IV,91	830	V,38	885
III,73	483	III,313	599	III,348	546a	IV,100	795	V,144	886
III,90	495	III,314	583	III,349	546	IV,113	831	V,145	887
III,91	496	III,315	625	III,352	531	IV,128	796	V,218	893
III,94	497	III,316	600	III,353	529	IV,129	803	V,400	897

Zervos numbers	Catalogue numbers	Zervos numbers	Catalogue numbers	Zervos numbers	Catalogue numbers	Zervos numbers	Catalogue numbers	Zervos numbers	Catalogue numbers
VI,1	1	VI,970	221a	VII,348	950	IX,129	1089	XI,313	1154
VI,35	7a	VI,978	145	VII,351	940	IX,149	1091	XI,358	1155
VI,43	9	VI,980	144	VII,352	952	IX,156	1090	XI,362	1156
VI,44	7	VI,981	143	VII,356	956	IX,164	1093	XI,363	1157
VI,61	12a	VI,986	233	VII,386	957	IX,166	1092	XI,367	1162
VI,62	13a	VI,992	147	VIII,38	971	IX,172	1094	XII,2	1169
VI,63	12	VI,1002	214a	VIII,43	966	IX,184	1095	XII,67	1171
VI,73	13	VI,1006	214	VIII,49	960	IX,193	1097	XII,87	1175
VI,84	22a	VI,1010	219	VIII,50	965	IX,194	1096	XII,89	1172
VI,87	22	VI,1011	155	VIII,51	958	IX,219	1099	XII,91	1173
VI,110	11a	VI,1014	172	VIII,52	959	IX,221	1098	XII,93	1174
VI,124	42a	VI,1015	237	VIII,53	968	IX,227	1100	XII,116	1177
VI,133	14a	VI,1021	227	VIII,54	972	IX,246	1105a	XII,117	1176
VI,136	14	VI,1024	159	VIII,55	962	IX,254	1106	XII,118	1178
VI,161	17a	VI,1065	215	VIII,56	964	IX,258	1104	XII,120	1179
VI,171	15	VI,1066	216	VIII,60	974	IX,259	1105	XII,127	1180
VI,179	10	VI,1067	222	VIII,65	973	IX,278	1103	XII,139	1193
VI,182	17	VI,1072	224	VIII,92	975	IX,285	1107	XII,142	1189
VI,194	19	VI,1073	217	VIII,93	982	IX,317	1108	XII,143	1188
VI,205	16	VI,1074	221	VIII,94	988	IX,331	1109	XII,144	1190
VI,211	16a	VI,1078	241	VIII,95	987	IX,339	1110	XII,145	1191
VI,224	19a	VI,1081	243	VIII,97	989	IX,348	1111	XII,146	1184
VI,225	20	VI,1085	238	VIII,98	991	IX,385	1112	XII,147	1185
VI,229	20a	VI,1088	242	VIII,100	990	IX,386	1113	XII,148	1186
VI,283	11	VI,1089	235	VIII,102	992	X,196	1114	XII,149	1187
VI,300	26	VI,1090	234	VIII,104	998	X,525	1115	XII,151	1183
VI,312	42	VI,1092	240	VIII,105	993	X,526	1116	XII,152	1192
VI,324	46	VI,1093	239	VIII,106	999	XI,115	1123	XII,176	1197
VI,328	36	VI,1104	246	VIII,107	994	XI,116	1125	XII,177	1196
VI,348	76	VI,1117	247	VIII,108	1000	XI,117	1126	XII,178	1198
VI,356	35	VI,1126	256	VIII,109	997	XI,118	1124	XII,179	1194
VI,390	50a	VI,1143	259	VIII,110	996	XI,119	1128	XII,180	1195
VI,412	59	VI,1151	354	VIII,111	995	XI,120	1127	XII,197	1199
VI,423	36a	VI,1194	362	VIII,113	1001	XI,121	1118	XII,219	1200
VI,428	55	VI,1195	363	VIII,131	986	XI,123	1120	XII,238	1202
VI,464	62	VI,1196	373	VIII,135	1006	XI,127	1121	XII,240	1201
VI,466	61	VI,1198	359	VIII,137	1004	XI,130	1119	XII,241	1206
VI,472	53	VI,1199	360	VIII,149	1003	XI,132	1132	XII,254	1203
VI,515	60	VI,1215	375	VIII,173	1021	XI,133	1131	XII,298	1205
VI,534	69	VI,1216	370	VIII,175	1020	XI,137	1122	XII,299	1204
VI,539	65	VI,1228	372	VIII,179	1019	XI,138	1129	XII,306	1210
VI,540	80	VI,1233	371	VIII,186	924	XI,139	1133	XII,308	1208
VI,555	70	VI,1238	349	VIII,212	1007	XI,140	1130	XII,312	1207
VI,561	57	VI,1255	351	VIII,216	1022	XI,253	1135	XII,318	1209
VI,565	75	VI,1266	321	VIII,222	1023	XI,254	1134	XIII,29	1211
VI,581	74	VI,1267	322	VIII,244	1031	XI,291	1140	XIII,30	1212
VI,599	66	VI,1302	382	VIII,249	1030	XI,292	1141	XIII,31	1213
VI,606	64	VI,1305	399	VIII,250	1027	XI,293	1142	XIII,211	1214
VI,611	50	VI,1306	384	VIII,252	1026	XI,294	1143	XIII,231	1215
VI,676	97a	VI,1321	383	VIII,255	1029	XI,295	1136	XIII,325	1217
VI,693	91	VI,1328	396	VIII,262	1028	XI,296	1137	XIV,130	1224
VI,707	92	VI,1331	387	VIII,275	1040	XI,297	1138	XIV,165	1239
VI,709	114	VI,1339	393	VIII,276	1037	XI,298	1139	XIV,169	1240
VI,721	97	VI,1347	479	VIII,278	1045	XI,299	1144	XIV,172	1245
VI,765	120	VI,1350	526	VIII,279	1038	XI,300	1145	XIV,183	1252
VI,802	115	VI,1368	644	VIII,283	1042	XI,301	1146	XIV,188	1238
VI,808	123	VI,1377	596	VIII,285	1051	XI,302	1147	XIV,190	1258
VI,887	117	VI,1378	629	VIII,287	1053	XI,303	1148	XIV,191	1238
VI,898	127	VI,1379	576	VIII,288	1052	XI,304	1149	XIV,192	1257
VI,904	141	VII,34	903	VIII,342	1062	XI,305	1150	XIV,199	1261
VI,912	215a	VII,114	910	IX,88	1083	XI,306	1152	XIV,270	1268
VI,917	210	VII,199	915	IX,116	1092a	XI,307	1151	XIV,273	1269
VI,926	132	VII,241	918	IX,118	1088	XI,310	1153	XIV,274	1271

Zervos numbers	Catalogue numbers	Zervos numbers	Catalogue numbers	Zervos numbers	Catalogue numbers	Zervos numbers	Catalogue numbers	Zervos numbers	Catalogue numbers
XIV,275	1270	XXI,354	67	XXVI,188	207	XXVI,381	232	XXVIII,189	335
XIV,278	1272	XXI,360	58	XXVI,189	136	XXVI,384	236	XXVIII,195	292
XIV,280	1273	XXI,368	43	XXVI,190	135	XXVI,414	244	XXVIII,196	290
XIV,315	1274	XXI,369	44	XXVI,192	209	XXVI,417	245	XXVIII,201	291
XIV,316	1275	XXI,370	77	XXVI,193	208	XXVI,423	257	XXVIII,205	276
XVI,251	1314	XXI,385	107	XXVI,194	151	XXVIII,5	248	XXVIII,207	275
XVI,252	1315	XXI,389	52	XXVI,261	142	XXVIII,11	258	XXVIII,210	298
XVI,253	1316	XXI,400	48	XXVI,264	152	XXVIII,13	254	XXVIII,211	299
XVI,254	1317	XXI,405	56	XXVI,271	171	XXVIII,14	289	XXVIII,226	280
XVI,256	1318	XXI,407	49	XXVI,273	154	XXVIII,18	263	XXVIII,234	303
XVI,277	1320	XXI,413	54	XXVI,275	206	XXVIII,26	261	XXVIII,237	281
XVI,278	1319	XXII,5	72	XXVI,276	148	XXVIII,29	269	XXVIII,239	317
XVI,341	1321	XXII,6	71	XXVI,278	196	XXVIII,33	264	XXVIII,272	331
XVI,344	1322	XXII,8	68	XXVI,279	194	XXVIII,34	265	XXVIII,278	318
XVI,350	1389	XXII,9	73	XXVI,280	156	XXVIII,36	266	XXVIII,279	334
XVI,351	1391	XXII,37	45	XXVI,289	202	XXVIII,40	260	XXVIII,282	304
XVI,400	1392	XXII,48	78	XXVI,290	203	XXVIII,46	267	XXVIII,305	326
XVI,475	1432	XXII,52	63	XXVI,292	199	XXVIII,48	268	XXVIII,313	314
XVII,163	1442a	XXII,53	38a	XXVI,294	153	XXVIII,54	270	XXVIII,328	346
XVII,164	1442	XXII,54	81	XXVI,295	200	XXVIII,64	293	XXVIII,332	323
XVII,327	1444	XXII,55	38	XXVI,296	173	XXVIII,65	274	XXVIII,333	345
XVII,403	1446	XXII,76	83	XXVI,298	201	XXVIII,67	295	XXVIII,335	344
XVII,415	1447	XXII,79	84	XXVI,304	161	XXVIII,73	294	XXVIII,337	329
XVII,416	1448	XXII,83	85	XXVI,305	157	XXVIII,75	301	XXVIII,338	325
XVII,417	1449	XXII,86	88	XXVI,306	160	XXVIII,76	282	XXVIII,339	347
XVII,418	1450	XXII,100	101	XXVI,307	158	XXVIII,78	286	XXVIII,345	328
XVIII,80	1452	XXII,104	79	XXVI,308	205	XXVIII,100	288	XXVIII,346	324
XVIII,492	1454	XXII,154	89	XXVI,309	164	XXVIII,101	271	XXVIII,347	327
XVIII,493	1454a	XXII,177	124	XXVI,310	166	XXVIII,102	285	XXIX,21	353
XVIII,498	1453	XXII,200	102	XXVI,312	170	XXVIII,107	300	XXIX,28	364
XIX,105	1455	XXII,206	96	XXVI,313	167	XXVIII,109	277	XXIX,32	352
XIX,447	1457	XXII,208	94	XXVI,314	175	XXVIII,111	284	XXIX,54	376
XIX,448	1458	XXII,210	98	XXVI,315	176	XXVIII,112	283	XXIX,56	333
XX,3	1459a	XXII,212	90	XXVI,316	218	XXVIII,113	297	XXIX,60	374
XX,4	1460	XXII,221	99	XXVI,317	178	XXVIII,114	287	XXIX,61	377
XX,5	1459	XXII,227	95	XXVI,318	177	XXVIII,115	278	XXIX,64	358a
XXI,10	4	XXII,235	110	XXVI,320	168	XXVIII,116	296	XXIX,65	358
XXI,11	4a	XXII,296	112	XXVI,321	179	XXVIII,127	307	XXIX,66	357
XXI,12	5a	XXII,334	113	XXVI,322	192	XXVIII,129	311	XXIX,77	361
XXI,13	5	XXII,425	116	XXVI,323	191	XXVIII,130	312	XXIX,78	365
XXI,17	2	XXII,437	93	XXVI,324	190	XXVIII,131	208	XXIX,85	379
XXI,19	3	XXII,443	118	XXVI,325	165	XXVIII,132	313	XXIX,92	353a
XXI,26	6	XXII,453	119	XXVI,326	163	XXVIII,136	309	XXIX,114	368
XXI,46	8	XXII,457	134a	XXVI,328	186	XXVIII,138	343a	XXIX,129	380
XXI,58	23	XXII,468	133	XXVI,329	162	XXVIII,139	342a	XXIX,162	381
XXI,73	24	XXII,472	129	XXVI,330	169	XXVIII,140	338a	XXIX,187	388
XXI,94	33	XXII,479	100	XXVI,331	197	XXVIII,146	310	XXIX,204	395
XXI,99	25	XXIII,4	1464	XXVI,332	184	XXVIII,152	279	XXIX,206	397
XXI,127	18	XXIII,33	1465	XXVI,333	181	XXVIII,155	320	XXIX,207	394
XXI,128	18a	XXIII,192	1466	XXVI,334	193	XXVIII,165	316	XXIX,211	389
XXI,194	41	XXIII,261	1467	XXVI,335	185	XXVIII,166	306	XXIX,217	476
XXI,200	34a	XXIII,262	1468	XXVI,336	183	XXVIII,167	309a	XXIX,241	413
XXI,202	34	XXIII,263	1469	XXVI,337	188	XXVIII,173	348	XXIX,243	465
XXI,203	27	XXIII,264	1469a	XXVI,338	180	XXVIII,175	305	XXIX,244	412
XXI,222	29a	XXVI,2	126a	XXVI,339	189	XXVIII,179	302	XXIX,245	421
XXI,223	29	XXVI,3	126	XXVI,340	187	XXVIII,181	337	XXIX,246	464
XXI,229	32	XXVI,4	125a	XXVI,341	182	XXVIII,182	336	XXIX,247	411
XXI,256	30	XXVI,5	125	XXVI,344	213	XXVIII,183	339	XXIX,248	466
XXI,296	39	XXVI,8	134	XXVI,351	174	XXVIII,184	340	XXIX,249	407
XXI,311	40	XXVI,16	140	XXVI,354	212	XXVIII,185	341	XXIX,250	461
XXI,312	40a	XXVI,98	146	XXVI,374	229	XXVIII,186	338	XXIX,251	460
XXI,338	37	XXVI,169	150	XXVI,375	223	XXVIII,187	342	XXIX,254	417
XXI,347	51	XXVI,173	149	XXVI,380	230	XXVIII,188	343	XXIX,255	416

Zervos numbers	Catalogue numbers	Zervos numbers	Catalogue numbers	Zervos numbers	Catalogue numbers	Zervos numbers	Catalogue numbers	Zervos numbers	Catalogue numbers
XXIX,256	415	XXIX,293	676	XXIX,379	582	XXX,9	682	XXX,51	701
XXIX,257	418	XXIX,294	410	XXIX,380	578	XXX,10	694	XXX,52	698
XXIX,258	414	XXIX,309	489	XXIX,381	557	XXX,11	691	XXX,53	700
XXIX,259	419	XXIX,312	741	XXIX,382	570	XXX,12	696	XXX,54	702
XXIX,260	469	XXIX,313	490	XXIX,383	575	XXX,13	689	XXX,55	702
XXIX,261	463	XXIX,347	534	XXIX,385	551	XXX,14	752	XXX,56	708
XXIX,262	462	XXIX,348	536	XXIX,386	631 (a)	XXX,15	733	XXX,57	721
XXIX,263	468	XXIX,350	565	XXIX,387	631 (b)	XXX,16	684	XXX,58	709
XXIX,264	450	XXIX,351	540	XXIX,388	631 (c)	XXX,18	686	XXX,63	718
XXIX,265	452	XXIX,352	532	XXIX,389	571	XXX,19	687	XXX,72	819
XXIX,266	454	XXIX,354	554	XXIX,390	572a	XXX,20	695	XXX,82	794
XXIX,267	453	XXIX,355	549	XXIX,391	574	XXX,21	692	XXX,88	798
XXIX,268	426	XXIX,356	548	XXIX,392	552	XXX,22	670	XXX,92	802
XXIX,269	456	XXIX,357	559	XXIX,393	603	XXX,23	834	XXX,98	808
XXIX,270	427	XXIX,358	559a	XXIX,394	606	XXX,24	837	XXX,120	855
XXIX,271	425	XXIX,359	548a	XXIX,395	604	XXX,25	725	XXX,151	841
XXIX,272	457	XXIX,360	547	XXIX,398	607	XXX,26	726	XXX,157	671
XXIX,273	458	XXIX,361	555	XXIX,400	605	XXX,27	835	XXX,222	843
XXIX,274	455	XXIX,362	566	XXIX,401	609	XXX,28	735	XXX,239	853
XXIX,275	459	XXIX,363	563	XXIX,402	591	XXX,33	750	XXX,262	833
XXIX,276	444	XXIX,364	560a	XXIX,403	608	XXX,37	749	XXX,267	861
XXIX,277	472	XXIX,365	560	XXIX,404	553	XXX,38	748	XXXI,203	1473
XXIX,278	441	XXIX,366	537	XXIX,405	564	XXX,39	704	XXXIII,267	1481
XXIX,279	445	XXIX,367	538	XXIX,406	580	XXX,40	747	XXXIII,387	1474
XXIX,281	443	XXIX,368	537	XXIX,407	567	XXX,41	727	XXXIII,439	1475
XXIX,282	473	XXIX,369	545	XXIX,425	634	XXX,42	740	XXXIII,513	1476
XXIX,283	474	XXIX,370	581	XXIX,432	667	XXX,43	732	XXXIII,514	1477
XXIX,285	471	XXIX,371	577	XXIX,440	648	XXX,44	737	XXXIII,516	1477a
XXIX,288	429	XXIX,372	614	XXIX,443	645	XXX,45	738	XXXIII,518	1478
XXIX,289	428	XXIX,373	630	XXIX,452	647	XXX,46	736	XXXIII,521	1479
XXIX,290	434	XXIX,374	621	XXIX,455	391	XXX,48	697	XXXIII,529	1480
XXIX,291	438	XXIX,376	592	XXIX,458	642	XXX,49	706		
XXIX,292	470	XXIX,377	598	XXX,1	707	XXX,50	705		

Drawings not appearing in the Zervos catalogue

Catalogue numbers	Catalogue numbers	Catalogue numbers	Catalogue numbers	Catalogue numbers	Catalogue numbers	Catalogue numbers	Catalogue numbers	Catalogue numbers	Catalogue numbers
3a	104a	138	231	337a	401	467	505	518a	558
8a	105	139	249	350	402	475a	506	519	561
21	106	142a	250	355	403	477	507	520	562
27a	108	147a	251	366	404	478	508	521	566a
28	108a	195	252	367	405	487	509	522	569
31	109	198	253	369	406	488	509a	523	572
39a	111	204a	255	369a	418a	494	510	524	573
47	112a	211	262	378	424	498	511	528	577a
51a	121	213a	273	381a	428a	498a	512	533	590a
86	122	219a	298a	385	439	499	513	535	612
86a	128	220	299a	386	440	500	514	536a	613
87	130	225	315	386a	442	501	151	539	616
101a	130a	226	319	390	446	502	516	541	617
103	131	228	330	398	447	503	517	550	618
104	137	228a	332	400	451	504	518	556	618a

Catalogue numbers	Catalogue numbers	Catalogue numbers	Catalogue numbers	Catalogue numbers	Catalogue numbers	Catalogue numbers	Catalogue numbers	Catalogue numbers	Catalogue numbers
619	719	793	889	949	1050	1182	1286	1349	1407
620	720	797	890	951	1051a	1201a	1287	1350	1408
635	722	799	891	953	1054	1216	1288	1351	1409
638	724	800	892	954	1055	1218	1289	1352	1410
639	726a	801	894	955	1056	1219	1290	1353	1410a
640	728	805	894a	961	1056a	1220	1291	1354	1411
641	728a	811	895	963	1057	1221	1292	1355	1412
646	729	814	896	967	1058	1222	1293	1356	1413
650	729a	815	898	969	1059	1223	1294	1357	1414
651	731	816	899	970	1060	1225	1295	1358	1415
651a	739	817	900	973a	1061	1226	1296	1359	1416
652	741a	818	901	976	1063	1227	1297	1360	1417
652a	742	821	902	977	1064	1228	1298	1361	1418
653	743	822	904	978	1065	1229	1299	1362	1419
654	744	823	905	979	1066	1230	1300	1363	1420
655	745	824	906	980	1067	1231	1301	1364	1421
655a	746	825	907	981	1068	1232	1302	1365	1422
656	746a	826	908	983	1069	1233	1303	1366	1423
657	747a	827	909	984	1070	1234	1304	1367	1424
657a	748a	828	911	985	1071	1235	1304a	1368	1425
658	751	829	912	1002	1072	1236	1305	1369	1426
658a	753	839	913	1005	1073	1237	1306	1370	1427
659	754	840	914	1008	1074	1241	1307	1371	1428
660	755	854	916	1009	1075	1242	1308	1372	1429
661	756	856	916a	1010	1076	1243	1309	1373	1430
661a	757	857	917	1011	1077	1244	1310	1374	1431
662	758	858	919	1012	1078	1246	1311	1375	1433
663	759	858a	920	1013	1079	1247	1312	1376	1434
668	760	859	920a	1014	1080	1248	1313	1377	1435
669	761	859a	921	1015	1081	1249	1323	1378	1436
672	762	860	922	1016	1082	1250	1324	1379	1437
677	763	860a	923	1017	1084	1251	1325	1380	1438
677a	764	864	925	1018	1085	1253	1326	1381	1439
678	765	865	926	1024	1086	1254	1327	1382	1440
679	766	866	927	1025	1087	1255	1328	1383	1441
679a	767	867	928	1032	1101	1256	1329	1384	1443
680	768	868	929	1033	1102	1259	1330	1385	1443a
680a	769	869	920	1034	1102a	1260	1331	1386	1445
681	769a	870	931	1035	1112a	1260a	1332	1387	1451
683	771	871	932	1036	1117	1262	1333	1388	1456
683a	772	872	933	1036a	1158	1263	1334	1390	1461
685	773	873	934	1039	1158a	1264	1335	1393	1462
690	774	874	935	1041	1159	1265	1336	1394	1463
693	775	875	936	1041a	1160	1266	1337	1395	1468a
699	776	876	937	1043	1161	1267	1338	1396	1470
700a	777	877	928	1043a	1163	1276	1339	1397	1471
703	778	878	939	1044	1163a	1277	1340	1398	1472
707a	780	879	941	1044a	1164	1278	1341	1399	
711	781	880	942	1046	1165	1279	1342	1400	
711a	782	881	943	1046a	1166	1280	1343	1401	
712	783	882	944	1047	1167	1281	1344	1402	
713	784	883	945	1047a	1168	1282	1345	1403	
714	789	883a	946	1048	1168a	1283	1346	1404	
715	790	884	947	1048a	1170	1284	1347	1405	
716	792	888	948	1049	1181	1285	1348	1406	